WALK WITH ME
Charles Dickens

JOHN COSTELLA

authorHOUSE®

AuthorHouse™ UK Ltd.
1663 Liberty Drive
Bloomington, IN 47403 USA
www.authorhouse.co.uk
Phone: 0800.197.4150

Published by AuthorHouse 01/02/2014

ISBN: 978-1-4918-8912-1 (sc)
ISBN: 978-1-4918-8911-4 (hc)
ISBN: 978-1-4918-8913-8 (e)

For Benjamin

CONTENTS

ACKNOWLEDGEMENTS

In researching this book I again entered a voyage of discovery which unearthed a host of interesting facts that were enjoyed by everyone who became involved in this book. Throughout each of these walks I have benefitted from the excellent assistance and wealth of information provided by members of staff from a number of libraries and archives, namely, the Barbican Library, the Holborn Library, Kensington & Chelsea Library, Marylebone Library, Shoe Lane Library, St Pancras Library, The British Library, London Metropolitan Archives, Guildhall Library, Camden Town Library, John Harvard Library and Finsbury Library.

My sincere thanks also go to Steve Potter who provided me with a great deal of local information on Southwark, as well as directing me to interesting locations to explore. Likewise I am very grateful to Marcus Risdell for giving me the opportunity to visit the Garrick Club and allowing me to read so many formal letters accredited to Charles Dickens, in addition to providing a great deal of information about the Victorian period. Similarly, I am indebted to Richard Jordan for the time, enthusiasm and enlightenment in explaining many interesting facts regarding Dickens early years in London and providing a personal tour of the Dickens Bi-Centenary Exhibition that he produced at St Luke's Church, Chelsea. I would also like to extend my sincere gratitude to Andrew Houghton who kindly allowed me to borrow several wonderful original Victorian journals, such as Curiosities of London (1855) for an indefinite period of time that not only captivated my interest but also enlightened my awareness of the 'rare and remarkable objects in the Metropolis'.

Finally, but definitely not least on my list of thanks, my dear wife Avril and daughter Louise, who deserve a special commendation for improving the quality of text and spending endless hours proofreading my work, not forgetting the fact that they had to listen constantly to my sometimes aggravating enthusiasm.

ILLUSTRATIONS

INTRODUCTION

Almost one hundred and fifty years ago Charles Dickens was close to the end of his life, a life which had experienced poverty and wealth, heartache and joy, all of which was made possible by circumstance and desire.

Life's sometimes kind and often cruel experiences had led Dickens on a continuous trail of investigation to understand, encounter and record the vagaries of a period in English history which changed so dramatically over a short period of years. What Charles Dickens mentally recorded in his absorbent and retentive brain provided the world with a plethora of outstanding literature that unlocked and provided a panorama of vision into the Victorian age. Major change was on the horizon and the world was to come of age in industry, politics, reform and travel, which in a relatively short period of years has remodelled our planet, for good or bad, into the 21st century.

Dicken's spent most of his adult life in London, which extended to every boundary of the Metropolis, a city that had grown substantially since the 18th century and developed into a capital of extreme societies. He enjoyed contrasting old architecture with new on his travels throughout Europe and America, and fully understood the need to experience each location he explored. Using various means of transportation throughout his travels, Dickens arguably enjoyed walking the best, especially those solo escapades in London throughout the nocturnal hours when his energetic mind failed to succumb to sleep.

From the age of twelve Dickens understanding of life entered a new stage of discovery when his family moved to London, and he was given the opportunity to experience first hand the enormous barrier between the social classes. His entire repertoire of characters

portrayed in his novels, papers and articles were all identified first hand, and stored in his mind when walking the endless maze of London's streets.

Like Dickens I am passionate about London although I tend to explore the architectural and historic aspects of our capital rather than its social attributes. My city walks, undertaken over a long period of years, have highlighted significant changes that London has undergone especially after World War II. Arguably I have encountered more visual change than Dickens may have experienced, with the introduction of high rise buildings dominating the skyline, a cleaner environment and certainly a much larger cosmopolitan community. Walking around the various boroughs and districts of our capital has revealed just how much 'hidden history' there is to discover, even street names usually have a fascinating provenance.

Dickens would have known many buildings of historical interest, even though the familiar Blue Plaque system we know today only started in 1867. Each plaque I see usually fires up my inquisitive imagination and places far more meaning on what is generally a standard location. When I read a plaque I immediately need to know more about the character it refers to, and my mind instantly attempts to visualise that same location in a much earlier period. Not every interesting building I come across has a plaque, which doesn't signify that it is any less interesting, in fact quite the opposite, as I usually see this as yet another challenge that requires researching.

With these thoughts in mind, I conclude how interesting it would be to have Dickens as an imaginary walking companion throughout a series of walks to former locations and buildings that he once knew, trying to envisage his comments and feelings from all that he saw. How would he react to the change around him both socially and environmentally, what opinions and arguments would he have when comparing his own inventive and creative era, compared to the 21st century? What would be his priorities today, would he object to the modes of travel, the arts, entertainment, dining, and social welfare? These and many more issues will no doubt manifest themselves on each walk, so with that in mind I intend to focus on historical facts mainly related to Dickens era, which he would undoubtedly have enjoyed.

As an artist, as well as an author, I shall include my own pen and ink illustrations to supplement the manuscript, and in doing so hope that

Dickens would have appreciated my efforts in providing a topographical and artistic account of each walk. I do not consider myself in the same league as Dickens talented illustrators, namely George Cruikshank, Hablet Knight Brown ('Phiz') or John Leech, however illustrations are an important aspect of my work as they were of his.

One important item I should point out is the fact that I will refer to the great man as "CD" throughout all my walks and ask his forgiveness in this matter. It is not my intension to shock followers and purists of Dickens, quite the opposite; I simply wish to link my commentary and his imaginary presence in some way to reflect the 21st century.

My interest in Dickens began as a child when I first watched the 1950's film Oliver Twist, unlike most followers of this great man I didn't read any of his novels until I was late into my adult life. As a young child watching that film I was made aware of an era, which I had no previous knowledge of and at the time it opened my eyes to the anguish and pain that was characteristic of the Victorian period. Coming from a lower middle class background I had no idea of the Victorian social depravities that children of a similar age had to endure and certainly no concept of the meaning of 'survival' in everyday terms. I was aware of the after effects of WWII and the damage inflicted by the Blitz as my parents lived and worked in central London up until the late 1940's. I clearly remember playing on those dangerous bombsites unaware of the frailty and danger of those locations, but I never once imagined or experienced what it was to be hungry, homeless or destitute, as many children were in Dickens era.

Whilst environmental conditions in the late 1940's were often atrocious due to the sulphurous fumes that contributed to the smog of that period, I guess conditions in Dickens time were slightly worse. Quality of life and living standards have greatly improved today, as have those horrific judicial penalties imposed for such trivial crimes. Central London in my early childhood was as I remember crowded, but there were reasonably efficient roads, railways, underground systems, food (although rationed), and I lived and played in a district which was seen as a safe environment. Pavements, streets and roads were firm and clean and if you were sick there was always somewhere to go for attention, Dickens had little if any of these basic worldly comforts as a child. When he grew older the comforts of Victorian

life improved for him in the society in which he lived, which I guess can be said for most people of my generation today.

As a child Dickens suffered both emotional and physical pain, setting himself aside from other children, and his early education was often cruel and non-informative. At ten years of age his father moved the family back to London, after a brief interlude living in Kent, which he enjoyed. Dickens idyllic life was soon to change as he became familiar with the vagaries of the capital, a lifestyle that fortuitously would generate ideas for his acclaimed academic career. His knowledge of street London began by walking out with his parents, then by making journeys of discovery alone into the mayhem of Victorian life. There was no gentle introduction to a massively overcrowded, corrupt and diseased London, which was made no easier when the majority of his family were imprisoned in the Marshalsea Jail, and both he and his sister were made to live apart.

In a far more acceptable fashion I too have explored the London districts that Dickens would be familiar with and for this journal will concentrate on the buildings he would have either rented, owned or socialised in. The geographical locations of each walk will at times overlap district boundaries, therefore the chapter headings are a generalisation of the immediate neighbourhoods and communities.

Using a street map of 1863 I make every attempt to follow possible routes that Dickens once walked and in doing so endeavour to capture the sights and scenes he would have encountered. My 1863 map, originally produced by Edward Stanford, is a wonderful example of Victorian cartography, as it identifies so many features of London familiar to Dickens, which have now disappeared. Edward Stanford deserves a word of mention for his fine work; born in 1827 he attended the City of London School, following which in 1848 he joined a business partnership with Trelawny Saunders who had recently established a map and chart shop at 6 Charing Cross (now 6 Whitehall). The partnership developed into the Stanford Map Company, which even today, is still providing first class charts and maps of the world.

Occasionally, I will remind the reader of certain events in Dickens life which are associated with each walk, however, I leave the biographical literature attributed to Dickens life in the articulate hands of the many noted authors, both past and present that have

published works. I should add however that without the knowledge I gained from reading several biographical works, the following chapters of my own journal would not have been possible.

Having geographically planned the sequence of walks into a spread of districts, it became obvious that it would not be possible to create a systematic group of locations in each chapter that were in sequential order to his actual movements. Fortuitously, this overlapping of boundaries and districts worked to my advantage, as I often discovered otherwise unknown and interesting facts.

Finally I share one other passion that Dickens also enjoyed, which was drinking coffee. Coffee houses in London evolved and took pace in the 17th and 18th centuries as public meeting establishments where customers were welcomed to discuss matters of commerce and general interest in a relatively alcohol free environment. Whilst on each walk I shall endeavour to highlight past coffee houses that were trading in Dickens time and assume that he knew of them and used them occasionally. During this period there were certain 'gentlemen's rules' which applied, and arguably coffee houses contributed to the 'Age of Enlightenment', where philosophers could rationalise scientific discoveries, religion, society, political and economic issues. By the time that Dickens had reached late middle-age coffee houses in London were in decline, social patterns had changed and people no longer gathered in these establishments, they preferred 'gentlemen's clubs' or eating establishments. Today, coffee houses no longer attract large vociferous groups of merchants in open debate, quite the opposite, they provide fashionable venues to socialise and relax in. People from all walks of life gather now to enjoy the superior coffee blends, eat quality food, study or work in relaxed and comfortable surroundings.

Dickens often frequented coffee houses, as I do, therefore I intend to share my frequent visits with one particular establishment, namely Caffe Nero, simply to enjoy their fine espresso coffee and food. For several years I have used this coffee house as I enjoy their own blended varieties and that extra kick which gives that Italian roasted flavour. Thankfully there are many Caffe Nero's to choose from on each walk, these give me the opportunity to rest, eat, drink and enjoy the day, in a civilised fashion, which I feel sure Charles Dickens would have approved of.

WALK ONE - STRAND

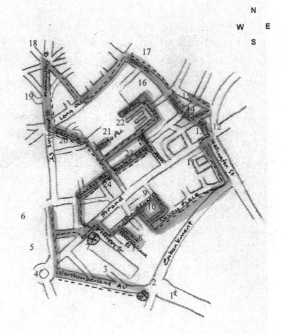

WALK 1

THE STRAND

"It was the best of times, it was the worst of times."
(A Tale of Two Cities—1859)

My walk today mixes the emotions of the theatre with youth and begins on the very edge of the Thames at a point where Charles Dickens (CD) would have been totally familiar for a variety of reasons. Looking somewhat different in appearance today, the area in question is where Hungerford Bridge sits on the Victoria Embankment. He would have been very pleased at seeing the completion of the Embankment which now stands as a backdrop to the rejuvenated Hungerford Bridge, and would certainly have had unpleasant memories of working there as a child at the age of twelve.

Standing at this spot I sense the torment and vague embarrassment that CD would have felt even though Warrens Blacking Factory site has long since been removed and replaced by the Playhouse Theatre. As every adoring fan of CD will know, Warren's was where he was put to work for all the wrong reasons, which made such an impact on his future and an episode in his life that was to be hidden for many years. His job as a boy was to put labels onto bottles of shoe blacking (a very lucrative business then) for the small wage of six-shillings a week (33p), which equates to £20.13 today! This mean amount of money would help to subsidise most of his immediate family who were confined in the Marshalsea Prison for non-payment of debts.

The factory was located at number 30 Hungerford Stairs (at this time fronting the Thames as the Embankment was yet to be built)

and remained as a business there until the adjoining Hungerford Market was torn down to make way for the fast expanding Charing Cross Railway Station. Thomas Warren, the owner of the factory, was a boot and shoemaker who also had premises in St. Martin's Lane. His two sons Jonathan and Robert created the blacking factory but later split partnership to form their own separate companies, following a long legal battle for the company's rights. This conflict later led to confusion of addresses and trading problems when the business diversified. There are differing reports as to which brother CD actually worked for, but eventually this untidy business unit was sold to the Chiswick Polish Company in 1913. CD's account of the factory is a grim tale, stating that it was a "crazy tumbledown old house, overrun with rats, the rotting timber floors would accentuate the sound of these grey rats squeaking and scuffling on the stairs, at all times". How different this area is today, still vibrant with people although mainly tourists, but completely free from those seedy labour intensive workshops. CD would have approved of The Playhouse Theatre, and also that Hungerford Bridge now accommodates both railway trains and pedestrians, this was not the case in his day.

On the 1863 map the area I am now standing in consisted of a series of wharf's which CD would certainly have been familiar with, namely Percy Wharf, Great Scotland Yard Wharf, Crown Wharf, and Middle Wharf, all of which served there respective owners. Great Scotland Yard faced Whitehall then, and there was an access route through to Northumberland Street, as it was then known, which travelled in the same direction but ended at the Strand beyond St Martin's Lane.

I have decided to walk from Hungerford Bridge along Northumberland Avenue in the direction of Trafalgar Square and in doing so make a short deviation down Craven Street to visit one special house that was once home to Benjamin Franklin, but before reaching this I see house No.26 which once accommodated Herman Melville the author of 'Moby Dick'. Craven Street today is much the same as it was during CD's age, and remains a very busy thoroughfare linking the Strand to the Thames; in those days there was limited access to the river. At No.36 I stop and view this beautifully preserved 1730's house, as are most of these terraced buildings and gaze upon the plaque, which tells me it was once the home of Benjamin Franklin. Franklin lived here for 16 years in an ambassadorial role,

most of that time spent in an attempt to improve relations between England and the newly formed America. Born in 1706, Franklin was an inventor, writer, painter, musician and philosopher, who became one of the founder members of the United States of America and worked extensively in England, France and his native America. He held many honourable positions in all three countries during his long and industrious life and he is sometimes seen as being the co-founding father and president of the newly formed USA. I feel sure CD would have known a great deal about Franklin, whether he would have been a follower of his political beliefs, I am not sure.

Making my way back along Craven Street, which was previously called Spur Alley, the new name being adopted in the 18th century at the same time as the land was sold to brewers by James I; who named a parallel road on the 1863 map Brewers Lane. The 5th Earl of Craven bought most of the houses here and developed the site we see today, in fact Craven Street has the longest stretch of 18th century housing of any other street south of the Strand. CD would certainly be familiar with this area and must have walked its streets many times. From Craven Street I backtrack to Northumberland Avenue and head towards Trafalgar Square being continually reminded of just how busy this area is, as it was in CD's time, the difference being that the sound of the traffic is far in excess of the horse drawn carriages that once paraded themselves here. Trying to imagine what CD's thoughts of transport today is a tricky one, I feel sure he would have welcomed any major improvements for modes of travel, being one who enjoyed travelling, as we know from his jaunts away from home. Today he would be spellbound experiencing new modes of travel, such as motor vehicles, jet planes and ocean liner's, just imagine what ideas would develop from his creative literary mind. The growth of London between 1750 and the first decades of the 19th century were fuelled by new wealth, created by the Industrial Revolution. Knowing and experiencing just how much change he encountered during this productive period would almost certainly have served him well as a sampler for the changes that were to evolve in the next 150 years.

Northumberland Avenue was formed after the 1863 map was produced, as originally it was the site of Northumberland House the ancestral home of the Earl of Northumberland who built his residence in this location, as did other noted people of

the 17th century. As a young boy CD marvelled when first taken by 'somebody' to see this grand residence and remembered in later years getting lost and having wandered off somewhere. In the mid 19th century most of the mansions in this area had been demolished largely due to the neighbourhood becoming industrialised, aided by the fact that the Duke of Northumberland had sold his land titles to the Metropolitan Board of Works for £500,000 (around £30.5m today). Today several government buildings occupy a good part of this busy avenue, namely the Ministry of Defence, the Air Ministry and the London School of Economics

Having arrived at Trafalgar Square I can now enjoy this wonderful arena of activity designed by John Nash in the early 19th century. Nash built here on instructions from George IV, in order to clean up what was then a very run down and disorganised area. CD would have seen the benefits of this redevelopment that we see here today as most of the work evolved during his adult lifetime. He would have revelled in the enlightenment of culture and arts that were shortly to be accessible to the public, but I am not so sure he would have approved of the vast sums of money being spent in this manner, as he would likely have wished that more funds be directed to the poor. I would guess that he might have visited the British Coffee House, a very popular meeting place of its time, which once stood in Cockspur Street.

Once the busy but dilapidated buildings of this district, then known as Charing Cross, had been demolished and cleared, the first stage of the development scheme was the National Gallery, which was started in 1832 and completed in 1838. Then followed Trafalgar Square itself, which was laid down in 1840 specifically to enhance the otherwise dull frontispiece of the National Gallery and provide a more interesting visual aspect. Construction began on Nelson's Column about the same time and took three years to complete, followed by the original fountains, which were altered in design in 1930. The bronze pieces were added later between 1840 and 1867 in addition to the four lions, each individual sculpture given a plinth. When visiting the square today visitors can enjoy different works of art that are regularly displayed on the fourth plinth, I wonder would CD have approved of the contemporary mixed with the traditional? On the 1863 map The National Gallery served also as the Royal Academy, which moved later in 1868 to its new location in Piccadilly.

The entrance to the Mall was considerably different in CD's day, as was the Mall drive, which incorporated four avenues of trees, and at the rear of the National Gallery stood St Martin's Workhouse. The Great Famine in Ireland in the late 1840's prompted many Irish labourers and their families to move to Britain, specifically London to chase work and they often ended up in one workhouse or another. St Martin's Workhouse was built around a former burial ground, it is shown quite clearly on the 1863 map as being one huge building nestled between St George's Barracks (long since gone to accommodate the extension to the National Gallery and the Portrait Gallery) and Charing Cross Road. It is worth mentioning that this workhouse had a terrible reputation, conditions were found to be appalling and the workhouse became the subject of a damming report in the Lancet. In the wake of this report the Metropolitan Asylums Board was formed and immediately had the building demolished in 1871!

Across the road from this workhouse still stands the church of St Martin's in the Field, which sits peacefully overlooking the square, a far cry from the bedlam of the late 19th century. There has been a church on this site since Roman times, thought probably to be burial grounds outside of the City walls. The original church built by Henry VIII in 1606 and later enlarged by James I, became dilapidated and therefore a new church was commissioned in 1720 and completed in 1724 to a design by James Gibbs. Prior to Trafalgar Square being developed, St Martins was hemmed in amongst a rather busy area that accommodated courts, houses, and a watchtower with assorted 'sheds' many of which were in direct contact with the walls of the church. Various 18th century notables are buried here, one being Thomas Chippendale (master cabinet maker and furniture designer) whose workshop was close by in St Martins Lane. The 1606 church entombed the bodies of Nell Gywnne and Robert Boyle amongst other fashionable people of that era but when the church was demolished their respective relations were allowed to re-intern their bodies. Even today St Martin's acts as a shelter for homeless individuals which is apparent when walking around the entrance, CD would have experienced this also in his time, so he would be familiar with this sight as indeed he was with many others in his life long plight to improve standards for the poor and needy.

Having almost circumnavigated Trafalgar Square it is time to move on along the CD trail so I now head to The Strand, which was first used by Roman settlers to form the main route linking Watling Street to the Fossee Way. This stretch of road was originally given the name of Ackemen Street, and was the main link from the Palace of Westminster to the City of London. The Strand was first given its title as a district in the Metropolitan area of London in 1855 when the entire area was under the control of the county of Middlesex, this was before the development of the London County Council (LCC). Today the Strand is now recognised as the street that starts at Trafalgar Square running eastwards to join Fleet Street, and along its route defines the boundary of the City of London.

Originally the riverbank of the Thames bordered onto the Strand (its original name in old English means bank or shore) but once the Victoria Embankment was completed the road then adopted the title Strand. Large palaces and mansions once lined the Strand but were removed by various property developers of the day. The area then went into a period of social decline having introduced many dubious coffee houses, cheap taverns and brothels and it was only in the 19th century that much of what we see today was rebuilt at the same time as the Victoria Embankment (1865-70). It was around this period of redevelopment that CD and many other noted intellectuals would have gathered to form various societies and clubs. The area then became more recognised for its theatres and nightlife and many of these wonderful buildings still remain such as the Lyceum, Savoy, Adelphi and Royal Drury Lane, all of which we will come across later in the walk.

Although the Strand itself is a feature of this walk, apart from one or two buildings that line its route I shall be exploring streets and places of interest north and south of this passage, the first being Charing Cross station itself. I can only imagine just how much interest and enthusiasm CD must have shown when this station was built in 1845 on the site of the Hungerford Market, as the market held no fond memories for him. The original Hungerford Bridge, built by Brunel, once crossed the Thames at this point, and was later demolished and replaced by a wrought iron replacement designed by Sir John Hawkshaw. Today's bridge retains its original design, however, the walkways were renewed for the Queen's Golden Jubilee in 2002.

The railway station was opened in 1864 and one year later the hotel was built as a frontispiece, CD would have used this facility and marvelled at its innovation, he wasn't however around when its roof collapsed in 1905! CD would also have been delighted in the fact that the station provided one of the first boat trains to Europe, a facility I feel sure he would have fully utilised. One interesting memorial sits inside the enclosed entrance to the station that millions pass every day, but few know what it represents; this is the 'Eleanor Cross'. The seventy foot high memorial to Eleanor of Castile, wife of Edward I, was erected in 1865 and replaces the original Cross which was built in 1291 and destroyed by Parliament during the Civil War. Originally the cross stood on the spot facing Whitehall where the bronze statue of Charles I now stands. Eleanor was devoted to Edward, and likewise he is said to have been sincere and honest to her throughout their marriage, by not keeping other women or fathering children outside of wedlock. When Eleanor died, Edward had twelve crosses made in her memory, which were erected between York and London (her funeral path) several of which remain to this day. The memorial at Charing Cross is recognised as being the central point of London, and therefore all distances to London are based from this reference point.

There were several coffee houses for CD to use in this area all located on the Strand, one of them being the Cigar Divan at No.102, where upon entry CD would have been offered a cup of coffee, a cigar and the use of newspapers and chess board! Another less salubrious venue was George's Coffee House at No. 213

As I pass the station and am about to walk down Villiers Street my interest is focused on a modern building to my left, namely Coutts Bank. This is the HQ of one of the oldest London banks (1692) and deals with private banking and wealth management. I have followed the early fortunes of this bank since I discovered on my regular trips to Venice that entombed in the San Moise church, close to Piazza San Marco, lies the body of John Law. It was Law, who in the early 18th century, as Comptroller to the French Government owed a great deal of money to Campbell's Bank (as Coutts was then called) following the English stock market collapse. It took many years for the bank to recover and eventually the granddaughter of John Campbell married a merchant in 1755 named James Coutts. James took his brother Thomas into partnership and eventually

Thomas's granddaughter Angela Burdett inherited the entire wealth of the bank in 1837. Angela took the name of Coutts and became the wealthiest woman in Britain, and devoted her entire life to philanthropy donating more than three million pounds to charities. CD became a life long friend of Angela's, advising her of charitable issues which would benefit from her support, and taking on projects such as the 'ragged schools' and the 'home for homeless women', of which both were generous supporters. Today CD might look upon this now active finance company and compare it to his own life, where he became wealthy, but went perilously close to the wall on many occasions whilst attempting to manage his own finances. All this is especially poignant having written those famous words by Mr Micawber in David Copperfield, relating to income and expenditure!

Having now turned into Villiers Street, which is a busy route to the Embankment Tube Station, I notice the covered walkway suspended across the street from the station and would imagine that this once linked the original hotel with the station. Nicholas Bourbon originally built Villiers Street in the 1670's, after the Great Fire, on the site of York House, owned by George Villiers (Duke of Buckingham) whose family name is quite prominent around this location. George Villiers was a favourite of James I who knighted him in 1623, unfortunately he was murdered in 1628 and his properties went to his son who sold the buildings to make way for the street. One condition of sale was that all the surrounding streets were named after the family i.e. George Court, Villiers Street, Duke Street and Buckingham Street. Nicholas Bourbon had a wonderful name, which read, Nicholas-Unless-Jesus-Christ-Had-Died-For-Thee-Thou-Hadst-Been-Damned-Bourbon! In the gardens at the end of the street sits a magnificent water-gate, originally part of York House which we will see later. John Evlyn (1620-1706) an English writer of note lived in this street in the 17th century, as did Richard Steele (founder of the Spectator and The Tattler), Charing Cross Medical School was also founded here in 1834. Prior to 1865 Villiers Street ran directly down the hill to Villiers Wharf, today the Thames is 50 metres south of that point following the construction of the Embankment. There were houses on the west side of the street in CD's day but all were demolished in 1860 when the railway was built.

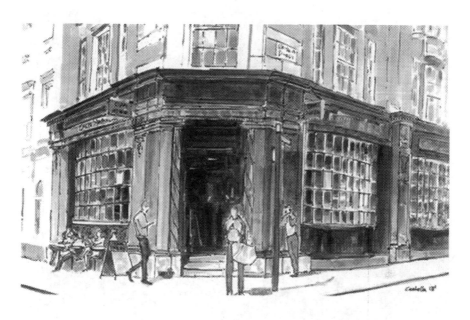

Fig 1 Caffe Nero, Bedford Street

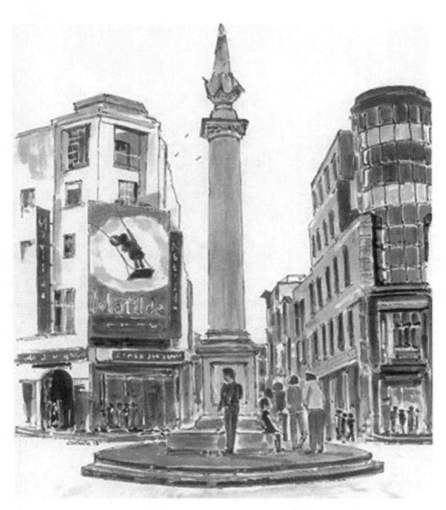

Fig 2 Seven Dials

Most of the buildings in this street would have changed since CD's time but there are still quite a few earlier examples in the immediate area to explore, which we will come across as I turn left into John Adam Street and walk a few yards to Buckingham Street.

CD would know Buckingham Street very well as he lived here as a young man at No.15 in 1834, sadly this building was destroyed in WWII and rebuilt in later years. Whilst living here CD worked as a reporter for the Morning Chronicle, which ran from 1769-1862 and it was at this period that he published short stories under the pseudonym of 'Boz'. No 15 at that time directly overlooked the Thames and the river boundary came very close to the house wharf, known later as Watergate. The building at the southern end of the road was then called York Stairs (now Victoria Gardens) and the Watergate is still there to view. Directly opposite the location of No.15 stands No.12, which also has some history, as it was once the home of Samuel Pepys who lived there from 1679-1688. Pepys lived there after being liberated from the Tower during the early Restoration period. Would CD have been influenced by the past presence of such a noted diarist? I would like to think that he may have researched Pepys work, lodging something away in his memory and later introduced some ideas into one of his own works. Whatever the case, Buckingham Street today remains much as it did when CD lived here and I feel sure that he enjoyed his brief stay at this address.

Before we return to John Adam Street it is worth walking down the few steps opposite No 14 to Victoria Embankment Gardens to get a closer look at the York House Watergate. Perhaps now is a good time to very briefly explain when, why and how the Embankment evolved and just when the beautiful gardens I am now entering were established (neither of these existed in CD's time.)

The York House Watergate, which now stands about 137m from the Thames was first built in 1626 and was later renovated, it originally stood beside the rivers edge prior to the construction of the Embankment. The gardens themselves were designed once the embankment had been completed and each individual garden is well worth visiting. Victoria Embankment was a major project conceived and designed by Sir Joseph Bazalgette, a civil engineer (Metropolitan Board of Works). Bazalgette, in my opinion, has been hidden in the mist of time when he should be celebrated on a scale similar

to all the other architectural designers of London. The reason for constructing such a large embankment was primarily to introduce a modern sewage system capable of containing and treating all of London (a gigantic project) and to relieve the vehicle congestion on the Strand and Fleet Street. Sewage waste during the mid 19th century had become a gargantuan problem and caused innumerable cholera epidemics, Bazalgette with the help of several others eradicated this problem.

Prior to the Embankment construction the Thames provided river access for watermen and sailor men with a series of small piers, creeks, pontoons, docks and wharfs to enable access for boat craft to land. In the early 1860's piers and creeks mainly serviced the river from Putney to Chelsea Reach, whereas the river from Chelsea Reach to Limehouse Reach and beyond was a constant bevy of wharfs and stairs. Much discussion and conflict followed between the 'river people' and property magnates to establish a sound reason for building an embankment, the wharf men saw it as a threat that would ruin their livelihoods, whilst the wealthy home owners saw it as the only solution to improve the vista of their properties. Government intervention and planning constraints took the side of the construction theory, which would link the waterfront from Chelsea to London Bridge. When Bazalgette eventually built a mammoth series of enormous underground sewers and pumping stations he relieved London of the filth, disease and smell that sewage had contaminated, including the River Thames. In building this system he was able to introduce tunnels below ground for the future underground system, reclaim land from the river and build a clean and serviceable river embankment, as well as introducing several splendid walkways and gardens for the general public to enjoy. I in no way wish to understate just how important his work was and hope that my brief resume is sufficient for the reader to understand just how his work shaped London; my previous book provides much more detail on this great engineer.

We now walk back up Buckingham Street to John Adam Street turn right then follow this historic route, which lends its name to a great architect of the 18th century. But before we actually get to one of John Adam's well-catalogued houses perhaps a few words about this location. On the 1863 map this street was formerly called York

Place and the site of a 'ragged school' of the same name, which was founded by the philanthropist Quinton Hogg in 1864. CD must have known of this school because of his involvement in earlier schemes of the same nature, as he was a supporter of this charity especially the Field Lane Ragged School in Clerkenwell in 1864, where he constantly donated funds.

Most of the buildings along John Adam Street to the right, heading east, are fairly modern by design, and although in character with those that are older, would be unknown to CD. With the aide of his brother Adams built a large number of wonderful buildings that still survive in this area and in doing so reclaimed and rejuvenated what was once a marshland. The Adams family were recognised as being prolific architects of their era, the nearby Adelphi Theatre and another building of a similar name, were adopted from the ancient Greek word meaning 'brothers' as a mark of respect. Their architecture incorporated a wide range of classical designs such as Palladian, Byzantine, Roman and Baroque, but perhaps not quite the scale as those masterpieces one would see on a Venetian canal.

One such building, which I find very attractive, is No.16, with its red brickwork and white stone facing that stands on the corner of George Court and John Adams Street, namely Buckingham House. The blue plaque on the wall tells us that Thomas Rowlandson once lived in this house, and informs us that he was a noted caricaturist of the 18th century, and as an artist studied at the Royal Academy and in Paris. Rowlandson was best known for his animated character John Bull and throughout his lifetime made, as well as wasted, vast sums of money on the gambling tables. From my limited research into his work I found that he was extremely good at depicting the society he lived in, and like Hogarth produced many saucy and sometimes smutty works. Although he died in 1827, CD would not have met him, but I see a similarity in artistic expression as both these giants of the arts studied all levels of society and produced works to depict both political and topical sketches that the public could share and enjoy. Definitely someone CD would have invited to his club for dinner, and a drink or two.

Walk a further 150 yards down John Adam Street we reach The Royal Society of Arts, a building designed by the Adams brothers, which is very special for many reasons. The society has a colourful

history, which dates back to 1754, and was founded by William Shipley (1715-1803) a drawing master, reformer and inventor. Its aims when first set up were to encourage enterprise, enlarge science, refine art, improve manufacturing and commerce, reduce poverty and secure full employment! That is as close to being a political party with character, and a manifesto that would grace any nation. Noted fellows and members read like 'Who's Who of the past 250 years, some favourites of mine being Benjamin Franklin, William Hogarth, Stephen Hawkins and of course Charles Dickens. The Society had several 'spin-offs' throughout its history, namely the Royal Academy of Arts, which includes members such as Thomas Gainsborough and Sir Joshua Reynolds. The RSA launched the first modern public examinations in 1882, and was the National Training School for Music, which later became The Royal College of Music. The Society awarded prizes known as 'premiums', which were given to people who successfully achieved a published challenge. One example being Capt William Bligh who made several attempts to ship 'breadfruit' from the East to the West Indies, which he eventually succeeded in doing and won his premium.

Today the RSA now occupies 2-6 John Adam Street as well as 18 Adam Street, which incidentally was the same address as the Adelphi Tavern who were its first occupants, the tavern being mentioned in The Pickwick Papers. We also have the RSA to thank for founding the Blue Plaque Scheme, which has kept me entertained for several years.

Having enjoyed looking at the façade of the RSA I backtrack along John Adam Street and turn into Robert Street, which features in the 1863 map, and will now walk around the majestic Adelphi Building. In doing so I pass several Georgian buildings beautifully preserved and at the end of the road notice an unusual building constructed of yellow stock bricks that although appearing to be single storey is in fact supported by a lower part that merges into Savoy Place, this could be the only remaining part of the original Adelphi Buildings. I can't help but notice at this point the wonderful architectural features of the Adelphi Building to my left, but before explaining more about this iconic structure I shall walk down the staircase from Robert Street, which will lead me onto Savoy Place. Once down the stairs I am now standing where the riverbank of the Thames once flowed, and look along this short stretch of road that

leads to Savoy Street. The street is used today as a route into the Savoy Hotel as well as access into the Strand, but once harboured a group of private wharfs, many of which have featured in several recognised works of art. I now retrace my steps back up the staircase to enjoy the Adelphi building.

The site I am now standing on was originally part of Durham House, built in 1345 for Bishop Thomas Hatfield. The hall and chapel of this building once faced the entrance, with private apartments overlooking the Thames. The gatehouse was in fact on the Strand side, which led to a large courtyard. Both Henry IV and V stayed in this palace which was eventually 'confiscated' by Henry VIII who then gave it to his daughter Elizabeth I. After changing ownership many times Durham House fell once again into the hands of Elizabeth I (after Lady Jane Grey was married here). Elizabeth eventually gave the house to Sir Walter Raleigh in 1593 and he lived here until the Queen died. Once Elizabeth passed away, the Bishop of Durham re-claimed the house with James I approval, but after a short period of years the house became dilapidated and certain parts of it were demolished. What remained of the house was then occupied by a group of milliner's shops that utilised the upper tiers on each side of the buildings central alleyway.

In the 1630's the Durham House Group (high church Anglicans) settled here and it was at this period that Durham Street was built by the Earl of Pembroke. The last remains of Durham House were cleared away during George III's reign and it was at this time that the brothers John and Robert Adam built the original Adelphi Buildings (1768-72). Many pictures, sketches and drawings of these buildings were commissioned and each one depicts the wonderful raised arches that were so prominent along this once fashionable wharf. CD would have known and visited at least one, possibly several of these fashionable residences during his productive years in London. The Adelphi Buildings were originally constructed as neo-classical terraced houses, occupying the land between the Strand and the Thames. Each of the terraced houses (11 in all) consisted of large front vaulted facades with wharfs running below the terracing we see today.

Unfortunately, all eleven terraced houses, which made up this very desirable group of residences were demolished in the early 1930's, causing a great deal of controversy, and replaced by the New

Adelphi Building, leaving only part of the original construction which is now offices of CIPFA. The New Adelphi Building we see today is a steel framed structure clad in Portland stone and constructed using vast amounts of concrete, but never the less a monolithic construction. Its strong Art Deco design is so typical of its age with curved balconies and bronzed artefacts, together with the jazzy patterns around each entrance point. The four enormous allegorical figures visible from the Thames elevation depict from west to east, Dawn, Contemplation, Inspiration and Night, each piece of work inspired by Gilbert Ledward. Equally attractive are the coats of arms of UK cities appearing at ground level, with the smaller panels depicting a variety of zodiac signs, agriculture and industry. N.A. Trent designed the attractive Art Deco carvings; depicting 'toiling workers', which collectively make up a very special Grade II listed building.

Internally, the Art Deco theme continues, none more so than the amazing entrance hall, which is accessed from John Adams Street. In the reception area two creative plaques either side of the reception desk inform visitors of the cast of notable celebrities, who in past generations were owners, tenants or simply guests of these former Georgian terraced houses. Some of those names include, Robert & James Adams, Richard D'Oyly Carte, David Garrick and many more masters from the past. There was a public hew and cry when this building was constructed not because of its design, but the fact that in order to erect it the original Adelphi Buildings were demolished, this is unforgivable, but it doesn't in any way take away the beauty of the New Adelphi Building which records a new generation of architecture. I'm not sure what CD's thoughts would be today, he surely must have appreciated the group of Adams buildings, and who is to say that their replacement, which incorporates many new art forms, would not appeal to his creative mind. A mixture of old with the new and the union of changing fashion and art must have excited CD in his quest for realism.

Having enjoyed this very fashionable area of the Strand I make my way back towards Adam Street simply to reach the Aldelphi Theatre. Before reaching the Strand I notice a plaque on a building to the right stating that it was from this location that a group of emigrants 'foundling settlers' left these isles and made their new home

in New Zealand, in the 18ᵗʰ century. At the top of Adam Street I can clearly see the Adelphi Theatre (named after the original building) and although the exterior appearance is arguably in need of refreshing its history is assured for all time. Founded in 1806 by merchant John Scott whose daughter Jane (theatre manager, performer and playwright) eventually obtained a licence to hold pantomime, melodramas, farces and comic operettas. The theatre took its present name in 1819 due to its ties with the original Adelphi Buildings and specialised mainly on melodrama. Once CD had become popular with his early stories, the theatre adopted many of them, the first being 'The Christening' in 1834, following which many other works were adapted for the stage. These performances continued throughout the next two decades before the theatre was eventually demolished in 1858. CD would have known this building very well and certainly would have visited it often during this period.

The second theatre to be built on this site became equally as popular with the public, but was marked with a real life tragedy. In 1897, a fellow actor, whilst entering the theatre through the royal entrance in Maiden Lane stabbed one of the theatres most popular actors', William Terris, to death. It is said that the ghost of Ferris still haunts Covent Garden Tube Station and the Adelphi Theatre! This theatre lasted until 1901 when it was demolished and its replacement built to accommodate a larger audience. The forth theatre on this site, the one we see today, was built just thirty years later, in the Art Deco style, and renamed the Royal Adelphi Theatre. Having only visited the current theatre twice my memories of its interior are vague, however, being told that Andrew Lloyd Webber may have a commercial interest in it I feel sure that future shows and performances will be of the highest standard. As for CD's views I hope that he would appreciate the talented playwrights of this age and understand just how popular modern musical performances are in keeping theatre alive and healthy. Certainly CD would have been mindful of the range of theatres during his lifetime, from the penny gaffs to the grander venues, therefore logically one would assume that today's theatre-land, which still retains a certain style and presence would please him.

Before I head back down Adam Street, I have noticed Caffe Nero on the Strand, which I have used many times before but

on this occasion I shall wait until I reach the Covent Garden area before enjoying the superb coffee they have to offer. Having seen the Adelphi Theatre I now head back down towards the Adelphi Building, and then walk down the far set of stairs on the left which take you to Savoy Place once again, this time I shall walk to the end of this road until we reach the rear of the Shell Mex House. This building, with its main entrance on the Strand, was built in 1930-31 on the site of the former 17ᵗʰ century Cecil House. The Shell Mex building, like the Adelphi, is Art Deco in style and was once as its name would imply the HQ to Shell Mex, today it belongs to Pearson Plc Group and is a registered office for companies such as Penguin Books and Rough Guides. More importantly for this walk is the fact that on the 1863 map it clearly shows Cecil Street, and it was in this street that CD once lodged in 1832, unfortunately the site of his former lodgings are now buried under the Shell Mex building. Close by to this area were Roman baths, in Strand Lane, which CD used during his brief stay here whilst the rest of his family were moving around to escape creditors, the baths can still be viewed today.

For the final time I am now making my way back to the Strand walking up Savoy Street and I cannot pass the Savoy Chapel without mentioning some of its history. The chapel is dedicated to St. John the Baptist and was originally built in the middle ages as part of the Savoy Palace, which later became a hospital of the same name. Through time and neglect the hospital became a ruin by the 19ᵗʰ century and the Chapel is all that remains today. The original church was used for a period after the Great Fire (1666) by St Mary-le-Strand church, until their new church had been rebuilt. The chapel oddly enough has changed denominations many times in the past but as an Anglican church in the 18ᵗʰ century it was allowed to conduct marriages without the traditional 'banns' being read. Few original features remain but there is a wonderful stained glass window, which was built in dedication to Richard D'Oyly Carte, who was married here in 1888. The chapel is still owned by the Duchy but the general public can worship here at specified times or just simply visit most days other than Monday's. In 1999 for the Queens Golden Jubilee, the gardens were landscaped and the chapel ceiling restored. Interestingly, the chapel is one of the very few that still use the 1662 King James Bible. CD would approve of the care and attention given

to this historic landmark of London, which is hidden away from the clamour of the 21st century.

Having reached the Strand once again, I cross over the road and make my way to Wellington Street, but before doing so I pause to look back towards Waterloo Bridge, and wonder just how much change has taken place since CD lived here. The bridge is new but Somerset House remains the same, and would certainly be familiar to him since his father John had worked there when CD was young. Looking down towards Fleet Street one can just pick out St Mary-le-Strand and beyond to St Clement Danes and although the Aldwich crescent had yet to be built many of the surrounding roads and streets such as Tavistock Street and Catherine Street would have been familiar to CD. Wellington Street however does not continue down to Waterloo Bridge as it did on the 1863 map, it has since been replaced by Lancaster Place.

CD spent a great deal of time living and working in Wellington Street, which was a most convenient address to have for social as well as practical purposes. At No.16 (now a modern office complex) CD once had an office there when writing 'Household Words' and this building featured many times in conversation in later years. In his biographical works he constantly records how much time he spent here both working and 'sleeping'. The location suited him perfectly as it was in 'Theatreland' as well as being close to many good coffee houses and restaurants. On numerous occasions he was said to have recorded that nothing was better than hearing the last cab going home and the first market barrows being pulled along the noisy streets, these statements refer to the twilight hours when he was supposedly resting, I can't imagine just how noisy, dirty and dangerous it must have been during daylight hours. Being a resident so close to the markets, shops, wharfs, and inns surely resulted in an infestation of crime and disease to a scale hard to imagine, why then did CD enjoy the 'rhythm' of these activities during the only period of rest following a day's labour? Just a few yards further up Wellington Street is No.26, where CD later moved to and started his journal 'All the Year Round' in 1858; these were larger premises providing private apartments and more domestic space in which to relax.

Opposite the former site of No.16 stands the Lyceum Theatre, which shares its roots back to 1765, the current building having

opened in 1835. The facade of this much restored building is quite impressive and the theatre can boast being the first to have a balcony overhanging the dress circle as well as introducing gas lighting. In the early 19th century the Drury Lane Company used the theatre extensively for a period of years as their theatre had burnt down. During the mid 19th century many of CD's novels and Christmas stories were enacted here. Charles Fechter was the theatre manager at that time, who befriended CD and from all accounts was quite a character even though he was said to be bad tempered and a sponger. None the less CD liked him and eventually endorsed his application for membership into the Garrick Club, which was accepted, albeit for a short period of time. CD spent a great deal of his time working with Fechter, and I suspect even in his mature age delighted in 'treading the boards', as he had adored every aspect of stage life since he was a young man. In more recent years the Lyceum faced closure for road widening purposes, which thankfully were later aborted, however, the theatre did become a ballroom for some years. Again in 1968 the Lyceum was put under threat of closure but fortuitously it was given a Grade II listing in 1973 thereby preserving its future.

Exeter Street stands adjacent to the Theatre and has remained unchanged since the 1863 map, and CD would have been familiar with the social problems, which encompassed this area. Newspaper articles report that there were numerous complaints from ratepayers regarding street traders who had become impoverished, and subsequently their trading standards had lowered whilst working in this location. One ongoing problem was prostitution, and it was recorded that one householder was keeping a brothel much to the dislike of the local inhabitants. Many reports were lodged with the police regarding the women of this particular house constantly crying 'murder' and always parading themselves almost practically naked in the street whilst in the company of drunken men. Just what were CD's thoughts on this matter, as he must surely have been aware of circumstances, and did he later use this as material for his work?

Just beyond Exeter Street, still walking north along Wellington Street sits Tavistock Street, and like Exeter Street had a very mixed group of residents living there during the mid-19th century. This street has changed little since late Georgian times and in fact I can make out one building that claims to have been built in 1656, 10

years before the Great Fire, perhaps I need to investigate further! There were several milliners and draper's shops here and like all small businesses no doubt had many goods displayed outside as well as cluttering the internal window area. It was not unusual for those who worked in these premises to also sleep in them, in most cases the upper floors were often sub-let to poorer workers in conditions boarding on slums. There would almost certainly have been dozens of street vendors working this area, some with stalls others simply carrying trays, all making a din in an attempt to attract trade. Records state that the parish surveyor had received numerous complaints regarding noise and the general condition of the surrounding streets, some residents claiming that sleep was impossible, again I question the fact that CD actually enjoyed these conditions as he claimed to, but then he was a complicated man, and full of contradictions.

Running parallel with Wellington Street is Catherine Street, and as with most other thoroughfares in this district, was laid out by the Earl of Bedford in the 17th century. I cannot fail to mention at this point, that to my left is Covent Garden and beyond that is The Royal Opera House, which we will explore later. Catherine Street eventually joined Bridges Street on the 1863 map, before reaching Bow Street where we are now heading I should also mention that CD, in his time, would have been aware of the smoke that drifted daily from the Papier-mâché works nearby, which has since been removed, as have many of the buildings of the early 19th century, however one iconic building still remains, namely the Theatre Royal Drury Lane.

The theatre we see today is in fact the forth to be built on this location, the first being built in 1663 (making it one of the oldest London theatres). Nell Gwyn was one of the first actresses who appeared here during the Restoration Period; unfortunately this theatre was burnt down in 1672. Christopher Wren designed the second theatre, which opened in 1674, and which survived for almost 120 years. Wren's theatre was eventually demolished in 1794, and within a couple of years the third building was erected, this one only survived for 15 years before also burning down in 1809! The forth theatre on this site was completed in 1812 and has survived for 200 years, and is now owned by Sir Andrew Lloyd Webber. Today's Theatre Royal is listed as being Grade I, and I really do like the exterior appearance and facade, both the colonnade and portico

being added a few years later, a feature which really does add value to its period and so realistic of the early 19th century. In its early days the current theatre experienced many problems, which caused concern as the productions were said to be of a 'lesser standard'. From 1826-1843 most productions were said to be financial disasters and ownership passed on to several entrepreneurs. The theatre's fortune rose again in the 1870's when it hosted annual pantomimes and presented more dance performances. Drury Lane is known today in theatreland as being the most haunted theatre, an inheritance that most actors see as a sign of good luck. CD would have been fully aware of these historical facts and certainly of the ghost called the 'Man in Grey' whose remains were found in a walled up passage in 1848. Other ghosts said to haunt this theatre are Joe Grimaldi and Dan Leno, both remarkable thespians of their age.

David Garrick (1717-1779) played an important role both here and in the world of theatre in general. Garrick deserves some mention as being a playwright, actor, manager, producer and friend of Samuel Johnson. The son of an immigrant Huguenot family he received a good education before enrolling in Samuel Johnson's school at the age of nineteen. He later opened a wine business that simply didn't flourish, and amateur dramatics being his first love he eventually decided to become a playwright and actor. After several successful years travelling the country, at which period he was initially rejected by Drury Lane, he was invited to join the company, which in later years he managed entirely and prevented its closure. Acclaimed as introducing revolutionary changes in the theatre (much the same as we see today) Garrick introduced a more relaxed rather than bombastic style of acting. His greatest legacy, apart from his performances, was summarised by an historian of his period who wrote, "The deaf hear him in his action, and the blind see him in his voice". So great was his 'reformation' of the theatre, he was the first actor to be given the honour of being buried at Westminster Abbey.

Moving away from Drury Lane we turn left down Russell Street and arrive at Bow Street, then head north to Long Acre. As I am so close to the Royal Opera House perhaps I should mention this wonderful building from this elevation. This iconic building is home to the Royal Opera, Royal Ballet and Orchestra, and was originally called the Theatre Royal. The building we see today is the third

edifice following calamitous fires to the previous two theatres in 1808 and 1857 respectively. Only the façade, foyer and main auditorium date from 1858 therefore CD would not be familiar with the new interior, which was constructed in the 1990's and is now a Grade I listed building. The original theatre of 1732 was mainly a playhouse but was soon given its Royal Charter by Charles II. Actor/manager John Rich introduced pantomime in order to be more competitive with its neighbouring theatre and in 1734 the first ballet was performed at the Opera House, at this time George Frederick Handel was named as its director of music.

Following the fire, which destroyed the first opera house, the rebuilding programme was very quick and architect Robert Smirke completed the rebuild by 1809. Shortly before the theatre opened, seat prices were increased, which upset the public and almost started a riot, consequently for the following several months there were major disruptions to performances until the demands of the audience were met. CD visited this theatre many times and at one period in 1831 decided to audition here for an acting part. Having fancied himself as an actor, he was given the opportunity to audition; but unlucky for him but lucky for us, he went down with influenza shortly before the arranged date and never endeavoured to try again. Grimaldi performed many pantomimes here following his success at Covent Garden, and though very successful as the harlequin 'Joey' never followed his father's role as ballet master at Drury Lane. We owe a great debt to the clown/actor Grimaldi as it was he who introduced the tricks of pantomime, such as audience participation, the dame, and exhausting and physical dance, sadly he became penniless by 1828. During the early 1800's gaslight was introduced into the theatre but by 1837 a new innovation called 'limelight' was staged, this form of theatrical lighting was a mixture of quick lime heated by a flame which engineered a spotlight effect thereby highlighting the performing actors.

After much controversy and dispute by other ballet companies, many performers transferred to Covent Garden and the theatre opened as the Royal Italian Opera in 1847, the word Italian was graciously dropped from its title when Wagners opera's were later performed here. In 1856 the theatre succumbed to fire, and was later rebuilt by architect Edward Barry, within eighteen months. Later

the theatre became the Royal Opera House (1892) and continued with performances until the outbreak of WWII when it reverted to a dance hall. In 1946 the building reopened and continued until the mid 1970's during which time it had undergone several renovations. After some generous funding initiatives a major reconstruction got underway in 1995, which resulted in the building we see today, plus the Paul Hamly Hall and Linbury Studio Theatre (below ground). Paul Hamly Hall is an attractive iron and glass structure, which stands adjacent to the stone façade of the Opera House and was originally part of the Covent Garden Market complex. Today this structure by design reminds me slightly of a section of the original 1851 Crystal Palace, and provides an atrium and main public area together with many glamorous wining and dining areas; the hall is also used for exhibitions and other functions.

As I continue down Bow Street I immediately think of the Bow Street Runners who were formed in 1739 by Henry Fielding, the road itself was put down in 1630, shortly after Oliver Cromwell moved here to reside. Today No.4 is probably the most recognised residence in this road, as it was once a magistrate's court, which in its early days housed the newly formed 'Runners'. The runners were London's first police force and when originally conceived had a compliment of just six officers. The magistrate's court was initially overwhelmed with work, in a vane attempt to cope with the escalating local crime, one major problem being the 'gin' revolution; consumption of this beverage increased to un-controllable proportions by the early 19th century. As crime escalated the small compliment of police officers increased, following which a new section was formed called the Bow Street Horse Patrol, this became the first uniformed police force in Britain. In 1829 the Metropolitan Police Service was formed and their offices extended to include numbers 25 & 27 Bow Street, CD would not be familiar with the current building at No 4 as it was not constructed until 1881. He would however have been totally familiar with British politics and would have followed the rapid career path of the new Prime Minister Robert Peel, who became instrumental in forming this new police force. Although perhaps not totally on the side of Peels government manifesto of the day, CD may have conceded to Peel's efficient proposals for policing. Peel's two terms in office did kick start the Conservative party of a fashion, and whilst on

that subject, amazingly CD would throughout his life experience 19 changes of Government. Gin consumption caused so many problems for the police as there were gin shops that sold nothing else in most streets, poor families drunk only cheap gin, some say as a comforter to help them forget there impoverished surroundings. CD mentions the drinking habits of the poor in all of his novels as cheap gin and brandy seemed to be commonplace, one has to remember that there were no licensing hours in this period and liquor was available on tap.

As I reach the end of Bow Street I have now arrived at Long Acre, which was also owned by the Earl of Bedford who laid the road in the 17th century. For many years this busy road consisted of a mixture of small shops and houses, unlike today where it is clearly a haven for large fashionable shops. This street was known as being the centre for coachbuilders whose many shop fronts led into workshops at the rear, CD may even have visited one or two coachbuilders here when purchasing this mode of transport, which he did when he became more prosperous. Walking west towards Mercer Street we pass Covent Garden Underground which was opened in 1906, long after CD's time, but never the less he did get to use the early underground system when it first opened in 1863. I feel sure he was interested in proposals to link an underground system into central London, which was discussed as early as 1830. In 1855 approval was granted to construct the world's first (tube) system, which travelled between Paddington Station and Farringdon Street, via King's Cross and was named the Metropolitan Railway. Within a few years the underground had spread its wings to other London destinations and CD would almost certainly have used this mode of transport. However I am not too sure that he would have enjoyed the major disruption caused to road and pedestrian traffic during this enterprise. The early construction methods used in building the tunnels were archaic, however CD would have been familiar with the steam engines that eventually propelled the trains and the ventilation shafts at street level, which expelled the discharge of steam. One such discharge vent was constructed not far from our present location near Leicester Square, and is cleverly fashioned into a concrete fascia resembling a private house.

I now cross over Long Acre and turn into Neal Street, which CD would not recognize today, however there are granite sets in the road,

which retain some of the flavour of the 19th century. Once I reach Sheldon Street I turn down Earlham Street, which will lead me to a very interesting area of this walk, namely Seven Dials. According to my 1863 map, a very large brewery occupied most of the immediate surrounding area at this period. Earlham Street was then called Great Earl Street for some reason, but there is no mistaking the busy circus location that confronts me, which is known as the Seven Dials. Seven Dials gets its name for obvious reasons, there are seven roads that converge into this very small circus. I have a personal interest in this location as my father owned a coffee stall here on the corner of Earlham Street for several years in the late 1940's and early 1950's, and as a very young boy I have fond memories of being here with him on occasions.

Originally Thomas Neale laid out this area in the 1690's in an attempt to maximise the number of buildings that could be built in a limited amount of space, for this fast growing area of London's West End. Covent Garden was built, and there was a need to build fashionable houses close to the market, but unfortunately the original scheme designed for Seven Dials never actually materialised as the area quickly became run down and developed into a notorious slum and 'rookery'. CD wrote in Sketches by Boz "The stranger who finds himself in the Dials for the first time . . . at the entrance of Seven obscure passages, uncertain which to take, will see enough around him to keep his curiosity awake for no inconsiderable time . . ." In other words this was a 'no-go' area as strangers would certainly have been mugged or at least robbed whilst walking across or around this small district of the West End. The original sundial that sits in the centre of the circus was removed in 1773 in an attempt to rid the area of undesirable street tramps who used it as a shelter, and a replica sundial was made as recently as the 1980's in an attempt to restore its long forgotten history. In CD's day this area was occupied by very poor English and Irish residents, most of whom were continually drunk from the cheap gin on offer, and the majority of which were living in abominable slum conditions. The streets were said to have had enormous piles of rotting waste vegetation left by the market traders dumping their spoilt goods at the end of each day. Local shops consisted largely of glass bottle sellers, rag shops, old iron dealers, left off clothing and sweet shops. Irish recreational sports were

active everywhere, in alleyways and streets, mainly boxing contests, gambling and of course drinking events.

CD acknowledges how poor the Seven Dials was and records some changes which he thought had improved the area in his Dictionary of London: Omnibuses pass by making some progress towards civilisation, one street in particular was interesting as it was lined with shops ideal for bird fanciers. Every variety of pigeon, fowl and rabbit, can be found together with rare breeds like hawks, owls and parrots. There are several cages of dogs on show and when standing where the seven streets meet CD quotes "Here poverty is to be seen in its most painful features. Shops sell nothing but second or third hand clothing, old clothes, old hats, old dresses and old shoes. Pub houses abound and women stand outside and wait hoping their husband will come out before the weeks money is spent."

Just how much material CD memorised, recorded and used from this one small area of London, is unknown, but judging by the location and interest that he had shown I guess many characters eventually became material for his novels. My personal memories are full of joy as I used to play in the surrounding bomb-sites all day on the days I was here, and only returned to see my father when I was hungry and he fed me with delicious meat pies and hot tea.

Today I have to say that the Seven Dials is a popular area to visit, vibrant, busy and has a really good Caffe Nero, which I have used often, but today I shall visit another of their coffee shops at the end of my walk.

I now make my way down Monmouth Street on the final leg of this walk and immediately notice the carefully preserved early 19th century properties in this street. One noticeable building is No.67, which has still retained the character of the mid 19th century by preserving the sign-written business details on its facade above ground floor. It reads 'Saddler & Harness Maker' 1847, the owner a gentleman called B. Flegg, I wonder did CD have a similar character in any of his novels? I like the feel of this street and today find it hard to imagine just how hostile this area was in the mid 19th century. If CD was looking over my shoulder right now I feel sure that he would have felt perfectly at home with the progress of time and these surroundings. Certainly this route from Seven Dials to Leicester Square would have been a route he was very familiar with especially as

I am now nearing Garrick Street, which as its name suggests is home to that very well known 'gentleman's club'.

Having now reached St Martins Street, I continue to the point where it joins Long Acre and head left into Garrick Street, where I find the Garrick Club to my right. This somewhat austere looking Victorian façade epitomises the robust architecture of its day. Internally it still retains the exclusivity, sophistication, and atmosphere of a period when the arts were revered, and gentlemen of note had enormous respect for principles and values (even though one or two did stray from time to time!) The club was founded in 1831 and was named after David Garrick, and was originally situated in King Street until 1864, when it then moved to its present location simply because it had outgrown the premises which by then served the needs of a larger number of noted actors, playwrights and artists. Today the club has around 1300 members, which include many distinguished actors and men of letters in England. Having been given the opportunity to view the club recently, I felt as if I had been transported into the Victorian era as the majority of furnishings and fittings depicted that age so well. In retaining this image I feel that this club deserves it claim to exclusivity if only to freeze a moment in time, and although I did feel a sense of elitism when observing members and staff alike, I fully understand why 'rules' once made should be adhered to in these circumstances, otherwise we would in time loose all traditional values in our society. The building houses a wonderful collection of paintings and drawings, a theatrical library, sculptures, and historical theatrical memorabilia, each of which would embrace any gallery or museum in the world. Whilst there, I was honoured to have been given the opportunity to view precious letters by CD, William Thackeray and Wilkie Collins all related to 'an issue between gentlemen' that eventually led to each resigning from the Club. Although CD was only familiar with the 1831 building, he would have been thoroughly at home here even though it was said that he was conservative in manner but liberal in ideals!

Having moved away from the Garrick Club, I walk the length of Garrick Street and into Bedford Street in order to visit St Pauls Church, which stands behind Covent Garden Piazza. Access to the church is via Inigo Place (Inigo Jones built the church in 1633), which leads to a delightfully grassed area (formally a graveyard) and

finally the church entrance. Affectionately known as the 'actor's church', internally there are scores of memorials dedicated to former actors and actresses, most of which are logged meticulously in books some of which are displayed. Inigo Jones brought Italian architecture to England, the Banqueting House and Whitehall being just two of his remarkable designs. As an architect, Jones was an avid follower of Palladio's work (an Italian architect from Padua who was besotted by Roman and Greek architecture). Between 1598 and 1603 Jones visited Italy and later decided to introduce Palladio's theories into English design. Amazingly, this wonderful architect of his age was said to have been an apprentice joiner who as a young lad worked in St. Paul's Cathedral Churchyard. In later years once he was established he gained the commission to build this church, his brief being to simply build a church "not much better than a barn" (which records tell me was the first church to be built in London since the Reformation). The interior unfortunately was later damaged by fire in 1795 but eventually restored retaining the outer walls, in 1798. The graveyard at the front of the church is the final resting place for the first victim of the Plague who died in 1665, as were several hundred more who followed. JMW Turner, (1775-1851) artist, was baptised here and Grinling Gibbons (1648-1721) sculptor, was buried here, both of whom are just two of my personal heroes.

Leaving St Pauls Church I backtrack to Kings Street and make my way directly towards Covent Garden, where I enter into the market itself. This group of streets is largely unchanged from the 1863 map so CD would not have been disorientated when approaching Covent Garden today, the shops may be different but the crowds of 21st century people busying themselves remain the same. What is missing of course is the vegetable, fruit and flower market, which migrated to Nine Elms in 1974 in order to ease traffic congestion in this area.

Medieval settlers and Benedictine monks originally inhabited this now popular and historic market square for a period of time, but in the main was purely a group of fields up until the 16th century. It was at this period that Henry VIII seized the land and bestowed it to the Earl of Bedford in 1552, in fact the Bedford estate consisted of an enormous landmass that stretched out to Drury Lane to the east, the Strand to the south, St. Martin's lane to the west and Long Acre to the north. Inigo Jones was commissioned to design and build some

grand homes for the wealthy here in the 17th century, in an attempt to upgrade the area. By 1654 Jones had designed the square and St Pauls Church in the style of a Piazza, but by then a public fruit market had settled here. During the course of time the market, as well as the surrounding properties gradually evolved into a low social standing district with the introduction of taverns, theatre, coffee houses and brothels, this resulted in the area becoming a notorious 'red light' district. The Market itself originated when local traders set up stalls against the wall of Bedford House (the Earls fashionable residence), following which a charter by Charles II was granted in 1670 allowing a fruit and vegetable market to open here every day of the week except Sundays and Christmas Day. The configuration of market stalls and sheds proved successful initially, but by the 19th century had become disorganised and disorderly which resulted in the Piazza becoming regulated by an Act of Parliament. William Cubitt & Co was eventually given the task of building today's neo-classical market, designed by Charles Fowler in 1830. Today the central building has developed into a shopping complex and vibrant tourist spot, which is surrounded by many wonderful restaurants and of course Theatreland.

We now leave the market by way of Southampton Street and make our way south to Maiden Lane, which was never the most fashionable area of this district but did attract many distinguished people during CD's period in London. Artists and businessmen have given this street some credibility none more so than JWM Turner, a personal hero artist of mine whom I have followed and researched for many years. Turner was born at No. 21 Maiden Lane in 1775 where his father ran a barbers shop, he later returned to live at No. 26 after finally establishing himself as one of England's greatest artists. CD knew of Turners work, as his first publisher, John Macrone, had in fact commissioned Turner to illustrate Paradise Lost in those early days, so I feel that CD would have appreciated this great artists technical abilities and his move to change art for the world to enjoy. CD would also have been familiar with a fashionable restaurant in Maiden Lane, and still open today is called Rules Restaurant. This very special emporium is the oldest restaurant in London and first opened in 1798 as an oyster bar that sold traditional English food. It continues to sell the same fare today and attracts visitors from all

corners of the world. Rules was a particular favourite of CD's who frequently dined with his friends here to enjoy the food and company, today there are many items of Dickensian memorabilia on show such as drawings, paintings and cartoons. During its 200 years in business Rules has catered for hundreds of famous personalities from every walk of life, and stories abound regarding Victorian scandals, it still remains a favourite to many of the current generation, myself included. The final part of my Strand walk takes me to the cross section of Maiden Lane and Chandos Place where I can enjoy a light lunch whilst viewing arguably one of the most memorable buildings associated with CD.

My lunch venue is Caffe Nero, which sits convieniently on the intersection of Chandos Place and Bedford Street, a vibrant area of Covent Garden. Having ordered my Americano coffee and my favourite paninni of vine tomato, mozzarella and basil, which is stone baked on a granite slab, delicious. I take advantage of the good weather and enjoy my lunch outside the café sitting directly opposite a large red building. In 1824, this red Victorian building traded under the name of Warrens Blacking Factory and amongst its employees was a 12-year-old boy name Charles Dickens. CD hated his work here as he felt it demeaning to be viewed by the general public whist he sat sticking labels onto shoe blacking pots, little did he know then that within a few years he would be on the road to a career that would make him the greatest novelist of the Victorian era.

My walk ends here on this high note and having savoured my panini I have now decided to finish my lunch with another Americano and a piece of delicious tiramisu cake, a perfect ending for today. Tomorrow I must complete my illustrations of the Strand walk and plan the next district to explore and enjoy.

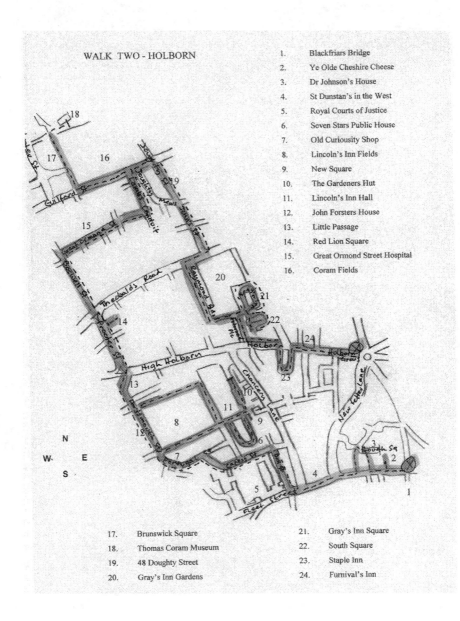

WALK TWO - HOLBORN

1. Blackfriars Bridge
2. Ye Olde Cheshire Cheese
3. Dr Johnson's House
4. St Dunstan's in the West
5. Royal Courts of Justice
6. Seven Stars Public House
7. Old Curiousity Shop
8. Lincoln's Inn Fields
9. New Square
10. The Gardeners Hut
11. Lincoln's Inn Hall
12. John Forsters House
13. Little Passage
14. Red Lion Square
15. Great Ormond Street Hospital
16. Coram Fields

17. Brunswick Square
18. Thomas Coram Museum
19. 48 Doughty Street
20. Gray's Inn Gardens

21. Gray's Inn Square
22. South Square
23. Staple Inn
24. Furnival's Inn

WALK 2

HOLBORN

"You must not tell us what the soldier, or any other man,
said, sir," interposed the judge; "it's not evidence."
(Pickwick Papers—1837)

The district of Holborn has an association with the legal profession which goes back several hundred years, and CD not only worked in the streets we are about to visit but also lived there for several years, this next walk will therefore encompass a formidable group of buildings that epitomise the roots of our legal system today.

Holborn was first mentioned and recorded around the 10th century and was thought to have been named from a Middle English word 'hol' meaning hollow, and 'bourne' being a brook, both referring to the River Fleet, which ran through this area. The church of St Andrew Holborn was the first building to be recorded here long before the area became popular to both the wealthy and the poor. The boundaries of Holborn have changed considerably over the years, but were originally defined as being an area of land between the City of London and Westminster, the geographical locality of which became extremely important in later years. When political and religious changes affected our legal profession, Holborn became the adopted home of the Inns of Court and Inns of Chancery, and more generally became home to the earliest London coffee houses. Henry V became its first developer by paving Holborn in 1417 to improve comfort whilst travelling in his carriages, however by the Elizabethan period there still remained acres of gardens, trees and shrubs in this fertile district.

Now is probably a good time to briefly explain the significance of both the Inns of Chancery and Inns of Court, because I shall refer to these honourable societies on many occasions, as their presence is extremely influential in this area of Holborn. CD had very personal views about the legal profession and as we know spent a good deal of his early career working in this environment.

Originally the Inns of Chancery were introduced to teach clerks and solicitors, later the buildings were used as accommodation for these honourable professions. They were formed around the middle of the 14th century, when it was decided that clergy could no longer teach law, and legislation prohibited any legal education within the City of London. Holborn was thus chosen as a suitable district for legal practice as it was situated between Westminster Hall and the City boundary. As a newly adopted district, lawyers then occupied buildings such as inns and hostels to practice law and in most cases the owners of these establishments gave their names to the various 'inns' and 'chanceries' that evolved. Barristers were also taught in these inns up until the mid 17th century following which they formed their own Inns of Court. There were around nine noted Inns of Chancery who were associated with both the Inner and Middle Temple (those within and beyond the boundary of the City of London).

The Inns of Court however were for barristers only, and each practicing barrister had to belong to one of these active groups. Each of the groups provided libraries, accommodation and dining facilities as well as having their own self-contained church, all encompassed in a self-sufficient locality. Over the course of several hundred years the number of active Inns of Court have reduced to the present day total of four; these being The Honourable Societies of Lincoln's Inn, Inner Temple, Middle Temple and Gray's Inn.

The walk today begins at Blackfriars Station, we simply walk north up New Bridge Street then turn into Fleet Street, walk past Shoe Lane until we reach Ye Olde Cheshire Cheese Pub. This remarkably old and historic pub was rebuilt one year after the Great Fire in 1667, the original one being constructed in 1538. Records would imply that this wonderful pub has entertained literally hundreds of noted people throughout its interesting history, including several former English monarchs. Having visited this pub

I can only suggest that the reader does likewise, and explores all of the appealing alleys and staircases, not to mention the maze of rooms which transport the customer into a past age, then find a little nook and try the ales and food on offer, fantastic. CD used this pub many times and even he would not feel out of place today, the ales and food may have altered but the ambience remains the same. Samuel Johnson was a regular customer here, probably because he virtually lived a five-minute walk away. Whilst enjoying a glass of ale or wine here, take note of the vaulted ceiling which could well be part of the original 13th century Carmelite Monastery that was once here, and search the historic walls for plaques displaying the names of former regulars, it becomes addictive after a while!

Leaving the Ye Olde Cheshire Cheese continue along Fleet Street, but before we reach our next destination lets not overlook just how significant a part Fleet Street played in this area over the centuries. The name Fleet Street originated in the 14th century and was taken from the largest of London's underground rivers, namely the Fleet. This busy and active street is positioned between the City and Westminster and serves as a central staging post for the legal profession, having both the Inner and Middle Temples to its south, and the Royal Courts of Justice and Criminal Courts to its west.

Between the 16th and the 20th century Fleet Street was known as the publishing heart of London, which first started when William Caxton set up his printing shop around 1500 close by to where we now stand. The first publishing house (Daily Courant) provided news for the city's population here from as early as 1702 and by 1730 there were scores of other newspapers being distributed from this location, records suggest at least 100,000 various copies a week were sold.

Not far from Fleet Street a certain Pasqua Rosee, a Greek immigrant, opened the first coffee house in London around 1652, and in doing so actually introduced a fundamental change in the social and commercial history of our country. During the following decade several other coffee houses appeared in this tightly occupied district, which instigated some concern for local inns and taverns, so much so that several people lobbied the Lord Mayor to introduce sanctions 'on the coffee culture' that was developing. The truth was that 'this bitter black drink' discovered by the indigenous Abyssinians in the 13th century, which simply became part of their diet long

before being discovered by western Europeans, was soon to become an important financial consideration to the economic stability of the UK. Londoners quickly became addicted to this product for many reasons, one being medicinal, another that it was seen as a social delicacy, but more importantly the fact that it was made from boiled water. Other than the alcoholic beverages that were available to be drunk without fear of disease, coffee, together with tea and cocoa, provided the public with alternatives to quench their thirst.

Coffee houses held copies of newspaper publications, which attracted all members of the public thereby creating both a gastronomic and newspaper boom during the 18th and 19th centuries. Censorship at the conception period of publishing was almost non-existent, unlike today. Journalists and publishers then enjoyed nothing better than eavesdropping in many business's, alehouses and local establishments, where they could print selective stories that they thought the general public were interested in and would sell newspapers. Income from sales alone didn't provide an adequate return for early newspapers, as is the case today, so even then there were large numbers of advertisements printed with the news.

Stories abound regarding historical Fleet Street, here are just a few snippets to savour: Geoffrey Chaucer was once said to have beaten up a Franciscan Friar here and was fined two shillings (10p): A goldsmith was once murdered here and his body thrown under the Temple Stairs: Students from the Inns of Court once rioted here and were driven back by archers: In Queen Anne's reign the drunken pests known as 'Mohocks' found pleasure in surrounding homeward bound citizens and pricking them with their swords! Even centuries ago headlines like those would have aroused the curiosity of many groups of newsreaders throughout the capital. Sadly today there are no major printing presses making headlines in Fleet Street anymore, and Reuters were the last major news office to leave this area in 2005. Before we leave Fleet Street it would be remiss of me not to mention the Daily News, a progressive newspaper based in the street, which provided CD with the opportunity to become editor when he was in need of a more permanent income. The Daily News evolved around 1846 when William Bradbury and Frederick Evans (printers and publishers) talked to CD about setting up a daily newspaper to rival the Times. This Liberal paper was partly funded by his publishers and

Joseph Paxton, Joseph being a wealthy businessman who would later design and create that wonderful building for the Great Exhibition, namely the Crystal Palace. CD did work as editor at the Daily News for a short period, but later realised that he would find it far too demanding on his literary career, even though it brought in a sizeable income as the paper did publish instalments of his novels. During his time at the Daily News I wonder if CD ever used Croom's Coffee House at No.16 Fleet Street, where coffee was sold for just 3d a cup.

Let's now continue our walk by turning into Bolt Court this could be considered an alleyway that will eventually lead us into Gough Square where we can view the former house of Samuel Johnson. CD would have been very familiar with the alleyway leading to the square, as nothing has changed since the 1863 map, and I feel sure he would have approved of Samuel Johnson as both a person and academic. We now arrive at No.17 where Johnson lived for several years.

Samuel Johnson (1709-1784) lived two generations before CD, but there are similarities I see in both as well as obvious differences, this may seem a contradiction in terms but first let us understand Johnson more fully. As an English author, poet, essayist, moralist, and literary critic and of course a lexicographer, Johnson did attend college in Oxford; albeit for only one year as his remaining fees could not be met. After leaving Oxford he returned to Lichfield (his place of birth) and took a junior teaching post but was hampered by a medical condition known as Tourette's syndrome (nervous tics and twitches). After a short period of time, he made his mind up to leave home and travel to London, thankfully with one of his former students and friend, the actor David Garrick. In London Johnson found both accommodation and work, and in 1737 sent for his wife to join him as he was now employed as a writer for the Gentleman's Magazine. It was during this period that he wrote poems, one being 'London', but due to his lack of academic qualifications he was unable to secure a teaching job in any school of repute, which proved a problem as he needed a more stable source of income. He continued writing while living the life of a poor author, and was forced eventually to send his wife Tetty back north, refusing on a point of principle to live off of her substantial savings from her previous marriage. Fortuitously, in 1746 a group of

publishers, anxious to produce an accurate dictionary of the English language, contacted Johnson and offered him a commission to undertake this task, which eventually took nine years to complete! During this period his wife Tetty returned to London, and they lived together at 17 Gough Square (with several other acquaintances), where he completed the dictionary. His dictionary remained the most commonly used reference book of its type for 150 years, eventually being superseded by the Oxford English Dictionary.

In middle age, following the death of his wife Tetty in 1752, Johnson reverted back to writing and he befriended many noted members of the arts such as Joshua Reynolds, William Hogarth and Adam Smith. During this period of his life he arguably wrote his best literary works including several masterful poems, at the same time re-editing many of Shakespeare's works, which were eventually published in 1765. Johnson was also introduced to Henry and Hester Thrale, wealthy brewers, with whom he lived for 17 years until Hester died in 1781. Around this period he became a friend of James Boswell who in later years accompanied him on a journey to Scotland, where he wrote about the struggles of the Scottish people. Throughout his lifetime Johnson often irritated his critics by publishing his political beliefs on patriotism, in a number of pamphlets and articles. Also his stature, appearance and behaviour often aggravated his peers, but he was a devout Tory humanitarian, a great speaker, moralist, Anglican and also a lover of cats! He had a very active and creative career although he suffered from poor health in later years, and eventually died in London relatively poor but surrounded by friends, and was given the finest accolade he could have wished for, he was buried in Westminster Abbey in 1784.

Having enjoyed viewing No. 17 Gough Square on several occasions in the past, I can well recommend a visit, as it remains almost unchanged from the period Johnson lived here. His former residence is a well-preserved 300-year-old building, built by a wealthy City wool merchant, Richard Gough. Although he was only a tenant in this house until 1759, as far as I know there are no other former houses still standing where he had previously lived. That makes the Gough house special as it does give you the opportunity to view original features including the wall panelling, wooden floors, open staircase, coal holes and door handles of his period. And what better

than to stand or even sit in the rooms where Johnson compiled his dictionary and greeted and entertained all of his friends, magic. All four floors are open to view and take the opportunity to use the audible equipment when touring, as the commentary is really informative.

It is time now to backtrack and return to Fleet Street, once there walk the short distance to view St. Dunstan's-in-the-West Church. An original church stood on this spot as early as the late 10th century, and remarkably it survived the Great Fire due to the diligence of the Dean of Westminster who raised a team to douse the flames. Amazingly this church remained intact until it was eventually rebuilt in 1831 by the architect John Shaw, the tower however was severely damaged in 1944 but mercifully rebuilt in 1950 with money donated by one of the wealthy newspaper magnates. St. Dunstan's is noted for having a landmark clock, which was installed in 1671, and was the first public clock to display a minute hand; it also has two giant figures that strike the hours, and quarters at the same time turning their heads. The exterior statue of Elizabeth I dates from 1586, and much of the interior fabric predates the 1830's rebuild. Internally the organ dates from 1834, and the wonderful communion rail designed by Grinling Gibbons sits adjacent the attractive stained glass window for all to enjoy. The church is now associated with the Worshipful Company of Cordwainers (shoemakers). Samuel Pepys worshipped here on a number of occasions and we know that CD was familiar with the church as he mentions the clock in David Copperfield. Today the church is home to the Anglican and Eastern Churches Association.

Although we are not visiting the Royal Court of Justice on this walk, it would be remiss of me not to mention this iconic structure, which is just a few yards from the church along Fleet Street. Commonly known as the Law Courts, the Royal Court of Justice is an edifice of Victorian construction, which was designed by George Edmond and built in the 1870's. Designed in a Gothic Revival style and boasting a magnificent Great Hall, this building is amazingly not dissimilar to many cathedrals in its layout. Internally one can stand and enjoy the beautiful mosaic marble floor whilst looking at the attractive stained glass windows, all of which signify the power and presence of the Law and its former authorities. The Royal Court of Justice is home to the High Court of Justice for England & Wales and

can be visited by the general public most days, I have been here several times and can confirm that it is well worth the visit, especially if you get the chance to view certain 'real time' lawsuits first hand. Quite close by to this area once stood the Grecian Coffee House (a fairly well known venue); perhaps CD visited it whilst in the neighbourhood, it was said to be a place where one can gain up to the minute news!

Before leaving the Fleet Street area of Holborn I should mention one specific coffee emporium that CD would almost certainly have known of, which was owned by the Gatti family, Italian immigrants who were to become one of the most popular restaurateurs and coffee houses in London for over a century. Carlo Gatti started as a coffee stall owner who traded from Holborn Hill; he also handled ice cream and other Italian confectionary delights. From Holborn he then moved to Hungerford Market (close to Warrens Blacking Factory site) where his business really took off. As a coffee stall owner Carlo would undoubtedly have worked (as would the other 350 stall owners of London) to accommodate the 'night people' of the capital, which would include nightwalkers, 'ladies of pleasure', and their customers. These small welcoming beverage stalls were seen as an oasis of sustenance, especially in the winter months, to the many who used them, and CD surely had need of their wares during his interesting night walks. Knowing the Italian love of coffee as I do, I feel sure that Carlo's beverages would not be disappointing even though it is generally thought that stall owners of this period used cheap ingredients. In defending the quality of food and drink served I should add that Carlo later transformed the culture of eating out for all walks of life, when his family later introduced restaurants that it is said 'transformed' social London.

Our walk continues now along Bell Yard, the Royal Courts are to my left and ahead I can see some pleasant Georgian buildings, and I feel sure that this short concourse could tell a thousand interesting stories. Certain past individuals of the 18th century are associated with this passage, one being Jack Sheppard (robber, burglar and thief), who used the former subterraneous passages that were once below here to escape the law, and who drank in a pub called the Bible; and the other person being Alexander Pope (poet) who always used this route when visiting his friend Fortescue who later became Master of the Rolls.

Leaving Bell Yard we turn left into Carey Street, a street named after Sir George Carey who was second cousin to Elizabeth I. Carey Street is sometimes used as a euphemism for being bankrupt, or in debt, an apt choice being surrounded by legal buildings, it also shares other secrets we can explore. Facing the rear of the Royal Courts of Justice stands the Seven Stars Pub, which according to my research is the oldest pub in London; a sign outside informs us that it was constructed in 1602. The Seven Stars miraculously escaped the Great Fire of 1666 by yards and was also far enough from the much later Kingsway development to avoid demolition! I have yet to enjoy the hospitality of this pub but from all accounts it has a wonderful atmosphere and offers good fare. Land records would indicate that both the pub and the building more recently known as 'Old Curiosity Shop' were built around the late 16th to early 17th century. The Old Curiosity Shop is positioned just slightly further along this road where it meets Portsmouth Street and although it has been restored many times since it was first built never the less provides a perfect picture of old London.

We know that CD was familiar with Carey Street as he wrote in 'Our Mutual Friend' in 1864 about a corrupt moneylender plotting to bankrupt his friends who lived in this area, which was also referred to as Queer Street! My 1863 map interestingly shows additional streets and Kings College Hospital adjoining Carey Street, this original hospital would have be known to CD as it was built in 1840 and remained in this location until it relocated to Denmark Hill in the early 20th century. Would CD have researched this hospital for ideas to include in his novels, I think he may have! In the short time that I researched this building I was constantly reminded (albeit hearsay or rumour) of the early practices used by the medical students and doctors in relation to dissection, and the fact that most patients shared a bed! These realities of living in the Victorian era, so close to a 'Rookery', really do focus my mind on the conditions Londoners had to bear, as CD stated, "London is the best and worst of towns and cities".

As we travel along Carey Street and cross over Portugal Street we now enter an area, which for many years, certainly throughout CD's life, was known as a Rookery, which simply meant a city slum occupied by the poor, criminals and prostitutes; it also takes its

environmental meaning from the nesting habits of the rook, as they live in noisy colonies and have untidy nests. The term is also linked to the slang expression 'to rook' meaning to either cheat or steal. For many decades Portugal Street was extremely overcrowded providing low quality housing, which nestled between densely populated narrow streets and alleys. Like Seven Dials, this area was very familiar to CD as were similar rookery areas in London, which CD experienced first hand. These unsavoury areas held a fascination for CD, in fact he was given a guided tour of St. Giles in 1850 by the Chief Detective of Scotland Yard, who ensured that they were accompanied by several formidable police officers backed by a complete squad of local policemen who it was said 'kept their distance'. One can only imagine how horrific it must have been just to stray close to the perimeters of these dangerous and filthy locations, knowing that your life as well as your purse was at risk, and it was most unlikely that police officers would risk patrolling these areas.

At the west end of Portugal Street stood the Insolvency Court (1883 map) where the Land Registry Office now stands, and the court itself backed onto the Royal College of Surgeons, which has remained here since CD's time. Before moving on I should briefly explain the function of the Debtors Insolvency Court, but will talk in more detail regarding this 'service' in Walk 3 when we travel to Southwark. These arguably corrupt session houses were familiar to CD as debt followed him around one way or the other, through certain periods of his life. As a young boy CD's father was summoned to one such court and spent several months in a Debtors Prison, and later as an adult he recalls similar events. The court in Portugal Street would have had three or four wigged judges who sat behind little writing desks in the centre of a dingy room, with a 'box' of barristers on their right and an enclosure of insolvent debtors to their left. Recovery of debts and the business of running a debtor's prison was a very rewarding business for both law practicing and law breaking members of the community, who generally had the ear of the law in this lucrative industry. In the 19th century, if an adult accumulated a debt valued at being over 40 shillings (£2.00) or £583 today, then he faced a period in the Marshalsea Prison at Southwark! Much more about this subject will be discussed in the next walk.

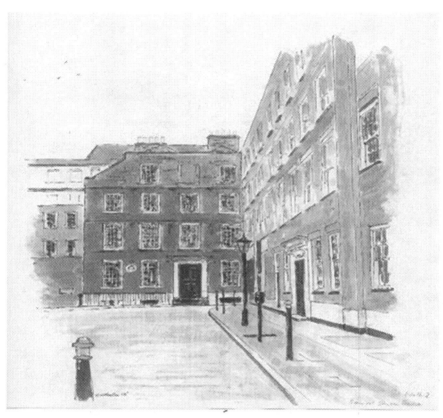

Fig 3 Dr Johnson's House

Fig 4 Head Gardeners Hut

Fig 5 Doughty Mews

Fig 6 South Square

Fig 7 Staple Inn

Moving on from Portugal Street we now reach the first of several really attractive, and almost unchanged areas of Holborn, that featured in many of CD's melodramas, I refer collectively to the area known as Lincoln's Inn Fields. Crossing over Sardinia Street we now enter Portsmouth Street which runs parallel to the west side of the attractive gardens of Lincoln's Inn Fields. These fields (gardens) make up the longest public square in London and were originally laid out in 1630. Named after the adjacent Lincoln's Inn Buildings, this luscious acreage of public gardens provide a very welcome oasis to enjoy, either simply by walking through or purely sitting down and 'chilling out'. The pathways provide access to recreational and refreshment facilities all of which nestle in a quiet environment surrounded by interesting trees and shrubs, the beautifully aged and sculptured Plane trees stand alone to be enjoyed. The Plane trees are just about everywhere I walk in London, each appear to have their own individual character (if that is the right expression), and we have the Victorians to thank for planting them. There was however a particular reason for this choice, apart from the trees magnificent appearance, London Plane trees are one of the few species that could survive the heavily polluted Victorian atmosphere.

Prominent and distinguished people once owned many of the houses that surround the Fields, one being No.66 that was built for Lord Powis in 1694 and in which the Charter of the Bank of England was sealed in the same year. In 1683 Lord William Russell was publicly beheaded here following an attempt to assassinate Charles II.

CD would have known several owners of properties here but none more so than John Forster (1812-1876) who lived at No.58. Forster, an English biographer and literary critic born in Newcastle to a family of substance who were devoted 'Unitarians' (New Testament beliefs, passionate for education and reformist polices). Equally important was the fact that he became a lifelong friend and confidante of CD. Like CD, Forster's main interests were literary and he contributed to many of the leading newspapers of his day, such as The True Sun, The Morning Chronicle and The Examiner. This intellectual aspect of Forster's career made him a prominent figure in what can best be described as a distinguished circle of friends which included Dickens, Thomas Carlyle, Robert Browning and Leigh Hunt to name but a few. Forster was actually called to the

Bar having entered the Inner Temple as a young man, and therefore extremely knowledgeable in Law, but oddly enough he never practiced as a lawyer. Having developed a close friendship with CD, Forster became his literary agent from the time of Pickwick Papers to his death and proved to be a loyal and true friend as well as an astute business colleague who carefully administered his professional interests. Forster was said to have a loud voice, decisive manner and authoritative features; however, he was also a tender and generous man and too many a staunch and faithful friend. He eventually married Eliza Ann in 1856, and following CD's death became his biographer and one of the executors of his will. John Forster died in 1876 and with the consent of Eliza, 'The Forster Collection' which comprised of 18,000 books, manuscripts, oil paintings, drawings, engravings and curiosities (which included many of CD's personal items), were bequeathed to the nation for future generations to enjoy and appreciate.

To the north of the Fields stands Sir John Soane's Museum where the visitor can enjoy so much of his architectural and artistic talents. Soane (1753-1837) was an architect who in 1795 was accepted as a member of the Royal Academy, and is probably best known for his work on the Bank of England. Unfortunately most of his work in this building has been destroyed, but his talent for design can be seen elsewhere, most of which acquired from his early Grand Tour to Europe in 1778. When he returned to England in 1780 he struggled to find commissions but was eventually assigned a building in Norfolk namely Letton Hall. Other minor commissions followed when in 1788 he succeeded Sir Robert Taylor as architect to the Bank of England, a position he held for forty-five years. During this period he worked on scores of prestigious projects throughout London, such as the Dulwich Picture Gallery, the New Law Courts, and the Palace of Westminster, all in all a veritable career of architectural edifices for us to enjoy today

Before leaving the Fields I now cross over to the far west side of the gardens and visit Lincoln's Inn itself before moving on. As I previously mentioned Lincoln's Inn is one of the original Inn's of Court and is arguably the oldest of the surviving legal establishments. One cannot fail to miss this edifice of a building from the gardens, as it sits in eleven acres of land and forms part of an attractive commune

of historic buildings. The Old Hall is said to be the finest of these buildings, which was originally built in 1490 but has undergone much restoration following war damage throughout the 20th century. It is used as a court of justice as well as being a dining hall. The Great Hall was constructed in the 19th century to meet the demands of an ever increasing membership and when built was opened by Queen Victoria in 1845. This resplendent hall is continually used throughout the 'four terms' of the academic year both as a students dining hall and for member's lunches. By design, the hall is acoustically excellent for choral and orchestral concerts, which are often performed here. The Chapel was completed in 1623 and quite possibly incorporated design features presented by Inigo Jones in 1618. By 1685 the hall was in need of major restoration, which it is claimed involved Sir Christopher Wren, who was a member here during that period. By the end of the 19th century further repairs were needed to the roof, and at the same time the chapel was enlarged. During World War I two windows were destroyed following a Zeppelin raid, which later prompted architects to remove all the windows during World War II, and they survive today. The Library was built between 1843 and 1845 and further extended in 1872, whereas the original library was relocated to the Old Hall, records would suggest that the library itself has functioned and remained open for five centuries. The original Gate House was relocated between 1843 and 1845, prior to this access to the Inn was through a gated entrance in Chancery Lane, unlike today where it is opposite the Fields. The great oak doors of the Gate House date from 1564 but the original gatehouse itself was much earlier, it was eventually restored and rebuilt in 1967. There is one final small building that I have to mention which sits opposite the entrance to the Treasury Office and is known as the 'The Head Gardeners Hut' and I am told, is the smallest listed building in this country. This delightful memorial shaped structure built in 1852, has craftsmanship oozing from every aspect of its construction and is certainly worth an illustration.

We now leave the imposing area of Lincoln's Inn Fields, and move to the north-west of the gardens, rejoin Portsmouth Street at the end of which is a short passageway called Little Turnstile, this will lead us on to the Holborn Road. Little Turnstile typifies Dickensian London, with its narrow lane and avenue of shops and

café's, hidden from time, but a joy to discover. Having reached Holborn Road it would be remiss of me not to mention the Kingsway, a busy major road running north that travels parallel to Portsmouth Street. Built in 1900 as part of a major redevelopment scheme to clear away the slums (Rookery) in an attempt to create an upmarket shopping and residential district. Whilst being developed, a tram (railed bus system) tunnel was also built below the Kingsway, which has since been superseded by the Strand Underpass. Kingsway can also be defined as the dividing point for the legal and theatrical districts of London.

After crossing over Holborn our walk continues north along Procter Street, then continues down Drake Street where we pass Red Lion Square on our right. Although CD would not be familiar with these roads as they have changed in direction and name since the 1863 map he would be familiar with this square. First laid out in 1698, Red Lion Square adopted its name from the Red Lion Inn, which once stood close by, and according to my records has a somewhat sinister history. It is said that the bodies of three regicides (killers of a king) were thrown on a pit on the site of the square, the three bodies belonging to Oliver Cromwell, John Bradshaw and Henry Ireton. All three were signatories on the death warrant of Charles I and when Charles II was restored to the throne, the bodies of all three men were said to have been exhumed, displayed in chains at Tyburn and finally at sunset taken to Red Lion Square and thrown in a common pit whist their heads were displayed on pikes at Westminster Hall! The square was also the centre of activities for a National Front meeting in 1974, which resulted in much civil disorder that spread, to Boswell Street and beyond, where sadly one person was killed in the fracas. Today one would not associate any such problems as the square is amazingly quiet and provides an ideal place to rest and enjoy the surroundings.

Continuing along Drake Street we cross over to Boswell Street and pass the Royal College of Anaesthetists, which CD would certainly have been aware of. The original building was in its latter stages of development when CD lived in London, and by the mid 1800's the use of ether and chloroform were being used in surgery. Today's college has a completely modern façade and is I feel sure still one of the most advanced institutions of its kind in the world.

We now arrive at Queens Square, previously called Queen Anne's Square, which sits fairly close to Russell Square but predates its larger neighbour by 75 years. The square was constructed between 1716 and 1725 on land originally owned by Sir Nathanial Curzon (1676-1758) a Tory Politician. Whilst the surrounding houses are extremely well preserved only those on the west side of the square retain their origin design, the remainder are mid-18th and 19th century, No.6 being the HQ for the Art Workers Guild, which was built in 1713. At the south end of the square one can see a well-preserved cast iron pump dated 1840. It was said that George III was treated for his mental illness in a house around the square and the pub called the Queen's Larder (southwest elevation) was said to have stored food for the King during his period of treatment. Many of the surrounding buildings are now connected to the medical profession namely The National Hospital for Neurology and Neurosurgery and The Royal Hospital for Integrated Medicine, to name just a couple. At the south side of the square one cannot miss the Anglican Church of St George the Martyr Holborn. This very charismatic and wonderfully designed church is worthy of mention for its external charm alone, originally built in 1706 by Arthur Tooley and later remodelled in the early and late 19th century. Fortuitously the church escaped any real damage when a Zeppelin bomb hit the square in 1915. The garden which is central to the square is a great place to escape the hustle and bustle of this busy location, it has some nice rose bushes, bedding areas and a selection of fairly mature trees, all of which can be enjoyed by taking advantage of the bench seating and appreciating all around.

After leaving this delightful square, and garden, we simply turn left into Great Ormond Street and immediately notice the façade of The Hospital for Sick Children. We of course know the hospital as Great Ormond Street Children's Hospital, which was founded in 1852 and was the first hospital in the world to provide beds for children. CD and his personal friend Charles West (Chief Physician) were major patrons of this project. When first opened the hospital could only accommodate 10 beds, today it has 387. In 1843 statistics indicated that of the 51,000 people who died in London that year at least 21,000 of those were children under the age of 10! Children then were still considered 'expendable', therefore certain caring

professional men decided to correct this failing and it was Dr. Charles West who was determined from the start to build a suitable hospital. By 1850 a group of eminent philanthropists joined forces and started a committee to raise funds for this project and by 1852 had sufficient backing to open a mansion on the current site, and staff it with two doctors and two nurses. In the hospitals early day's child patients were treated for a wide range of ailments all funded by subscriptions and donations, together with fund raising events. CD played a major part in this initiative by writing a powerful article in his popular magazine Household Words, as well as attending fund raising events with other eminent speakers such as Oscar Wilde. By 1858 CD helped to raise further money, which allowed the committee to purchase 48 Great Ormond Street thereby increasing the patient bed numbers from 20 to 75. During the following twelve years the original two houses had outgrown their usefulness and were in need of major restoration so Dr West and his Hospital Board raised a small fortune, which enabled them to construct a new purpose-built hospital using the existing site, in addition to utilising extra land in Powis Place. Work on the hospital commenced in 1871 and the project was completed by 1878 resulting in a state of the art paediatric hospital designed by no less an architect than Edward Barry (son of Charles who was responsible for building the Houses of Parliament). This new hospital had 100 beds and 6 new wards; a purpose built operating theatre, a heating system and Gothic chapel. The Chapel remains today but the hospital was replaced and enhanced yet again in 1990. CD would be proud to see that his tireless work together with his eminent group of friends, over 160 years ago, still cares for children and is recognised throughout the world.

Leaving the hospital site we continue east and turn left into Lamb's Conduit Street, which after a short distance will take us to the site of yet another remarkable story concerning the welfare of children. We need to turn the clocks back a century earlier than Great Ormond Street, and discover another compassionate philanthropist, little known, but in fact he was instrumental in establishing the Foundling Hospital, in the 18th century, I refer to Thomas Coram. Before we talk of the hospital we should first mention Coram Fields, which before crossing Guilford Street we now arrive at. These fields, which occupy 7 acres of land, include children's playground, sand

pits, duck pond, a pet's corner and nursery. There are very strict rules when visiting the fields, adults (over 16 years of age) are only allowed access if accompanied by children, rules which I understand but sadly which stop me entering, as my grandchildren live some distance away. Initially the fields formed part of the grounds of the Foundling Hospital, which later relocated outside of London in the 1920's, however, wealthy benefactors and local residents raised sufficient money to re-purchase this wonderful recreation area for children in 1936. The fields are surrounded by pleasant gardens, which the general public 'of all ages' can enjoy, and there is also an interesting museum to the north of the fields, which houses a remarkable collection of artefacts and memorabilia associated with the Foundling Hospital. In order to get to this museum we have to walk around Coram Fields along Brunswick Square where the entrance can be found.

Although long since moved, the original Foundling Hospital was built on this Bloomsbury site by the philanthropist and sea captain Thomas Coram, in 1741. Although known as a hospital the building was in fact a children's home, which was used to teach and look after deserted young children, the word hospital was then used to mean hospitality rather than a medical term. When first opened the hospital initially kept boys and girls separated, and the maximum age for admission was between 2-12 months. By 1746 over 14,000 children had used this charitable establishment but many succumbed to the evil vagrants known as 'Coram Men' who made a business of transporting children from other counties to the London hospital, and often used the system simply to cover a child trafficking scam! As was sometimes the case the recruitment of children for the hospital became questionable, simply because of the selection process and sheer volume of movement, therefore the government intervened. A bill was produced to improve the selection process thereby only allowing the first child of an unmarried mother to be admitted. Many noted people of the time were associated with this scheme namely, Frideric Handel, William Hogarth, Josuah Reynolds and Thomas Gainsborough to name but a few, all of whom played a major role in raising funds. The hospital relocated out of London to the countryside in the 1920's and still runs as a charitable institute, however, there still remains some evidence of Coram's work displayed

in the museum, which stands on the site of the original hospital. As for Thomas Coram, he was a noted sea captain who originally had a ship building business in Taunton before becoming a wealthy merchant. He spent a great deal of his time attempting to establish a colony in the U.S.A (Maine) as a business venture which failed, after that he concentrated his time in establishing the Foundling Hospital after being appalled by seeing the homeless and abandoned children simply left in the streets of London. I strongly advise visiting this museum if only to understand the torment experienced by 18th century mothers who were sadly confronted with the agonising decision of giving their children away.

From Guilford Street (the children's entrance to Coram Fields) we now make our way east towards Doughty Street but before reaching there we will pass an interesting group of buildings on our left that form Goodenough College. This college is an international residential centre for postgraduates either studying or training in London. Goodenough was founded in 1930 primarily to house future leaders of what was then a 'Great Empire' in an environment similar to the Oxbridge lifestyle. Today our great empire may have reduced considerably but the college still retains its elegant and stylised façade, which I understand has recently had a major refurbishment. Incidentally I should point out that there was once a very popular coffee shop named Peell's Coffee House close-by in Crane Street, which I'm sure CD and his group would have used at some time.

Just beyond the college, cross Guilford Street and you will notice a small road entrance called Doughty Mews, and a few yards further along is Doughty Street, this is where we are heading next. The name Doughty derives from Sir Edward Doughty who once owned a considerable acreage of land in this area and who sold off parts in order that the surrounding roads could be laid in the late 18th century. Both Guilford and Great Ormond Street were made possible because of this enterprise. Doughty Mews is a delightful thoroughfare, which runs almost parallel with Doughty Street and takes the walker back in time to the late 18th century. These amazing mews buildings stand isolated from the 21st century in a time warp and in my opinion are very desirable properties to live in. The mixture of houses in this mews together with the absence of modern paving and ergonomically friendly street lighting systems is a joy to see in comparison to some other fashionable addresses. At the end

of the mews there is a rather nice gastro-pub called The Duke, which is well worth visiting. On this occasion however, we continue past the mews until we reach Doughty Street.

Doughty Street is quite different from the mews, much busier, but none the less beautifully laid out with trees lining the pavements, and many of the properties here are listed and were built between the 1790's and 1840's. Arguably one of the most famous former residents who once lived in this street was Mr Charles Dickens himself, who resided at No. 48. CD lived here between 1837 and 1839 and wrote Oliver Twist during that period; today the building is now home to the Charles Dickens Museum, and has remained so since 1925. CD resided here with his wife Catherine and three of his children, together with his younger brother Frederick and Catherine's sister Mary. Although CD lived in many houses in London, which we will discover throughout this journal, Doughty Street still remains the only one that has not been altered. It was here that he completed Pickwick Papers, wrote all of Oliver Twist and Nicholas Nickelby and worked on Barnaby Rudge. Having visited the museum several times I have been told that CD would not notice much change in its interior other than the furniture arrangement and display cabinets, and as I write the building has recently undergone some major restoration. We have to thank the Dickens Fellowship (founded in 1902) for saving this property and retaining its original image, which gives the world a realistic view of CD's early domestic life. This location is certainly well worth a visit, and I for one cannot wait to see the finished restoration work.

At this point of the walk we are now on the homeward run and it is time for a rest and some refreshment and I know exactly where my next Caffe Nero stop will be. Continue walking down Doughty Street, then on to John's Mews until you reach Theobald's Road, turn right into this road and walk a few yards west and that familiar and welcoming blue and black sign is in site. The minute I enter Caffe Nero the aroma of fresh coffee greets me and the choice of food stirs my appetite, and this little gem of a coffee house looks very comfortable. After an enjoyable lunch I feel pleasantly nourished and with my energy levels fully charged, I continue on my Holborn walk knowing full well that CD would also have approved of this modern coffee house, and the quality of fare on offer.

Leaving Caffe Nero I simply cross Theobald's Road and ahead of me is Gray's Inn Gardens, I then walk down the narrow street which passes Raymond Buildings, where CD once worked as a young clerk. I refer to the former company of Ellis & Blackmore (Gray's Inn Place) where as a fifteen-year-old CD worked as a messenger/clerk for 18 months. It was here that his education was put on hold (much against his will) but where he learnt shorthand, which would greatly help him in future years. He also visited many theatres at this period, which as we know are in close proximity. I sense CD would have enjoyed the gardens we are now standing in, which must have seemed like an oasis from heaven compared with neighbouring districts at that time. Today the gardens are quite busy, there are many people enjoying their lunch break simply sitting on the grass or benches, most of them escaping from the stresses and strains of their working environment.

At the end of this group of buildings, we simply turn left and walk towards Field Court where we arrive at Gray's Inn Gardens. Gray's Inn, as I mentioned before, is one of the original four Inns of Court that accommodated judges and barristers alike, who were expected to subscribe to this honourable society. The Inn has been and still is home to many distinguished barristers and politicians of note, one former example being Francis Bacon, together with many regal and civic patrons such as Queen Elizabeth I. By the 13th century a decree by Henry III stated that institutes of legal education should not exist within the boundaries of the City and Papal Law prohibited the clergy from teaching common law as apposed to canon law, which in essence created the Inns of Court. In developing these changes, as I previously explained, the legal profession migrated to the Holborn area and local inns were adopted as places of work and accommodation. The history of Gray's Inn is fairly vague up until the 16th century, but by the Elizabethan period became more prominent and enjoyed what was known as the 'golden era'. At the outbreak of the English Civil War legal education was suspended, and from the Restoration Period onwards, membership has declined rapidly for a variety of reasons. Now the smallest of the original four Inns of Court, Gray's Inn still remains a very attractive and active location, having wonderful gardens, buildings, and a Great Hall and Library.

For a short period of time CD worked in South Square, which is a short distance away, on the far side of an attractive archway leading

from the gardens. In South Square today stands a majestic statue of Francis Bacon, which is set within another delightful but smaller garden, be sure not to miss a very interesting building in the square which displays a build date of 1759. Close to South Square stands Gray's Inn Square, yet another well maintained grassed area, again surrounded by wonderful buildings each home to the large number of legal practitioners.

Although the majority of buildings in both of these squares are relatively recent in general terms, the walks remain much as they were in the 16th century, although extended in later centuries. Gray's Inn Square (1930-1931) is delightful, having a centrally positioned lawn with attractive flowerbeds and a wonderful assortment of trees. As with many other areas of Holborn, this location suffered extensive damage during World War II, but today the entire location is a joy to visit as it is beautifully maintained and provides every visitor with a serene and peaceful place of refuge from the often-noisy metropolis.

It is now time to leave the very elegant area of Gray's Inn and head back to Holborn simply by walking through a narrow passage called Fulwood Place. Once back on the Holborn road we now cross over to the other side and make our way west for a few yards to yet another interesting area that CD would recognise, as little has changed since the 1863 map, I refer to Staple Inn and Staple Inn Chambers. Staple Inn is instantly recognisable once we have reached Holborn, the façade of which could be used as a backdrop for historic melodramas. Actuaries have used this area of Holborn since 1887 at a period when their Institute was being formed. The earliest reference to Staple Inn was in the Norman period (1292), as a house on this site was known as Le Staple Halle, and was probably part of a covered market. Halle being the name for market in French, and staple being the name given to tax duty on wool, which would signify that wool was weighed and taxed here for many years. Although the actual Great Hall of Staple Inn miraculously survived the Great Fire (1666), it was hit by an incendiary bomb in World War II severely damaging parts of its structure, which were later restored. The Society of Staple Inn, an organisation of lawyers (1415) once practiced here, as academic research has uncovered legal documents of that period. By 1586 the name Staple Inn was synonymous with lawyers, and an established Inn of Chancery was training future legal practitioners here.

The interior of the current Great Hall has stained glass windows each depicting various Fellows, Stuart Monarchs and Judges; this hall was built in the mid 16th century and as were many of that age heated by an open fire under the tower. In 1756 fire broke out in Court No. 1 and although it missed the hall it caused a great deal of damage to other rooms. By 1800 the number of legal students had declined therefore demoting the building to a social club for lawyers and others who occupied the surrounding chambers. During the following years Members of this Honourable Society sold the premises to the Prudential Assurance Company for £65,000 in 1886. In 1887 the Institute of Actuaries took residence and during this period funded the restoration of the original site, at the same time as the Prudential were building the new Staple Hill complex on the site adjacent. Restoration of the original building was completed by 1936 but unfortunately the hall and roof were badly damaged as I previously mentioned, by a flying bomb in 1944. The hall was rebuilt again in 1954 and fortuitously many parts of the original structure were salvaged and incorporated within this restoration project. Those parts that were salvaged included the mechanism of the three-faced clock, previously housed on the gallery, and the original stained glassed windows, which were removed and stored at the outcome of World War II.

The gardens and courtyard to Staple Hill are particularly attractive, gardens of one form or another have been here since the late 16th century; today one can enjoy the fountain, flowerbeds, trees and shrubs. The historic courtyard is traditionally paved and has a number of wonderfully mature plane trees and there is seating and some period lampposts, all of which portray a scene from a Georgian period. One cannot overlook the Chambers themselves, which surround the courtyard, each building enhancing the character of the site. Clearly displayed in stone above each entrance door is the year of construction, age's range from 1729-1759. Did CD ever walk through, sit in or even visit one of the chambers within this small square? I can't help but think he did, and if he did where in his marvellous literary works are they described in some way?

Leaving Staple Inn Chambers, walk back to Holborn where our walk will end today, and in no more fitting a location as the former site of Furnivals Inn. Simply cross back over the Holborn road and

make for Holborn Bars. A fitting reference to Furnivals Inn is clearly visible on the large red-bricked building we now face, a building that CD would not be familiar with at all. Much of the street layout in this specific area has changed dramatically since the 1863 map, largely due to the advent of the Holborn Viaduct; there are however numerous street names that CD would be familiar with but their orientation has altered considerably.

Furnivals Inn was founded around 1383 and was once attached to Lincoln's Inn, by the 19th century lesser Inns of Chancery were gradually dissolved. Purchased by new owners Furnivals was mostly rebuilt only to see it completely demolished in 1897. The former historic Inn can boast some very important tenants such as CD and J M Barrie, CD lived here from 1834-1837 where he started writing Pickwick Papers. CD's first child was born at Furnivals Inn and although his chambers consisted of just three rooms, and the use of the cellar and loft, he recalled in later years, whilst living at Doughty Street just how much he enjoyed living there. The new Holborn Bars constructed between 1879 and 1901 for the Prudential Assurance Company remained remarkably uniform in design despite all the additions carried out in later years. This is a testimonial to the Victorian Gothic model of construction, in this case terracotta matched colours, which were quite easy to duplicate. Today Holborn Bars is occupied by Sainsbury's and used as a Head Office building.

Fittingly this walk has incorporated much of CD's connection with the legal profession, which at times throughout his life proved for him to be both repugnant and unfriendly.

My second walk now over, I see another Caffe Nero in the distance; time to grab another coffee before my journey home.

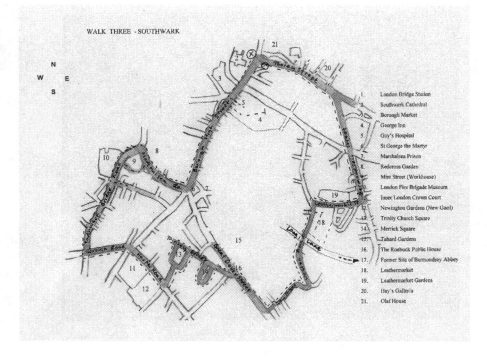

WALK THREE - SOUTHWARK

N
W E
S

1.	London Bridge Station
2.	Southwark Cathedral
3.	Borough Market
4.	George Inn
5.	Guy's Hospital
6.	St George the Martyr
7.	Marshalsea Prison
8.	Redcross Garden
9.	Mint Street (Workhouse)
10.	London Fire Brigade Museum
11.	Inner London Crown Court
12.	Newington Gardens (New Gaol)
13.	Trinity Church Square
14.	Merrick Square
15.	Tabard Gardens
16.	The Roebuck Public House
17.	Former Site of Bermondsey Abbey
18.	Leathermarket
19.	Leathermarket Gardens
20.	Hay's Galleria
21.	Olaf House

WALK 3

SOUTHWARK

"Whatever was required to be done, the Circumlocution
Office was beforehand with all the public departments in
the art of perceiving—HOW NOT TO DO IT"
(Little Dorrit—1857)

This third walk will encompass many aspects of CD's life and I
feel that if he were walking the same streets of Southwark today,
he would be slightly overwhelmed by the change in certain areas,
long ago so familiar to him. He spent a good deal of time exploring
areas of Southwark, which housed the poor, including the last resort
shelters, namely the workhouses that serviced the needy population.
On a warmer note, he would be equally familiar with a variety of
inns, coffee houses and general entertainment that were popular in
this area.

Southwark is sometimes undermined in the annuals of history,
but is to my mind as interesting as any other borough of London. The
name Southwark is said to have derived from the Anglo Saxon phrase
'Suthringa geweorche' meaning 'fort men of Surrey'. Records show
that Southwark is recorded in the Doomsday Book (1086) and was at
one time simply known as Borough, where, two Roman roads, Stane
Street and Watling Street met at what is now Borough High Street.

Considered to be a good location by the Romans due to its close
proximity to the bridge that crossed the Thames, Southwark became
an important site until they finally departed these shores. During
the next few centuries this former area of high activity entered
into a period of decline. The Borough eventually recovered in the

7th century, and developed into a thriving market town with a large proportion of the surrounding land owned by the Church.

Throughout its chequered history the Borough has been both a fashionable and industrious area to work and reside in, it built many wonderful churches and various buildings of note, attracted and inherited a plethora of essential industry and commerce whilst still keeping sight of the arts. Southwark has witnessed extensive regeneration in the last decade; although its busy wharfs and light industry have ceased trading, there has been a massive residential development programme, which to my mind sits comfortably amongst a modern corporate invasion.

Our walk begins the instant we step under the railway bridge, which leads from London Bridge Station to Borough Market, at this point we turn left into St Thomas Street, a busy little street that once served the former St Thomas' Hospital. Although the hospital has long since moved to its current location in Lambeth, being replaced by Guys' Hospital, it is worth mentioning just how important it once was in serving the local community for many centuries. The original St Thomas' Hospital was said to have been founded around 1173 following the canonisation of St Thomas Becket, and was run by an order of Augustinian monks. My 1863 map clearly shows that this hospital was sandwiched between Tooley Street and St. Thomas Street approximately where the approach to London Bridge Street is now located, and was originally run as a shelter and treatment site for the poor, sick and homeless. At the end of the 17th century, the hospital was in need of some major repair and was eventually rebuilt by the City of London Mayor, Sir Robert Clayton. In 1721 Sir Thomas Guy (a governor of St Thomas's) founded Guy's Hospital, which treated incurables who were discharged from St Thomas's. In 1871 St Thomas's relocated to its current location when the land it was built on was compulsorily purchased to build a viaduct linking London Bridge Station to Charing Cross. Today parts of the original hospital church still remain, now offices, which incorporate 'The Old Operating Theatre' (now a museum) together with several Georgian houses near Joiner Street. The current Post Office used today has been built on the site of the 1842 Women's Ward. Although separated by a few miles, today's St Thomas' Hospital forms part of the Guys' & St Thomas' NHS Foundation Trust.

As we are now close to Guys' Hospital it is a good time to take a brief look around this medical complex which now occupies a great deal of the surrounding area. The hospital was founded in 1721 by Thomas Guy, who was also a successful businessman, publisher and one of the few who actually made a fortune during the South Sea Bubble fiasco. When first planned the hospital was carefully designed around a courtyard that faced its neighbouring hospital St Thomas'. Today a courtyard still exists, with a chapel building to its right that leads to a very well maintained set of gardens, and a feature within one of the gardens is a former stone pedestrian alcove that once graced the New London Bridge (replaced in 1973), with a bronze statue of John Keats sat on a bench. The entire ground floor area surrounding this entrance has retained a very Georgian flavour; especially some houses close by in St Thomas Street. This area was greatly extended throughout the following decades and by 1829 a further 100 beds were accommodated due largely to a bequest of £200,000 given by Lord Nuffield (a major benefactor and past governor).

In 1974 Guys' Tower was built which consisted of a 34-floor structure, 143m high and said to be the tallest hospital in the world. The Tower is split into two sections, the top floors housing the dental school and lower floors being medical departments. The entire site consists of 19 interconnecting buildings, which incorporate medical services, teaching facilities and a large residence for students who interestingly have nicknamed the building 'The Squirrel' due to the unusual silhouette portrayed by its strange shape. More recently Thomas Guy House was completed (1995) as an addition to the clinical building and today over 8,000 staff work in this joint NHS Trust. Between them they represent two of the oldest teaching hospitals and apart from the colossal number of medical patients, amazingly provide a dental service, which also supports 120,000 patients a year!

It is now time to return to Borough High Street backtracking along St Thomas Street in order to visit a very ancient and historic marketplace that has traded in this area for almost a millennium. I refer to Borough Market, which is located by carefully crossing the high street and walking along Bedale Street. Borough Market is one of the largest food markets in London and arguably one of the oldest. Records suggest that it started in the 13th century, whereas claims have been made that it has been trading here since the 11th

century. In common with Covent Garden and other markets the borough was granted a royal charter to formalise a market in the 17th century, which was later rescinded by Parliament when trading created unmanageable traffic problems. An engraved plate from the 17th century clearly shows just how the congested market impacted on travellers, by restricting their passage from entering or leaving the City. Although its original location alongside London Bridge made it easy for traders to transport their products, it was eventually moved to its current site, a triangular piece of land known as 'The Triangle'. I never fail to enjoy watching the busy trading that takes place here, with commodities of food from every corner of the British Isles and parts of Europe being sampled and sold. CD could quite possibly have experienced a similar setting, as the architectural features of this marketplace almost remain the same today.

Whilst exiting from the market into Stoney Street, I should mention that the next street due west (Park Street) once housed the Barclay & Perkins Brewery, which features on my 1863 map, a feature which you can't help but notice, as it covered 14 acres of land. This imposing brewery was noted for its strong ales, Chaucer and his friends were said to have drank copious jugs of this ale and proclaimed that it was "the strongest ale to be sold in the Tabard Inn!" a building which I will identify later. The brewery was once owned by Mr Henry Thrale (if you remember, a friend of Samuel Johnson) and Mr Thrale is also remembered by a street being named after him just a few yards further west. Immediately across the road from this former brewery once stood an almshouse called Deadman's Place, named after the number of dead interned there during the Great Plague! It is said that the almshouse was built and run by a former saddler to Queen Elizabeth I.

Today in Southwark Street (where Stoney Street ends) to our left stands the Hop Exchange, which was built around 1864, therefore not featured on the 1863 map, but still known to CD. This majestic Victorian edifice is now Grade II listed and apart from some damage to its upper floors during the Blitz has still retained its wonderful façade.

Back to our travels, and having walked to the end of Stoney Street, I am now confronted with the very busy and somewhat confusing historic road, which is of course Borough High Street. Whenever I drive, walk or even stand confronted with the volume

of pedestrian or vehicle traffic in this particular area I realise immediately just how congested London can be at times and can imagine what it must have been like centuries ago, when this was the only access to cross the river. At one time London Bridge was the only dry passage across the Thames until Westminster Bridge was constructed. Borough High Street is one of the oldest roads remaining in London, and was once recorded as having the most coaching inns in the Capital, 23 in total at one time. Until the New London Bridge was erected (1831), the street pattern had remained unchanged for centuries, and was only slightly altered again in 1843 when London Bridge Station arrived.

It is easy to recognise many original 17th and 18th century building facades that remain almost unchanged today. The only noticeable difference being the street numbering which was changed in 1870 due to the street widening, the realignment for London Bridge and the forthcoming railway viaduct. Unfortunately many interesting buildings have been destroyed over the years, firstly in a fire in 1676 and more recently in the Blitz, which ruined so much of historic London. At No.77 (formerly No.70) stands The George Inn, a 17th century coaching inn, which has still retained the original three storey facade and attic, together with wooden dormers and walls partly of timber framing and brick. A feature of this building includes part of the busy courtyard, protected by gates on the high street elevation. This inn is a wonderful reminder of how most coaching inns functioned in their heyday and how attractive, albeit hazardous, were these modes of transport in an earlier era. Coaches set off from this point to many destinations, mainly in Kent, and an adjoining area close to the inn also served as a central terminus for a depot housing goods wagons. The ground floor of The George Inn connects a number of bars today; the Old Bar was once a waiting room for coach passengers, whilst the Middle Bar was used in CD's time as a coffee house, which he visited often. Both CD and many other noted authors and playwrights (Shakespeare being just one) were said to be frequent visitors to the inn, CD referring to it in Little Dorrit, and Shakespeare frequenting it when working at the original Globe Theatre.

Many former personalities from the annuals of history have either lived or stayed in residences along Borough High Street. In No.83

there once stood the Tabard Inn, which was the meeting place for Chaucer's Pilgrim's, and at No.105 is where The Queens Head Inn once stood, this is mentioned in many stories and tales from the past. John Harvard was said to have inherited the lease of this inn just before he sailed to America, the Harvards' being a local family who ran various businesses in and around the high street itself. No.180 High Street was once the site of a former mansion called Suffolk Place (demolished in 1557) after which the surrounding area became a criminal enclave known as The Mint. The High Street can also boast of once having two prisons, namely the Marshalsea and the King's Bench, and of course we must not forget a very well used premises called the Surrey Coffee House which was quite popular during the 1840's, one possibly that CD may have visited.

Before walking down Borough High Street, it is well worth mentioning a wonderful building, parts of which still remain, which is located across the road from The George Inn, namely Calvert's Inn. Hidden behind No.50 at the intersection of the High Street and Southwark Street, stand the timber frame relics of this former inn, concealed within a modern office building. This former drinking house was originally called the Goat Inn and later The Brew House. The Goat Inn was once the oldest medieval building in Southwark. Look around and you can still see several wonderful buildings from the high street elevation that have survived the test of time, each nestling comfortably overlooking the viaduct which accommodates Counter Court (the present location of the war memorial).

Time now to simply walk south down the High Street and try to visualise just how much change has occurred over the past 150 years. CD would certainly have walked this passage many times as both a young boy, and later as an adult, to visit his family in the Marshalsea Prison or simply head to his temporary lodgings in Lant Street. In later years he would have travelled here, possibly by hackney carriage, either on a four-wheeled 'growler' or the two-wheeled 'cabriolet'. CD mentioned cab drivers in many of his works and said of them that most were noticeably uncivil about payment of fares! When CD was young he would have seen many horse drawn Mail coaches noisily thundering along the streets pulled by four athletic horses, each coach beautifully displaying the royal cipher. These wonderful vehicles would be phased out in the 1860's when the railway arrived.

Imagine these carriages waiting in one of the coaching yards we have just passed, then loading their passengers and bursting forth into Borough High Street on their journey to the coast or other awaiting destination.

What hasn't changed at all is our next building of interest, namely St George the Martyr Church, which we can clearly see to our left at the busy traffic junction where Borough High Street meets Great Dover Street. The name St George was adopted by the Crusaders, after their third crusade, following the Battle of Acre (1189-1191). There have been two previous churches on this site, little is known of the first one, however it is recorded that Henry V visited a church here on his return from Agincourt (1415), in the same year that St George became patron saint of England. The current church was rebuilt in 1736 and still retains its classical style of construction, built from red bricks and Portland stone (a wonderful partnership); a Government commission and several City Livery Companies largely funded the rebuild. Although CD would be familiar with the external Georgian appearance, he would not recognise the new ceiling internally, which was introduced in 1897. The organ has retained many of its original parts from the 18^{th} century, as have the church bells, which were repaired and re-hung in 1735. CD has strong associations with St Georges', firstly as I mentioned earlier when his family were 'guests' of the neighbouring prison and in later years when he wrote Little Dorrit and made several references to the church and its surrounding area. In fact, in the east window of the church a small representation of Little Dorrit can be seen in the stained glass window as a mark of respect to the great novelist. Unfortunately I have yet to enter the church as it is only open at specific times, but I hope to remedy that situation at some time in the future.

Whilst we are here it is time to visit an area, which made a great impact on CD's life, an area that has retained some structural evidence of the past, albeit simply a high brick wall. I refer of course to what was once the Marshalsea Prison, which can be seen by simply walking to the rear of the church, adjacent to the John Harvey Library and heading along the narrow corridor now known as Angel Place. This area of Southwark was not only known for its tanneries, breweries and workhouses, it was also recognised in CD's time for its penal institutions. Two prisons were located very close to Borough

High Street, one in particular, just yards from St George's Church, which was called the Marshalsea and known as the debtor's prison. The first Marshalsea prison was in fact sited on what is now 161 Borough High Street, between King Street and Mermaid Court, and like the second building of the same name was used to incarcerate debtors. I referred in the Strand walk to No 5 Portugal Street, which in CD's day was the Insolvent Debtors Court, perhaps I should now explain briefly what purpose these served.

In 1813 during the reign of George III, an Act of Parliament was passed to help the criminal penal process meet the demands of the prison system, in relation to the large number of debtors passing through the judicial courts. Those imprisoned for debt could later apply to the court to be released by reaching an agreement with their creditors, this did not however apply to people who were in 'trade' or guilty of fraud. The idea was to confine debtors rather than punish them, and the lifestyle they were subjected to in prison was largely dependent on the generosity of family or friends. Until 1841 bankruptcy was confined to traders owing more than £100, debtors however were not traders and did not qualify to become bankrupt, they simply became insolvent debtors. Insolvency simply means that a person is unable to pay their debt when they are called in. Bankruptcy dissolves the debts once and for all and if there are sufficient assets the supervisor will distribute funds raised as a dividend, during this period a bankrupt is prevented from managing his financial affairs. To be insolvent means that a person is unable to pay their debts immediately they are called in, by 1861 this Act of Parliament was finally rescinded.

The original debtor's section of the Marshalsea prison was quite small, its footprint measuring only 177ft x 50ft and was managed by private individuals on a profit basis. This prison segregated male and females, the Master Side having 50 rooms for rent, the Common Side consisting of just 9 small rooms into which 300 people were incarcerated from dusk to dawn! Conditions in the Master Side were said to be dire but manageable providing the room rents were paid regularly. Families were allowed to lodge here, again on payment of extra rent. The Common Side was however a totally different experience, living conditions were horrific, prisoners barely having sufficient room to lie down and rest. The practice of torture was quite

common for prisoners in this area, thumbscrews, head restraints and whippings were commonly applied. Prisoners here were fed by the income raised from local charities, after the gaolers had taken their cut. In 1729 a Gaol's Committee was appointed to visit Marshalsea, and other similar prisons, following accusations of cruelty and murder. This resulted in several key officials within certain prisons being tried for their heinous crimes. A certain overseer of the prison named William Acton allegedly bribed key witnesses for his defence and was eventually exonerated from all charges! By 1811 the prison had been demolished as it was said to be in a 'ruinous state, insecure, ready to collapse and unimaginably filthy'.

The second Marshalsea was built soon after and located just 130yds south of the original prison on the site of the former White Lion Prison, known locally as the Borough Gaol. Like its predecessor the second prison was extremely cramped, there were 8 houses each with 3 floors containing 56 rooms approximately 10ft x 8ft in size. Apart from the overcrowding, conditions were slightly better, however there were still many financial punishments inflicted by a debtors committee. This committee acted responsibly and quickly in overseeing unsanitary conditions and criminal acts when they occurred. Traditional practices prevailed such as 'garnish' and 'chummage', garnish being the money prisoners were expected to pay to use privileged areas of the gaol such as, the use of the kitchen, candlelights, and newspapers etc. Chummage meant that prisoners were expected to 'churn' with others and rotate rooms, those wealthier could pay extra and have a room of their own. If a prisoner was declared insolvent (assets of less than 40 shillings) they were not expected to pay chummage and if their creditors agreed, they could be released after 14 days. One additional building, formerly part of the Old Borough Gaol, was allocated for Admiralty prisoners awaiting court martial, these prisoners sometimes exercised in the same yard as the main prison. The Marshalsea closed in 1842 and prisoners were relocated to either Bethlem or Queens Prison.

CD's father was an inmate at Marshalsea in 1824, taking most of his family with him, for a period of 3 months. As a young boy of twelve CD walked with his sister every Sunday from Camden Town to visit his family in the prison, his meagre wages paying for their keep. Eventually CD took lodgings in an attic of a house in Lant Street, which belonged

to the vestry clerk at St Georges' Church, thereby making his visits much easier to bear. Marshalsea featured in three of CD's novels, The Pickwick Papers, David Copperfield and Little Dorrit, and one cannot but help thinking just how ingrained the memories of this period of his life affected his entire outlook on future events. Strangely enough, through pure curiosity or perhaps for research purposes CD revisited the site of the Marshalsea in 1867 and recorded his findings. Today all that remains of the prison is a large brick wall that marks the southern boundary and can be viewed from Angel Place, beyond the wall stands a pleasant garden that was once a graveyard.

Time now to leave this area but before doing so it is worth crossing the busy intersection and walking a short distance along Great Dover Street (even though our walk will take us next into Marshalsea Road) and simply look back towards the church where you will see old and new architecture at its best. By this I simply mean that the immediate vista highlights the recently completed 'Shard' Building, which stands alongside London Bridge Station, a fitting backdrop to St George's Church, fantastic, like it or not (and I do) these creative icons of architectural beauty will certainly be captured as a future illustration.

To continue the walk we cross over the busy intersection and make our way down Marshalsea Road, which in CD's day was called Mint Street. This particular area was once a notorious rookery district, overpopulated and riddled with poverty and crime and one can appreciate why it attracted philanthropists and social reformers. Today we turn right off of Marshalsea Street and walk into Disney Place where we are confronted with Little Dorrit Park, a small but pleasant playground for children which was established in 1902. In fact a large part of the surrounding area in this district is named after characters immortalised in the works of CD as it really was an area he knew and visited often. Looking around these streets today one can see just how compact housing districts evolved, my research tells me that in CD's day the population was three times as great! Beyond the park that we have now arrived at sits Little Dorrit Court, which nestles alongside another amazing hidden treasure called Redcross Gardens. These gardens were established by Octavia Hill (1838-1912) a social reformer, who in 1887 created this tiny oasis that was set amongst tanneries and breweries which provided work for the deprived local

population as well as their children. Once the Church had eventually purchased this land from its former owners (paper manufactures) the gardens we see today were built by volunteer workers conscripted by Octavia. This garden is still extremely well maintained and has three delightful mature trees and a wonderful row of cottages as a backdrop. An ornate pond and attractive paths lead to a tiny bridge, which spans this tranquil water feature that really does compliment the entire area. Well worth a visit, and I feel sure that Octavia would be delighted to see her garden in such good condition today.

Further along Redcross Way, I am told but have yet to find, is a spot called Cross Bones, which was in medieval times a paupers burial ground for 'single women', research would indicate that this term referred to prostitutes.

Heading back down Redcross Way we turn back into Marshalsea Road and a few yards further along to our left we come to what was once the site of Mint Street Workhouse. Where once the workhouse stood is today is a very pleasant public garden area, well maintained and judging by the residents walking past, well used. Known then as St Georges' Workhouse, a name probably transferred over from the former workhouse, which in 1731 once stood close to this spot. The original building was built by St Georges' Church, which housed 68 inmates (men women and children) who it is said worked here in 'reasonable' conditions. A workhouse is clearly shown in the 1863 map, this one was built to hold 624 inmates (grossly overcrowded), males and females being segregated from a further group of people called 'foul cases'! This workhouse like many other similar ones in London continued into the early 20th century, Mint Street Workhouse ceased running in 1920 and was demolished in 1935, and interestingly enough CD was said to have used this building as a model for Oliver Twist. Just one mile from this workhouse stood another named the Workhouse of St Saviour (now the site of Southwark College), which accepted inmates as early as 1834. Conditions were so bad in these institutions, there followed a government inspection of workhouses, and articles like the one printed in the Lancet provoked a public outrage. Following these reports legislation was passed which introduced the Metropolitan Poor Law Act of 1867, that consequently improved conditions in these and similar institutions.

Workhouses feature everywhere in my walks of London, so perhaps a brief explanation of the Poor Laws may help to understand just how fragile the populous of our capital was. Arguably, the years between 1837 and 1844 brought the worst economic depression that had ever afflicted the British people. Many of the nations business's came to a halt and more than a million paupers starved from lack of employment. At the start of the 18ᵗʰ century local parishes dealt with the relief of the poor, and in 1834 the Poor Laws were changed and the administration of these duties was taken out of the hands of the parishes, this was when the Poor Law Unions were formed. The Poor Law Commission's findings of 1832 aimed at transferring workers to urban areas where work was said to be more plentiful, and also to protect urban rate payers from paying too much! Workhouses' were seen as places to act as a deterrent, especially as the population was increasing faster than resources, therefore there was no room for a system that mollycoddled people in deprived areas. The number of children born within each family continued to remain untenable in so far as it remained increasingly difficult even to feed offspring; contraception was simply a byword and ignorance a pleasure. Even CD was a party to the birth rate phenomenon as he is said to have only wanted 3 children and a doting wife; he had 10 and didn't know what to do with them. In his case his income was his saviour, the poor had no saviour. It was thought that The Poor Law would reduce the cost of looking after the poor, take beggars off the streets, and encourage poor people to work harder to support themselves, and a solution was considered achievable by the process of workhouses.

CD wrote Oliver Twist as a means of slandering the Poor Law Act and I shall always remember a recorded conversation which summarised the complete debacle of this period, it records that Queen Victoria once asked Lord Melbourne if he could recommend the newly published novel Oliver Twist, which was attracting much fame. Lord Melbourne replied that he did not want her to read it. "It's all among workhouses and coffin makers and pickpockets I don't like these things; I wish to avoid them; I don't like them in reality, and therefore I don't wish to see them represented." Lord Melbourne was Prime Minister at that time and had just brought in the New Poor Laws of 1834. Was his response to Victoria a little understated, it's a pity that spin-doctors were not around then as I feel he had a real need for one!

Fig 8 Leather Market

Fig 9 London Bridge Station & Guy's Hospital

Fig 10 St George the Martyr Church

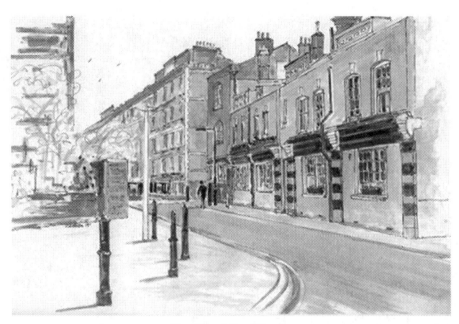

Fig 11 Mint Gardens

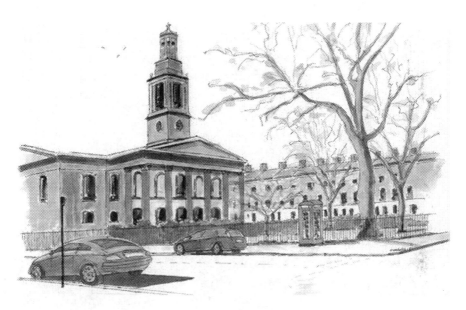

Fig 12 Trinity Church

Before moving away from Mint Street look across Southwark Bridge Road where the London Fire Brigade Museum now stands. This monolithic building was once part of the original Southwark Fire Station and today houses a unique collection of historical fire fighting machines and equipment. I understand that certain parts of the museum once formed part of what was then Winchester House. London's fire-fighting service first got underway following the Great Fire of London (1666) when insurance companies demanded an insurance premium that prompted new companies to form their own fire brigades. Clients who enrolled and paid their premium had plaques sited on the exterior facades of their premises as a means of identification. Fire fighting equipment was fairly basic then, until in 1721, Richard Newton patented a new water engine (pump) which was hand operated, although quite effective when used on fires his pump proved very tiring for fire fighters to use, and ordinary members of the public were said to have been offered 'beer tokens' to man these pumps while the appointed staff rested!

In 1833 James Braidwood became Chief Fire Officer when 10 independent companies formed the London Fire Engine Establishment (LFEE). Braidwood had previously formed the worlds first municipal fire service in Edinburgh in 1824 and was the first to introduce uniforms, equipment and research programmes in fire fighting and prevention. Sadly Braidwood is probably best remembered today for his bravery when in 1861 he organised a massive call for help after a fire developed at Cottons Wharf, which almost eclipsed the ferocity of the Great Fire of London. Cottons Wharf (which we will pass later) stored both hemp and jute, both were highly inflammable, when a fire eventually ignited there it encompassed the majority of wharfs between London Bridge and today's Tower Bridge. Braidwood distinguished himself during the fire but unfortunately lost his life in doing so, when a falling wall crushed him to death. It took two days to recover his body, following which his heroism led to a massive funeral enclave in the streets of London a week later, the Tooley Street fire however continued to burn for a further two weeks. A memorial statue of Braidwood was erected in Parliament Square in 2008, and thankfully five years after his death the Metropolitan Fire Brigade was formed, as the LFEE would no longer take responsibility for London fire protection and subsequent compensation costs.

As we leave Mint Street gardens and head towards Weller Street take a look to your left and you will see the remains of an old brick wall, believed to be part of the original workhouse. Continue to the end of Weller Street, turn right into Lant Street and walk ahead until you reach Southwark Bridge Road, but before we get there I should mention once again just how significant Lant Street was when CD was a young lad. It was in this street (generally thought to be No1) that CD was given lodgings as a twelve-year old boy whilst his family were inmates of the Marshalsea. Although the original house No.1 has been demolished, it is generally thought that it was located at the Borough High Street end of Lant Street, on the corner of the junction with Sanctuary Street, and the house overlooked a timber yard, which again has long disappeared. Lant Street was virtually divided into two halves when the more recent Charles Dickens Primary School was built here; therefore one has to walk back to Borough High Street to gain access to what was once No 1 Lant Street. When CD's family entered the Marshalsea both he and his elder sister Fanny faced a long walk each weekend to visit them, which distressed young Charles. By getting lodgings nearer to the prison he was able to have both breakfast and dinner daily in their company. It was during this period that CD worked in the blacking factory, which he hated, and lived in Camden Town, whilst his sister Fanny was improving her musical skills by living and working in the Royal Academy. He used this street name in Pickwick Papers when he wrote of Bob Sawyer having lodgings in Lant Street.

The street name Lant derives from a wealthy property developer, named Thomas Lant, who owned a substantial piece of real estate and rented out several hundred homes in this area in the 18th century.

We continue our walk by heading back to Southwark Bridge Road, which incidentally was created in 1819 to ease congestion and improve access from the south to the City, and to Westminster areas following the construction of both Blackfriars and Westminster Bridges. This dream to improve the chaotic congestion problems was not fully achieved till much later when Southwark Street was introduced. Incidentally, where Southwark Bridge Road and Borough Road meet, once stood yet another house of detention, namely the King's Bench Prison, which was built in medieval times and eventually closed in 1880. Like Marshalsea Prison, this prison was

used for debtors, bankrupts and other 'misdemeanours' until the penal system was reviewed in the mid 19th century. This prison was renamed Queens Bench Prison in 1842 and is clearly identified on the 1863 map. Its history is worthy of some mention, it was rebuilt in 1758 and reputed to have been dirty, overcrowded and prone to outbreaks of typhus, no different to others of that period you might say. In 1768 a radical named John Wilkes was imprisoned here, which caused a monumental riot now known as the 'Massacre of St Georges' Fields', twelve years later the prison was again damaged badly in the Gordon Riots. At a later date Lady Emma Hamilton spent time here, as did Marc Isambard Brunel who was incarcerated for debt. CD also used this prison in his novels, Mr Clenham discussed the prison in Little Dorrit, and Mr Micawber was here for debts as was Madelaine Bray and her father in Nicholas Nickleby. The Bray's incidentally were granted the Rules of the King's Bench, which allowed them to live within 3sq miles of the prison, how different the penal system is today!

At Southwark Bridge Road turn left in the direction of Borough Road, and on arrival simply cross over Newington Causeway and enter Harper Road. At this point the change in the 1863 and 2012 map becomes extremely complicated therefore I will simply refer to the present map for the time being.

The moment we enter Harper Road I have more Gaol's and stories to reveal, it is no wonder CD's creative mind built upon situations, events, and social circumstances, all of which would keep his readers captivated, especially the earlier serial formats. Rich or poor, just imagine the suspense and interest he aroused through his novels, as they materialised into epic documentaries of both industry and society.

Today the Inner London Crown Court sits looking very stately on the corner of Harper Road and Newington Causeway, but was once the site of penal institutions that have a chequered history. Originally this was the former site of the Borough Gaol that dated from the Tudor period, following which Horsemonger Gaol was constructed between 1791 and 1799, and was said to be the largest prison in the country at that period. Horsemonger Gaol remained Surrey's principal prison and place of execution until its closure in 1878. It was built to accommodate 300 inmates, mainly debtors and

criminals, and prison records will confirm that over 130 prisoners were executed here between 1800 and 1877. In 1859 the Gaol changed its name due to the newly developed road (Union Road) and was then called New Gaol. New Gaol was closed in 1878 and demolished in 1881, making way for what is now Newington Gardens, and the Inner London Crown Court was built later in 1917.

In 1849 CD attended the public hangings of Frederick and Maria Manning, convicted of murdering Maria's lover, which attracted thousands of spectators partly due to the fact that this was the first husband and wife hanging in London since 1700. A published article referring to this horrific exhibition indicated that the wealthier spectators paid a great deal of money to gain good vantage points to view this ordeal, fashionable ladies used opera glasses to get a better view while street traders sold novelties and broadsides (an often inaccurate account of the crime). During this lengthy spectacle several spectators were crushed to death in the press to catch a glimpse of the final act!

Whilst researching this prison my eyes were opened to the manner in which many public executions were performed here, in fact the gallows themselves were erected on a level area of the roof facing Harper Road which was then called Union Road. The positioning of the gallows was said to allow the maximum number of spectators to get a good view! There are scores of illustrations, paintings and reviews on these executions, which seemed to attract the general public in a manner like any arena sport today.

CD attended this public hanging (he may have viewed others) following which he is said to have written to the Times newspaper expressing his revulsion at the proceedings. He later campaigned with a number of influential people to abolish public hangings, which finally came about in 1868. Whilst I consider CD to be arguably the finest Victorian novelist of his day, my research for this book leads me to question some incidents in his life which I feel dampen his character at times. One incident in question is a hanging, when CD hired a back kitchen in nearby Bath Terrace, with roof space and several rooms for himself and 5 friends, at a cost of 10 guineas, simply to ensure a good view. My dilemma is that did he write to the Times simply to complain about the carnage he witnessed amongst the spectators, or as we are to believe, was he genuinely upset

about the entire spectacle. If the latter is the case then why did he even attend this event, and why on earth did he go to the trouble of making himself and his colleagues comfortable, whilst ensuring a good view?

Not wishing to labour on this point it is now time to leave the area of Newington Gardens, which today maintains a tranquil and peaceful appearance and shows no sign of the events that took place here just over a century ago. The walk now continues opposite these gardens where we turn into Brockham Street and head towards the rear elevation of what was formerly the Holy Trinity Church. Brockham Street contains a mixture of old and new buildings, the older ones to our right retaining a Georgian appearance but the treat is to come when we eventually turn left into Trinity Church Square. Once in the square we can see the graceful terraced housing of Trinity Village, which remains exactly the same today as it was almost two hundred years ago, CD would be very familiar with this view today.

Trinity Village is an 1820 development of classic Georgian terraced housing owned by the Corporation of Trinity House, the rent provided from these properties contribute to a substantial part of the Corporation's income. Trinity House itself plays a major role in safety measures for shipping, being the General Lighthouse Authority for England and Wales; in doing so it maintains 69 lighthouses, 3 vessels, several small boats and a helicopter. The corporation was founded in 1514 by Royal Charter, and their first Master, Thomas Spert, captained the Mary Rose. The organisation's headquarters are at present in Trinity House, close to the Tower of London, which we shall pass in a later chapter. In the centre of the square, surrounded by these wonderful houses now stands Henry Wood Hall, named after Sir Henry Wood (1869-1944) who is best known for his promenade concerts. The hall was originally Holy Trinity Church, built in 1820 by Francis Bedford, which closed in 1960 for one reason or another and was gutted by fire in 1973. The deconsecrated church was almost totally restored in the early 1970's to provide a suitable and permanent rehearsal space for London's orchestras. Both the London Philharmonic and London Symphony Orchestra companies' appointed Arup Associates to undertake this restoration once this former derelict church had been chosen. The original owners of the church, Corporation of Trinity House, then funded the restoration at

their own expense and the Henry Wood Hall project was completed in 1975. Apart from the rehearsal rooms the hall includes a new restaurant in the crypt, libraries and recording rooms, and today visiting orchestras from all over the world rehearse here along with many famous singers and instrumentalists.

Having circumnavigated around this square to enjoy the architecture, continue down Trinity Street for a few yards and you reach yet another smaller square which is equally attractive and has a well preserved garden called Merrick Square. This attractive development of 32 houses was completed in 1856 and central to the square lies a very attractive gated private garden, which I have been informed is open to the public periodically on the occasion of the Open Garden Square's Weekend. Standing here absorbing this village atmosphere I can envisage the presence of CD, as the entire surroundings are captured in a time capsule, and I would like to think that he enjoyed walking around this area even though it seemed light years away from the poverty that was apparent in neighbouring streets.

At the end of Trinity Street where it meets Great Dover Street stands the Roebuck Public House, which is a Grade II listed inn of character built in the 19th century. Continue down this street until you reach Blackhorse Court, turn left into this road and continue along Law Street, in doing so we cross a medieval street once called Kent Street, now Tabard Street. Kent Street was once a favoured street so much so that an Act of Parliament declared that it should be paved with hard stone as far as Lock Hospital, this hospital was a leper hospital, which once stood near Bartholomew Street. To the left is Tabard Gardens and beyond a maize of more recent housing estates.

At the end of Law Street we join Weston Street which features on the 1863 map but only starts from Long Lane, this street was previously called Baalzephon Street, a very old name that I cannot believe CD could have overlooked in one of his novels, had he seen it! We have now crossed Long Lane into Weston Street which I am told houses the HQ of the Co-operative Party who were set up in 1881 by the Co-operative Union primarily as a watchdog group on parliamentary activities. In 1917 the party was duly formed and its first national secretary was a Mr Samuel Perry, father of tennis legend Fred Perry, John Keats also lived in this street when he was

a medical student at Guy's. Today, Weston Street is surrounded by 1950's council houses, and 1920's and 1930's LCC (London County Council) properties, which I have to say present themselves as a well maintained group of estates, a far cry from the housing conditions in CD's day.

Before continuing I would like to make a short diversion down Long Lane until I reach Bermondsey Street, which is on my left. At this intersection stands the church of St Mary Magdalene, which has a rather attractive churchyard/garden area to the rear, but my interest lies in finding Market Place, as it was here that once stood Bermondsey Abbey. Unfortunately the site of the former Abbey is now built upon, but Market Place stands directly opposite the church and is an open public area.

Bermondsey Abbey was a Benedictine Monastery dedicated to St, Saviour that once stood on what is now known as Bermondsey Square. The Square today hosts a fashionable hotel and Bermondsey Market still trades here on Fridays, but the Abbey's historical value is the real treasure of this district. A monastery was known to have existed here before 715AD but only in the Doomsday records can I find a more accurate description of a building being here in 1086. Henry I acquired a great deal of land in Southwark at this period but the monastery and surrounding land were gifted to an order of Cluniac Monks (from Cluny in France) who had an indifferent relationship with both their tenants and English sovereigns throughout the ages.

Henry VIII seized the Abbey after the dissolution of monasteries and eventually the building was sold on to Sir Thomas Pope, founder of Trinity College. In 1545 Sir Thomas pulled down the old priory church, which stood close to the Abbey, and built Bermondsey House.

To the east of the former Abbey now stands St Mary Magdalene Church, built in the late 17th century, an original church of this name is recorded in 1290 but was demolished and rebuilt in 1690 and made much larger. Internally, the church was redecorated to a Gothic Revival style in 1852 and has retained two carved stone medieval capitals, which are thought to be from the Abbey itself. One piece of silver from the Abbey is kept in the Victoria and Albert Museum and is said to be the only remaining piece of silverware from the building that is in existence today. A medieval cross was however found whilst

excavating the Abbey site in 1984, this enamelled bronze figure of Christ is made of copper alloy, enamel and gold, and is said to date from the 13th century.

Having wandered off my scheduled walk to explore the site of Bermondsey Abbey I now make my way back to Weston Street in order to visit a once very industrious area of Southwark, which at one time employed an army of local people.

A few yards along Weston Road to my right stands the impressive building known as Leather Market, and just beyond that is Leathermarket Street and Gardens. Southwark really registered itself on the map in the Tudor period for unpopular reasons when it was decided to relocate the increasing number of 'noxious' trades from their City locations to the Surrey side of the Thames. Relocate is probably an understatement as most of the undesirable businesses such as tanners and leather dressers were forced to move due to the unsavoury working practices which caused enormous waste and environmental problems that were uncontrolled. As these problems escalated, City officials realised that these noxious trades created far too many problems for the residential population, therefore it was decided to group each industry into a remote site which could accommodate and discharge their waste products without affecting the surrounding neighbourhood. Although the area selected was indeed better for environmental reasons, as the 'tidal streams' in this district provided a larger quantity of water from the Thames, all that happened was that the problem was removed to another site.

Wool and hair were also finished in this area and large profits were made from this disposable waste product in a similar fashion to leather. A charter was granted to leathermakers by Queen Anne in 1703 and once in place the Bermondsey area became the main leather working centre for the south of England. Today many of those former 19th century leather factories have survived in building form, if not in operation, especially the huge Leather, Hide and Wool Exchange which we can view today, albeit that the internal features have altered and accommodate a number of modern offices and studios. Having made some attempt to describe conditions in this district during the heyday of trading, I discovered an article written by Charles Dickens Jnr in his Dictionary of London 1879, which I thought summarises conditions perfectly. The article read as follows:

'*The surrounding neighbourhood was devoted entirely to thinners and tanners and the slum conditions reeked of foul smells, and the workforce wore filthy stained clothing when they walked the streets. There were literally thousands of hides piled up, or soaking in the pits, within the exchange. It is said that almost a third of the processed leather in this country came from Bermondsey Leatherworks'.*

How different this district is today I cannot begin to imagine just how foul the stench of soaking carcasses must have been, it is said that the smell could be recognised as far away as Mitcham when the wind was in the right direction!

As we make our way along Leathermarket Street to rejoin Bermondsey Street on the final leg of this walk, I should mention Leathermarket Gardens, which we pass, as this popular oasis of greenery and flowers really does lift the surrounding area. In 1863 this immediate area consisted of leatherworks, tanneries, workhouses, distilleries and a police station all of which were spread within a radius of a couple of hundred yards, how different it is today. The gardens although surrounded by buildings look inviting and provide a calm and serene setting for not only the residential community but also the busy industry and commercial businesses that now serve this area.

At the end of Leathermarket Street turn left into Bermondsey Street and continue along this very vibrant and active thoroughfare, laced with interesting shops, cafes, restaurants, studios, offices and the like. Bermondsey Street itself developed in status in the 17th century especially after the Great Fire of London when well-to-do residents settled along its concourse making this area more urbanised and almost a garden suburb. Even a pleasure garden was created here and called 'Cherry Garden Pier' which Samuel Pepys used and recorded having left it "singing finely". The terrain around this area was originally marshland with small interlocking islands and with a causeway laid to cross this once swampy area. Early houses that lined this street were built from masonry recovered from the former Abbey, but when the 'noxious trades' arrived most of the residents left the district. Bermondsey Street declined when industry moved out of London, however certain markets, warehouses, offices and shops remain here and present themselves in a stylish and chic manner.

At the point where we reach St Thomas Street, cross over this intersection where we are confronted with the very long pedestrian

tunnel which takes us under the railway entry point to London Bridge Station. Through the tunnel we now approach Tooley Street which connects London Bridge to St Saviours Dock, then continues pass Tower Bridge, which of course was not constructed during CD's lifetime. The name Tooley is a corruption of the original church named St Olave, as the church had previously been referred to as Toulas, Toolis and Toolies in past times. There are now many converted wharfs on the riverside passage of Tooley Street, which form part of London Bridge City, a development that materialised in the 1980's. Hay's Lane House is arguably the most famous of these wharf buildings, first being mentioned in a document of 1651, and throughout its industrious history has had many historic features to record, one being its use as the dock where Ernest Shackleton's ship The Quest lay prior to a later voyage in 1921. Today the area of dock that accommodated The Quest has since been 'filled in' and the surrounding area redeveloped into a complex known as Hay's Galleria, the central section is a very innovative piece of moving mechanical artwork called the Navigator.

On the south side of the street there are many interesting tourist attractions, one depicting an early medieval dungeon and another recreating the Blitz of London. It is thought that 68 people lost their lives in a confined area near Tooley Street during one Blitz raid, and due to the enormous extent of bomb damage rubble, casualties were said to have been left and reburied in the masonry of London Bridge Station, how true that is remains a mystery. Tooley Street once accommodated the largest hat factory in the world, and also the Southwark Coffee Shop, which was located close to Hay's Wharf. I would like to think that CD used this coffee shop during one of his night walks? Several people of note are associated with this immediate area, George Orwell lived here as a tramp (in a doss-house) for several weeks in order to get a first hand view of poverty, John Keats lived close by, and JMW Turner painted his famous piece 'The Fighting Temeraine' (a warship being towed to Rotherhithe to be scrapped) in 1837, from the Bermondsey riverside.

At the western end of Tooley Street once stood the church of St Olave's, named after Olaf the Norwegian prince (later to be king) who became an ally of England during several early skirmishes in the early 9th century. A church of the same name was rebuilt by

Henry Flitcroft in 1740 and its presence would have been known to CD, this church luckily survived a fire in 1843 that spread along the wharf. By 1926 St Olave's church was declared redundant and eventually demolished, following which an office complex was built, in Art Deco style, on this site and named Olaf House. It is claimed that the top of the original spire of St Olave's can now be seen in Tanner Street Park (off Bermondsey Street), which now takes the form of a derelict water fountain. Many centuries ago tradition and religion thought that by having a church either side of the south entrance to London Bridge, namely St Olave's and St Saviour's, would act to sanctify the bridge.

We have now reached the end of this walk but I cannot sign this chapter off without mentioning London Bridge Station itself, as it is one of the oldest railway terminals in London with a complex history to match. In 1836 the earliest train services terminated as far East as Bermondsey Street until the present terminus was extended and use of the tracks were shared with several other railway companies. First to use this terminus was the London & Greenwich Railway who agreed to share the tracks with London & Croydon Railway, who later built their own independent station. Shortly after opening, both the London & Brighton Railway and South Eastern Railway were planning routes to Brighton and Dover respectively, and Parliament then decided that these two routes should also share lines and develop a station of their own complicated or what! Confusion, costs and space now became an issue for this multifunctional terminus and all sorts of schemes and plans were drawn up for a joint station. During the following two decades the problems became even greater as schemes were thwart with commercial change, just how Bradshaw maintained his meticulous railway guide is a mystery to me! On my 1863 map however it clearly shows that both the Greenwich and Brighton companies were clearly in control, CD must have been confused like many others during those development years, not to mention his nervousness with rail travel following the horrendous crash he experienced first hand at Staplehurst in Kent, when travelling to Charing Cross. Today I am pleased to say that National Rail seem to have consolidated rail travel in the 21st century and I hope that both London Bridge and Victoria stations continue to serve us well, simply because they are my links to glorious London.

Having completed, and enjoyed my circular route of just a small part of Southwark, I am now in need of some refreshment so I have decided to use the busy Caffe Nero that is located in the middle part of Tooley Street, and I have already decided what to have for lunch. Today will be a nice warm soup complete with a chunk of fresh bread, just right for a cold October afternoon, and of course my usual cup of Americano together with a chocolate panetone, the diet is on hold!

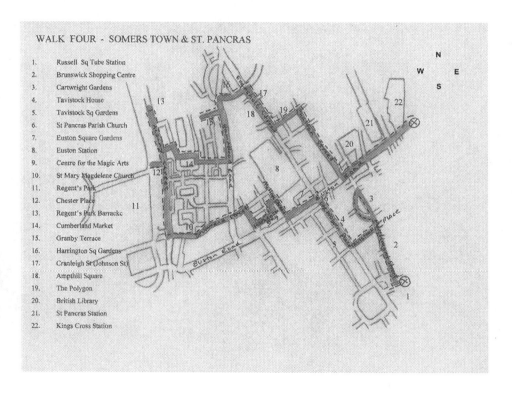

WALK FOUR - SOMERS TOWN & ST. PANCRAS

1. Russell Sq Tube Station
2. Brunswick Shopping Centre
3. Cartwright Gardens
4. Tavistock House
5. Tavistock Sq Gardens
6. St Pancras Parish Church
7. Euston Square Gardens
8. Euston Station
9. Centre for the Magic Arts
10. St Mary Magdelene Church
11. Regent's Park
12. Chester Place
13. Regent's Park Barracke
14. Cumberland Market
15. Granby Terrace
16. Harrington Sq Gardens
17. Cranleigh St Johnson St
18. Ampthill Square
19. The Polygon
20. British Library
21. St Pancras Station
22. Kings Cross Station

WALK FOUR

SOMERS TOWN &
ST PANCRAS

"O let us love our occupations,
Bless the squire and his relations,
Live upon our daily rations,
And always know our proper stations"
(The Chimes—1844)

This walk will focus much more on the Industrial Revolution for one reason only, that being the introduction of steam powered railways and the close proximity to three of London's energetic railway stations. Before the advent of steam, precision engineering generally centred on optical and light mechanical devices, but with the introduction of steam more refined machine metal tooling was possible as well as greatly improved iron making techniques.

By the beginning of the third quarter of the 19th century railways had developed enormously in London, thereby becoming the key centre of the early railway network. The shape of London changed internally as the railway lines joined and bisected the already busy urban street patterns. Rail transformed postal services from London prompting the introduction of postage stamps and in 1848 news services improved when the network of W.H.Smith's railway bookstalls were opened in Euston Station.

CD, as well as the majority of the nation, would have marvelled at the rapid development of the railway system, he would have been overjoyed mainly because it prompted improvements to the road

links both in and out of London, which laid the foundations for the building of new bridges across the Thames.

The districts of Somers Town and St Pancras immediately paint pictures in my mind of Georgian and Victorian history simply because I associate their names with industry and rail. Somers Town evolved from a large triangular area of land between St Pancras, Hampstead and the Euston Road that developed into a small and in some respects self sufficient community, which for the purpose of this walk had many literary associations with CD that are worth exploring. Somers Town was named after Charles Somers (1725-1806), the 1st Baron Somers, who inherited the land from John Somers (1651-1716) following a grant of ownership by William III. The first houses that were built on this land in 1784 took the name of Polygon and were once fields, brickworks and market gardens, which strangely enough appealed to middle class French who escaped their Revolution and took shelter in London. During this period Somers Town was considered to be a more upmarket location, which unfortunately changed once the railway arrived. In the 1830's a large population of transient labourers lived in squalor here, and Charles Booth's record of the area stated that it was the worst slum district in London in the aftermath of his survey. CD and his parents lived here for several years, as we will discover later.

Somers Town's neighbour, the once metropolitan borough of St Pancras was originally a medieval parish with its centre focused on St Pancras Old Church (thought to be the oldest site of Christian worship in England). In the 14th century the population close to the Old Church abandoned the site and moved to the Kentish Town area because of the continual flooding from the River Fleet. By the 1790's the Earl of Camden developed land north and west of the Old Church, which is now known as Camden Town.

By the mid 19th century two major railway stations were built (a third followed later) which transformed and clearly divided the districts, making the residential area to the south and east of the Old Church the district we now know as Somers Town. St Pancras was once well known for its cemeteries in the 18th and 19th centuries, namely the local churches of St James Church, Piccadilly, St Giles, St Andrews, St Georges and St George the Martyr, all of which

were closed in 1854 under an Act of Parliament when St Pancras Cemetery in East Finchley was built.

Our walk today starts in Bloomsbury at Russell Square Underground Station, which was opened in 1906 and designed by Leslie Green (1875-1908), an architect known for his wonderful designs of iconic underground station buildings. Green studied in London and Paris and became a full member of the RIBA (Royal Institute of British Architects) in 1899. His Arts & Crafts style designs were unique in all his stations, an example being the external cladding you see at Russell Square, that takes the form of ox-blood red glazed terracotta blocks. The station was deliberately built with a flat roof to encourage commercial offices to be erected above; this work was only made possible by Green's introduction of load bearing steel frame structures. Given the opportunity to visit each of Green's underground stations you cannot help but notice that all the platforms have individual colour schemes and geometrical tile patterns. Strangely enough only three of his surviving stations have been listed, which I find hard to believe, they are Holloway Road, Mornington Crescent and Gloucester Road. Tragically this amazing architect died at the early age of thirty-three and I can't help but wonder what other ideas and designs he would have produced had he lived longer.

Walking away from the underground station we now pass a very modern complex of shops and apartments in Marchmont Street that have transformed this area, merging several architectural styles into one, a union which I enjoy seeing when it works. The shopping centre I refer to is the Brunswick Shopping Centre that is immediately to my right, which offers the residents of this district a controlled and unique set of retail outlets, restaurants and a cinema set in a corridor of open space. The external appearance of this development reminds me of drawings I once saw of the fabled Tower of Babel that projected a megalithic design, which appeared to recede progressively as it rose vertically. Many Georgian buildings still survive in Marchmont Street several of which have blue plaques on their walls, one reads Kenneth Williams (actor) another tells us that Percy and Mary Shelley lived here, Percy being best known as the great English poet and novelist, and Mary his wife who we know as creator and author of Frankenstein.

By way of a short deviation I shall cross Marchmont Street at the busy crossroads that host an inviting group of small shops and

cafes, and walk a few yards further until I reach Cartwright Gardens. The gardens sit on my left and as I cross over the road to enter them my attention is taken by the small army of groundkeepers who maintain this area for the public to enjoy. It never ceases to amaze me just how well kept our London gardens are, which is a credit to each District Authority, but on this occasion I think credit must go to the City Guild of Skinners who own this part of the estate. Cartwright Gardens were built in 1810 by James Burton (1761-1837) who transformed large parts of Bloomsbury together with areas around the Foundling Hospital we visited in an earlier walk. There is an attractive array of terraced Georgian buildings that follow the contour of the crescent, a large majority of which are now hotels. Each of these period houses strikes a contrast with the more modern structures on the opposite facing elevation. In the centre of the gardens stand tennis courts, which I assume are used regularly. The Gardens were originally called Burton Crescent (as shown on the 1863 map) but the name was changed following the brutal murder that took place here in 1878 of Rachel Samuel, an elderly woman living at No.4 who was battered to death.

Many other noted personalities are associated with this location; John Cartwright (1740-1824) lived here (to whom the gardens are now named) who was a Radical political reformer who campaigned for woman's suffrage, ballot voting and the abolition of slavery. Cartwright was also a Navy officer who in later life became a Major in the Nottingham Militia; and his brother it is said was credited with inventing the power loom. Arguably the most noted resident of these gardens was Sir Rowland Hill (1795-1879), a teacher, inventor, and social reformer who completely remodelled the English postal system by introducing the Penny Post. Hill took a serious interest in the postal service and in 1835 wrote a series of reform articles one of which sparked some interest and led to the introduction of stamp duty in 1840, resulting in the now incredibly rare 'penny black' stamp being issued. This stamp alleviated the previously complicated postal rates system and stopped the fraudulent coded information practices that were already in place. Prior to postage stamps the mail recipient generally paid the postage fee, but often refused payment by not accepting the letter. This devious practice allowed the recipient to read coded information, usually on the corner of each letter, thereby getting

the service free by not accepting the item of mail. Hill also worked to create a utopian settlement in South Australia that he hoped would not accept deported convicts; when he died he was honoured by being buried in Westminster Abbey. CD would have known of these inventive men and I would like to think he may have met them at some time, one thing is for sure that he would have been familiar with the gardens and attractive crescent which surrounds this area.

It is now time to move away from these gardens and walk back along Marchmont Street and turn right into Tavistock Place where we find a blend of old and new properties, which leads us to Woburn Place and eventually Tavistock Gardens. The gardens themselves are a beautifully maintained group of lawns featuring mature sculptured trees, which were first laid down in the 1820's by the builder Thomas Cubitt (1788-1855). The square around the gardens forms part of the estate owned by the Duke of Bedford. Many blue chip organisations have buildings surrounding Tavistock Square, the most noticeable being BMA House, which is the HQ of the British Medical Association. Standing on the west side of the square sits a row of attractive Georgian houses that CD would have been familiar with. There are also several memorials that can be found in the gardens, such as the statue to Mahatma Gandhi, a bust of Virginia Woolf, a memorial to Surgeon Dame Louisa Aldrich-Blake and a cherry tree planted in 1967 in memory of the nuclear bombing of Hiroshima. The somewhat unusual bust of Virginia Woolf is a fitting sculpture for this modernist literary writer, who was plagued by mental illness throughout her life; her family incidentally moved to the adjacent Gordon Square in 1904 and shortly after formed the Bloomsbury Group. Sadly Tavistock Square was the scene of one of the four terrorist bombings on the 07/07/05 when 13 members of the public were killed on a double-decker bus.

Before leaving Tavistock Square I should mention the fact that James Burton (1761-1837) built a wonderful house for himself here in 1807 called Tavistock House, which in 1851 was leased by CD when he moved from his residence in Devonshire Terrace. CD wrote several of his works, in part or complete, whilst living here, namely Bleak House, Hard Times, Little Dorrit and A Tale of Two Cities and at varying times performed amateur theatricals, some of which were written by his friend Wilkie Collins. CD performing as

well as stage managing these plays in his home for invited audiences, which often included his servants, and local tradespeople, he named this The Smallest Theatre in the World. It was in this house that he sadly separated from his wife Catherine and eventually sold the lease in 1860. Tavistock House was demolished in 1901 and today is the site of the BMA building. What happiness and pain he experienced here and what unforgettable memories he must have had of the views overlooking the square and gardens.

We now continue north along Woburn Place until we reach the intersection with Euston Road, and to our right is a colossus of a building known as St Pancras Parish Church.

Often referred to as the New St Pancras Church, this edifice has become a monolithic landmark on what is a major London intersection. I have to confess that the grounds which encircle the church are disappointing even though there are a couple of well established trees, and I guess that finance has limited work on the external surroundings. The church was built between 1819-22 in a Greek revival style by William & Henry Inwood, renowned architects whom between them created several other wonderful buildings. William Inwood (1771-1843) also worked on three other churches in the Parish of Camden with his son Henry, these being All Saints (Camden Town), St Peters (Regent Square), and St Mary's Chapel (Somers Town). As a leading architect of his day he also built Westminster Hospital in collaboration with another son Charles Inwood (1799-1840). Henry Inwood (1794-1843) on the other hand was known as the scholar of Greek revival, and travelled to Italy and Greece publishing several papers on their architectural splendour. Sadly Henry died quite young (in the same year as his father) in a shipwreck whilst on a journey to Spain.

St Pancras Parish Church was intended to be the new principle church for the parish of St Pancras, replacing the old church, which we shall visit in a later chapter. Built from brick, faced with Portland Stone and with several crafted terracotta capitals, the new church is similar in many ways to the Erachtheum in Athens. Looking at the external elevations of the church I am amazed at the caryatids (sculptured female figures which serve as supports instead of using columns or pillars), each goddess supporting an entablature on their head. Behind the figures stands a stone sarcophagus and each cornice

is displayed as a lion's head. The caryatids incidentally are made of terracotta which are constructed in sections around cast iron columns, Lord Elgin brought an original back to England which is now in the British Museum. The stone portico and tower above the roof project a classical yet powerful external profile to this place of worship, and suggests an almost impregnable solidarity within its structure.

Internally there is a flat ceiling with a span of almost 60ft with galleries supported on cast iron columns. The crypt, which extends the full length of the church, was designed for 2000 coffins but only 500 internments were undertaken up until 1854 when the practice was ended.

An art gallery now serves the crypt, which during World War II served as an air raid shelter to protect the public from bombing raids, a fitting story to endorse the strength of this historic edifice. When walking around this wonderful church one cannot fail to enjoy the stained glass above the altar together with the smaller rectangular windows, which run along the lower areas of each aisle. Several restoration projects have been carried out on this church and today it has rightly been given a Grade I listing, but there are continuing concerns regarding its stained exterior, due to high pollution levels caused by traffic. It is somewhat sad to think that this church, like many others, has survived so much aggression from the impurities of the mind that it is now threatened by the contaminants of progress.

We now turn left into Euston Road and experience just how noisy and busy this intersection is, traffic moving in all directions and pedestrians in a hurry to reach their destinations often disregarding the dangers of crossing roads when clearly advised. To my right are Euston Square Gardens, which were originally laid out in the early 19th century in two rectangular sections on opposite sides of the Euston Road, whereas today they are confined to one side only and split into two areas. The gardens are divided by a slip road today, with a traffic island in the centre that accommodates a war memorial, which was erected in 1921. Much architectural change has taken place here, the area provided for the station entrance was completed when the station first opened in 1837 and is now flanked by two lodges, which were erected later in 1870, both of which had once provided the original entrance to the station. These two lodges together with the statue of

Robert Stephenson are in fact the only remains of the original frontage to Euston Station, which was demolished in the 1960's.

Euston Station itself is today the sixth busiest rail terminal in London and serves as the main gateway to the West Midlands, North West, North Wales and parts of Scotland. Originally opened in 1837 (London-Birmingham) and constructed by William Cubitt, from a design by Philip Hardwick. When first opened it had just two platforms, departure and arrival, and until 1844 trains were pulled uphill to Camden Town by cables due to the prohibition of locomotives in the Euston area, this was enforced by Lord Southampton who owned land near to the train line! One unique fact that I mentioned earlier was that in 1848, the network of W.H.Smith's railway bookstalls were first opened at Euston Station.

Externally the original building itself was pure architecture, the front elevation and entrance having a wonderful arch, known as the Euston Arch, with the two lodges built on either side. This towering portico entrance, made of sandstone had four columns, bronze gates and stood 70ft high, which stood further back than today, nearer to Drummond Street away from the Euston Road. Internally the station had a Great Hall built in a classical style with allegorical statues representing the cities of London, Liverpool and others, and in the centre stood a double flight Renaissance staircase that led to offices.

In 1960, Euston Station was scheduled to be demolished, considered to be impractical, too small and inconveniently sited. Much debate and resistance was made to retain these Grade II listed buildings but by late 1961 demolition commenced. More recently in 1994, historian and architect Dan Cruickshank located at least 60% of the stone from the Euston Arch, which lay under water in Prescott Canal and so began a movement to rebuild the arch and today that dream could be a reality.

The current Euston Station was built and opened in 1968 in time for the new electrification of the main line in tandem with the more recent National Railway programme. Today the frontage of the station, which measures 197m in width has a bus terminal and accommodates three office towers, all of which have created much controversy. The new design certainly doesn't reflect the historical significance of this station, and words such as hideous, dingy, and tawdry have been used to describe it, would CD voice some criticism of these changes, I

think he probably would on this occasion. The removal of Victorian architecture is unfortunate and sometimes criminal, and if there is a definite lack of artistic spirit embodied within its replacement, people will react. Whatever comments are aimed at the design element of the station, its services remain good, and sometimes one must accept disappointing architectural features for 21st century functionality. At the time of writing this I understand that it has been agreed to redesign the station and programme a 'make over', time will tell if it succeeds, I can only say that the Millennium Bridge may look out of place with its neighbours, but it still serves a very useful purpose.

Moving past Euston Station and heading west we turn right into Melton Street, then left into Euston Street which takes us to North Gower Street then finally to Drummond Street, but before doing so it is worth mentioning an interesting building in Stephenson Way namely the Centre for the Magic Arts. The Magic Circle wasn't formed until 1905, and originally in Soho not Camden, but nevertheless the art of magic had been around for many centuries. In Victorian times there were literally hundreds of magicians performing vanishing tricks, levitation, escape production, prediction and teleportation to audiences throughout the world, especially in the capital. I would like to think that CD would have approved of this group had it been there in his day.

Back on our walk I am now making my way along North Gower Street and it is amazing how the noise and bustle of the Euston Road simply disappears, this street still has some attractive Georgian buildings on the left that have retained their iron railings. When arriving at Drummond Street turn left, continue walking then cross over the lower end of Hampstead Road, where to the left you have a great view of the Euston Tower. Drummond Street isn't the most picturesque walkway in London but it is a convenient passage for our journey, on our right we pass a University College of London building and to our left is the large complex known as Regent Place, which is a formidable high-rise modern structure that incorporates both office and residential facilities. At the junction with Longford Street lies Laxton Place where there is a really attractive church called St Mary Magdalene Church—St Pancras, this Gothic styled church was built in 1852 by architect Richard Cromwell Carpenter (1812-1893), with funds donated by the Rev. Edward Stuart, and

is described as being 'the most artistically correct new church yet consecrated in London'. I have tried on two occasions to view the interior of the church without success so it remains an enigma, but the exterior is an extremely good mix of brickwork and stone that has some fine Gothic arches that enhance the attractive stained glass windows, which on the east elevation are accredited to Augustus Pugin (1812-1852). The church sits on the edge of a busy council housing estate that although seemingly overcrowded has retained two significant areas which feature on the 1863 map, I refer to Clarence Gardens and Munster Square both of which serve the local inhabitants as a recreational retreat, designed with children mind.

We have now reached Albany Street, which is a long and often busy thoroughfare that leads from Marylebone Road to Gloucester Gate on the east side of Regent's Park. On this occasion we cross over the road and turn right and have a choice of routes to take. On the west side of Albany Street, walking north, one can appreciate a long row of Georgian houses called Colosseum Terrace that are striking, as they have retained the architectural grandeur that makes this period of our history so memorable. This wonderful row of houses is only interrupted for a short distance by a large very dark grey brick modern building, which I assume was built on land that was previously part of this magnificent terrace and had been subjected to war damage. In any event Colosseum Terrace continues beyond the new building for some distance along this street.

On the east side of Regent's Park behind these terraced houses a large building called the Colosseum was built in 1827 to accommodate and exhibit the largest painting ever created, called the 'Panoramic View of London' by Thomas Hornor. Hornor based his painting on many drawings he made from a temporary hut on the top of St Paul's Cathedral! The idea was to sell off views of London using the 360° picture as a marketing ploy, which failed, and both he and his backer eventually fled to America in 1828 due to enormous debts incurred from this business adventure, the Colosseum was eventually demolished in 1837.

As I indicated earlier our walk can either continue along Albany Street until we reach St George's Cathedral, or we can opt to turn left into Chester Gate and walk along either Chester Terrace or the Outer Circle of Regent's Park. On this occasion I have chosen the Outer

Circle of Regent's Park simply because it will give me the opportunity to mention the park and the magnificent houses that flank its east elevation. To gain access to the park side of Albany Street we need to walk further along this road until we reach Chester Gate where we turn left and walk straight ahead in the direction of the park. To access the park we have to cross the Outer Circle Road, walk a few yards, and then enter through Chester Gate just as CD would have done when he lived in this area.

Regent's Park is one of London's Royal Parks and is situated partly within the City of Westminster and partly in the London Borough of Camden. Prior to Henry VIII snatching this open space as part of the Dissolution of Monasteries the park was once part of the Manor of Tyburn in the Middle Ages and was owned by Barking Abbey. In 1811 the Prince Regent (later George IV) commissioned John Nash (1752-1835) architect, to redevelop the entire area as part of his grand scheme, which was later curtailed. Nash was however responsible for much of Regency London and worked for the Prince Regent for a large part of his career. I think I am in order to say that without Nash's influence and genius, London would be a duller place as he built some remarkable buildings, many of which have disappeared a small proportion of which include, Brighton Pavilion (in Sussex), Regent Street, and of course the majestic terraces we see today around this beautiful park. He also set up the Regent Canal, which linked West London to the River Thames, and we must not forget one of his classic theatres namely the Theatre Royal Haymarket. Nash's career virtually ended when George IV died as there was much resentment about his relationship with the King and he decided to retire to his house on the Isle of White where he died in 1835. Although he was certainly a wealthy man during his lifetime, he did leave his wife with substantial debts, which she had to settle, Nash is buried with his wife on the Isle of White.

Regent's Park was officially opened in 1835 and many new areas have been added since then such as the Queen Mary's Gardens (which form the Inner Circle) and numerous sports pitches and courts catering for a host of activities such as tennis, netball, cricket, football, hockey and rugby. Cyclists enjoy travelling around the Outer Circle, as do young children who enjoy the three playgrounds made available for them. The various peripheral roads, which encircle the

park, allow for a traffic free environment, which is enhanced by the wonderful display of white stuccoed terraced housing designed on the south, east and west elevations by Nash. In addition to this the Regent Canal runs through the northern end on its passage to connect to the Grand Union Canal. Within its 410 acres of parkland one can enjoy the boating lake, London Zoo, an open-air theatre and the London Central Mosque. Near the western and northern boundaries of the park and around the Inner Circle are various villa's which again enhance this truly remarkable setting and I feel sure that CD would have enjoyed his walks here, knowing that the views are relatively unchanged since his day. Having walked around this park several times before I leave that delight for the reader to enjoy and continue my planned walk which I am pleased to say will include passing close by another of CD's former residencies.

Having arrived back to the Outer Circle I make my way along this concourse that runs parallel with Chester Terrace, which like Chester Gate is stunning. These beautiful terraced houses are to dream for as they not only command arguably one of the best views in London but must also be magnificent internally, all of which have meticulously retained their period features largely due to the way they are maintained. I would place these buildings in the 'des-res' category without any shadow of a doubt; they not only look palatial and regal but also freeze a moment in the age of the Regency period. These neo-classical terraced houses designed by Nash in 1825 are the longest un-broken facade in Regent's Park and consist of 42 Grade I listed properties. Built by James Burton, each end of Chester Terrace has a fantastic Corinthian arch with the terrace name clearly painted in large lettering script above. The external painting of the stuccoed walls simply enhances the architecture, especially the houses which have columned facades.

Having now arrived at Cumberland Mews turn left and there is still one more fabulous building to view, which is No 3 Chester Place and the former residence of CD when he lived here in 1847. The properties here have super balconies and railings which nestle amongst a small oasis of mature shrubs and trees, out of respect for those who live here I suggest a quick look then move on down the sloping road in the direction of Albany Street, using the same pathway as CD would have done. CD made a home for his family

here when his eldest son Charlie was recovering from an illness and it was at this address that his fifth son Sydney was born. Knowing CD's dislike for high society I guess he must have put aside his feelings on this subject on occasions, especially in this case when he chose to live in such a desirable area, but surprisingly enough a short distance away from here on our next stage of the walk was a far less desirable place to live in CD's time.

Once back onto Albany Street we walk down this route for a few yards, cross the road and standing before us sits a building named St George's Cathedral, which was built in 1837. This building was built by James Pennethorne, architect (1801-1871) he was a second cousin to Nash who created many areas for the poorest people in the capital. One such area being Victoria Park in the East End, which they say resembled a smaller Regent's Park where the workers made it their own! St Georges Cathedral was built for the large working class district of nearby Cumberland Market. Although the exterior looks slightly overpowering and in need of major restoration, it is said to have stained glass windows, which were designed by Dante Rossetti, named 'Sermon on the Mount', and Rossetti's sister Christina and family visited the building often. This monolithic giant of a church/cathedral looks indestructible by design and is run by the Antiochian Orthodox Group and interestingly my research tells me that George Orwell's funeral service was performed here.

Before leaving the park area my curiosity takes me further north up Albany Street to what is now Regent's Park Barracks, known as the Cavalry Barracks on my 1863 map. The location for these barracks were first developed in the early 19th century and originally housed the Royal Horse Guards, who were first formed in 1650 by Oliver Cromwell and later fought with distinction with the Household Brigade at the battle of Waterloo. In 1991 they became part of the newly formed Household Cavalry Mounted Regiment and moved to Hyde Park Barracks in Knightsbridge. Today the barracks house the Royal Logistic Corps, Artists Rifles and the Queens Royal Hussars.

Returning to the church we now make our way down Redhill Street to what was once a very important trading area in CD's day, and today still retains the name of Cumberland Market. This former market was originally built in the 19th century and traded in straw and hay and was called Cumberland Hay Market, and remarkably

continued to trade until 1920. Due to its semi-isolated location, it was decided to build a canal (or cut) from the Regent Canal to the market, primarily to deliver goods into North London as well as service the needs of the market, the canal is clearly shown on the 1863 map and was then known as Regent's Park Basin. Two other general markets were also built in close proximity to Cumberland Hay Market, namely Clarence Market and Munster Market (two areas I briefly mentioned earlier), both of which closed down much earlier, and today are gardens and playground areas. When all three markets were trading, small houses were built around them by a group of speculative builders; the market traders themselves mainly occupied these. Shortly after the hay market was built Sir William Adams built the Ophthalmic Hospital on one corner of the market square and treated former campaigning soldiers, but the hospital closed in 1822, sadly the hospital was sold on to a number of entrepreneurs who failed to use the premises for trading needs and the building was eventually used as a gin distillery until it was eventually demolished in 1968.

With the growth of the railways and the opening of Euston Station the Cumberland Market and surrounding area declined dramatically which greatly affected the entire community east of Albany Street. Although the railways brought work to the district (albeit cheap labour) 4,000 houses were demolished and 32,000 residents were made homeless in order to fulfil this project. CD was quoted at that time to have said, "Railway works cutting their way through Camden was likened to a great earthquake." With the railways came industry, and factories were built near to the Regent Park Basin resulting in the entire east side of Regent's Park, beyond Chester Terrace, becoming a slum area for the poor, and as you can imagine this created a very sensitive social divide between the two neighbouring districts.

Although Cumberland Market only traded for 3 days a week alongside the general produce markets, its proximity to the newly developed canal basin attracted many business's, stone masonry being one which later prospered due to the ease in getting base materials to London. The last group of trading barges ceased business in 1930 which brought the area into almost total decline, fortuitously it was at this period that the council housing estates were developed in the immediate area which transformed the stigma that surrounded this area for many decades. The canal was eventually drained in 1938 and later

filled in, and the land used as allotments for a period of time, especially during World War II. After the war, this area having been bombed considerably, due to its close proximity to both Euston and Kings Cross stations, was completely redeveloped by St Pancras Borough Council who built the housing estate we know today as Regent's Park Estate. This former market area in its heyday attracted noted artists such as Walter Sickert and James Whistler, sculptors Mario Raggi, Henry Foley, Fredrick Leighton and Thomas Brock, and philanthropist Miss M Jefferey who was once secretary to Octavia Hill. This immediate district also served as a base for several women's movements.

The next part of the walk will take us further north; therefore we leave the interesting area of Cumberland Market and make our way along Varndell Street, which leads to the Hampstead Road. At Hampstead Road we turn left and continue along this busy road until we reach Granby Terrace. Although this part of the walk isn't the most scenic of routes it does provide us with an understanding of just how high the occupancy levels must have been in such a tightly compacted community, which was far more overcrowded in CD's time. When we reach Granby Terrace, where in 1825 CD attended Wellington House Academy, we turn left and walk a few yards down this street. The Academy stood on the corner of Mornington Place and Granby Street but has long since been demolished, having originally been 'sliced off' to make room for the London & Birmingham Railway. The academy school provided CD with the impetus to write short tales for his friends and classmates to enjoy, and with over 200 boys of differing academic abilities he must have had a captive audience, what perfect grounding to enhance his writing skills

The entrance to the academy was actually in Hampstead Road and only a short walk from his house in 29 Johnson Street. CD is said to have enjoyed his two years here, as it must have seemed a perfect world, much like his earlier idyllic life in Kent, and far from those dark days working in the blacking factory separated from his family. He was however not too enamoured with his teachers although he did reasonably well in lessons, and he did enjoy his theatrical escapades with his classmates. CD's father still continued to amass debts at this period, which almost surely curtailed his time at the academy, whether this impacted on CD's early career one will never know, in any case history eventually fell on the side of success.

Whilst returning to the Hampstead Road it is worth mentioning the dark red Victorian brick building on the left named Euston Granby Terrace, which I understand, was one of a number of former railway buildings constructed when land was requisitioned in the 1830's. Continuing our walk we cross over Hampstead Road and walk along Harrington Square towards Eversholt Street. Harrington Square Gardens to our left was laid out in 1843 as part of a planned development scheme for the Duke of Bedfords estate. When first built there were two rows of terraced houses overlooking the triangular gardens, the south terrace being bombed in World War II, and later being completely demolished in the 1960's to make way for the modern housing development we see today. Only 10 of the original houses (1842-48) remain today and they serve as a reminder just how opulent these premises must have been which is why they attracted many wealthy families. The gardens were planned at the same time as their neighbour Mornington Crescent Gardens, which incidentally only survived until the late 1920's when the Carreras Tobacco Factory was built on this site. Today Harrington Square Gardens provide a peaceful area amidst a very busy road intersection, which the public seem to enjoy as they sit alongside the pleasant flowerbeds and mature trees.

Having now reached Eversholt Street I should mention that there was once a popular coffee house (whose name I cannot establish) that once stood in St Pancras High Street (now north Eversholt Street), which I would like to think CD visited at one time or another.

Today Eversholt Street is a broad thoroughfare which runs from Oakley Square to the Euston Road and in 1863 it comprised of three separate roads the other two being Crawley Street and Seymour Street. Many of the side streets in the immediate vicinity have been altered or completely disappeared since the early 19th century, one of which was significant in CD's period. I refer to a house, which CD lived in with his parents from 1824-1827, when he attended Wellington Academy. This building was once either No.13, or 29 Johnson Street (my research provides conflicting numbers), which today is now Cranleigh Street. Further south along Eversholt Street to our right stands a large Georgian building known as 183-203, its façade constructed of yellow stock bricks which I personally find agreeable, and when first constructed served as a ticket office for Euston Station. Today 183-203 retains its 19th century elegance, and is still warmly

referred to as 'The Ticket Office', by those who work here. Internally this building has retained several historic architectural features whilst having been tastefully transformed into a large complex of offices, studios and galleries. I wonder if CD walked up that short flight of entrance stairs when he lived here, and what would his comments be on the transformation of this wonderful building?

In complete contrast to 183-203, across the road stands a large number of period Georgian terraced houses, which by appearance look to be completely neglected and empty. As I walk down Eversholt Street I cannot imagine how these houses that have so much character and history, could have been allowed to fall into such disrepair. One would hope that these buildings will eventually be restored to their former glory and preserved and maintained accordingly, they certainly deserve some loving care!

To the right stands Barnby Street, which we walk along until we reach Ampthill Square Estate, again a former area that held some family interest for CD. The name Ampthill incidentally was taken from Ampthill Park in Bedfordshire, hence the Lord Bedford connection. It was here that CD took a home for his widowed mother, which in his day was an irregular shaped crescent that had a group of Georgian houses aligned north to south. Each group of houses had attractive balconies and facades, the crescent was one of three groups of small attractive gardens which CD would have enjoyed visiting. It is sometimes difficult to envisage just how the boundaries of suburbia have altered in the last 150 years but one complete eye-opener for me personally was when I viewed a wonderful oil painting called Rhodes Farm that was painted in 1844, which captures a view of Ampthill Square and puts progress into perspective. What today is now a 1960's housing estate comprising of three tall tower blocks was in the mid 19th century gentle countryside with views across acres of fields and farmland. Ironically there is an inscription on the reverse of the oil painting, which infers that either the artist or owner was dismayed and concerned then about suburban issues, it reads, "All that remained in the year 1844 of the once celebrated Rhodes Farm, Hampstead Road, now called Ampthill Square".

Back on Eversholt Street I should mention the church of St Mary the Virgin, Somers Town, that was built in 1824, which has a grey brick and stone dressing exterior, and internally enjoys several

bays with aisles all built to a Gothic design. The original site and furnishings were paid for out of the local rates whilst the building itself was funded by a government grant, its architecture being slightly lambasted by Augustus Pugin, for in its early days it was referred to as Mr Judkins Chapel. Judkins was a reference to the Rev Judkins who officiated here, and had amongst his worshiper's cabmen from Euston Station, which he thought would create a social bonding within the local society. CD's school friend Owen Thomas, from Wellington House Academy, recorded how he and CD piously attended morning service at this church.

Just past the church on the left stands Polygon Road, which doesn't feature on the 1863 map, however the area then known as The Polygon was a significant earlier development. Houses were first built here in 1784 when it was simply fields, brickworks and market gardens and CD lived at No. 17 with his parents from 1827-1829. Mary Wollstonecraft (1759-1797) writer, philosopher and feminist lived in The Polygon with her husband William Goodwin until her early death in 1797, having led an active but traumatic life, which was the talking point of society. Her literary career was spent justifying women's equality and she published many articles and books on this subject. Mary died just days after giving birth to her second daughter, also named Mary, who as I mentioned earlier in this chapter married Percy Shelly and later wrote the novel Frankenstein. Portrait painter Samuel De Wilde (1751-1832) lived in this street as did Edward Scrivens (1775-1841) an accomplished engraver. The Polygon development ran from east to west through what was formerly Clarendon Square, the name Polygon taken from the interesting architectural experiment that presented itself in the centre of the square. Clarendon Square (shown on the 1863 map), once stood on the former site of the Life Guards Barracks, and a certain Mr Job Hoare, a little known carpenter from St Pancras, built houses within this square. Job undertook a challenging task to build 32 terraced houses, of four stories with iron balconies and attractive garden walls, each house was to be connected to appropriate sewers, all fully completed and ready for occupancy within 12 months, and succeeded in doing so!

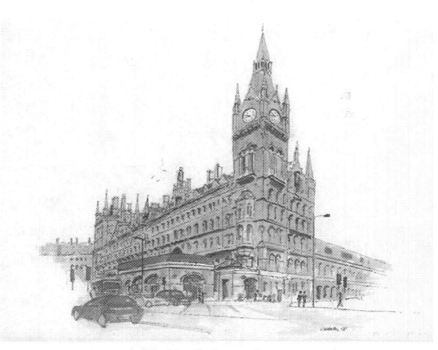

Fig 13 St Pancras Station

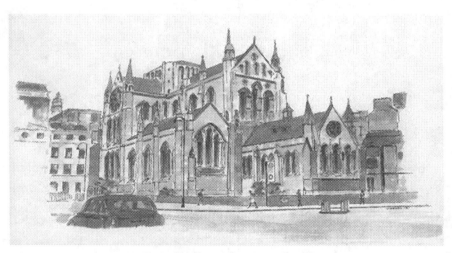

Fig 14 Christ the King Church

Halfway along Polygon Road we turn right into Chalton Street and walk south towards Euston Road where we pass Phoenix Road (formerly part of Clarendon Square). In this street sits the St Aloysius Convent School, which although only built in 1972 has a wealth of interesting history. In 1830 several former French citizens were invited to Somers Town to take charge of a convent school on this site established for the poor and needy. At this time there were many middle class French émigré's who had settled here after leaving France during their Revolutionary Period. The convent remained here from that period onwards helping those that were in need, and later became a convent grammar school, which has since amalgamated with St Vincent's School to become the Maria Fidelis Convent School. An interesting 1850 oil painting by Joseph Swain clearly depicts St Aloysius Church standing in what was once The Polygon.

Returning to Chalton Street we head down to the Euston Road for the final part of this walk, which will include three prominent locations in what has been a very interesting district, they are The British Library, St Pancras Station and finally Kings Cross Station. But before visiting these sites, a few words about Euston Road itself. Euston Road was originally formed in 1756 as the New Road that stretched from Paddington to Islington and was intended to provide a route for sheep and cattle being driven to Smithfield Market. It was also intended to serve, as a quicker route for army units to reach the Essex coast should there be an invasion threat, thereby avoiding central London. When first built, no surrounding buildings could be erected within 50ft of the road and once the Fitzroy family became more prominent owners in 1852 the road had changed its name to Euston (Euston Hall being the family country house). One early Fitzroy named Henry, was an illegitimate son of Charles II and created Earl of Euston, later Duke of Grafton. Most of the Fitzroy estate was developed in the late 18th and early 19th century, and the majority of the streets had disappeared by the ongoing development schemes of the 20th century.

Back once again on the Euston Road we now head east towards the font of all knowledge, I refer of course to the site of the British Library. This architecturally pleasing building was created in 1973, and prior to that date was part of the British Museum, who provided the majority of its holdings to form the new library. For many years

the original library collection, known as the 'Foundation Collections' were housed in several buildings in London, all of which had been generous donations and acquisitions from Sir Robert Cotton, Sir Hans Sloane, Robert Harley and both George II and George III. Architecturally the library building has gained a great deal of respect from most people who visit it, however it did take an age to materialise, in total 37 years from the original brief to completion. Externally the red brickwork blends perfectly with its close neighbour St Pancras Station, however its real value lies internally.

There are 11 well-equipped reading areas within the library, which will accommodate over 1200 readers, 4 basement levels for storage, and a 60,000-volume collection once owned by George III. A mechanical book handling system ensures that books are sent to the correct collection points, and boasts 3 exhibition galleries together with a conference centre for public events. Amazingly the library collection exceeds 15,000,000 separate items! I am a member and enjoy every minute of each visit I make here, although I sometimes get overwhelmed by the Herculean size of this structure.

Just a few yards away from the library and having reached the final furlong of this walk I arrive at the entrance to what is arguably the most classical of all London railway stations, I refer of course to St Pancras (International). This Victorian edifice, which is now a Grade I listed site was first opened in 1868 by the Midland Railway, and designed to connect the East Midlands with the Yorkshire lines. Once the concept of building a station materialised the site was ruthlessly cleared without any consideration or indeed compensation given to the dwellers of properties in this area. Even the church that stood on the building footprint was demolished, however it was rebuilt piece by piece in Wanstead, but very little concern was centered on the adjoining burial ground until building works were well underway.

The civil engineer responsible for the station design was William Henry Barlow (1812-1902), a designer who was mainly associated with railway projects. Barlow was also an expert in bridge construction and later worked with John Hawkshaw to complete Brunel's Clifton Suspension Bridge. His knowledge of iron construction was said to be second to none, which served him well throughout his career, especially when he sat on the official committee investigating the tragic Tay Bridge disaster. Part of his

early career was spent in Turkey working on and designing factories and lighthouses and on his return to Britain he worked on the Manchester & Birmingham Railway, and it was while working there that he designed a unique method for laying track. He then assisted Joseph Paxton with the structural calculations for the Crystal Palace building and in later years experimented with sound recording where he invented his 'recording instrument' called a Logograph. Of all the innovative ideas he introduced his best-known work was arguably the Barlow Train Shed at St Pancras, which in its day was the largest single span roof construction in the world. This design allowed maximum use of the space below created by the absence of pillars, thereby gaining better utilisation of the ground area, which in turn improved income revenue.

Due to the natural slope of the railway site, trains entered the station building on the first floor, which resulted in 800 columns being built into the design to raise the floor level by 17 feet, the space below being rented out. Both beer and grain were the largest commodities stored there and in doing so the space between the columns was accurately calculated to accommodate 3 barrels of beer! Originally the roof span was painted dark brown but the Midland railway insisted that it should be painted sky blue, a minor consideration seeing as the cost for the roof alone was a staggering £117k, which appears quite reasonable when you consider that the station itself cost £320k.

The station was completely remodelled and renovated during the 2000's at a cost of £800m, at the same time as the Eurostar services were launched. There are now 15 platforms, a shopping centre and bus station together with good access to the Underground, which has catapulted St Pancras into the new millennium that surely would have pleased Barlow.

The hotel which fronts the station, originally called the Midland Grand Hotel (now called the St Pancras Renaissance London Hotel) was first constructed in 1873 and designed by George Gilbert Scott (1811-1878). Scott was an English Gothic revival architect who worked mainly on churches and cathedrals, but started his career designing over 40 workhouses! Inspired by Augustus Pugin he designed the Martyrs Memorial at Oxford and later won a competition to rebuild a cathedral in Hamburg, by 1849 he was

appointed architect to Westminster Abbey. In 1854 he remodelled Camden Chapel, following which he received critical comments from John Ruskin with regard to his work, which he resented. The Midland Grand Hotel was arguably his finest work, which still maintains its Italian Gothic appearance. When first built this hotel had 300 rooms and was considered to be very expensive for its day, with rooms costing as much a 14 shillings (70p) a night, that being more expensive than most other fashionable hotels in London.

Structurally, the hotel was built of almost 60 million bricks using 9,000 tons of ironwork and featured a very grand staircase, gold leafed walls and fireplaces in every room. Some innovative features included hydraulic lifts; concrete floors, revolving doors but it had no bathrooms. Its eventual downfall and closure in 1935 was brought about for several reasons, one being that it became far too outdated and another because it became far too costly to maintain. Records show that an army of servants were employed to carry chamber pots, bowls and spittoons alone.

Like the railway station, work commenced in redeveloping the hotel in 2004, many original rooms were restored and a new wing built on the Barlow Shed elevation, today the new hotel has 224 bedrooms, 2 restaurants 2 bars, a ballroom and facilities for meeting and function rooms. The retention of this historic station is largely due to Sir John Betjeman and is due to his endless campaigning work and endeavour to save the station from demolition, for which the nation is truly grateful. In recognition of his efforts a pleasing bronze statue of Sir John sits comfortably on the station platform.

Finally we reach the last point of our walk, which is located a few yards from St Pancras Station, which is of course Kings Cross Station. At the very beginning of this walk I did indicate just how significant a role railways played in the social and industrial development of this district, not to mention the country in general. The railway transformed attitudes and perceptions of distance; speed and comfort were now seen as being commonplace when CD was around. In achieving these goals I should mention that the railways needed a more accurate 'standard-time' for their service timetables due to variations from east to west in Britain. The Greenwich Observatory was the adopted standard for 'railway time' and from 1852 The Electric Telegraph Company, based in the Strand communicated

Greenwich Mean Time to all parts of the country. In the same year that this began Kings Cross Station was opened and became the southern terminal of the East Coast Main Line.

The concept for building this station was first muted in 1848 and shortly after detailed designs were made by Lewis Cubitt (1799-1883), younger brother of Thomas Cubitt (1788-1855) master builder of 19th century London. Lewis like William Barlow also built bridges during his career, however they were mostly in South America, Australia and India. At an early age, Lewis was bound over to his brother Thomas as an apprentice where he became a member of the Carpenters Company. By 1822 he was placed in charge of house construction in Berkeley Square and later went on to design many housing developments built by his brother. Oddly enough he was no longer engaged in professional work after 1852 other than building the granary, which sits behind the station. The platforms on Kings Cross have been reconfigured many times, originally there was only one arrival and departure, and today there are eight. Kings Cross is known for the selection of wonderful trains that once were associated with steam, which worked from here, namely The Flying Scotsman, Gresley A3 and of course The Mallard (which still holds the world record for steam). In 2005 a £500 million restoration of the station got underway, resulting in the transformation of the entire complex including construction of a new departure concourse to cater for increased passenger flows. This stunning engineering feat is claimed to be the longest single span roof of a railway station structure in Europe.

Having completed this walk I will probably head back to Euston Station and take advantage of the Caffe Nero coffee house, which will provide me with my favourite drink and some comforting food. In fact it will also give me the opportunity to plan the next walk, which is only a short distance away from here.

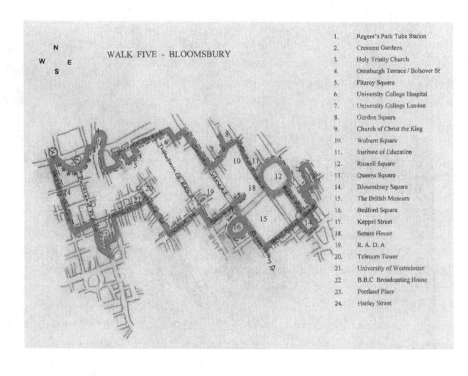

WALK FIVE - BLOOMSBURY

N W E S

1. Regent's Park Tube Station
2. Crescent Gardens
3. Holy Trinity Church
4. Osnaburgh Terrace / Bolsover St
5. Fitzroy Square
6. University College Hospital
7. University College London
8. Gordon Square
9. Church of Christ the King
10. Woburn Square
11. Institute of Education
12. Russell Square
13. Queens Square
14. Bloomsbury Square
15. The British Museum
16. Bedford Square
17. Keppel Street
18. Senate House
19. R. A. D. A
20. Telecom Tower
21. University of Westminster
22. B.B.C Broadcasting House
23. Portland Place
24. Harley Street

WALK FIVE

BLOOMSBURY

"Reflect upon your present blessings, of which every man
has many—not on your past misfortunes, of which all men
have some"
(Sketches by Boz—1836)

B loomsbury is an area that lies between Euston Road and Holborn which was first developed by the Russell family in the 17th and 18th century. This stylish and often crowded district is noted for its large number of squares and gardens, as well as the vast spread of academic buildings and healthcare institutions. In recognising these features the following walk does occasionally stretch beyond the boundaries of Bloomsbury and encroach on neighbouring areas, one being 'Fitzrovia', a title given to this historically bohemian neighbourhood.

The Doomsday Book records that the ground we are about to walk once had recognised vineyards and was a habitat for wild pigs, whilst the name Bloomsbury is said to derive from its Norman landowner, William de Blemond who resided here in 1201. Edward III acquired Blemond's manor in the 14th century, which was then handed to a group of Carthusian Monks, who they held until Henry VIII took the land, and granted ownership to the Earl of Southampton. It was Southampton that created Bloomsbury Square in the 1660's; however, the district was not fully developed until the 18th century when the 3rd Duke of Bedford arrived in 1730, one of his first tasks being to open Bloomsbury Market.

Around 1800, the 5th Duke of Bedford designed most of the delightful squares within Bloomsbury and it was he who created

Russell Square making it his 'centrepiece'. Little did he know that within a century his centrepiece would be matched by the introduction of several amazing buildings such as the University of London, London School of Hygiene & Tropical Medicine, The National Hospital for Neurology & Neurosurgery, and the British Museum, to name but a few.

Bloomsbury later became quite a contemporary district for several reasons, firstly in the late 18th century when John Russell, 4th Duke of Bedford, created the Bloomsbury Gang of Whigs when he joined the Whig party as a member of the House of Lords, this group became extremely hostile towards the Prime Minister who at that time was Sir Robert Walpole. Then by the mid 19th century the Pre-Raphaelite Brotherhood, a group of amazing artists, were founded by John Millais when he was living in Gower Street, the Pre-Raphaelites preceded the Bloomsbury Group, a fashionable sect of writers, intellectuals, philosophers and artists, who evolved in the early 20th century.

Our walk starts at Regent Park Underground (opened in 1906), one of several stations, which has no surface building, as access is directly from the subway via lifts or by using a staircase. Work commenced on this station in 1898 and was financed by a mining magnate named Whitaker Wright who sadly committed suicide whilst attending the Royal Courts of Justice when convicted of financial misdemeanours, during the development of the underground. Regents Park was one of the first deep-level railways and amazingly caused far less disruption when being built due to the advances of tunnelling techniques, a fine legacy but a sad ending for pioneer Whitaker Wright. Originally when built the Bakerloo Street and Waterloo Railway ran only from the Elephant & Castle to Baker Street, today however the Bakerloo Line serves approximately 111 million passengers each year!

Having left the station I now turn left along Marylebone Road and then left again into Park Crescent which encircles both a charming garden and a group of magnificent terraced houses. The first impressions of this crescent are quite striking, the stuccoed finished Georgian buildings have attractive balconies that overlook the gardens, with their mature trees and solid iron railings that create a wonderful scene from the 18th century, spoilt only by the inevitable high volume of noise coming from the vehicle traffic.

Originally a small forest of trees covered this area they were felled by Cromwell in 1649 to pay for war debts from the sale of land and income from the timber. Later the land was transformed by John Nash who designed the crescent and gardens in 1806, leaving Charles Mayor to build the terraced housing which eventually bankrupted him. The elegant stuccoed semi-circular terraced houses still retain their Georgian flair many of which today have been converted into very expensive apartments, in a similar vein to Park Square. When the houses here were first built they remained empty for a long period of time, many unfinished, as they were considered to be in open countryside and not a town environment. In fact records state that many half built houses were in such a sorry state that grasses were growing from the brickwork. The immediate location was originally intended to be developed as a large circus, but was changed once the houses were eventually completed in 1826, an underground passage was constructed under the roadway (Marylebone Road), called the Nursemaids Walk, which then divided the neighbourhood. The Prince Regent wanted to build a summer palace here, which was vetoed by the Government, following which the circus was planned, however only the crescent evolved. Park Square to the north was developed in 1823/25, the houses on the north side being built as two parallel terraces east and west of the central garden. This led to the Nursemaids Walk being built, connecting Park Square with Park Crescent.

On the east side of Park Square once stood the 'Diorama' built by architects Morgan & Pugin, which opened in 1823, its purpose was to exhibit two dioramic views one being the interior of Canterbury Cathedral. Pictures 80ft high and 40ft wide were suspended in separate rooms and spectators standing in the centre of each circular room were turned around 360° in darkness whilst light was transmitted to the pictures. This phenomenon created by MM Bouton & Daguerre, was originally on display and shown in Paris, by 1848 the Diorama was closed due to financial problems.

During World War II some properties in Park Crescent were destroyed as were many other terraces surrounding Regents Park, and when eventually the crescent was restored in 1960-63 the original front elevations were meticulously reconstructed. A statue of Prince Edward, Duke of Kent, by sculptor Sebastian Gahagon nestles in the

crescent; and I can see the facial resemblance between Edward and his daughter Queen Victoria in this sculpture.

CD would have watched this area develop whilst taking his inspirational walks and I suspect that even he would have recognised the increasing amount of traffic that paraded itself around the perimeter of a now very busy Regents Park.

It is time now to cross over the very busy Marylebone Road with its continual movement of traffic, and head towards Albany Terrace where we can enjoy the architecture of a former place of worship, namely Holy Trinity Church. Sir John Soane built this splendid church in 1828, which overlooks probably one of the busiest road intersections in London. This former Anglican Church formed part of the group of 'Waterloo Churches', is said to have been erected in celebration of the defeat of Napoleon. The front of the church is quite unique as it has an external pulpit on the left building, which is beautifully enhanced by several Ionic columns on its façade, all of which are in remarkably good condition. Built to a Grecian architectural style in Bath stone and brick, this building has a formidable portico with accompanying balustrades, together with an interesting clock which is somewhat of a landmark today. Internally the former chapel was copied from Soanes home in Lincoln's Inn Fields and the many stained glass windows compliment what was, and still is, a quality building. Sadly, just over a hundred years after this church was opened it ceased being used for its original purpose and was utilised by Penguin Books as a storage depot, and in 1937 when Penguin Books moved out, the Society for Promoting Christian Knowledge moved in and remained there until 2006. Today the former church is now used as offices and occasionally as an art gallery, there are however plans to convert the structure into a shopping arcade.

The pattern of roads surrounding the church are unaltered since CD's time, whereas the buildings have altered considerably, at No.9 Osnaburgh Terrace CD rented a property in 1844 for a short period of time, and his children stayed at No. 25 whilst he was on his American tour. The name Osnaburgh Street is said to have derived from the name Osnabruck and its connection with the royal family goes back to the early 18th century, the connection being the Duke of York & Albany (Ernest Augustus), the German younger brother of

George I. Ernest took the title of Duke of York in 1716 on his visit to England and was later created Knight of the Garter. He never married and his British peerage therefore became extinct after his death in 1728.

We now cross back over Marylebone Road and make our way down Bolsover Street which again features on the 1863 map, however, it is worth mentioning that this road was originally called Norton Street, the name change relates to the Cavendish family and their Derbyshire estate connection. Bolsover Street was known for being home to many Victorian artists and sculptors of their day, and today as we walk its pavement we see a mixture of Edwardian and Victorian buildings, which nestle amongst the newer builds that appeared following the Blitz of World War II. One notable building in this street is the Royal National Orthopaedic Hospital, founded in 1905, it being a more recent addition to the former group of orthopaedic hospitals which dated from 1838. The RNOH is a very important building today as it treats a vast range of neuro-musculoskeletal problems and provides a teaching centre for a large number of orthopaedic surgeons.

A third of the way down Bolsover Street we turn left into Greenwell Street and now find ourselves in what is now known as Fitzrovia. This interesting district, which is situated between Marylebone and Bloomsbury, has an association with Bohemian academics of the 20th century. The name Fitzrovia is said to have originated from a local tavern in Charlotte Street called the Fitzroy Tavern, which was used by radicals and Bohemians as a meeting point, and groups of these intellectuals would gather in the tavern in the years between the world wars. The tavern itself was named after the Fitzroy family and was first constructed as a coffee house in 1883, and then converted into a pub in 1887, how CD would have delighted in using this watering hole and mixing with such vibrant company had it been there when he was alive. CD would certainly have been very familiar with this area as he and his family moonlighted to several nearby addresses in order to dodge creditors chasing his father. In later years he housed his lover Ellen Ternan in Fitzrovia and also created a home for a group of child prostitutes here.

At the end of Greenwell Street turn left into Cleveland Street (which we will revisit later) walk a few yards then turn right into Warren Street.

Walk a few yards down Warren Street then turn right into Conway Street, which will lead us nicely to Fitzroy Square. Conway Street, where we now stand, was previously called Southampton Street on my 1863 map and I can only guess that the name change occurred when Fitzroy Square was remodelled. The houses in Conway Street remain unchanged since they were constructed in the Georgian era, having nice balconies, iron railings, stuccoed facia walls and basements, all in all a delightfully preserved thoroughfare. One observation I should make is that the Telecom Tower is noticeable from almost every direction I walk, more of this structure later.

We have now arrived at Fitzroy Square, which in my opinion is one of the nicest Georgian creations in London and was developed by Charles Fitzroy, 1st Baron Southampton in the late 18th century. Both the southern and eastern sides of the square were originally designed by Robert Adam (the only square he designed in London) and built by his brothers James and William in 1798, unfortunately the south part was rebuilt following the devastating damage incurred during the Blitz. Due to the Napoleonic Wars the development of the northern and western areas of the square came later and were not completed until 1835, this however did not detract from the original concept of building very special houses for aristocrats. Both north and west elevations seem to have stucco fronted façades, which speak quality and are built to a very high standard.

This large and open square seems to draw light from every angle of the sky, and the central garden seems so restful with its flower-beds and mature trees. I like the way the pavement and road surrounding the garden have been recently laid to one level, which provides so much space on each corner of the square, and the way the railings and lampposts have been sympathetically designed to enhance without overpowering the ambience of this setting.

Walking around the square it is hard to miss the number of blue plaques on show, a few of which include former noted people such as: No.8 once home to painter James McNeill Whistler, No.21 where Prime Minister Lord Salisbury once lived, No.29 home at one time to both George Bernard Shaw and Virginia Woolf, and No.37 where artist Ford Maddox Brown once lived. Today various Consulates each proudly displaying their national flags occupy several of the residences.

I wonder if CD would approve of the slight changes introduced here, would he have been sympathetic to change for stylistic reasons, or was he a man who generally liked things left unaltered. Moving away from this delightful square we head back to Warren Street, which was named after the family of Lady Southampton, daughter of Admiral Sir Peter Warren, who incidentally founded Greenwich Village in New York and gave his name also to Warren Street in the same city. Peter Warren (1703-1752) was a British naval officer who rose to the rank of Admiral and later became very rich through trophies of war, politics and land speculation in America. He married the daughter of the Governor of New York where his major land investments evolved, namely the purchase of the majority of the lower end of Manhattan Island! Charles Fitzroy laid down this street in 1799 which originally had three storey terraced houses, these being built by speculative builders as a residential area, but in later year's shops and offices were introduced and is now largely given over to business. The tube station, which was originally called Euston Road, was built in 1907; one can still see the original name on the glazed tiling on the platform of this Northern Line station. Most of London's streets have an interesting story to tell, this one is no different and can boast the trials and tribulations of many former noted artists, but sadly it is remembered for an incident involving a gunman who murdered both a resident and a pursuing policeman.

At the end of Warren Street I cross Tottenham Court Road turn right and walk along Gower Street until I reach Grafton Way where I turn left, and in doing so pass the rear of University College Hospital on the left. This venerable hospital was founded in 1834 to provide training for the medical classes of the university, the reason for this being that students of the medical profession were not allowed in the wards of neighbouring Middlesex Hospital. UCH is said to be the first hospital in Europe to have used ether as an anaesthetic, administered during an operation performed by Dr Robert Liston in 1846.

In 1828 a small dispensary was opened in George Street to assist the medical classes of the university, which later amazingly developed into a hospital following considerable funding and an agreeable design by architect Alfred Auger were agreed. By 1838 a south wing had been added and in 1846 it was followed by the north wing extension. In 1906 a further large building was added (Cruciform Building), by now the

hospital occupied an island site, which later extended to Gower Street, Grafton Way, Huntley Street and University Street.

Today the hospital is one of the most complex NHS Trusts in the UK, providing academic led acute and specialist services for patients throughout the UK and overseas. Over 700,000 outpatients yearly together with 120,000 admissions annually, now use the recently built new hospital development, completed in 2005. How wonderful to think that this modern hospital trust originated by the formation of a group of hospitals, namely Westminster (1719), Guy's (1721), St George's (1733) and the London Hospital (1740) which when first opened were all established as charities relying on donations and subscriptions a remarkable history.

Whilst walking east along Grafton Way I cant help but notice the iconic figure of the former hospital building (Cruciform Building) to my left, which can be seen more clearly if I walk down Huntley Street. The Cruciform Building is a real Victorian Gothic masterpiece, its complex design and structure of red brick, pitched steeple and weathervane all symmetrically placed makes a definitive statement about period architecture. Designed in 1896 by Alfred Waterhouse and opened in 1905, following the split with the University, this Gothic revival building was one of over 30 structures built by Waterhouse, one other being the Natural History Museum. Waterhouse's design was quite unique for its period as it allowed sunlight, fresh air and ventilation into all the wards, which were each linked to long corridors. This bold diagonal edifice incorporated durable materials such as hard brick and terracotta dressings all coloured in red and earth tones, which were hard wearing and easily cleaned. The hospital building closed in 1995 and was purchased by UCL and is now used by the Wolfson Institute for Biomedical Research.

At the end of Grafton Way, I now reach Gower Street with a mixture of stylish period houses which forms part of the University of London, many of which have interesting stories to tell. The name Gower Street derives from Lady Gertrude Leveson-Gower (1715-1794) who married the 4th Duke of Bedford, Lady Gertrude's father (1st Earl Gower,) was Governor of the London's Foundling Hospital. When Gertrude was widowed in 1771 she shared the reins of management of the Bedford Estate, and extended the then built up area of Bloomsbury both west and north. In the intervening years both

Bedford Square and Gower Street were built. Gower Street itself has a very noble pedigree, it was first laid out in 1789 by leases granted by the estate and consisted of three storey Georgian houses (with basements), which initially were fairly uniform in design but later changes were introduced in each phase of development. Today much of the northeast end of the street accommodates the UCL buildings.

CD and his parents lived in Gower Street North at No.4 in 1823 for a short period of time, the house had recently been built and was later renumbered No.147 following further housing development. It was here that CD's mother Elizabeth made a vain attempt to start a school, which didn't really get off the ground. In her efforts to promote the school she had CD deliver a large number of circulars advertising the benefits of this enterprise and even had a large brass sign made which was fixed to the front wall of the house which read 'Mrs Dickens Establishment'. Sadly for her the school was a failure, and CD's father John was eventually sent to the Marshalsea Prison from this address, for his debts.

Sadly Gower Street did not hold any fond memories for CD but it did for several other noted former occupants, some of whom included the naturalist Charles Darwin (1809-1882), architect George Dance the Younger (1741-1825) and the artist John Everett Millais (1829-1896). In fact it was here at No.7 Gower Street that Millais and his two friends William Holman Hunt (1827-1910) and Dante Gabriel Rossetti (1828-1882) formed the Pre-Raphaelite Brotherhood in 1848. The Brotherhood aimed to break from conventional techniques of art and produce works that included abundant detail, intense colours and very complex compositions. They opposed the ideals and academic teaching of art by artists such as Sir Joshua Reynolds and gradually produced coded works in order to create a new movement of British artists. They had many critics, one of which was CD, who described Millais painting of 'Christ in the House of His Parents' as being blasphemous and ugly. They did however have one very important ally, namely John Ruskin, who defended their work and influenced their future works by his now well-recorded theories. I find it hard not to like the PRB work, I admire and enjoy reading Ruskin's theories, at the same time being an ardent admirer of CD's works, so I can only sit on the fence and harbour my opinions, for what they are worth.

It is time now to leave Gower Street and head down Torrington Place and in doing so I have to mention the wonderful Victorian building to my right, which is Waterstones bookshop. This grand, stylistic and attractive building is one of their largest stores and holds a special place in my literary career, as it was in this bookshop that my first published work was displayed. No book signings, no advertisements, no marketing, just three copies of 'The Four Seasons of Venice' sitting amongst the many waiting for a buyer, I really wish now that I had bought at least one if not all three, simply to see it wrapped, priced and handed to a customer . . . sentimental or what!

At the end of Torrington Place you really get a feel for just how large the spread of University College London really is, the road itself dog leg's to the left and once manoeuvred I am overpowered by the volume of students walking in every direction. UCL was founded in 1826 and was the first of its kind in London to admit women students on equal terms as men, today that may not seem special but in the early 19th century it was thought to be revolutionary. The original building was known as the Octagon Building, designed by architect William Wilkins (1778-1839) who also designed the National Gallery. It was originally called London University and was the first to offer English as a degree subject in 1828. By 1830 London University had founded London University School, then in 1834 opened a teaching hospital for the university medical school. Two years later the university became known as UCL and in 1871 the Slade School of Art was founded. By 1907 University College Hospital and University College School became separate institutions. By the early 20th century UCL had developed enormously introducing many faculties which included medical, scientific, mathematical, historical, engineering, building, law, arts and humanities. Its research and teaching output into many subjects is world-renowned and today is considered one of our leading universities. Having attempted to give the reader a brief resume of UCL I think that its reputation far exceeds any description from me, and I shall simply enjoy the open campus atmosphere, which clearly generates around every corner of this neighbourhood.

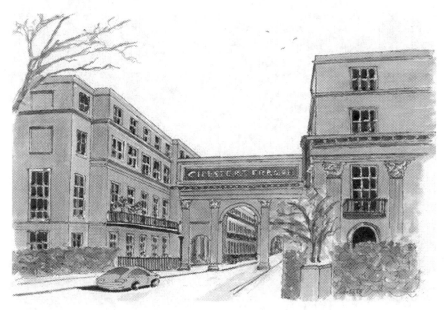

Fig 15 Chester Terrace

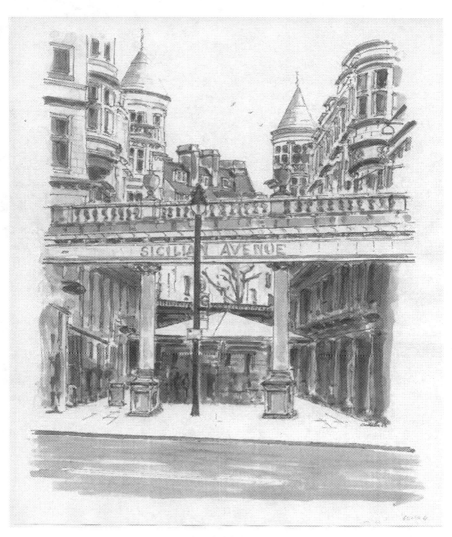

Fig 16 Sicilian Avenue

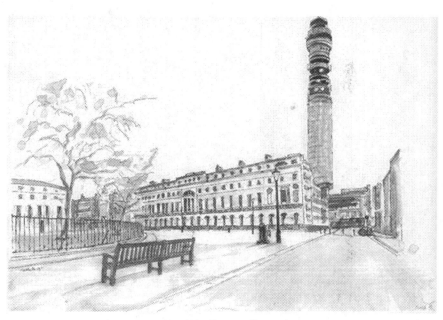

Fig 17 Fitzroy Square

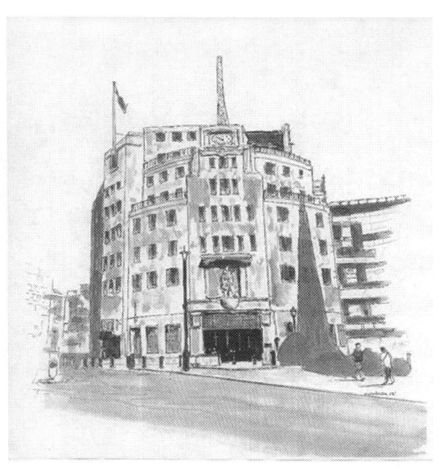

Fig 18 Broadcasting House

Before reaching Gordon Square Gardens I simply cannot pass the Church of Christ the King, on my left, without mentioning this architectural feast. Ralph Brandon and a Mr Ritchie built this large Gothic edifice in 1850, which sits to one corner of the square. From the road I can enjoy its beautiful stained glass windows, which enrich both the internal and external appearance, not to mention the very ornate decoration inside. The church itself is built of Bath stone and modelled on Westminster Abbey, but incomplete in size according to the original design, the tower was also left unfinished. This iconic church is built to a cruciform plan having a nave, side aisles, sanctuary and a Lady Chapel. One of the many striking external features includes the rose window designed by Archibald Nicholson, and it is said that Augustus Pugin designed the sanctuary lamp. When first built the church served the Catholic Apostolic Church (proclaimers of the second coming of Christ), in more modern times it was known as the University Church of the Diocese of London. Today it is mainly used by students and for certain organised London events, which include 'Music in Worship'. Services ceased in 1992 and in later years a crypt café functioned for several years, sadly today it remains a Church of England house of prayer without a parish.

Close to the church lies Gordon Square, with its attractive gardens developed by Thomas Cubitt in 1829 that stand alongside its neighbour Tavistock Square (which coincidentally was built to the same dimensions). The square was named after Lady Georgina Gordon (1781-1853), the second wife of the 6th Duke of Bedford who in fact designed the gardens, and it was Georgina who had an affair for several decades with Edwin Landseer, the artist. Most of the site was eventually sold to the Government in 1920 for the building of the university. The gardens, which were refurbished in 2005, have some attractive mature plane trees that settle amongst the lawns and shrubberies all owned by the University College London. UCL also own many buildings surrounding the square that are used as academic departments, including Nos.16-26, which was built later in 1855. The economist John Maynard Keynes (1886-1946) once lived in No.46, the same house that was used by the Bloomsbury Group.

Directly opposite Gordon Square lies Woburn Square, which deserves a visit so we shall walk through its concourse, the square being yet another attractive area built by Thomas Cubitt between

1829 and 1847 and named after the Duke of Bedford's countryseat Woburn Abbey. This square is the smallest of the Bloomsbury Squares. Originally there were 41 houses built around the square, which like Gordon Square was once swampland, and prior to the 1970's the estate extended down as far as Russell Square. The houses around this square are well preserved and very attractive, as one would expect in this corner of Bloomsbury. Woburn Square Gardens were originally for private use only, until London University acquired part of the site in 1928. By 1958 the Warburg Institute built in the northeast corner and later in 1972 the Institute of Education and African Studies constructed further buildings. Mature trees provide an attractive setting to this rectangular shaped garden (once said to be the most attractive in the neighbourhood), today there is a children's playground and small shelter which were later additions.

At the far end of Woburn Square to the left stands the Institute of Education (IOE), which is a public research university that specialises in postgraduate study, and is said to be the largest educational research body in the UK. Established in 1932 as a constituent college of the University Of London, it originated from an earlier scheme for training teachers, which started in 1902 as the London Day Training College (LDTC) administered by the London County Council (LCC). In 1909 the LDTC became part of the University of London and was later renamed the Institute of Education. In 1960 Denys Lasdun creatively drew up plans for a new IOE building and by 1977 the building, which we see today, was officially opened. Although modern in design and having a dark brown concrete and stone exterior, IOE does have a uniform shape and clearly projects a message of its prominence and position in the academic world, I like the way it sits high on a level plain with a 'drawing' effect that invites prospective students to enter the building.

I am now standing in Thornhaugh Street and to my right looking south I can see such buildings as the Brunel Gallery and an amazing bronze statue of a Buddha, which sits comfortably on a small area of greenery. Again the number of students and other pedestrians walking through this area is constant, most are heading in the same direction as me.

I think CD would approve of the grouping of gardens and squares around this neighbourhood either within or bordering Bloomsbury, simply because they provided the opportunity to sit and rest during one of his daytime or evening walks. There were also a number of coffee houses close by to most of the squares, offering him the opportunity to enjoy a beverage, whilst recording all manner of social classes around him who would one day provide material for future works.

Having enjoyed the buzz and clamour of being within a university campus surrounded by gardens for the past hour, we arrive at yet another wonderful garden with a difference, as this next one takes me back to a more spacious London suburbia. I refer of course to Russell Square and its spatial expanse of garden. The square is named after the Russell family, who as Earls of Bedford gained possession of Bloomsbury in 1669 by marriage into the Southampton family. The Bedford's in fact laid out the now familiar street plan, which formed the square, on the site of their former home, Bedford House. In 1804 Humphry Repton (1752-1818) finally designed the square on a piece of land that was originally called Southampton Fields. The original houses were built by James Burton, and these large terraced homes were primarily for the well-to-do and sadly just a few survive on the south and west elevations. Today the most prominent building on view around the square is the Hotel Russell, a chateau styled, reddish-terracotta edifice built in 1898 by architect Charles Doll.

More recently, in 2001, Russell Square Garden was beautifully restored to its original design and although the mature lime trees do not date back to 1805 their arrangement and pattern have been duplicated. A major enhancement includes the innovative jet fountain that has been added to the centre of the garden, which works well in merging both old and new design into an area of recreational pleasure. I enjoy sitting in this garden, which is generally busy and provides lots of open and tidy space for people to relax or simply walk through. There is another interesting feature close by the square, which is sometimes completely overlooked; I refer to the Cabmen's Shelter. This well persevered shelter for drivers of hansom cabs and later hackney carriages was first established in 1875 and is one of 13 still remaining in London, and is a Grade II listed structure.

These unmistakable green shelters originated from a fund created by a certain Captain George Armstrong (former editor of the Globe newspaper). Armstrong having failed one day to find a cab when returning home, discovered that all the local cabmen were drunk in a pub, following which he decided to remedy this matter by creating shelters for 'cabbies', where they could park and were free from the temptation of alcohol!

CD used cab-drivers quite often as well as featuring them in his novels, but I am not quite sure if he warmed to their character, today however I have no doubt in my mind that Black Cab drivers would make more interesting travel companions than those in the Victorian era.

Before leaving Russell Square Gardens I must mention the statue that sits on the far side, near Bedford Place, as it is a fine piece of sculpture, which is in need of cleaning but nevertheless depicts the Duke of Bedford in all his splendour. Having studied the statue I now head down Bedford Place and like most roads in this vicinity has some wonderfully preserved Georgian buildings, and externally look in remarkable condition. There are several quite exclusive hotels in this street each having a prestigious entrance, but still maintaining the historical character of the neighbouring terraced houses. I really like the double front door designs notably displayed at No.22, The Penn Club and No.24 that has some super stained glasswork. All in all I would say that Bedford Place has to be one of the most attractive and well-maintained streets in London, a credit to the owners.

At the end of Bedford Place I turn right into Great Russell Street and make my way towards The British Museum, and whilst walking along this street my mind wanders back to a little snippet of a story I came across whilst researching this immediate area. In 1774 there were two old maiden sisters named Capper who lived in a farm, which bordered on Great Russell Street and they disliked anyone who came near to their property. It was recorded that when out riding they committed many misdemeanours, such as taking shears to cut the string lines of kites flown by boys, and later accused of stealing the clothes of boy's bathing in waters whilst on their land! Just how young were those boys and how inquisitive were the Capper sisters, I bet CD could have written them into one of his novels had he known of these events!

Before actually arriving at the museum I have decided to continue on the 'square theme' and visit Bloomsbury Square, after all it is in Bloomsbury. Having crossed over the road from Bedford Place I enter the gardens of Bloomsbury Square in order to take account of this obviously popular site judging by the interest taken by all those around me.

The square was developed in the late 17th century and was originally known as Southampton Square, built by the 4th Earl of Southampton. By the 19th century Bloomsbury had become less fashionable to the upper classes and the larger houses were demolished to make way for slightly smaller terraced buildings occupied mainly by the middle-classes. The former Prime Minister Benjamin Disraeli lived here at that time with his father at No.6. In fact there are several blue plaques which confirm just how popular it was to reside here throughout the past three centuries, certainly the style, quality and appeal of each building demonstrates the craftsmanship of that period.

In 1694 a famous dual took place here between John Law (economist) and an Edward Wilson, Law killing his opponent with his sword. Law escaped from his prison cell after being sentenced to death for murder and fled the country, later founding the Mississippi Company as well as becoming the unofficial prime minister of France! I had come across the name of John Law several years ago when researching my book on the history of Venice and discovered that the remains of his body are entombed in the San Moise Church close to St Mark's Square. It was the same John Law I mentioned in chapter one who owed a great deal of money to Campbell's Bank (forerunner of the Coutts Bank).

At one end of Bloomsbury Garden sits the wonderful bronze of Charles James Fox (1749-1806), who was a Londoner of fame having achieved the post of a Whig politician, an anti-slavery campaigner, staunch opponent of George III and a supporter of the French Revolution! He was also a friend of the then Duke of Bedford who commissioned his memorial. Looking around one can see the Art Deco Victorian building designed by Charles William Long that was built between 1922 and 1932 and which adds value to the elegant setting on the east elevation of this square. This particular building known as Victoria House was erected for the Liverpool Victoria

Friendly Society, which was founded in 1843. The LVFS provided the early 'penny polices' for life insurance that the poorer classes could afford, and today the building provides space for a number of offices but still retains its pleasing architectural features.

As I enjoy the relatively peaceful environment here today, I cannot help but think of the turmoil that took place on this spot in 1780 during the Gordon Riots, when several of the houses were burnt to the ground. The rioters aimed their displeasure at the house numbered 29, which was home to Lord Chief Justice Mansfield, because of his approval of the Roman Catholic Relief Bill (1778). Mansfield escaped the throng by climbing through the back door of his house before it caught fire, he did however later sit on the bench at Lord George Gordon's trial, where three of the huge mob who burnt his house were sentenced to hang a few days later in this very square! CD would have been familiar with this account of events as his novel Barnaby Ridge centres on the Gordon Riots, and I feel sure he would have visited this area constantly, what change he would notice today.

Just opposite Bloomsbury Square to the left of Southampton Road stands the very continental looking Sicilian Avenue, which is an architectural treat. This fairly unique London location was developed in 1910 and the setting is reminiscent of a number of locales in southern Italy. I like this idea of bringing an Italian flavour to this spot, especially the group of restaurants, which offer a range of appetising food. Architect R J Worley created the design for this avenue, and his brief was simply to provide an arched arcade supported by columns, which gave a realistic Roman ambience; I think he succeeded in doing so.

It is now time to walk west along Great Russell Street and pass the iconic British Museum building, which is just a short walk away. On the left side of the street I have spotted a blue plaque on the wall of a terraced house which informs those passing that Nos. 66-70 were the first works by John Nash, you can't get much better than that! My research also informs me that there were once two very popular local coffee houses nearby, according to certain artists of the 1850's, that both sold 'delicious chops', one of which was called Martin Coffee House. Sadly my 1863 map doesn't indicate their exact location but I bet CD knew where they traded. It is nice to see that the surrounding

streets situated opposite the museum have changed little over the years, many buildings of which form a parade of interesting shops and houses.

Having now arrived at the entrance to the British Museum (BM) I am not surprised to see hundreds of visitors entering and exiting this very popular building, which has retained its Georgian elegance and survived two world wars. The BM was first established in 1753 by the physician and scientist Sir Hans Sloane (1660-1753), his amazing collection of artefacts was bequeathed to George II. George had already collected his own extensive book collection and he then decided to open the forerunner of today's group of national museums by an Act of Parliament. The trustees of this newly formed group then purchased Montague House for £20,000 for the purpose of creating a museum, which initially included both antiquities and books. Montague House was a 17th century mansion owned by the 1st Duke of Montagu prior to its purchase.

By 1802 the museums collection became so extensive through the discovery of artefacts from Greece, Italy, Egypt, colonial expansion and the French wars, that it was necessary to expand Montague House. By 1823 the total collection, which included artefacts George II had later donated together with the entire Royal Library (as he had no interest in reading) forced the trustees of the museum to demolish Montague House and build the first phase of the building we see today. Construction continued for almost 30 years as each phase of build introduced new collections of books and artefacts, which came from donations, and archaeological excavations of that period.

By the time of the Great Exhibition (1851) the museum building was still a work in progress, and the recorded book collection alone was said to exceed one million. By the late 19th century yet another phase of construction began as the collection exhausted the museum space yet again, and by 1925 mezzanine floors were added to cope with the vast number of books alone. At this period the museum was attracting over one million visitors a year. By the bi-centenary of the museum many new departments were formed to administer both the collections and educational services, and in the 1970's it was recorded that over 1.5 million visitors alone visited the Treasures of Tutankamun exhibition. In order to sensibly accommodate the now massive collection of antiquities within the museum, together

with the numerous administration departments it was agreed that a new British Library would be built at St Pancras, and in 1998 that programme was finally achieved.

Today the BM collection has increased from the original 1753 figure of 71,000 objects of all kinds, to over 13 million at Bloomsbury, with 70 million at The Natural History Museum and 150 million at the British Library. It is almost impossible to give a brief overview of just how much there is to see and enjoy at the BM, one has to visit this fantastic building time and time again to get a real flavour for the complete history of ancient and historic cultures, places, people and materials of our precious world.

Before moving on from this wonderful museum I should add that CD as a young man applied for a BM ticket to the Reading Room and for several years used this facility to study Shakespeare and Roman history among many other subjects. Even when he worked as a reporter in Westminster he still managed to spend a great deal of time in the former Reading Room and one can only imagine just how much material he stored away in his memory for his future novels.

Passing the BM, I now turn right into Bloomsbury Street and walk along this long and busy road passing Bedford Avenue on the left which has some attractive buildings on show, some having traditional red brick facades, with balconies and tiled roof terraces. After a short walk it is difficult not to be excited when confronted by Bedford Square on the left, which is arguably the best preserved and maintained group of period buildings in London. This small area of housing must rank as being one of the most desirable addresses to live in within our capital, as it offers a great location, fantastic architecture all of which is meticulously preserved, there is perhaps one exception, that being an area in Chelsea which sits close to Stamford Bridge (the academy of football excellence!).

Bedford Square covers part of an area that was once the 'old rookery' of St Giles, and is part of the Bedford Estate, which included Bedford House that was later demolished to allow both Russell Square and Bedford Square to be built. It is questionable who the original architect was that designed Bedford Square, however a number of houses have been attributed to Thomas Leverton, architect (1743-1824) who employed designers that had previously worked with the Adam brothers. All of the original houses, built between

1775 and 1783, sit overlooking what I would term as a circus with a central private garden. Added to this is a wide expanse of pavement, which compliments the entire vista of the square. The central features of each row of terraced housing, on the four sides of the square, are the beautiful stuccoed facades, each having pilasters and pediments in the Iconic order. The houses at the end of each row have balustrades above the main cornice, and other than the central buildings, the remaining round-headed entrance doorways have rusticated Coade stonework. If I were asked to describe Bedford Square in a few words it would be 'an elegant Neoclassical Georgian feast'.

As you would expect, there are many blue plaques which signify former noted residents of many of the houses in this square, a few being; No.44 Margot Asquith (1864-1945), No.10 Charles Gilpen MP (1815-1874) and William Butterfield architect (1814-1900). Probably the most interesting noted occupant was the former Lord Chancellor, Lord Eldon (1751-1838), who was ridiculed in several caricatures of the day. It was recorded that Lord Eldon had a memorable meeting with the Prince Regent, later George IV, when he resided at No.6. Bedford Square. Apparently the Prince Regent wanted Lord Eldon to confer the title of Master in Chancery to one of his close friends Joseph Jekyll, which Eldon bluntly refused (at the time he was bedridden with gout). The Prince Regent then threatened not to leave Eldon's bedroom until he obeyed his wish, following which Eldon involuntarily conceded to grant the request!

It is time to leave Bedford Square and head back up Gower Street to locate another address, which featured in the life of CD, I refer to Keppel Street, which today is much shorter in length than it was in 1863. Keppel Street stands a few yards north of Montague Place and CD rented a house at No.34 for his father in 1851. Unfortunately Kepple Street does not run continually through to Russell Square as it did in CD's day, as UCL have since moved in and built one of their flagship buildings known as Senate House. The street originally contained 40 Georgian houses with a further 42 homes in Keppel Mews. It was a well to do area which attracted many distinguished residents such as John Constable, Anthony Trollope at No.16, Harry Houdini at No.10, and of course CD at No. 34.

My research informs me that on the night of the 30th March 1851, CD, his mother, two brothers, sister, and brother in law were

registered on a national census as being at No.34, they were visitors to the house of Robert Davey, a medical practitioner. Mr Davey had performed an operation on CD's father in this house on the 25th March and it was here that John his father, later died.

Anthony Trollope (1815-1882) owned No.16 Kepple Street, and as a novelist like CD wrote about political, social as well as topical issues of the day and resided here for some time. Trollope was not entirely complimentary regarding CD's work however, as he once labelled him 'Mr Popular Sentiment', whilst other members of CD's literary brethren were perhaps less public in criticising his novels. Thomas Trollope (1810-1892), Anthony's brother, did however become a good friend of CD, when in 1844 he contributed to the magazine 'Household Words'. Thomas, who was born in Bloomsbury, produced a vast amount of journalistic work which included 60 works of travel writing, in addition to his historical and fictional publications. He lived in Italy for a great deal of his adult life, before returning to England where he died in Bristol.

At the far end of Keppel Street one cannot miss noticing the Art Deco building known as Senate House, which as I pointed out earlier is part of the UCL campus. Senate House was constructed between 1932 and 1937 and designed by Charles Holden was of its time the second largest building in London, having 19 floors. Whenever I look at this imposing structure, I am instantly reminded of the huge Stalinist buildings I experienced whilst visiting Moscow, and like the larger Russian counterparts, Senate House is to my mind imperialistic and offers a powerful architectural statement. The original building design, created to accommodate the rapid growth of UOL, was curtailed due to initial lack of funding, nevertheless it has since proved to be invaluable firstly as home to the University Library, as well as accommodation for the Vice Chancellor of UOL, and also provides considerable archive space. The library has an amazing collection of books which occupy the 4th-18th floors, and has over 30, 000 registered UOL users, it holds approximately 3 million volumes, many of which date before 1851.

Returning to Gower Street, we cross the road and continue north before turning left into Chenies Street which stands as a division between three important buildings connected with the arts, namely the Royal Academy of Dramatic Art (RADA). The main RADA

building is located in Gower Street, whereas the rehearsal rooms and studio spaces are found in Chenies Street.

RADA was established in 1904 by Herbert Beerbohm Tree, who often starred and performed in CD's plays at His Majesty's Theatre, then the academy address before it moved to its present location, in 1905. RADA's prime objective was to become the foremost drama school in the world, as well as being an affiliate school of the Conservatoire for Dance and Drama. A Royal Charter was granted to RADA in 1921 on having established a remarkable array of prominent actors and play writes within its managing council; Sir James Barrie and George Bernard Shaw were just two of those well-known people. RADA continued to grow in both esteem and notoriety during the following years leading up to World War II, gaining government subsidy as well as generous donations within its membership circle.

RADA's current President, Lord Attenborough joined the academy in 1941 as a scholar and by 1955 Sir Keith Barnes, its long serving director had retired. Changes took place during this period when the number of students were considerably reduced, making entry more difficult, this however did not compromise the remarkable talent that evolved from the academy. Today RADA accepts only 28 new students annually for BA courses in acting, but has introduced technical theatre and stage management subjects, again only allowing 28 new entries each year. There are also opportunities for a further 35 students to enter courses covering several other aspects of stage management. This prestigious academy has many noted RADA alumni, far too many to list, however a few of my favourites include; Richard Attenborough, Kenneth Branagh, Michael Gambon, Anthony Hopkins, John Hunt, Vivien Leigh, Roger Moore and Peter O'Toole. Can you imagine just how much CD would have enjoyed being part of this academy given the opportunity?

Having viewed the RADA building I now make my way to the end of Chenies Street and cross over Tottenham Court Road and make for Goodge Street. Tottenham Court Road has a long history that was recorded as far back as the reign of Henry III (1216-1272) when William de Tottenhall owned a manor house at the intersection with Oxford Street (the area then known as Totten). By the Elizabethan period the manor was leased to the crown and

became Tottenham Court, then around 1675 Charles II created the title Duke of Grafton, for his illegitimate son, Henry Fitzroy. Today this very busy road is a hub for commercial enterprise ranging from consumer electronic outlets, to furniture and household retail outlet shops. Like most areas of London this road has its own sinister story to tell, one of which centres on a once popular shooting range, which traded from premises at No.92. This shooting range was associated with many misdemeanours and radical events, one such incident being the place where certain suffragettes practiced their weaponry skills. Allegedly they were later to have conspired here in an assassination attempt aimed at Prime Minister Herbert Asquith (1852-1928), who was the husband of Margot then living in Bedford Square. Several other events were recorded from this shooting range like the one in 1914 when a certain Alice Storey, an attendant at this address, who was actually shot by someone using a revolver in the range after she allegedly made a racist remark!

Moving on now to Goodge Street, which doesn't have a great deal of architectural elegance, a legacy no doubt from the bombing during World War II, but there are many eating places to enjoy and its name did become fashionable in the swinging 1960's when it featured in popular music. There is however a very nice Caffe Nero nearby in Charlotte Street which is worth a mention especially if you are in need of a cup of good coffee and a bite to eat. I use this coffee house often, in fact whenever I venture to Waterstones in Gower Street.

This walk is now well on the homeward run and as I reach the end of Goodge Street I turn right into Cleveland Street and pause for a few seconds where the Middlesex Hospital once stood, its former site currently being re-developed. The original hospital finally closed down in 2005 and its staff and services moved to various other hospitals within the University College London Hospitals NHS Trust. Today this very busy building site appears to be well into its redevelopment programme, and when finished will be called Fitzroy Place, completion is due around 2014. Fitzroy Place, according to developers, will consist of 237 luxury apartments, over 200,000 square feet of prime office space that will incorporate a number of shops and community facilities. Whilst I feel sad that yet another hospital has closed and its history and purpose within the local community will disappear, I also realise that Middlesex Hospital

became extremely expensive to maintain by virtue of its age as well as the financial constraints of the present economic climate. I just hope that the NHS services will one day balance their books and improve on the medical services, which our country is in desperate need of.

Cleveland Street itself has a formidable history, records can be traced back to the early 18th century, and it was in this street at No.22 that CD, as a three-year-old boy, settled in his first London home in 1815. This address was very close to what was then Cleveland Street Workhouse (originally known as Strand Union Workhouse on the 1863 map), which was built in 1775, and later became the Annexe of the now demolished Middlesex Hospital. The workhouse itself closed down in the late 18th century, as it was ill matched like its contemporaries, to provide adequate provision for the poor and needy. CD would have greatly admired one champion reformer in his relentless campaign to improve workhouse conditions, especially at Strand Union, namely Joseph Rogers (1821-1889) who was both a doctor and surgeon. Rogers campaigned and worked effortlessly to rectify standards within the Strand Union and other similar buildings, which later put considerable strain on his health.

More recent research has revealed that it was highly likely that the Strand Union Workhouse inspired CD to write Oliver Twist, not from his early memories as a three year old, but from a later period in 1828 when he returned to live in this street as a young man of sixteen. What remains of this now empty former workhouse, which is located opposite House Street, undoubtedly gives some indication of what a Victorian workhouse was like (certainly from the exterior), albeit that there have been several alterations made since it was first built. The stark and rather cold exterior brickwork and uniform appearance of this building is more reminiscent of an early Victorian prison, and I feel sure that CD had graced its interior several times during his years of campaigning for reform.

Before moving on I did discover one very scandalous event in this street in 1889 that took place at house No.19, which was front-page news of its day. Apparently this house was used as a male brothel emporium, which was discovered quite accidentally by the police. It would appear that this dubious establishment allegedly had many notable clients, mainly from the upper classes, who used the services of 'telegraph-boys' as male prostitutes, these boys apparently working

as daily messengers for the Post Office in their normal working day. When this misdemeanour was first discovered, the Government was accused of a major 'cover-up' as it was rumoured that certain members of the Royal Family, peers of the realm, senior military officers and many noted personalities were involved in visiting this brothel. After much debate regarding the 'cover-up', which lasted several months, public interest in this scandal faded and almost all of the 'clients' escaped punishment, even the telegraph-boys were recoded as 'being given light sentences'.

As I walk to the mid-point of Cleveland Street I simply must stop and view one building that seems to have followed me throughout this walk, I refer of course to the Telecom Tower. Standing directly opposite the ground floor of the tower I at long last can get some perspective of its scale, instead of just catching a glimpse of its structure from almost every location throughout the walk. The tower was built in the early 1960's by the former General Post Office, and its iconic design was created by the Ministry of Works architects, in answer to the increasingly fast track development of telecommunications throughout the country. Made entirely of concrete, steel and glass, and shaped to optimise the towers components, this 190m giant was built at that time for the vast sum of £2.5m!

I well remember the construction programme especially the enormous crane straddled above the site, and thrilled at seeing each floor grow like a Lego frame. It seemed even then that the tower appeared wherever one walked around London, and it created a unique skyline image, much like today's Shard building. The original design of the tower accommodated technical equipment on the first 16 floors, above which were 'layers' of microwave dishes and aerials with a further 6 floors for offices, kitchens, equipment and a fairly unique revolving restaurant, and above all of this stood the cantilevered steel tower. Most of the defunct antennas and 1960's technology equipment have been removed, and the public no longer have an opportunity to visit the restaurant, as sadly a terrorist bomb exploded on the top of the tower in 1971 and public access has ceased. I understand that today the main body of technical equipment remains, having been completely upgraded for use in the new millennium. For me, this Grade II listed building still provides a

nostalgic sight on the London skyline, even if its inconspicuous base and entry point remains almost hidden amongst its neighbouring buildings.

Walking back a few yards along Cleveland Street I now cross over the road and head down New Cavendish Street where I cannot help but notice the entrance to the University of Westminster, which was founded in 1838. This university started its life as the Royal Polytechnic and was awarded its present status as late as 1992, however that does not undermine the significance of this place of learning which accommodates almost 24,000 students. The original campus was sited in Regent Street and soon developed as an institution by adding additional buildings in Marylebone, Harrow and Fitzrovia, the building we see today in New Cavendish Street houses science, engineering and computer laboratories. As one would expect from a university of this status there is a plethora of subjects for students, such as accounting, art, computer sciences, English, journalism, politics, and sociology to name but a few. History was made in the Regent Street campus when in 1896 the Lumiere brothers first screened a 'moving' picture show as a cinema, and today with the aide of Lottery funding this former cinema (currently a lecture theatre) will be restored to its former glory, and is due to open in 2014. Having been born in the district of Westminster I am so pleased that a university of that name now exists, and I for one will make every effort to visit the cinema.

Moving along New Cavendish Street I can only assume that the heavy bombing during the last war took its toll here, as there appear to be many modern designed buildings on view. This theme continues as I turn left into Great Portland Street and head south to Langham Street, where I am about to view a group of buildings which are associated with radio and television broadcasting, I refer of course to the British Broadcasting Corporation (BBC).

The group of buildings that now confront me form part of what is better known as BBC Broadcasting House. The original Broadcasting House is found in Portland Place and is the registered HQ for the BBC and was built in 1932, eight years after the formation of the company. This wonderful Art Deco building, designed by George Val Myer and MT Tudsberg is arguably an historic icon of architectural beauty. Built of a steel frame

construction carefully disguised by Portland Stone, amazingly, the original frontispiece was built to incorporate retail outlets in order to finance the company, this option was however never required.

There are several pieces of sculpture on the external stonework, namely the statues of Ariel and Prospero, created by Eric Gill, in addition to The Ariel Frieze depicting Wisdom and Gaiety, all of which are sculptured in the characteristic Art Deco style of its day. Thankfully the BBC has since restored and improved their flagship building, the work being completed in two phases. The original interior has been re-energized and areas such as the Reception have been tastefully renewed. During the restoration of Phase I, a new wing named the Egton Wing was introduced and completed in 2007, which is similar in shape to the original building and features stone cladding on its façade. A second phase building was added in 2010 connecting these two buildings, which created an interesting piazza that compliments both the old and new design. This newly paved area designed by Mark Pimlott, reflects the global reach of broadcasting by the BBC as it identifies several hundred inscribed flagstones of many countries around the world.

Another interesting feature to note is the original lattice styled radio mast on top of Portland Place, which is familiar to us all and which now shares the skyline with a coned shaped glass structure, titled 'Breathing'. This wonderful work of art on the Egton Wing roof, was sculptured by Jaume Plensa, and is accompanied by a very touching illustrated poem by James Fenton (on continuous display) both serving as a memorial to all the BBC journalists killed in the line of duty.

When researching the BBC building, I was staggered to discover just how much the total spend was for the entire restoration and rebuild; reports claimed it to be over one billion pounds (£1b). Even in today's terms that sounds incredible, but I was reminded that in creating this trio of broadcasting excellence all of the BBC's prime services are consolidated into one location, therefore future spend should be considerably less. The remaining operational division of the BBC have vacated their former complex in Haringey at this very time of writing, and now both TV and radio broadcasts are united together in one unit. With this unification of services I now think it was worth the spend and effort, but I cant help but wonder what comments CD

would make if he was with me today, and had made comparisons with the total building cost of John Nash's All Souls Church (1824) that stands close by, which was built for just £18k!

Leaving the BBC buildings and moving north along Portland Place perhaps I should briefly mention this historic road first laid out by the Adam brothers for William Bentinck (Duke of Portland) in the late 18th century. This now well-used road was once to have been redesigned by John Nash to incorporate a 'great thoroughfare', which stretched from Regent Street through and beyond Portland Place to a 'magnificent palace' for George IV, which we know was eventually abandoned. Portland Place was however, originally adorned by several mansions, two of which being Foley House and Mansfield House and there is also Langham Place that once hosted the Portland Bazaar (German Fair). This popular fair began around 1839 and was ruined by fire on one occasion, but was rebuilt and did attract thousands of visitors who purchased items imported from Germany, France and 'other foreign countries'. One part of this enormous Portland Bazaar complex was in fact used as a skating rink, which was popular with the public and was called Langham.

Today Portland Place provides us with a very imperial looking and busy thoroughfare consisting of a mixture of embassies, company HQ's and professional institutions of all manner, which serve this prestigious piece of desirable real estate. One such professional institution I am familiar with is the Royal Institute of British Architects (RIBA), which is located opposite the Chinese Embassy. Formed in 1834 and granted a royal charter in 1837, the RIBA moved to Portland Place in 1934. Although I am not an architect I have used their fantastic library collection whenever I needed detailed information on architecture, incredibly they house over 4 million items of important architectural significance. On the occasions when I have been privileged to use the library I am simply overwhelmed by the collection of drawings and manuscripts housed here that include pieces by Andrea Palladio, Frank Lloyd Wright, Sir Christopher Wren to name but a few revered past masters.

My Bloomsbury walk is almost over but there is still one more historic road, which I simply cannot fail to mention before completing the full circular route back to Regents Park where we started. Having now reached Cavendish Street I simply turn left into

this road and walk a few yards then turn right into Harley Street. Harley Street needs no explanation, however I shall mention that it is thought to have been named after Robert Harley (1661-1724) 1st Earl of Oxford and Earl Mortimer, who was both a politician and statesman. Robert actually served in both the Whig and Tory ministries, serving as First Lord of the Treasury under Queen Anne. By 1710 he was appointed Chancellor of the Exchequer and in the following year was stabbed by a French refugee while in office, fortuitously recovering from this attack within a year. In 1711 he was made Baron Harley and appointed Lord Treasurer in 1712, that same year a second attempt on his life was made which was foiled by none other than Jonathan Swift (1667-1745), author of Gulliver's Travels. Robert Harley's popularity amongst the Jacobites was tenuous as he did on occasions break several promises during his political role and by 1714 surrendered his title as Lord Treasurer. When George I succeeded Queen Anne, Robert was impeached by the King and served two years in the Tower on charges of treason, he was eventually acquitted and allowed to keep his peerage.

When I first read of Robert's injuries I immediately thought how coincidental it was that today Harley Street is known worldwide for its medicine and surgery, attracting arguably the finest specialists, consultants and doctors who have established clinic's here. Robert's son Edward (1689-1741) also a politician, developed Cavendish Square and the surrounding streets that were later passed to his daughter Margaret (1715-1785) who married the same William Bentinck mentioned earlier.

Today the large number of doctor's practices, hospitals and medical institutions has grown from 20 in 1860 to around 3,000 today. There are several blue plaques to be seen in this street, some of the noted people who lived here being William Gladstone, JMW Turner and Lionel Logue (who treated George VI for his speech impediment).

At the top end of Harley Street we end our walk of Bloomsbury.

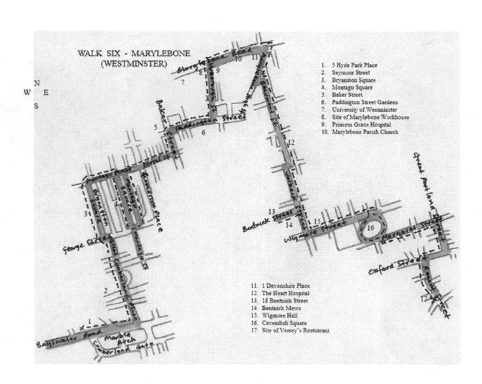

WALK SIX - MARYLEBONE
(WESTMINSTER)

1. 5 Hyde Park Place
2. Seymour Street
3. Bryanston Square
4. Montagu Square
5. Baker Street
6. Paddington Street Gardens
7. University of Westminster
8. Site of Marylebone Workhouse
9. Princess Grace Hospital
10. Marylebone Parish Church

11. 1 Devonshire Place
12. The Heart Hospital
13. 18 Bentinck Street
14. Bentinck Mews
15. Wigmore Hall
16. Cavendish Square
17. Site of Verrey's Restaurant

WALK 6

MARYLEBONE (CITY of WESTMINSTER)

"Vices are sometimes only virtues carried to excess!"
(Dombey and Son—1846-48)

Occasionally past chapters of this book have crossed into other districts of London during these walks and Marylebone will be no exception, as CD was renowned for changing addresses throughout his life. In order to concentrate on a set path within each district, relative time periods during CD's life will still remain jumbled, and Marylebone is no exception. One thing I am sure of is that CD would have thought that class and social values throughout his life were important and that Marylebone certainly fulfilled that criteria.

The district of Marylebone sits in an area which extends to Oxford Street, Marylebone Road, Edgware Road and Great Portland Street and is still known by many as Marylebone Village. Its name derives from a church called St Mary le burn (now Marylebone Parish Church) meaning a rivulet or bourn, which was built on the banks of the former stream known as Tyburn, a name mentioned in the Doomsday Book (1086). Henry VIII used this district as a royal hunting park and subsequently built a hunting lodge close to what is today Devonshire Mews. In 1611 Tyburn and its enormous estate were sold by James I to Edward Forest, he then sold his manor of Marylebone to the Austen family which was then called Marylebone Park Fields.

In later years the manor was sold to various members of the nobility such as the Earl of Oxford and the 2nd Duke of Portland who

then developed the land north of Oxford Road and Cavendish Square whilst, at the same time laying out many streets. At the beginning of the 18th century Marylebone really was quite a small village which stood some distance away from the boundaries of the Metropolis. After a series of further owners, the Crown repurchased the northern part of the estate in 1813 and by the 1900's had merged the area into what we know today as the City of Westminster.

Marylebone has for many years been noted for having two prestigious estates, one being the Portman Estate, which dates back to 1553 and comprises of around 110 acres of land which include Oxford Street, Marble Arch, Edgware Road and more. It also has some of the finest squares in London, namely, Bryanston Square, Manchester Square, Montague Square and Portman Square to name but a few. The Howard de Walden Estate is the second largest which comprises of around 92 acres and has a geographical spread from Marylebone High Street to Portland Place. CD delighted in being a resident of Marylebone throughout his time in London, he had many personal friends living here, in fact a large majority of the streets had residents of some note.

The path of our walk today is virtually unchanged from that of my 1863 map, some street names have been changed, some were simply not there at that period so fittingly the walk begins at Marble Arch which is arguably the best known area of Marylebone. Apart from the changes in architecture since the mid-19th century, which we will soon discover, the other most significant change to this area has to be the introduction of the circular street plan around Marble Arch itself that now includes Cumberland Gate. When CD lived here, this corner of Hyde Park would almost certainly have been far more congested with traffic converging into one road rather than the diversionary and controlled system we are now used to. Originally designed by John Nash in the 19th century Marble Arch was a fitting entrance to Buckingham Palace, and was later enlarged for Queen Victoria, following which it was dismantled and rebuilt in its current location.

Let us then begin in Hyde Park Place, No 5 to be exact, which sits facing Hyde Park and is positioned at the very end of the Bayswater Road, which in 1863 was originally the Uxbridge Road. The building we are now facing was the site of the former home of the Liberal MP Milner Gibson and it was here that CD began writing

his amazing mystery novel Edwin Drood in 1870. The building CD would have known was a splendid Victorian structure with six floors including the basement and a superbly crafted frontage. The house stood higher than its less decorative terraced neighbours and its lower façade consisted of a grand arched front entrance accessed by climbing a short flight of marble stairs, above this sat balconies on the remaining floors. The left side of the front elevation was slightly recessed but never the less decorative, having a sculptured design which becomes less extravagant on each floor. CD often remarked just how much he enjoyed living in this location much the same as his time in Wellington Street, as he could hear the sounds of early morning traffic making its way to the various markets within the city.

Before moving away from CD's former house I should briefly mention just a few of the many historical associations this immediate area has to offer, none more so than the infamous site of Tyburn and its terrifying former gallows. The gallows itself has long ceased to exist once public executions were moved elsewhere in 1783, but I feel sure that CD was fascinated by its history as the gallows were originally located literally just across the road from where he lived. Tyburn had been the principle execution site for London criminals, traitors, and martyrs since the 12th century and the notorious Tyburn Tree was erected here in 1571 which consisted of a 'triple tree' design that could accommodate several people at any one time! A memorial to the 'Tree' can be seen in the pavement, on the island road junction, facing Marble Arch at the end of Great Cumberland Place. Elizabeth I was the first to send a victim to the 'Tree' and oddly enough the remains of Oliver Cromwell were hung here after being disinterred, in 1661, as an act of revenge for his part in the death of Charles I.

Moving off in the direction of Oxford Street we reach Great Cumberland Place where we turn into and immediately Bryanston Gardens can be seen in the far distance. Great Cumberland Place is a very busy road which always seems to have a large queue of taxis parked in readiness for the hotels close by. The street is a mixture of fairly modern buildings and some beautifully designed period properties at the northern end, there is also a charismatic crescent to the right as we walk north crossing Seymour Street. Seymour Street (formerly Upper Seymour Street) is however arguably more interesting, it was named after the family of Seymour's from whom

the Portman's descended, namely Viscount Portman of Bryanston. When Sir William Portman, the 6ᵗʰ Baronet, died in 1690, the family estate passed under a settlement to the latter's first cousin Henry Seymour who took the name of Portman.

CD would have known of the artist, illustrator, poet and author Edward Lear (1812-1888) who lived in Upper Seymour Street. Lear, originally from Holloway, amazingly came from a family of 21 children and although having suffered from epileptic fits for most of his life travelled extensively abroad and produced some wonderful water colours, oils, illustrations and sketches of his travels. He eventually settled in San Remo, Italy, where he died and was buried there.

Of the many amusing stories associated with Upper Seymour Street that CD would have been familiar with was one incident that took place next door to the Lear's house at No 14 and was centred on a young American doctor named Robert Hunt. Dr Hunt had opened his practice here in 1864 and treated patients who suffered from consumption (tuberculosis) which was a killer disease at that time. Initially his practice attracted many patients but it was challenged in a libellous court case that questioned the type of treatment he offered, which used a form of oxygen inhalation. Although Dr Hunt had many satisfied customers one dissatisfied patient, the young wife of as local tobacconist in nearby Baker Street, had claimed that Hunt indecently assaulted her during her course of treatment, when in her own words was 'out for the count'. Hunt was eventually acquitted of the charges following a scandalous public investigation and trial. Hunt eventually left the UK and made his fortune in Europe before returning to the USA. As for the woman accuser, she and her direct family who it is said had fabricated some evidence, were reprimanded, but by then the good doctor's career was over in the UK.

As we move further north along Great Cumberland Place we now reach George Street and face Bryanston Square. Before crossing George Street I simply must mention a very special nurse who lived here and is best remembered for her work with British troops in the Crimean War. No, not Florence Nightingale of whom I have a great deal of respect, but a wonderful Jamaican lady named Mary Seacole (1805-1881). Sadly history seems to have dismissed much of Mary's work in the Crimea but fortuitously she was rediscovered more recently and has finally received the accolade she richly deserves.

Born in Jamaica to a Scottish soldier and Jamaican 'doctress', Mary learnt her nursing skills by working and tending the sick with her mother during several cholera outbreaks in 1850. The following year she nursed people in Panama City, before returning to Jamaica in 1853 to assist in the devastating Yellow Fever outbreak. Upon hearing the news of the cholera outbreak in the Crimean War she travelled to Constantinople in 1855, at her own expense having been refused funding, hoping to assist Florence Nightingale as well as open a hotel for wounded and sick officers.

Mary Seacole did however nurse in open conflict by simply being there and 'working on the battlefield', under fire, tending wounded troops. Although Mary was revered by the troops she was not accepted as being one of the official nursing team as her motives were thought to be financial, I simply can't believe that was entirely true having read various accounts of her bravery. At the height of this conflict both CD and Angela Burdett-Coutts contributed in some way to the Crimean War effort by having a new and innovative Jeakes Drying Closet built and shipped to Constantinople to assist with the massive laundry problems within the wartime infirmary. When Sebastopol eventually fell in 1855, Mary was the first British woman to enter the city where she remained to tend the sick and was reputed to have been the last to eventually return to England, at which time she had lost all of her money and was in poor health. Fortunately through various fund raising schemes she was nursed back to health and when recovered later returned to Jamaica. Returning to London in 1870 Mary had hoped to assist Florence Nightingale in the Franco-Prussian War but was snubbed once again allegedly for personal and subjective reasons.

I don't think CD ever met Mary in his lifetime but he was certainly aware of her activities and I have some reservations regarding his attitude towards her motives, if not her deeds and actions. Florence Nightingale for no reasons of her own, overshadowed Mary Seacole's work, and whilst I applaud Florence's war efforts I felt slightly saddened when researching Mary's contribution, which I think may have been tainted by social and racial prejudice.

Returning to our walk I am now standing in Bryanston Square which on first sighting looks like a very well maintained and exclusive

location. Directly facing me is a well sculptured bronze of William Pit Byrne (1806-1861), who was a newspaper editor and owner of The Morning Post. His memorial was erected here shortly after he died, which has a very artistic feature at the base, instead of the normal granite plinth, there is a collection of various stone pieces which form a raised base to the drinking fountain above. This carefully modelled and attractive square is named after its original owner Henry William Portman, whose hometown was Bryanston in Dorset and forms part of the Portman Estate. Henry Portman was an 18th century housing developer who transformed over 200 acres of this area from what was originally meadow land that lay between today's Oxford Street and the Regent Canal. Portman Square was the first major phase of this project, built in 1764, followed by Manchester Square in 1770, then Bryanston Square together with Montagu Square around 1810.

The Bryanston Square development took around 20 years to complete, the houses on the eastern and western elevations were of a grand design having stuccoed frontages beautifully enhanced by columns and pediments. From an onlookers point of view the exceedingly well maintained private gardens, with their manicured lawns, well planned shrubbery and artistic flower beds, really do enhance what is simply a long oblong narrow piece of ground. Coupled with this are the mature plane trees, neat hedging and ornate metal railings, and a 19th century cast iron pump which features at the northern end of the gardens.

Having now arrived at the northern end of the square we turn right into Montagu Place and after a few yards immediately arrive at Montagu Square, which is almost identical to the one we have just visited other than the gardens are slightly narrower. The square was built between 1810 and 1815 and as previously mentioned forms part of the Portman Estate, the builder being David Porter, and the square having been named after his former mistress Elizabeth Montagu who was a social reformer, literary critic and writer. Mrs Montagu was also noted for providing an annual party for selected chimney climbing boys, one of which was David Porter long before he became a builder, and I guess that's when their relationship developed. The houses that form Montagu Square are to my mind slightly less decorative than those of its neighbour Bryanston Square, with the properties having brown brick facades. I would say that the private gardens are equally

attractive and in character with the Regency tradition of having a graceful vista to enjoy, especially when enclosed by trees, decorative railings and shrubbery making the location very exclusive. CD's very close friend and later biographer John Forster (1812-1876), lived here at No 46 shortly after his marriage in 1856. Another blue plaque informs us that John Lennon, Paul McCartney and Ringo Starr all lived at No 34 at one time or another, during the early part of their career.

Continuing along Montagu Place we have to cross Gloucester Place, a long and busy road which stretches from Marylebone Road to Wigmore Street. At No 62 Gloucester Place once lived the American patriot Benedict Arnold (1741-1801) who was a general in the Continental Army during the American Revolutionary War, and who later defected to the British Army. Having bravely fought with the American Militia from 1775-1779 throughout the northern states Arnold became unhappy and disillusioned with his country and publically stated that it was financially in ruin, had an army who were dissatisfied and had a Congress who spent too much time fighting amongst themselves. He was however given command of West Point and decided to plan its surrender to the British following which he would change sides, his scheme failed and he fled to safety joining the British who gave him a command in their army. Much is written about Arnold and his defection, his business acumen (allegedly being accused of using the war to achieve financial gain), his bravery in action, and resentment in being undermined throughout his American Military service. Since his death he has been labelled a traitor, and was rebuked when tributes and memorials to the War of Independence heroes were awarded. I personally have mixed feelings about Benedict Arnold simply because I can only make judgement from the recorded evidence at hand, however I have the utmost respect for this man as a soldier of courage, and a business man of some distinction and endeavour, whether the latter brought about his political and moral undertaking only he will know, it is not for me to judge.

Having now crossed over to Gloucester Place we find ourselves in Dorset Street. Dorset Street is a mixture of old and new buildings, those to our right constructed more recently whereas to our left we can enjoy some period architecture. Again most London streets have their

people's hero's, but I'm not quite sure about my next luminary, I refer on this occasion to Charles Babbage (1791-1871) considered to be the 'father of the computer'. CD was an ardent admirer of Babbage's work as an inventor, mathematician, and philosopher. In a speech CD gave to an intellectual audience in 1869 he quoted Babbage as a way of expressing his own talent (vocal attributes) which at the end of his life he felt he needed to re-qualify. The reference CD made of Babbage was taken from a piece of his work which reads as follows: "a mere syllable thrown into the air—may go on reverberating through illimitable space for ever, seeing that there is no rim against which it can strike: no boundary at which it can possibly arrive." Although CD admired Babbage's work he would not have shared his dislike for the lower classes, in particular his hatred for what he termed 'degrading street activities'. These activities or public nuisances according to Babbage, were well published issues of their day and created a public outcry, which centred on banning street organ grinders and young boy's hoop-rolling on pavements! In fact his general distaste towards commoners went as far as labelling them 'The Mob', something which CD may well have objected to. Apart from the endless list of 'street nuisances' (almost 200 in total), Babbage was simply a genius of his age and we do owe a great deal to this man.

Babbage studied at Cambridge, then lectured at the Royal Institute in 1815 as well as various other academic institutions in both the UK and France. He relied on his father for an income and made his home in Marylebone where he lived with his wife and children, when his father eventually died he inherited a fortune (£100,000) which then made him independently wealthy. From thereon he founded the Astronomical Society in 1820 and continued recalculating mathematical tables and the like before working on his 'analytical engine'. By the 1830's he had published several works on the economics of machinery and manufacture, natural theology and later the metrological programme. As a member of the Royal Society he worked with Brunel and his son on many aspects of railway construction, and in the 1850's worked on cryptology which was used in the Crimean War. Arguably the greatest accolade awarded to him was given for his work on the mechanical computer, which in essence is said to be similar in architecture to today's modern computer.

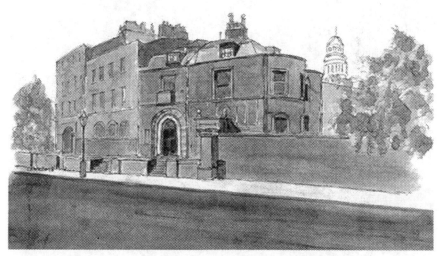

Fig 19 No 1 Devonshire Terrace (1839)

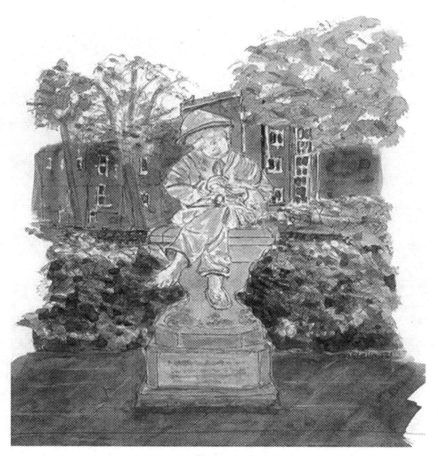

Fig 20 Street Orderly Boy

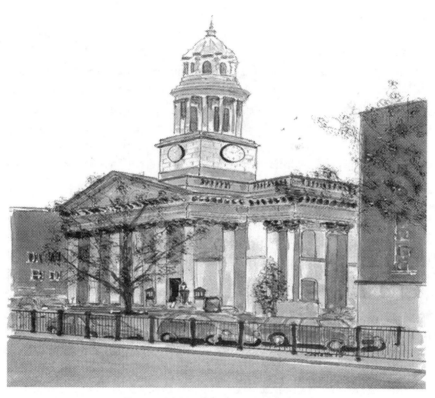

Fig 21 Marylebone Parish Church

We next arrive at Baker Street, which we cross and turn immediately left and walk in a northerly direction until we reach Paddington Street. Baker Street was first laid out in the early 19th century and was semi-revered during the Victorian era largely because it became the address used by the fictional detective Sherlock Holmes, who was said to have lived at No 221B. Originally Baker Street was considered to be a very fashionable address, having a plethora of amazing residential buildings, which in the main today are commercial premises. To me this street injects a sense of urgency whenever I visit it, maybe because of the mixture of business and leisure, it never the less remains bubbling with activity and serves as a direct link north to south across Marylebone. In 1835 another well respected establishment was built in this street, namely Madame Tussauds Waxworks, which in 1884 moved to its present location in the Marylebone Road. In 1940 the HQ for the Special Operations Executive (SOE) moved to No 64, the Beatles Apple Corporation was based at No 94 and William Pitt the Younger (1759-1806) Britain's youngest ever Prime Minister, lived at No 120, a man well worth some recognition.

William Pitt had two spells in office in arguably one of the most dominant periods of the war in Europe during the reign of George III, in which he experienced the French Revolution and Napoleonic Wars. Pitt was said to have been one of our greatest Prime Minister's as he introduced a 'new order' within the kingdom, without creating any violent upheaval. Although he failed to achieve all the reforms he had wished, such as the abolition of slavery, he did promote freedom and human dignity when many people opposed the idea that all people were of equal value. Pitt was a close friend of William Wilberforce and shared his ideals, as well as confronting the Prime Minister Lord North by denouncing the continuation of the American War of Independence and urging him to make peace with the American Colonies. Pitt's career wasn't plain sailing, he was originally appointed Chancellor of the Exchequer then later stripped of the post before eventually being trusted with the job of Prime Minister, when George III finally recovered after his illness.

Returning to our walk down Paddington Street, which itself dates from the 1760's, we have to cross over Chiltern Street before reaching our next destination which will be Paddington Gardens. At

the crossroads of this intersection look to the right and you will see a Blue Plaque in honour of Sir Henry Seagrave (1896-1930) who was a distant boyhood hero of mine, as he achieved three land speed records as well as a water speed record, being the first to hold both at the same time. Seagrave was born in the USA and became a British national when his family moved to Ireland. He later studied at Eton College before serving as a fighter pilot in World War I. When the war was over he joined the newly formed Royal Air Force but later resigned once he had become infatuated with racing cars, then later focused his attention on achieving world speed records on land and later water.

He initially raced at Brooklands, then in 1923 became Britain's first Grand Prix winner in a British car, he went on to race in Europe and win further Grand Prix's before turning his attention to that land speed record. In 1926 he set his first land speed record of 152mph, the following year he regained the record and broke 200mph which he improved upon again in 1929 setting a speed of 231mph. He then decided to concentrate on motorboat racing in 1929 and travelled to America where he was very successful, and the following year returning to England and achieved the water speed record on Lake Windermere. Sadly that same day Seagraves record winning water boat capsized whilst performing a follow-up run and both he and his mechanic, Victor Halliwell, were killed. Seagrave was for many of my generation a distant schoolboy hero and I take great pride whenever I visit the National Motoring Museum at Beaulieu and gaze at his original record breaking Sunbeam's and Golden Arrow cars. Had CD been alive to witness Seagraves achievements I feel sure he would have been equally proud.

At this point we are in sight of Paddington Street Gardens to our right, which is a delight to see set amongst the building construction activity which is taking place all around. These beautifully maintained and preserved public gardens are an oasis of delight having winding paths that meander past attractive flower, shrub and rose beds. What is instantly noticeable is the pagoda, which sits in a predominant position in the gardens, having plenty of seating around and is used for hosting entertaining summer concerts. The array of mature trees completes the vista which includes cherry, laburnum, hawthorn and of course the tried and tested mature London Plane which Victorian

landscapists were aware would thrive in the polluted atmosphere of London. The gardens were formed in the 18th century on land given over as an additional burial ground for the Old St Marylebone Parish Church, the land being granted to the parish by Edward Harley, Earl of Oxford, in 1730. By 1814 St John's Wood burial ground was then opened here which continued to be used until the late 19th century when it was officially closed, the ground still remaining consecrated. In 1885 the gardens became a recreational site and almost all of the tombstones were then removed, however one fine piece of mausoleum craftsmanship remains in memory to the family of the Hon Richard Fitzpatrick. When walking around the gardens don't miss the wonderful statue titled 'Street Orderly Boy' by Donato Baraglia (1849-1930) of Milan, which was erected in the gardens surprisingly enough in 1943 whilst the Second World War was still raging. Donato was a sculptor of remarkable talent who produced his first work at the age of just 17. During the 1860's he had become an established sculptor gaining worldwide recognition, and attained even greater recognition when displaying works at International Expositions in both Vienna (1873) and Philadelphia (1876).

Leaving these pleasant gardens I cross Paddington Street and head directly up Luxborough Street towards Marylebone Road, and immediately notice the long terrace of Victorian apartments to my right which have stood the test of time and still look in remarkably good condition. These typically Victorian styled red brick and stone buildings form a group of co-joined apartments which have at varying intervals attractive architectural entrances. Each elaborate entrance way is accessed by a short flight of stone steps leading into a communal hallway.

To my left at the top of the street is the University of Westminster building, its design more in keeping with 20th century architecture, and which forms part of the group of buildings I mentioned in an earlier chapter.

Having now arrived at Marylebone Road we now face Madame Tussauds Waxworks and turn left heading east towards Marylebone Parish Church, but before doing so I simply must mention a former building which once stood where the university now stands, namely Marylebone Workhouse. This former workhouse stood here for many years and provided comfort to thousands of poor and needy people of

this district and one which CD would have been familiar with as he lived only a hundred yards or so from its gates.

The workhouse stood on land given over by the Earl of Oxford in 1730 to assist in a project to build an alms-house, workhouse and burial grounds, which for financial reasons didn't get underway until 1736. The burial ground, which I mentioned earlier, was the first phase of this project to be completed, and by 1752 the workhouse building was completed, which after a short period of time proved to be inadequate in size as well as being rat infested from the sewers that ran below ground. By 1776 a much larger building which accommodated up to 1000 inmates was built, and the old building which became an infirmary was eventually demolished in 1792, deemed unfit for use, and a new infirmary was built on the exact site. Throughout the French Wars these buildings were full to capacity with paupers, and from the turn of the 19th century were expanded in an attempt to cope with the influx of needy people, by 1843 the workhouse had almost 1500 inmates and the infirmary had 300 patients.

Conditions at this workhouse were no different to others in London, overcrowded, food rationed, and menial tasks were imposed to help finance the situation but little assistance was given by the Poor Law Commission. The general situation in institutions such as Marylebone Workhouse had deteriorated rapidly from 1834 onwards and 'nightly' asylums were introduced for the vagrants of the district (one night only) and even stricter demands placed on the inmates. By 1846 there were 2264 recorded inmates here, who it is recorded were accommodated in 'every corner of the workhouse'. One novel attempt to help the situation was the introduction of Steven's Patent Bread Making Machine, which claimed to make mass produced bread more hygienically, one can only imagine how it was made before! By 1866 the Lancet undertook a campaign to improve conditions in London Workhouses and reported on its findings. The recommendations for Marylebone were published soon after and suggested that the infirmary be retained for hospital purposes and that the entire unit should be rebuilt. It was also suggested that the in-house medical officer should have at least three additional medical assistants and that the 'farming out' of medical expenses and duties to only one physician should be reviewed. Temptations towards negligence were

inconspicuously recorded! Having said that in 1867 the workhouse played a major role in assisting casualties when 200 ice skaters using the frozen lake in Regents Park fell into the water after the lake gave way, 160 survived by receiving prompt medical attention from Marylebone medical staff, the remaining 40 that died were taken and laid out to rest in one of the workhouse buildings.

Between 1878 and 1901 there were several major new buildings constructed on site, however the quality of the new build proved to be disastrous as problems arose with the foundations and structural detail that caused massive damage. The workhouse provided sanctuary for war refugees during 1914-1915 and by 1930 had become St Marylebone Institution and cared for the elderly and infirmed. In 1965 the former workhouse closed and the buildings were demolished and replaced with apartments and accommodation for the London Polytechnic, which today is the Marylebone campus for the University of Westminster.

Having laboured once again on the significant role that London workhouses played in both Georgian and Victorian society, I cannot end this note without mentioning CD's connection with this former building. CD was reminded of Marylebone Workhouse throughout his life and experienced first-hand the essence of its undertaking when he was persuaded, as a young man, to act as a juror in 1840 on an inquest held in rooms there. The inquest was about a case relating to infanticide, where a local servant girl was accused of causing the death of her new-born child whilst in service. During the inquest CD was taken to the mortuary of the workhouse to view the dead child and vividly described the anguish at both seeing the corpse and listening to evidence given on the sequence of events leading up to the child's death. Sparing my readers the awkward facts and innuendo related to this inquest, CD was eventually able to persuade the somewhat dubious collection of jurors that the young woman in question was innocent of the charges, eventually she was exonerated from the charge of murder.

As we now leave this area and continue our way along the Marylebone Road onto a very busy three lane major traffic route in either direction, which runs from Euston Road in the east to Paddington in the west and forms part of London's Ring Road. When first put down in 1756, this road was known as New Road

and was used as an early by-pass which ran parallel with the northern boundary of what was fast becoming a 'built up' area. The New Road actually connected the corner of Lisson Grove to Islington but was greatly disputed by the Duke of Bedford who insisted that the boundary of buildings on its path should be at least 50ft from the roadway.

The first London omnibuses were started here at a pub called the Yorkshire Stingo in July 1829, these early three horse drawn carriages ran as far as the Bank and then returned via the same route. Amazingly the carriages were able to transport 22 passengers for the fare of one shilling return each (just over 5p), and a certain Mr Shillingbeer who owned the carriage company provided newspapers for the journey. Not far away from the omnibus station stood the first of a group of bath and washhouses made available to the Marylebone public. During the late 17th century Marylebone Road was considered to be a treacherous route used by 'highway—men' and 'footpads', and one such malicious incident recorded in 1763 spoke of a toll-man of the Marylebone Turnpike being brutally murdered in his toll house and the money stored there taken by the assailant.

We now pass The Princess Grace Hospital, which is a private hospital recognised as being one of the best equipped multi-disciplinary units of its kind in the capital. It has several fully equipped operating theatres for orthopaedic surgery, vascular surgery and robotic surgery using some of the most advanced radiological diagnostic facilities in the country. Its featured specialist services include breast care, gastroenterology, hepatology, orthopaedics, spinal surgery, sports and exercise medicine, urgent care and urology.

Walking further along this noisy road we arrive at York Gate on our left which provides a wonderful entrance to Regents Park, with some of John Nash's elegant stuccoed houses flanking the entrance road. To our immediate right stands St Marylebone Parish Church in all its splendour which we simply must visit as CD did many times, and even had one of his sons christened here. Several parish churches have been built in Marylebone, the first being close to Marble Arch and built around the beginning of the 13th century and dedicated to St John the Evangelist. In 1400 permission was granted to demolish a church nearer to the local village centre, but retaining the existing churchyard, when the new church was eventually built additional

burial ground was provided. Several noted people used this church, one being Sir Francis Bacon (1561-1626) English philosopher, statesman, scientist, jurist, orator and author, who was married there in 1606 to Alice Barnham, his junior by 31 years. By 1740 the church was in a poor state and consequently demolished, the third church was then built on the same site and completed in 1742. This church served the community well for many years, Charles Wesley was buried here, Lord Byron baptized here as was Horatia, daughter of Lord Nelson, who also used the church, but this church was eventually demolished in 1949 and a small public garden marks the location, which can be found at the north end of Marylebone High Street.

The church we see today was originally designed as a chapel-of-ease, permission granted to build on this location was agreed upon in 1811. Work commenced in 1813 and was completed by 1817 and after some debate a decision was made that it should serve as the parish church. Architect Thomas Hardwick's original design was said to be truly remarkable, the Corinthian portico has eight sculptured columns that are based on the Pantheon in Rome. The church is designed with three storeys the lower is a square plan, the second a circular plan with twelve Corinthian columns which support an entablature (bands which lie horizontally above columns), the third level is reminiscent of a temple surrounding eight caryatids (sculptured female figure acting as supporting columns), finally above all of this stands a dome and weathervane.

Internally this delightful church has arch windows which provide a burst of light into the main body of the building, the tiered galleries are supported on iron columns which are positioned on three sides. The organ is above the altar screen and originally displayed a painting by Benjamin West, change inevitably came throughout the 19th century and many alterations were commissioned to suit Victorian fashion. This brought about the removal of the upper galleries allowing extra light to enter, the introduction of a chancel for the robed choir (mahogany stalls) and a sanctuary within the new apse. These alterations follow the Neo Classical design that favoured Pre Raphaelitism and looks very effective, but CD would barely recognise the interior today. Whist living at Devonshire Terrace he would have used the church and enjoyed the original design as well as noting it as

a statement of British architecture. Even today having survived severe bomb damage during World War II, pieces of the original stained glass window are still on view, and St Marylebone Parish Church remains an iconic addition to this elegant and interesting district of London.

Leaving the church and continuing east we pass The Royal Academy of Music on our left, which from the outside is an attractive red brick building with relief work on the façade and has a wonderful arched entrance. As we reach the northern end of Marylebone High Street stop and look at the large sculptured mural of CD that sits on the wall of what was once No 1 Devonshire Terrace, CD lived here from 1839-1851. This fitting mural was sculptured by Estcourt J Clack in 1960 and is quite striking in its design and craftsmanship, many of the characters from CD's novels are depicted and a portrait of the great man (in his later years) dominate this fine piece of work.

As for No 1 Devonshire Terrace, today we see a modern building where once stood a unique group of three individually styled terraced houses. The one belonging to CD perhaps having more architectural features than the other two, together with a fine view overlooking Regents Park. The original house was taken on a twelve year lease and was surrounded by a brick wall that enclosed the garden on New Road elevation. The garden was said to have complimented the external appearance of the house which had sizable bow windows and a brick and stone portico. Internally the huge hallway led to a curving staircase to the left and a library sat to the right, the garden could be accessed through the library. There was a large dining room which overlooked the garden and the floor above consisted of a drawing room, several bedrooms and a nursery. CD was said to have made numerous improvements to this property which became one of his favourite homes, by adding water closets, mahogany panelling and carved marble. The house was sadly demolished in the 1950's, but fortunately for us was well documented and has photographs remaining of its external appearance. CD wrote several of his wonderful novels whilst living here, such as The Old Curiosity Shop, A Christmas Carol, Martin Chuzzlewit and David Copperfield and two of his many children were born here. It was while living here that he travelled to North America and Europe, having let the house to several other people during his time away from home.

Our walk now takes us right, down the top half of Marylebone High Street, this is a narrow section of street at the beginning but becomes much larger and busier as it moves south. We shall only be walking a few yards along the high street before turning left into Beaumont Street, but before we do, enjoy the small St Marylebone Parish Gardens on the right which has a huge mature tree as its centre piece enclosed by a circular hedge-row.

As we enter Beaumont Street notice the short row of period terraced houses on the left which are stunning and have survived the test of time where others close by have been replaced by more modern buildings. At the crossroads with Devonshire Street look in both directions and notice the number of Georgian houses that still remain, all extremely well maintained, it is at this point that you get a good view of the top of the London Telecom Tower. On our right we pass the Marylebone Library which houses a wealth of history about this district, before crossing Weymouth Street. Weymouth Street also has many wonderful properties to enjoy before entering Westmoreland Street, still heading south, and after a few yards we reach The Heart Hospital on the left. This prestigious and well acclaimed hospital now forms part of the University College London's NHS Foundation Trust.

The Heart Hospital is one of the largest cardiac centres in the UK with 95 in-patient beds and performs over 1000 surgical heart operations annually. In addition to this it treats over 1700 out-patients yearly together with 5500 follow up patients and 1200 in-patients. Founded as the National Heart Hospital in 1857, the hospital's location has moved several times in the past first at Oxford Street (1869) then Soho Square (1874), and has also changed its name to include the treatment of paralysis, epilepsy and insanity. In 1913 the building we see today was constructed and was the first to specialise totally on cardio-vascular disease, as well as offering training and research facilities. Unfortunately the hospital was closed in 1991 when the services moved to the Royal Brompton Hospital and the building was eventually sold to a private hospital in 1997. By 2001 the private hospital had fallen into debt and subsequently re-joined the NHS, at this time it was renamed The Heart Hospital. The hospital now faces yet another move as there are plans for all the services it now provides to be moved to the Royal Brompton, by late 2014.

At the junction of Westmoreland Street and New Cavendish Street (in CD's time known as Gt. Marylebone Street) turn right then immediately left into Welbeck Street which is a mixture of apartments, office buildings and hotels. A short distance further down this street we arrive at Bentnick Street, named after the Bentnick family who were a prominent name associated with both the Dutch and British nobility. Their ancestral seat is linked to the Dukes of Portland, William Bentnick the 1st Earl of Portland was a close friend of William III. Today these beautifully restored properties in Bentnick Street are currently used as offices, apartments and hotels, and the attractive terraced facades built of red brick facings and stone, offer a delightful Georgian styled appearance with their appealing windows and portico's. CD lodged on the upper floor of No 18 in 1833 with his family, when he worked as a newspaper reporter at 'Doctor's Commons' and also the House of Commons. It is well recorded that his shorthand ability was second to none which served him well throughout his life. CD favoured the Gurney method of stenography rather than the current widely used Pitman style and was said to have mastered this art in less than a year when most other students would take three.

It was at this address that CD is said to have enjoyed staging family plays at home, getting all of his family to rehearse and perform on a regular basis. It was also whilst living here that he applied for an audition at Covent Garden Theatre but failed to arrive due to a bout of influenza.

Before leaving this immediate area I should mention two other characters of note (both completely unconnected) who made an impact on society one way or another. The first is Edward Gibbon (1737-1794) an English historian and MP who lived at No. 7 Bentnick Street. Gibbon's most noted work was The History of the Decline and fall of the Roman Empire, and one which had a great influence on Sir Winston Churchill. Gibbon was born in Putney, London, and was sent to a private school in Kingston shortly after his mother died when he was aged just six. Although suffering from ill health he was later sent off to Magdalene College, Oxford, at the age of fifteen where he converted to Roman Catholicism. His father hearing of this immediately withdrew him from college and sent him to Switzerland, where he eventually reconverted to Protestantism

once his father threatened to dis-inherit him. When he returned to England in 1761 he published his first book, and then embarked on the Grand Tour in 1762, when in Rome he was captivated by its past, and decided to write of its history. He returned to London in 1765 and became a member of Dr Johnson's Literary Club and later professor of history at the Royal Academy. Before finalising the publication of his outstanding works on Rome, Gibbon entered politics as a Whig. In later years he travelled extensively in Europe but succumbed to ill health suffering from a debilitating disease that caused scrotal swelling, and after several operations he finally died. Gibbon was hailed as being the son of the 'Enlightenment' which at this particular period was very brave as he attempted to reform all walks of society by challenging old ideas with facts based on scientific progress.

The other person who I feel should be mentioned was simply a cricketer named Douglas Jardine (1900-1958), the English Cricket Captain who was famous for his 'bodyline' tactics which shocked the world of cricket at that period. Jardine lived at No 21 Bentnick Mews (close to Bentnick Street), and was born in India the son of a colonial lawyer. His cricket career really got underway at Oxford when captaining their team and later when chosen to play for Surrey, whilst practising Law. Having made his test debut for England against the West Indies aged 28, he was later selected to play for England in the Ashes Series in Australia. Whilst developing quickly into a first class cricketer, Jardine was not well liked by most due to his 'snobbishness' behaviour, especially to the Australian public (perhaps this was because he made their bowlers look like novices). By 1933 he had been given the captaincy of the English Cricket Team and when confronted by the superb batting of a certain Donald Bradman decided to halt his incredible form. After researching Bradman's performance Jardine realised that the Australian had a weakness from fast paced deliveries which were short pitched and aimed at the body. Bradman had by now scored almost 1000 runs during this test, and when confronted with Jardine's tactics was forced to simply defend deliveries rather than score runs. At that time these tactics were seen to be 'ungentlemanly' whereas today they would be seen as acceptable, therefore I have every respect for Jardine as being a pioneer of his time. In his first class cricket career, Jardine played 22

test matches for England, scoring 1296 runs, an average of 48. It was said of him that "If ever there was a cricket match between England and the rest of the world, and the fate of England depended upon its results, I would pick Jardine as England Captain, every time".

Arriving at the end of Welbeck Street we turn left into Wigmore Street and again immediately find ourselves on another of London's busy travel routes. This street runs parallel with Oxford Street and flows east to west in both directions between Portman Square and Cavendish Square. Not quite as energetic or overrun by departmental stores as Oxford Street, Wigmore Street is a busy shopping centre and has a good number of eating establishments. Historically the name Wigmore Street derives from the Earl of Mortimer, Robert Harley, whose son Edward was named after the neighbouring Harley Street at a period when he was developing this district.

One of the more interesting buildings in this street is Wigmore Hall, which was built between 1890 and 1901 by the German piano manufacturer Bechstein, his elaborate showroom once adjoined the hall. The entrance to the building is delightful but one could pass it without noticing, for although it has some stunning period features it is quite small, this is not a criticism of its designer Thomas Collcutt who also created the Savoy Hotel and the Palace Theatre. This attractive hall was built in a Renaissance style using both marble and alabaster as an interior finish to the walls, the auditorium itself is said to have one of the best acoustic properties in Europe. In 2004 the hall was refurbished and its 545 seats provide the perfect setting to stage leading international recital concerts, it presents around 400 concerts annually as well as providing weekly concerts which are broadcast on BBC Radio 3 to an international audience. Throughout its history it has staged many concerts featuring top performing artists such as Benjamin Britten, Andre Segovia and Janet Baker, to name but a few.

Across the road from Wigmore Hall you can't fail to miss the wonderful façade of No 33 which has similar features to the Royal Academy of Music, I can't find any history on this building but know that its architect must have been extremely talented to create such a wonderful edifice as this.

Continuing along Wigmore Street we now focus our attention on Cavendish Square Gardens and will have to cross over at the Harley Street junction. Entering Cavendish Square Gardens my attention is

immediately focused on the John Lewis Building which tells me that we are very close to Oxford Street which stands at the southern end of the square. The splendid gardens we now stand in are laid out in a circular fashion, with a bevy of mature trees interlaced between the ornamental lawns, flower beds and shrubbery, all of which provide a perfect oasis to enjoy amongst a very busy area of London.

In the early 18th century the 2nd Earl of Oxford developed this area including these attractive gardens for his wife Henrietta Cavendish-Hollace, which served as an ideal setting for the elegant homes that were to be built here. At first the gardens were laid out as a simple enclosed area of grazing for sheep but as building work progressed so did the elaborate landscaping. Today visitors can enjoy viewing the wonderful bronze statue of Lord George Bentnick (1802-1848) Politician and racehorse owner, which replaced an earlier bronze of William Duke of Cumberland, remembered for his part in the Battle of Culloden. Having said that I should point out that there is an amazing statue on view today depicting the Duke which was modelled out of soap, yes soap, created by artist Meekyoung Shin that was designed to last for one year, although quite weather beaten now it is still an amazing piece of work. More recently the gardens have been redesigned by Michael Brown, his style of architecture and landscaping have proved to be very popular with those who like key features such as the circular grass mound for sunbathing.

The attractive houses that surround Cavendish Square Gardens were first developed in 1717 but due to the financial crisis known as the South Sea Bubble work was delayed for a long period of time. Once the building work was underway again it produced some very desirable residences that were occupied by the Duke of Portland, the Duke of Chandos, and Princess Amelia. No 20 was once owned by H H Asquith (1852-1928) Liberal Prime Minister and also Quinton Hogg (1845-1903) English philanthropist, known for being the benefactor of what is now the University of Westminster. He also founded York Place Ragged School, which CD would have endorsed.

Leaving Cavendish Square Gardens where we entered, it is time now to walk the short passage along Margaret Street taking into account the high volume of traffic and pedestrians, before crossing over Regent Street which we shall return to at the end of our walk.

The name Margaret Street was given in honour of Lady Margaret Cavendish-Harley (1715-1785) daughter to the Earl of Oxford, who was known for her amazing collection of fine arts and natural history specimens.

CD lived at No 70 Margaret Street with his family for a short time in 1831 at a period when his father had to dodge creditors who were constantly hounding him. John Dickens, CD's father, was continually in debt throughout his life as we discovered earlier, and at this time he was proving to be somewhat of an embarrassment to CD when it was reported in the London Gazette that he had been declared insolvent once again.

For the final part of our walk we simply make our way back to Regent Street and follow its passage south, crossing Oxford Street to the former site of Verrey's Restaurant which was a favourite of CD's. Before arriving at this site I shouldn't overlook the significance of Regent Street itself in the life of CD and a few words would be in keeping. The street needs no introduction as it is not only a famous Georgian historic thoroughfare but is one of the major shopping streets in the capital which attracts many tourists and people from all over the UK. The street runs from Regent's Park in the north to Charlton House in St James's which in turn passes through Oxford Circus and Piccadilly Circus. Built by John Nash, architect to George IV (for whom the street was named) was designed as part of an amazing scheme to produce and create a master plan for the former Prince Regent. Although the street layout remains the same today, almost all of the original buildings have since been replaced, the one remaining structure that has survived the march of time is All Souls Church which stands supreme amongst its neighbours.

Once Nash's Regent Street scheme had been approved building commenced in 1814 and was almost completed by 1825, the developers included Charles Cockerell, Sir John Sloane and Nash himself who formed a syndicate which funded most of the enterprise and received massive ground rents from the long leases that were offered. CD enjoyed these exclusive stores and commented on the way in which the shops were dressed and the elegance of the carriages which stood and waited outside to collect their respective owners. By the end of the 19th century the retail outlets originally designed were considered too small in comparison to other fashionable shopping

locations of the time (departmental stores were now all the rage) and therefore a complete re-development scheme was proposed. The new scheme incorporated a design which included a unification of street facades, which had to be finished in Portland Stone, each block of similar height with uniform external features.

The majority of Regent Street today is said to be owned by the Crown Estate which in more recent years has developed many of the side streets as well as parts of Regent Street itself, this entailed revamping the many office interiors and the reconstruction of the Quadrant at the southern end of the street. An interesting description of the original Quadrant serves as a reminder of the elegance of an earlier era, "there was a Doric colonnade on either side, projecting over the foot-pavements. The columns, some 270 in number, were of cast iron, sixteen feet high exclusive of the granite plinth, and supported a balustrade roof". CD would have been familiar with this structure which sadly was removed as early as 1848, possibly because of the change in fashion but largely due to the quality of build, which by the end of the century was being questioned, as were most of the other buildings in the street.

Sadly as we walk along Regent Street I realise that our walk today is almost complete but I have one other location to visit, that being the original site of Verry's Restaurant which CD so enjoyed using during the latter part of his life. Verry's exact location was No. 229 Regent Street, today the restaurant has long since gone but its memory remains, for it was sited opposite the Hanover Street junction. CD dined here often with Wilkie Collins as it was considered to be one of the best in the capital and praised very highly by the wealthy, only the top echelon of Victorians could afford its prices. Having researched the limited information about Verry's I did find reference to a meal enjoyed here in 1899 by a wealthy couple, the meal alone (based on the menu) excluding drink came to almost £300 at today's prices, their drink bill wasn't recorded but from what I had deduced it was of a similar amount! For over 20 years CD savoured the delights this restaurant had to offer which included the very best French cuisine, usually offering at least 10 courses, and I guess in his mind it endorsed his passion for France as a nation. His many invited guests would have been impressed by this venue and also its location, especially the Persian Room which was described as

being 'the loveliest dining room in London', and he himself would have revelled in the company of the 'very finest people' in London.

As for me I am now going to enjoy the delights of Caffe Nero equally as well, at No 273 Regent Street, and like all of my visits there will savour both their food and superb coffee. Relaxing isn't a problem in one of Caffe Nero's coffee houses, quite the opposite, its dragging myself away from the enjoyment of feasting, people watching and reminiscing about this interesting walk I've had today. What better way to end the day.

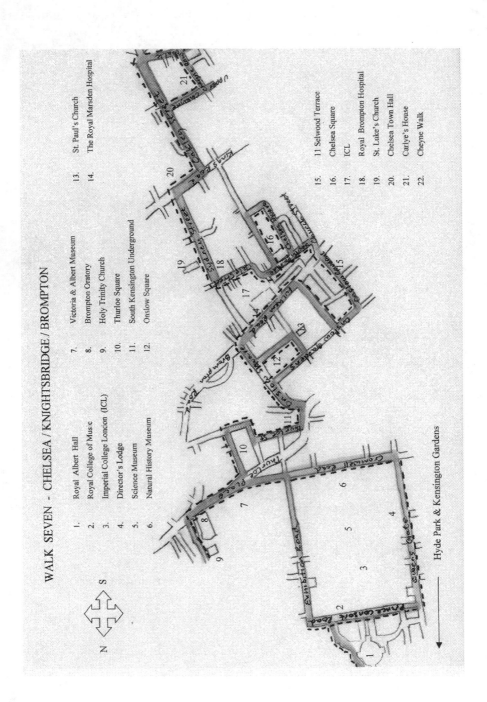

WALK SEVEN - CHELSEA / KNIGHTSBRIDGE / BROMPTON

1. Royal Albert Hall
2. Royal College of Music
3. Imperial College London (ICL)
4. Director's Lodge
5. Science Museum
6. Natural History Museum

7. Victoria & Albert Museum
8. Brompton Oratory
9. Holy Trinity Church
10. Thurloe Square
11. South Kensington Underground
12. Onslow Square

13. St. Paul's Church
14. The Royal Marsden Hospital

15. 11 Setwood Terrace
16. Chelsea Square
17. ICL
18. Royal Brompton Hospital
19. St. Luke's Church
20. Chelsea Town Hall
21. Carlye's House
22. Cheyne Walk

Hyde Park & Kensington Gardens

WALK 7

CHELSEA ~ KNIGHTSBRIDGE ~ BROMPTON

"A heart well worth winning, and well won. A heart that,
once won, goes through fire and water for the winner, and
never changes, and is never daunted"
(Our Mutual Friend—1864-65)

Whilst planning my series of walks I realised that almost all of the districts I walk through would have many buildings directly associated with CD as well as a plethora of gardens and historical edifices he would at least be familiar with. This particular walk encompasses three districts, namely Chelsea, Knightsbridge and Brompton, which then would have been on the periphery of CD's London but never the less still contain many familiar sites he would have visited for one reason or another. With that in mind perhaps a very brief resume of these districts will set the scene for this walk.

The name Chelsea is recorded as far back as 787 (the Synod of Chelsea at Chelchith), but the first manor house dates to the 9th century. The most common theory for the name derives from a 'chalk landing place' i.e. a chalk or limestone wharf. It became an affluent area of central London once it was acquired by Henry VIII and later substantially developed by Charles II, following which it was absorbed into the 19th century development boom that invaded the capital.

Knightsbridge was named after an ancient crossing called Kingesbridge, which crossed the River Westbourne (now underground). Early records tell us about a meeting of the citizens of London and Matilda (daughter of Henry I) being held here in 1141. Originally this district was simply a small village on the outskirts of the City of London and for centuries the haunt of highwaymen, robbers, and cutthroats who attacked travellers making their way into the City from the western approaches. Today Knightsbridge is one of the most fashionable areas in the West End.

Early records of 17^{th} century Brompton indicate that Brompton Village continued to grow once William III established his court at Kensington Palace. The area was surrounded by open fields, which remained until the early 19^{th} century when development spiralled. The village name for Brompton is a mystery, however the surname Brompton can be traced back to the 7^{th} century when a typical village was named 'Brom-ton' (broom village), its name means a farmstead where broom grows.

Having researched all the three associated areas described above, my first thoughts were that CD only resided in a couple of places in these districts, one of which was his first house after getting married in 1836, which was situated in Chelsea. In fact he commented several times about his preference to living closer to the City rather than being in the 'countryside', as Chelsea was during his lifetime. CD was a city boy and the absence of street lighting, pavements and other amenities so abundant a few miles further east, together with localised crime may have been the reason that CD quoted Chelsea behaviour on occasions as the "barbarity of Chelsea".

What I have since discovered having walked this route several times that there is an extremely close relationship with CD and a circuit of friends who resided here, such as critics, acquaintances, adversaries and business associates who were often mentioned throughout his life. In fact this walk is almost a short history of many of the major players in Victorian history who themselves were established leaders in their own fields.

On my 1863 map the surrounding districts we walk through were simply market gardens and fields, as yet these rural areas had not been spoilt. Further east the metropolis of perhaps the busiest capital in the world had already developed into a vibrant community of mixed races.

The walk starts at Hyde Park (Lancaster Gate Entrance) amid the relatively unspoilt and spacious gardens and lakes, then meanders through a history of the Industrial Revolution, passing iconic buildings of their age such as the Natural History Museum, The Victoria and Albert Museum and Brompton Oratory. Then in common with other districts in London, we discover hidden squares and gardens created amongst a host of magnificent period buildings that have survived wars and time itself. Amongst the many period buildings and arterial roads, hospitals and churches were built which served not only the local community but also visitors from all corners of the world. Finally the walk reaches the mighty Thames and we can enjoy the beautifully preserved houses of CD's companions and friends together with a group of remarkable artists whom he publicly criticised for reasons best known to himself.

Having taken the underground to Lancaster Gate I leave the station using the underground lift, turn left onto Bayswater Road before crossing this busy junction where one can then clearly see the entrance to Hyde Park and Kensington Gardens. At the entrance to the park you will instantly see a location map with directions around both the park and the gardens, unfortunately the walk simply takes us due south towards Kensington Gore, however I will provide a brief overview before continuing on our prescribed route, for those who wish to circumnavigate the entire grassed landscapes of both the park and gardens.

~

Hyde Park

Hyde Park stands directly to our left when entering the gate in Bayswater road and is one of London's largest parks, and like most others in the metropolis has remained almost unchanged since it was laid out to its current design. Its history as a royal park goes back to Tudor times when Henry VIII 'acquired' the manor of Hyde from the Canons of Westminster in 1536. The park was opened to the general public in 1637 and fifty years later William III took a fancy to these fertile green spaces and moved into Kensington Palace. At the same time he created Rotten Row, which is a wide track, leading from Hyde Park Corner to the Serpentine Road. William had this

route laid as he wanted a safer way to travel to St James Palace and subsequently lit the route with hundred of lamps (said to be the first artificially lit road in the UK). When first opened Rotten Row (formerly King's Road) was the place for the fashionable upper class to parade themselves in public. Geographically Hyde Park interlaces alongside Kensington Gardens with the Serpentine being the dividing line making both areas proportionally the same.

The Serpentine itself was created in the early 18th century by draining a small river that flowed through the park, it has a magnificent bridge spanning its girth which was designed by George Rennie in 1826, which links the 'gardens' to the 'park'. Several notable events have taken place in Hyde Park the most famous being the Great Exhibition of 1851, when Joseph Paxton built the monumental structure known as Crystal Palace that was originally the centrepiece of the exhibition. CD wrote of the Crystal Palace in his journal Household Words: "There is no one circumstance in the history of manufacturing enterprise of the English nation which places in so strong a light as this, its boundless resources in materials . . ." Hyde Park has a grand entrance, which is situated close to Hyde Park Corner, this feature being erected in 1824-25 to a design by Decimas Buxton, which overlooks the famous Speakers Corner. This particular location has been host to many radical demonstrations in the past, such as The Chartists, The Reform League and the Suffragettes movement to name but a few. In more recent times the Park has been host to some amazing concerts and Olympic events and when I compare it to the 1863 map little has changed, most of the labyrinth of small pathways remain, however the more recent Bird Sanctuary has replaced a barracks and magazine area!

Kensington Gardens

Set out to the west side of Hyde Park, Kensington Gardens were originally designed by Henry Wise and Charles Bridgeman between 1728 and 1738. It was Bridgeman who created the Serpentine water feature; this lake being divided into two parts, the uppermost end known as Long Water, which includes the very ornate and attractive Italian Garden. The lower part of the Serpentine has a boating lake, a lido, and restaurants, providing good resources for visitors.

To the west side of the gardens stands Kensington Palace, the royal residence of many current members of the Royal Family such as the Duke and Duchess of Cambridge, the Duke and Duchess of Gloucester, Prince and Princess Michael of Kent and soon to be home to Prince Harry once William and Catherine take residence at the former home of Princess Margaret. Although the last reigning monarch to live at the palace was George III there were many before him who enjoyed the splendour of its palatial grounds and buildings, which have been continually extended since the Jacobean period. Internally the Palace is a labyrinth of apartments and regal rooms, more notably The Cupola Room (1722) and the Kings Gallery (1727). It was William III and his wife Mary we have to thank for developing what was originally a Jacobean Mansion and of course Sir Christopher Wren for extending, improving and characterising this wonderful palace we see today. At the far south of the gardens stands what is probably one of the finest memorials to grace the London parks, I refer of course to the Albert Memorial which we shall visit on route.

~

Continuing on our walk having entered the park by Marlborough Gate (Lancaster Gate Entrance) we immediately notice the Italian Gardens to our left, this area of Kensington Gardens is so picturesque with the four delicate fountains bringing alive these ornamental gardens with their sculptured urns that are enclosed by black wrought iron railings.

Walking with The Long Water on our left we pass an area, which has scores of wild birds to enjoy, all carefully described on an information board, and today I can enjoy the bevy of primroses and daffodils in bloom, all growing wild along the footpath. Cyclists are forbidden to use the footpaths here however there are certain areas of this huge mass of greenery where it is permissible to cycle. The route we are following is one that leads to Princess Diana's Memorial but we will change direction shortly after we pass the next location on this path, which is the Peter Pan Statue. No matter how many times I view this delightful sculpture commissioned by the author of Peter Pan, J M Barrie, I notice different aspects of Sir George Frampton's work, as it displays so much movement in its design when viewed 360º.

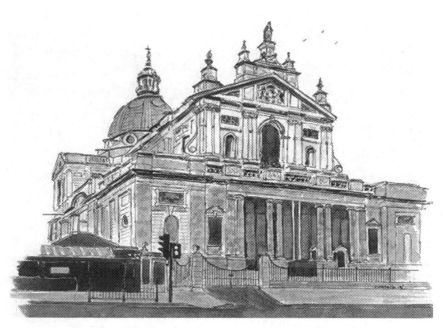

Fig 22 Brompton Oratory

Fig 23 The Director's Lodge

Fig 24 St Luke's Church

Leaving the Peter Pan statue we continue along the pathway and bear right towards the Serpentine Gallery, at the same time glancing across The Long Water where we can see Henry Moore's distinctive sculpture 'The Arch' (1980) which recently underwent some major renovation as this piece became quite unstable at one time. A short distance along our path brings us to the delightful classical summerhouse named 'Queen Caroline's Temple' (wife of George II); this precious edifice was built in 1734 and is attributed to William Kent, and was carefully restored in 1976. I feel sure that CD would have approved of this little gem, which no doubt was a popular site in his day. It is not difficult to understand just why these gardens and park are a popular venue for the spectacular events that are staged here, as there is an underlying warmth to the open grassed spaces, which although vast seem to protect the enjoyment of isolation from the busy metropolis.

We now reach a five-way intersection and before us is the popular Serpentine Gallery, and we can clearly see in the distance The Albert Memorial. The Serpentine Gallery focuses on modern and contemporary art which is housed in what was a former 1934 tea pavilion that I have to say is an attractive building in its own right. The gallery was established in 1970 and many noted artists such as Henry Moore, Paula Sego and Damian Hurst to name but a few, have exhibited here. On a selected spot in front of the museum stands a sculpture called 'Rock on Top of Another Rock' which for my limited taste in modern art is very interesting, simply for the sheer dynamics of its size and balance. The Swiss artists Peter Fischi and David Weiss are to be applauded for their amazing sculpture, which I understand will remain here until 2014 when it is replaced by another exhibit, like the gallery, it is well worth viewing.

The busy road to my left is in fact the West Carriage Drive which allows vehicular access across the centre of both Kensington Gardens and Hyde Park, where at one point it crosses the Serpentine via the beautiful five arched bridge designed by John Rennie (1761-1821) who also designed the former London Bridge. At this point the Albert Memorial is in full view, albeit under restoration, but one can still enjoy this magnificent edifice purely from its size and presence.

Before viewing the Royal Albert Hall I simply cannot fail to mention the Royal College of Art, which is situated in Kensington Gore (West), a busy road that lies in front of us. Simply cross the

road and look to the right. The college was founded in 1837 as a public research university, which today offers Master of Arts, Master of Philosophy and Doctor of Philosophy degrees. Formerly the National Art Training School, it received its present name in 1896 and subsequently a Royal Charter in 1967. The building we see today was built in the 1960's, and arguably not so formidable and iconic as most of its neighbours, however, it has played a major role in the birth of modern art, design and architecture having had former pupils who are now iconic masters of the 19th and 20th centuries. Names such as Gertrude Jekyll, Henry Moore, and Barbara Hepworth are but a few artists, and one in particular who I personally consider to be one of the finest of my age namely Ken Howard. Ken is not only a skilled draughtsman, but can with any medium at his disposal capture and create light in every scene he depicts, his work is inspirational and therefore in my opinion one of the former star pupils of the RCA.

Before moving away from Kensington Gore look back across the road and get a good view of the Albert Memorial which was commissioned by Queen Victoria in memory of her husband Prince Albert who died in 1861, at the age of 42. Once a suitable memorial had been agreed for Albert in 1862, a committee was formed to raise funds and appoint a suitable architect. In 1863 a design by George Gilbert Scott (1811-1878), the eminent English Gothic revival architect, was approved and the 54m memorial was completed and opened in 1872. The total cost for the memorial reached £120,000, which was raised by public subscription. Three years later a gilt bronze statue of Prince Albert by the sculpture John Henry Foley (1818-1874) was eventually completed and placed inside the memorial, which depicts Albert seated and looking towards the Albert Hall. On all four corners and the central section of the memorial there are beautifully carved allegorical sculptures by several eminent artists depicting four continents as well as a further group displaying agriculture, commerce, engineering and manufacturing. All of these remarkable works being associated with the glorious World Exhibition that Albert had played such a major role in organising and designing. Unfortunately CD was not alive when the memorial was completed, however he would have been impressed when viewing the early stages of its construction and witnessing the superb craftsmanship of its design.

Equally CD would have been complimentary about the building facing the memorial, this we know and enjoy as The Royal Albert Hall. Having now crossed Kensington Gore, which is a very busy road, walk to the right of the Royal Albert Hall and continue walking around the south elevation, after a few yards simply about face and enjoy the wonderful vista of this fine building. The hall was designed by Captain Francis Fowke (1823-1865) and Major General Henry Scott (1822-1883) and was first opened in 1871 by Queen Victoria. It was decided to build the hall on the site of the former Gore House, the one time residence of William Wilberforce (1759-1833) politician, philanthropist and perhaps more importantly leader of the movement to abolish slavery. This iconic Victorian building is in fact elliptical in shape and covered with a large and fairly complex wrought iron glass dome designed by Rowland Mason Ordish, who was mentioned in an earlier chapter. Wrought iron being very fashionable at this period and the craftsmanship in its construction really does speak well for the quality of build. Externally this building is a prime example of Victorian grace. When viewed from the Prince Consort Road elevation, this building looks stunning, clearly visible are the numerous mosaic figures depicting both the arts and sciences, and also displaying large terracotta lettering above which refer to biblical quotations. Equally attractive is the pattern of windows, square on the lower level and arched on the middle level, with a band of terracing above that sits just below the figures. The red brick and stonework compliment the entire design and brings together a level of unity to a perfectly proportioned building . . . superb. Internally the hall itself now provides an excellent viewing area for performances, albeit that it did require a redesign when first opened. Initially the acoustics proved to be a major problem; originally on each performance a resounding echo was experienced throughout the auditorium, this was eventually corrected by introducing a giant canvas horning in the ceiling, which remained in-situ until 1949. The horning was then replaced with fluted aluminium panels set below the glass roof.

A major redevelopment programme took place between 1996-2004 to improve ventilation, increase dining facilities, install new seating, and finally enhance the rather archaic technical and backstage areas. Today this amazing hall provides a magnificent venue for an audience of 5544, catering for events such as opera, ballet,

television, popular music concerts and of course the stage for the Promenade Concerts, which have been ever present since 1942.

Before moving on from the hall I should mention the wonderful buildings that surround this area, the majority being of red brick construction, one particular group having ornate stepped gables reminiscent of those we would see in Holland and other Flemish countries. One particular structure, which has always fascinated me, is the tower like red brick construction, which sits strangely majestically in the middle of the street, as far as I know it has no name and serves no purpose, but I could be wrong, it is for you to decide and investigate.

We now make our way down to Prince Consort Street by way of the steps leading from the Royal Albert Hall and as we arrive on the street it is worth looking back to view another statue of Prince Albert, created by Joseph Durham in 1858 that graces the south side of this concourse. Facing us across the road is The Royal College of Music (RCM), again a familiar Victorian red brick design in keeping with others in an area sometimes referred to as Albertopolis. The RCM is an eminent college established in 1882 and is one of the leading conservatoires in the world. Prior to the formation of the RCM, a building was first constructed here to house the National Training School for Music, which opened in 1876. In the early 1890's a new building was commissioned (the one we see today) and designed by Arthur Bloomfield (1829-1899) a London born architect who again promoted the Gothic Revival style. This red brick and buff coloured stone design really does capture the age and like most other similar structures was built to last. The college museum houses a remarkable collection of instruments and various items, which include autographs and musical scores from many past masters, as well as claiming to hold the oldest keyboard instrument. The list of former teachers and alumni include many prolific musicians of the 19th and 20th centuries, including Gustav Hoist, Ralph Vaughan Williams, and Benjamin Britten to name but a few.

Further along Prince Consort Street we pass Holy Trinity Church on our right, which was built in 1901 by a Mr George Bodley and a Mr Cecil Hare, and stands almost hidden amongst such iconic neighbours as Imperial College London to our left. At the end of the street we turn left into Queens Gate, a wide and

busy thoroughfare and head south towards the Museums. On our left is Imperial College London, which occupies a vast amount of land in this area, and has a history dating back to the 15th century. The current main campus of the college was constructed in 1907 following the newly established Board of Education, and in the early 19th century several medical schools were opened following which the Royal College of Science was established in 1881. Imperial College is recognised today as being one of the top colleges in the world as a science based institution attracting over 13,000 students of international quality, specialising in science medicine, engineering and business studies. Former noted alumni include Thomas Huxley, Sir Alexander Fleming, and H.G.Wells amongst many others, which I hasten to add, include numerous Nobel Peace Prize Winners. This formidable site owned by Imperial College is a complicated collection of buildings that have evolved from its early days (formerly the Royal Horticultural Society Gardens) as identified on the 1863 map. The first of Imperial College buildings on this site was the Imperial Institute, designed by T.E. Collcutt to a Neo-Renaissance style, which was opened in 1893. Since then much change has evolved and in 1907 with the merger of several technical colleges and institutions the campus developed and spread its wings to all corners of this large land mass, in company with some very special museums.

CD would not be familiar with the appearance of the buildings we are now to pass as change has altered and extended the museums that we see today, although the concept and design theme was in place much has altered in presentation. Having now walked a short distance along Queens Gate and recorded the very attractive roads such as Queens Terrace, which lead off of this concourse, we reach a superbly designed and attractive period looking building to our left, which sits in the grounds of The Natural History Museum (NHM) close to the Darwin Centre, and is known as the Director's Lodge. Constructed of precision dressed light stone, this building has nicely proportioned Roman arches and a high-pitched roof of slate, which is reminiscent of a small French château. On the ridge of the roof sit statues of a cat and a dog and above them stands an ornate chimneystack that accommodates 6 chimney pots, all in all a very attractive structure, but what of its history?

At the first crossroad junction, before turning left into Cromwell Road and heading towards the entrance of the NHM, glance across the road and you will see Baden Powell House, a scouting hostel owned by The Scout Association and named after its founder Lord Baden Powell (1857-1941). We now find ourselves walking along busy Cromwell Road, which was layed down in the 19th century and named after Richard Cromwell (1626-1712), son of Oliver Cromwell (Lord Protector) who inherited his fathers role if only for nine months! I should also mention while in Cromwell Road that close by at No.21, Sir Charles James Freake (1814-1884) architect and builder, lived for a large period of his life, and was responsible for so many famous 19th century facades in West London.

As we pass The Natural History Museum on our left, there are hordes of children exiting from the queue of coaches which have brought them to the museum, set aside this annoying distraction and view the stuccoed houses across the street, all very desirable but looking slightly tired compared with those in Queens Terrace. Although the road configuration has changed little since CD's day, the heavy volume of traffic is certainly greater.

Having reached the NHM, which opened in 1881, one can now stand back and enjoy the architecture of this wonderful building, which owes its history to the collection that originated within the British Museum. As previously mentioned, the collection belonging to Sir Hans Sloan formed the basis for what we see today, but unfortunately over a period of years there was some heavy undermining criticism aimed at the original museum for its inability to preserve and record many of the specimens that the museum held. This created many internal problems and the general public were not encouraged to visit the natural history exhibits until the appointment of Richard Owen in 1856, which transformed visitor's expectations into the true purpose of museums in general. Owen quickly realised that additional space was urgently required to display exhibits therefore suitable land in Kensington was acquired and a competition held to design an appropriate building, which was 'fit for purpose'. The eventual winner of the competition was Captain Francis Fowke (designer of the Albert Memorial) but sadly he died prematurely before construction got underway, and Alfred Waterhouse (1830-1905) an architect, was given the brief which

included revised plans as he favoured a Romanesque style rather than Fowke's Renaissance submission.

Work started on the new building in 1873 and was completed in 1880. Waterstone made good use of terracotta tiles both internally and externally and the many relief sculptures of both flora and fauna together with the remarkable 'living and extinct' species, all provide a fantastic setting for this incredable museum. However, by separating these fascinating species there was direct conflict with Darwin's theory of natural selection. Many changes have taken place since the building first opened, it absorbed the adjacent Geographical Museum, and then more recently developed the Darwin Centre, before including The Attenborough Studio, which will have a wonderful multi-media studio.

Like its neighbours, one can only comment that to fully appreciate these wonderful buildings one has to visit them several times over, as it would be an impossible task to simply catalogue their treasures. Incredible as it may seem there are over 70 million specimens held in this museum alone, ranging from microscopic slides to mammoth skeletons making it arguably the largest natural history museum in the world.

Continuing our journey we have to cross the junction of Exhibition Road, which has been given a more stylistic appearance by removing the former kerb levels when crossing the traffic lights. This new system may have a more meaningful purpose but I consider it slightly un-nerving as I feel it indicates a pedestrian passage for walkers, which it isn't, be careful and aware of traffic when crossing.

By way of a diversion to our walk, in turning left at Exhibition Road you will after a short walk arrive at The Science Museum (SM). This is the second of the prestigious museums in the area and not surprisingly attracts close to 3 million visitors annually.

As a point of interest, after the Great Exhibition of 1851 was over, many surplus items from this event were used to form part of the South Kensington Museum (SKM), which later were shared with the Victoria and Albert Museum (V&A). When the V&A eventually opened, the science collection was separated from the SKM to form a unique museum accommodating scientific artefacts, and today we have the Science Museum, which was opened in the early 1900's. Over 300,000 items are kept in this museum and include

many historical machines from the Industrial Revolution, together with 'much earlier as well as more recent' scientific discoveries that changed the course of the world! There are far too many items to simply glide over so a visit is a must.

Back on our walk itinerary we continue down Cromwell Road and reach the Victoria and Albert Museum, which is the last of the impressive museums on this walk. The V&A is arguably the world's largest museum of decorative arts and design with over 4.5 million objects to display. Founded in 1852 the V&A was possibly the prime reason for this district being labelled Albertropolis. There are over 145 galleries to view which house collections dating as far back as 4,000BC to the present day. The early collections were housed in several buildings throughout London following the Great Exhibition, and in 1854 it was finally agreed that a new purpose built museum should be constructed. The V&A moved to its present site in 1857 following which many new acquisitions arrived, as the museum grew in size and status, several further buildings were added later. To understand, let alone describe the complex development of this museum is almost impossible and I would not wish to undermine all of the architects, designers, and artists who played their part in achieving such a fine structure. In 1891 another competition was held to consolidate this group of buildings and finally achieve a uniform appearance, both architects Francis Fowke and Henry Scott (yes those two again) had previously built various extensions. Surprisingly it was Aston Webb (RA) architect (1849-1930) who finally re-planned what we see today and his Renaissance and partly medieval designs were completed by 1909. Queen Victoria actually laid the foundation stone and gave the museum its current name in 1899.

We are now about to visit two very significant churches, which are situated very close to one another but are so different in shape, size and religious following, however they have both served the Brompton Community equally well over the years. I refer to the Brompton Oratory and Holy Trinity Church, which stand literary a few yards from the V&A and are found by walking east towards the Brompton Road intersection.

Brompton Oratory is difficult to miss as it sits back from the busy main road with its impressive Renaissance façade, like many you would find in Northern Italy. The Congregation of the London

Oratory called for designs to construct this present building in 1876, in doing so it provided a Catholic Church whose true name is 'Church of the Immaculate Heart of Mary'. Prior to this there was an Oratory House built here in 1854 followed by a temporary church, both of which I feel sure were known to CD. The London Oratory itself was a community of Lay Brothers founded in 1849. We can thank Herbert Gribble (1847-1894) for designing this beautifully styled Renaissance church which although completed and opened in 1884 had further major works added later, such as the façade in 1893 and the outer dome in 1896. The actual brief for Gribble's design was structured for the community of priests called the 'Congregation of the Oratory of Saint Philip Neri' (1515-1595), this saint born in Florence, and later to become a priest in Rome, laboured amongst the sick and poor giving him the title of Apostle of Rome.

The façade of the church is faced in Portland stone and uses a selection of marble to enhance its rich interior. The Italian Baroque sculptures were acquired from various churches in Italy and over the years many other noted architects have introduced the mosaic, plaster and woodwork making this church not only the second largest Catholic church in the UK but equal to many of our spectacular religious treasures. During my research of this church I discovered that Alfred Hitchcock married Alma Reville here in 1926.

Moving on, our walk takes us immediately left once we have passed Brompton Oratory and into Cottage Place where after a few yards we arrive at Holy Trinity Church. This much smaller church was built in 1829 to a design by T.L. Donaldson (1795-1885). Donaldson was one of many architects who did not win the competition to design the Albert Memorial and was unfairly criticised for his design of this church. However he must have been a good architect as he was President of the RIBA and had a major input into the design of the Crystal Palace itself. This Gothic Revival styled church sits almost hidden from the general public, although access is not difficult it does however mean walking along a driveway, this land was previously purchased by Brompton Oratory. The balance of small and large pointed arched windows, and turrets close to the tower give Holy Trinity Church an attractive appearance, and equally architecturally pleasing is the well-maintained exterior stock brickwork with Suffolk facings and Bath stone. This Anglican

Church, like many others within its group, has strong religious beliefs in the transformation of society and the preaching of the Christian Gospel. In doing so they have restored many Anglican churches which I find highly commendable in an age of financial instability.

Our walk now takes us away from the extremely busy area of museums as we backtrack to the Brompton Road, which we cross over and head in the direction of Thurloe Square. Having reached the square it is amazing just how quiet it has become even though we are just a few yards away from the noisy traffic and can now enjoy the seclusion of this attractive area. Some road names in location have changed since the 1863 map but this immediate area remains much the same as CD would have known it.

Thurloe Square was first laid out and developed in 1840 by Elias George Baseri (1794-1845), a noted developer who tragically was killed prematurely in a fall while inspecting Ely Cathedral. The square itself was named in honour of John Thurloe (1616-1668) Secretary to Cromwell's Protectorate, who was said to have been the Spymaster for Cromwell. Thurloe was born in Essex but later trained as a lawyer at Lincoln's Inn Fields. During the Civil War Thurloe adopted a rather backstage view of the troubles but eventually became part of Cromwell's government as Secretary of State. His major role was head of intelligence and during this period he masterminded a network of spies throughout England and the Continent. By 1654 he was Member of Parliament for Ely and one year later made Postmaster General. Shortly after however he was accused of treason but managed, with the help of his spies, to uncover a plot to assassinate Cromwell and was later reinstated into Cromwell's 2nd Council. After the Reformation although arrested for treason again, Thurloe escaped punishment and was released in 1660.

The surrounding estate was once owned by a distant member of the Thurloe family and in 1799 the estate was left to a relative named John Alexander, who in the 19th century developed much of the immediate area we see today. It is fair to say that the Alexander family also had a major input into developing this area with Baseri, who incidentally had originally suggested a much larger garden area (2 acres) laid out informally with shrubs and small trees. Today's Gardens are private (like most in London) and therefore are hidden from the public by an abundance of hedgerow, never the less one can

see beautifully maintained shrubs, trees and a children's playground set amongst the lawn areas, an oasis within the Metropolis.

Having walked almost the complete distance around the square I exit via Thurloe Street, which incidentally was renamed in 1939, on the 1863 map it was known as Alfred Place West, a road where Lewis Carroll (1832-1898) once lived, at No.4 for a period of time. Nearing the end of Thurloe Street the tranquillity of this sheltered break in our walk opens up into quite a busy area as we near South Kensington Tube Station, but just before we arrive there we pass Exhibition Road on our right with its cafes and bistros full of customers enjoying the alfresco atmosphere. Exhibition Road terminates at this spot and we can clearly see along its entire passage, past the museums we had seen earlier, and on until it reaches Kensington Gardens, an unbroken view for well over half a mile.

Just around the busy street corner is South Kensington Tube Station, built in the late 1860's by the Metropolitan Railway Company (MRC) as an extension to Notting Hill Gate, as well as a line extension eastwards to join West Brompton. A certain Mr.H.B. Alexander, then the owner of this estate contested the intrusion onto his land and properties for building purposes, but was overruled by Parliament and eventually 19 houses were demolished. In 1853 John Fowler (1812-1898) became Chief Engineer of the MRC in London, which was to be the world's first underground railway. Fowler's 'cut and cover' process for digging trenches for this line was revolutionary but caused a great deal of problems for residents, one being the same Mr Alexander whom we mentioned earlier! CD often recorded his views relating to problems that arose by this enormous industrial undertaking. By 1868 the station was completed, the rail lines laid, and two platforms built. It is not surprising therefore to read that in 1863, for his gigantic engineering achievement, Mr Fowler was made the highest paid engineer earning £157,000 (equivalent to £10 million today) from the MRC alone. This event was ground breaking history, because in 1863, the first ever line between Paddington to the City was opened, which attracted 38,000 passengers on the first day, keen to travel this route! Although South Kensington was not the first underground station to open, one of the greatest engineers of the day built it.

John Fowler, a Civil Engineer, was born in Yorkshire and I think a forgotten genius of the Industrial Revolution. He was responsible

for so many major railway schemes (for several companies) both in the UK, Europe and the USA, which we take for granted today. Just a few of his schemes include: most of the railways in the UK, Grosvenor Bridge (also known as Victoria Bridge), the Forth Railway Bridge, and various steam locomotives. South Kensington Station was in fact designed in two parts, one a sub-surface platform opened in 1868, and a deep level platform, which was completed in 1906. The original sub-surface station building was known as Pelham Road when it first opened and has lifts today, its designer being Leslie Green (see walk 4), who favoured those distinctive ox-blood red glazed terracotta façades.

Before heading to our next location which is Onslow Square, I will find time to visit Caffe Nero at No.66 Old Brompton Road (which is just a few minutes walk away from the station), for my usual lunch and coffee indulgence, today's treat will have to be fairly quick as I have an appointment later at a house which was once rented by one of CD's close friends.

Fully refreshed from my hot soup, cake and coffee, I am now back on the walk trail and pass South Kensington Station on my right then head south down towards Onslow Square, passing the recently renovated bronze sculpture of Bela Bartok (1881-1945). Bartok as many of you will know was an amazing Hungarian composer, who in his hey-day resided for a short period of time at 7 Sydney Street, when performing in London. He must have made quite an impact as an artist to warrant this fine piece of art created by Imre Varga, which is delightful to the eye and portrays Bartok in the modern idiom, having gentle silver leaves displayed around its base.

Having arrived at Onslow Square, which was originally designed by George Baseri, and built by Sir Charles James Freake on land that was owned by the Henry Smith Charity Estate. This noble charitable organisation was founded as early as 1628, originally to combat the disadvantaged and poor, today it continues its good work and its capital endowment consists of substantial portfolios of stock market investments, Hedge funds, and private equity. Although Baseri's designs were altered before his untimely death there still remains a dressing of his stylish stucco faced houses on show that are interfaced with the grey stock brickwork. The square can boast many noted residents from the past such as at No.36 William Makepeace

Thackery (1811-1863) novelist, No.38 Robert Fitzroy (1805-1865) commander of Darwin's ship HMS Beagle, No.4 Sir Albert Hastings Markham ((1841-1918) naval officer and explorer and at No.16 was where Sir Edward Lutyens (1869-1944) architect, was born. The secluded gardens of the square are private and gated and as you would expect well maintained. Nestled within the square stands St Paul's Church, which was built between 1859 and 1860 and designed by James Edmeston (1791-1867) an architect and surveyor who was best known for his church hymns. The church was made redundant in the late 1970's and an attempt was made to sell it off to developers, fortuitously in the 1980's the Anglican fellowship, HTB, that saved Holy Trinity Church, which we viewed earlier, stepped in and the church was saved. Today limited services have been resumed and thankfully this Gothic style building, constructed in Kentish ragstone with a tower flanked by single bay wings and having a beautiful arched doorway will be around for many years to come.

Having walked around Onslow Gardens we now turn south and make our way to the Fulham Road, which is a passage of highway that gained its name from the ancient word 'Fullonham' meaning a habitat of birds and fowl. Certainly before the early 19th century the immediate area to the west of the road was a blanket of hundreds of acres of fields, greens and gardens. Today this extremely busy road stretches from Pelham Crescent (Brompton) to Fulham High Road (close to Putney Bridge). Along this interesting thoroughfare there are many important landmarks such as The Royal Brompton Hospital, The Royal Marsden Hospital, West Brompton Cemetery and of course Stamford Bridge (home to Chelsea Football Club).

Although West Brompton Cemetery is not included in this walk, it deserves some mention, as its significance in historical terms is pretty meaningful. The cemetery was built to remedy the overcrowded graveyards in Central London, and opened in 1840 and is one of the oldest and distinguished garden cemeteries. It is known as being one of the 'Magnificent Seven' group, which were originally founded by a consortium of private companies. There are many noted personalities buried here, two being Emmeline Pankhurst (1858-1928) political activist and leader of the British Suffragette movement, and John Snow (1813-1858) physician, who is sometimes overlook by the public for his contribution to the medical science. Snow adopted the

use of anaesthesia (personally administering chloroform to Queen Victoria), and he was the one who traced the source of the cholera outbreak in Soho in 1854, by systematically mapping out the worst mortality areas and identifying the cause and source of the outbreak. Up until then most medical practitioners believed in the 'miasma theory' (pollution or bad air was the cause) Snow pursued the 'germ theory' of diseases and was able to identify the polluted water pump in Broad Street, Soho, that caused so many deaths.

As we head west along Fulham Road we come across a very important hospital on our left namely The Royal Marsden Hospital (RMH) which was founded in 1851 by Dr William Marsden (1796-1867), an English surgeon who initially provided palliative care for cancer patients, then initiated the first comprehensive study and research unit in the world. Dr Marsden was born the youngest of eight children in Yorkshire, and at the age of 20 moved to London as an apprentice to a surgeon apothecary before starting his own practice. In 1824 he enrolled as a student of surgery at St Bartholomew's Hospital and qualified as a full MD in 1838. Marsden was one of the first early pioneers to provide free medical treatment for the poor, and established a free hospital. He opened a small dispensary in 1828 in Hatton Garden, Holborn, which was later, named The Royal Free Hospital. In 1858 Marsden focused his attention on cancer suffers and set up an establishment in Westminster for this purpose.

The hospital moved its location several times during the 1850's before its benefactors found a permanent site at Brompton in 1862. Earlier in 1855 the board of the hospital obtained the patronage of Baroness Angela Burdett-Coutts, whose extremely generous loan made it possible to purchase the Brompton site, following which architect David Mocatta submitted designs and the building foundation stone was laid by the Baroness in 1859. Angela Burdett-Coutts, as I stated in chapter one, was a philanthropist and daughter of the banker Thomas Coutts, and is certainly worthy of a second mention. She spent the majority of her wealth on a wide range of philanthropic causes and as we know from the earlier chapter she was a good friend of CD when they jointly established 'Uranta Cottage' in Shepherds Bush, which was a home for young women. Her medical and scientific foundations, which included the

RMH, consisted of missionary and nursing projects with Florence Nightingale (1820-1910). During her lifetime Angela Burden Coutts donated over £3 million to scores of major philanthropic causes ranging from training ships for the navy, soup kitchens, lifeboats, the Ragged School Union, and the Temperance Society. In recognition of this great women who died in 1907, Parliament provided a place by the West Door of Westminster Abbey for her final resting place. Queen Victoria conferred her peerage in 1871, for her work and she became the first woman to be presented with the Freedom of the City of London in 1874. CD dedicated his novel 'Martin Chuzzlewit' to her and she like Florence Nightingale (whom I have mentioned in some detail in a previous book) are possibly two of the greatest English women to grace the Victorian era.

The Royal Marsden is today one of the worlds leading cancer centres specialising in diagnosis, treatment, care, education and research into all known cancers. In 1991 the RMH was the first hospital presented with the Queens Award for technology and drug development, and became one of the first NHS Foundation Trusts in 2004. In addition to diagnosis, tests, and investigations, the RMH has the finest specialist treatment departments for, Surgery, Chemotherapy, Radiotherapy, Rehabilitation and several other equally important therapies. All these services are supported by teams of highly skilled clinical oncologists, medical physicists, and therapeutic radiographers using the latest radiography machines and techniques . . . how proud Dr Marsden would be today.

Before leaving this important hospital location I should mention that on my 1863 map RMH is simply shown as the Cancer Hospital and also shown across the road where Rose Square now stands, was once the Hospital for Consumption. Continuing along Fulham Road we take a short diversion to view a house, which CD would be very familiar with even today, as little has changed externally. To reach this house we turn right at Foulis Terrace continue north to Onslow Gardens (an area further along from our previous location) and then reach the corner of Neville Terrace where we turn left, walk a few yards and facing us across the road is No.11 Selwood Terrace. This quite inconspicuous small terraced house was home to CD and his wife Catherine for one year and it is here that they spent their honeymoon in 1836.

This little gem of history could quite easily go unnoticed, as there seems to be no mark to indicate that CD once lived here, I guess this is a personal statement from previous owners, which I respect. None the less, this is one of the few remaining houses that CD rented as a young man and therefore has a place in any biographical account of his life. Looking at this property today on my 1863 map it is easy to envisage the rural surroundings which CD would have been familiar with, although the house is linked with others in the road there were fields to the west and north elevations. We know that CD didn't particularly like living in what he described as 'countryside' as he was a city person, and like many of his generation that lived in highly populated areas did feel a sense of security and vibrancy, which Chelsea at that period of time didn't offer. When researching Chelsea, I failed to discover much information of CD's activities in this local community other than his association with friends who moved to this area later in his life. I can only imagine that he considered living in this small yellow stock faced house, with its basement and single upper floor, as being simply a stepping stone in his already busy life, which was to change so dramatically within a short period of time.

As I pass 11 Selwood Terrace I feel pleased that I have acknowledged this property with some reverence, and look forward to the remainder of the walk, which I know will prove even more interesting. Heading back south to the Fulham Road, which I cross, I now make my way down Old Church Street where after walking a few yards turn left into South Parade. From South Parade it is just a short distance to our next destination, Chelsea Square.

Chelsea Square was originally called Trafalgar Square (1863 map), and was first laid down in 1810. Surrounding the square is a mixture of wonderfully preserved period houses mixed with those more recently built. In 1928 many houses around the square were demolished including a 19th century building on the west side named Catherine Lodge, joyfully the new buildings which replaced the former ones are to a Georgian design and although no substitute for the original build never the less look extremely good to the eye. The lower end of the square is simply fantastic, the reason being that more recent buildings have been constructed which I feel gives this area even more exclusivity, each one very different in design but iconic in appearance. This group of new buildings, which differ in design, have

an inbuilt style and period awareness which complement one another, and a great deal of effort has gone into ensuring that the square's integrity is not undermined, especially by the studious attention placed on the choice of building materials that were used.

At this point Chelsea Square links up to Manresa Road before reaching the King's Road, which can be seen ahead. I should mention the architectural delight that we pass just a few yards along this road that was once the former Chelsea Public Library. This very well preserved and attractive building with its symmetrical brick and stone façade, Ionic porch and arched windows was originally opened in 1891. Having circumnavigated Chelsea Square we head east to Cale Street before turning right into Sydney Street. Once onto Sydney Street we cannot fail to see the wonderful spire of St. Luke's Church.

St Luke's Church was to play an important part in CD's life, as it was here in 1836 that he married Catherine Hogarth, a young lady of 21, who two years earlier had arrived from Scotland with her family when her father took the job of music critic for the Morning Chronicle. Catherine and CD had ten children during their rather acrimonious marriage, which sadly ended in 1858 when they separated. The Hogarth family were living in Chelsea when they first met so this church was an obvious choice for their marriage ceremony, as it had everything to offer.

St Luke's was designed by James Savage (1779-1852) one of almost 40 architects that entered a competition set by the Church Building Act Committee to design a suitable building for the community. Built of Bath stone in the Gothic Revival style, this church has superb external 'flying buttresses', which enabled the structure to adopt a perpendicular style, a technique that had not been used for several hundred years. This splendid Anglican Church was partly built as a result of the Church Building Act of 1818 & 1824, which was initially formed following the triumph of Napoleons defeat at Waterloo. The Act's real aim however was to accommodate the increasing population in urban centres and provide pastoral services by the church. These 'Commissioner's Churches' as they were known, were built in the wake of the French Revolution where it was hoped that the influence of the Church would be a deterrent against a similar occurrence happening in England, and also to settle internal problems within the Church of England.

By 1810 a Commission was formed with both clergy and laity members, they were appointed to apportion Parliamentary funds and independent resources into building many new churches, and at the same time sub-divide parishes. Each design for a specific church was decided by competition, and vigorous building control standards were enforced. Today St Luke's (often referred to as Chelsea's Cathedral) stands in majestic fashion for both parishioners and the general public to enjoy, with its graceful tower enhancing the skyline creating a formidable landmark in this district. Externally this sympathetically restored church sits back from the busy Sydney Street, which allows for a sizeable drive and a formidable front entrance, and although the former original burial grounds (to the north and south) have since been altered to accommodate other pursuits, none of the splendid architecture has been compromised.

The interior of the church is likewise very impressive, its scale, sanctity and spatial awareness bring together the passage through the nave to the altarpiece effortlessly, one is only distracted by the warmth and craftsmanship which is apparent everywhere. St Luke's intrinsic and artistic values are there not to be questioned, just enjoyed, and many period features survive such as the attractive font (1826) and wonderful painting beyond the altar titled 'Burial of Christ' by James Northcote (1746-1831), who also designed the original east window. There are many other eye-catching aspects of this beautiful church, which include the memorial chapel commemorating the Punjab Frontier Force, and the more recent modern urn like sculptures of Adam and Eve created by Stephen Cox. However there is one other remarkable feature that immediately took my breath away when I first visited the church, that being the current East Window.

The East Window was designed by Hugh Easton and replaces the original stained glass by Northgate, which was destroyed during a bombing raid in World War II. This 1959 replacement is simply stunning, when I first visited St Luke's on a cold and dismal March afternoon it still produced a blanket of colour that filled the church with joy, on a bright sunny day it is magnificent. What immediately attracted me to the window, apart from the blaze of colour, was the interesting way that Easton depicted insignia's of former saints rather than human figures, which I found refreshingly unique. Having viewed literally hundreds of churches in my travels I believe that the

designer has succeeded in capturing the image of piety and saintliness without just producing a complicated symmetrical composition.

Whilst visiting St Luke's I should mention that I was extremely pleased to have had the opportunity of viewing a bi-centenary exhibition of CD which featured a superb collection of historical documents, photographs and memorabilia created by Richard Jordan.

When leaving St Luke's Church look directly across the road and you will see the Royal Brompton Hospital, which is yet another very important building that deserves some mention. This splendid hospital was founded in the 1840's by Sir Philip Rose (1816-1883) whose name is remembered in Rose Square, which faces the Fulham Road opposite the second of the Royal Brompton buildings. Rose Square being the original location for the Hospital for Consumption (HC) shown on the 1863 map. Sir Philip Rose was by profession a lawyer but is probably best known for his work in establishing the HC and Hospital for Diseases of the Chest. He spent a great deal of his life working with the hospital as well as later being recognised as the first 'agent' for the Conservative Party and close friend and adviser to Benjamin Disraeli (1804-1881).

Consumption (TB) in the 19th century was considered an incurable disease and all patients received little or no treatment whatsoever. Prince Albert laid the inaugural stone for the hospital in Brompton in 1844 and the first admission was recorded in 1847. The newly built hospital contained many innovative features, the most important being the forced warm air ventilation, which was considered important for the recovery of patients. In later years as the hospital developed even more, substantial bequests were left to RBH enabling it to purchase surrounding land and houses. These charitable donations, legacies and fundraising schemes were aided by the likes of CD and Jenny Lind (1820-1887) a Swedish opera singer, among many noted people of the day. Today this amazing hospital is the largest specialist national and international leader in heart and lung disease treatment. The doctors, nurses, and health care staff are leaders in their field and carry out some of the most complicated surgery procedures in the world, treating both adults and children. The Royal Brompton with Harefield Hospital is a partnership NHS Foundation Trust and between them undertake more than 130,000 outpatient appointments and some 30,000 inpatient stays each year. The partnership also works on numerous research

projects producing a vast number of scientific papers aimed at reducing these associated diseases.

It is now time to head further south and conclude this walk so we follow Sydney Street down to the Kings Road. This trendy upmarket road was originally a private road used by Charles II, which enabled him to travel from Whitehall to Hampton Court unhindered. Legend has it that Nell Gwynne's house was on this route and that Charles sometimes called at this address, to use certain facilities when it was convenient! The road remained private up until 1830 and only those who owned a special copper token displaying the King's Head were allowed to travel on it. Not surprisingly many houses were built on this road from the 18th century onwards as it attracted many wealthy buyers, which has continued to this day.

At King's Road turn right, walk a short distance to the Fire Station, where we pass the former site of the Chelsea Workhouse (1863 map) on our right, which CD would have been aware of. Sir Hans Sloane donated the original ¾ acre piece of land around 1737 to build St Luke's Workhouse as it was then called, and a new workhouse was later built in 1843, this is shown on the map. At this busy junction cross over the road and head down Oakley Street, which as a location has a veritable history within this district. By the 16th century wealthy landowners built manors here that ran down to the Thames, most of them surrounded by large orchards. Henry VIII owned a Tudor manor here, this was later demolished in 1790, and several of his wives once lived here during their marriage years to the Monarch. In 1857 Oakley Street provided access to the newly built steamboat quay that was designed in readiness for new housing development schemes. As one would expect in this area many noted people lived in Oakley Street, namely Captain Scott (1868-1912) Antarctic Explorer, lived at No. 56, Lady Wilde (1821-1896) mother of Oscar Wilde, at No.87, Dame Sybil Thorndyke (1882-1976) Actress, at No.74, and George Best (1946-2005) Footballer, at No.87.

At the end of Oakley Street we reach Cheyne Walk where we turn right and walk along this stretch of the embankment. Cheyne Walk derives its name from William Lord Cheyne who owned the manor of Chelsea until 1712, when prior to the construction of the Embankment in the 19th century had houses which fronted the Thames. The Chelsea Embankment is just part of a mammoth

undertaking and engineering feat which reclaimed a vast area of marshland previously undeveloped. One cannot begin to undermine this undertaking, as the prime reason for its construction was to alleviate the almost non-existent sewage scheme that served London, and one man in particular was responsible for creating a vast network of subterranean sewers that are still in use today. I refer of course to Joseph Bazalgette (1819-1891) a civil engineer who was mainly responsible for designing the new embankment which consisted of a labyrinth of underground chambers and interceptors to cope with the massive sewage inadequacies London was experiencing. These atrocious conditions caused many cholera epidemics and by 1858 Parliament agreed a Bill, which allowed Bazalgette to begin his mammoth project. In doing so Bazalgette also made provision for an underground railway, still used today, and of course the splendid riverside walkway and gardens that we now enjoy. Having previously described Bazalgette's remarkable achievements in more detail in an earlier book, I simply cannot explain in a few words just how much London owes to this man, mainly as a result of 'unintended consequences' due to his energy, endeavour and accomplished work.

We are now almost at the end of this walk, and it is time to identify just a few of CD's valued friends and acquaintances that once resided in both Cheyne Walk and Cheyne Row. As we continue west along Cheyne Walk towards Cheyne Row we pass No.4, once the home of George Eliot (Mary Anne Evans) 1819-1880, an English novelist, journalist and translator. Eliot used a male pen name to ensure that her work would be taken seriously and also to shield her family from public scrutiny, her most notable novels include 'The Mill on the Floss' (1860), 'Middlemarch' (1861), and 'Adam Bede' (1859). After a sheltered and fairly suppressed early life, Eliot at the age 30 developed her radical thoughts by moving to London and becoming assistant editor of The Westminster Review. She wrote two stories in Blackwood's Magazine, her first adventure into novels, which CD enjoyed. CD in fact wrote to her commending her first published work 'Scenes of Clerical Life' and also told her that he thought the work was in fact by a woman and that her pseudonym could not disguise the author's sex! CD later dined with Eliot and her partner George Lewis, and also chaired a meeting to remove trade restrictions on literature, which Eliot attended.

Just a few doors further along Cheyne Walk at No.16, is the former house of Danti Rosetti (1828-1882) poet, illustrator and painter. Whilst Rosetti wasn't a personal friend of CD, nor were his fellow Pre Raphaelite Brotherhood group, he was never the less someone who was said to have influenced him as he did a great deal of reading in his youth. Conflict grew between CD and Rosetti following certain well-published newspaper articles of the day, when CD voiced his disapproval of certain Pre Raphaelite works, therefore distancing himself from this very creative group of artists. Born in London to a middle class family, Rosetti aspired to become a poet as did both his sisters and brother, his work was characterised by the medieval revivalism and his poetry was greatly influenced by John Yeats. He painted many images of both Fanny Cornforth and Alexa Wilding, models who featured in his memorable pieces, together with Elizabeth Siddal with whom he had a long and passionate love affair. Elizabeth Siddal became his pupil before marrying her in 1860. In later life Rosetti concentrated on Italian renaissance artists of Venice such as Titan and Veronese.

At No.18 I was surprised to discover that this was once the location for a very well known coffee house called Don Saltero's Coffee House (est. 1695) which was first opened by James Salter, a former member of the Sir Hans Sloane household. Salter first opened his coffee house in Lawrence Street, then moved to Danvers Street before finally moving to 18 Cheyne Walk in 1717. The house of James Salter was also used as a small museum for his collection of historic artefacts once owned by Sir Hans Sloane, items that were not donated by Sloane to the British Museum when it first opened. The coffee house itself traded with all the museum pieces on show and attracted many customers. When James Salter died in 1728 his daughter continued running his emporium until 1760, and by 1799 the house and museum's contents had been sold and eventually moved to a nearby tavern. Situated on the embankment The Tavern is said to have displayed a sign reading Don Saltero's Coffee House, this was eventually demolished in 1867, and rebuilt as a private house.

There are far too many other noted people who once lived in Cheyne Walk to mention, many personal heroes of mine, one in question being J.M.W Turner, but I simply cannot end this chapter without walking further and turning right into Cheyne Row. Having

reached Cheyne Row and identified so many people who had featured in CD's life, there is just one more place to visit in this amazingly interesting district. An early survey of London (1913), provided me with an accurate description of Cheyne Row which was first laid out in 1708, and was formed of ten houses (now numbered 16-34) being built on property leased from Lord Cheyne which occupied the site of a former bowling green. The eastern boundary of Cheyne Row being the old Tudor wall of Shrewsbury House and amazingly my research informs me that house No.28 is the only house that has been rebuilt, several others have been re-fronted, and a few of the remaining properties have even retained their original roofs.

Cheyne Row is a street captured in time, without the vehicles parked on the kerb one could so well imagine being transported back two hundred years and looking at a vista that was familiar to CD. A sign on the corner of the street provides the first clue for what is to come, walk a few yards further along Cheyne Row and you arrive at possibly one of the most interesting houses in London, I of course refer to No. 24, the former house of Thomas Carlyle. The house may look very non-descript when compared to those in Cheyne Walk, however its historical significance to anyone interested in literature and Victorian lifestyle may feel it has no equal.

Thomas Carlyle (1795-1881) was a Scottish philosopher, writer, essayist, historian and Victorian teacher and the eldest son of a stonemason who was a strict Calvinist. His parents expected him to attend divinity school following his time at university in Edinburgh, but he rejected this offer and became a mathematics teacher in 1814. In 1821 he abandoned the church and focused on a writing career, which sat well with Victorian society whose minds were focused on social and scientific change. That year he first met his future wife Jane Welsh (1801-1866), whom he married in 1826. In 1834 they moved from their moorland retreat in Craigenputtock to the then 'unfashionable' district of Chelsea, Thomas travelled ahead to find suitable accommodation. In one of the many thousands of letters the Carlyle's wrote, it was plainly obvious that Jane's practical assessment of suitable houses highlighted her intellect and awareness of financial, domestic and health considerations, which was to be the pattern throughout their married life, and confirms why she was later cited as being 'the reason for Carlyle's fame and fortune!' Jane was also

an eminent letter writer of her time who it is said attracted many insurgents, critics, revolutionist's as well as other noted writers (CD being one), whom she respected and admired.

Around the time of the move to London, Thomas had become a noted expert in literature and philosophy, and by 1837 the first of his principal works 'The French Revolution' had been published. By 1839 he also became engaged in public lecturing largely due to a shortage of money, and like both CD and John Forster, Carlyle was a wonderful orator, albeit with a high pitched and heavily pronounced Scottish accent! Following his first major publication and his lectures on German literature, which it is said 'lifted him above want and brought him fame'; "The Life and Letters of Oliver Cromwell" (1845) was published, establishing his position as a leader of literature. His fame was enhanced again in 1865 when he published "Fredrick the Great", which took him seven years to complete. It is fair to say that Thomas's success was in some part helped by his friend, adviser and business agent John Forster, who worked to establish ownership of copyrights and stereotypes amongst other things. It is also true to say that Carlyle's career 'took off' financially by Forster's influence in shaping the commercial status of his work.

Thomas, having spent most of his life worrying about his own health, lost his beloved wife Jane in 1866 when she died suddenly (she had been constantly unwell throughout her life). Jane's death had a major impact on his future work, and could have been one reason for his disapproval of political reform, which prompted a complete about turn in his political beliefs.

Thomas lived a further fifteen years after Jane's death and died at the age of 86, and had lived at No.5 Cheyne Row (as it was then numbered) for almost 50 years. Considering that Thomas was said to have been a crotchety, argumentative and disagreeable person, he with the help of Jane had acquired many friends throughout their lives who included Millais, Ford Maddox, Whistler, Lamb, Ruskin, Dickens and Wilde to name but a few. From my limited knowledge of this great man it comes as no surprise to discover that he had a plethora of friends and acquaintances who admired both his views, and his work, I simply admire the influence he injected in so many people, and I feel this places him on a higher plain than many of his peers. Many who have been inspired by his works have no

doubt influenced others, and one would hope that his command of literature would help generations to come.

CD first met Thomas and Jane in 1840 and they became close friends for life, CD once told his son that "Thomas Carlyle was the person who had influenced him the most", he also told his sister-in law that "there was no one for whom he had higher reverence and admiration". CD clearly used Carlyle's work of the French Revolution as reference material for his later novel "A Tale of Two Cities", and as a later mark of appreciation and respect dedicated his novel "Hard Times" (1854) to his inspirational friend.

Having provided an extremely brief synopsis of Thomas Carlyle I simply cannot finish this chapter without revisiting the interior of his former house, a task I had previously thoroughly enjoyed. From the first time I sighted 24 Cheyne Row I could see from the external elevation that the building has been sympathetically maintained, retaining almost every detail of its original façade, a good start, the interior is even better. Having operated the front door bell pull I was standing in the main entrance hall within seconds and immediately sensed that I had been transported into another age. The dark panelled walls and adjoining rooms were so reminiscent of the early Victorian period, which excited my inquisitive mind, as I knew instantly that all the questions I would ask of the building were there to be answered. Having said that I felt sure that the wallpaper decorations no longer were laced with the familiar arsenic compound used in CD's time! What I half suspected, and was pleasantly surprised to receive was the immediate attention of National Trust staff who were so enthusiastic in explaining the history associated with this house. Having already completed some research on Carlyle I was uplifted by the brief introduction to the house and within a few minutes was exploring a wonderful and revealing piece of history, I thoroughly recommend everyone who reads this book to do the same.

Having reached the end of this walk, my motivation to explore the remaining districts of this wonderful city of London is fired up once again, and I have CD to thank for helping me discover so many hidden treasures, which have previously escaped my attention.

WALK EIGHT - CLERKENWELL

1. Castle Tavern
2. Smithfield Market
3. St Bartholomew's Hospital
4. Site of Hick's Hall
5. Passing Alley
6. St John's Gate
7. Site of Cannon Brewery
8. Clerkenwell Medical Missionary
9. Former Finsbury Bank for Savings Building
10. Former Ingersoll Factory Building
11. Site of House of Detention
12. The Horseshoe Public House
13. Peabody Buildings
14. St James's Church
15. Clerkenwell Green
16. Clerk's Well
17. Coach & Horses Public House
18. St Peter's Catholic Church

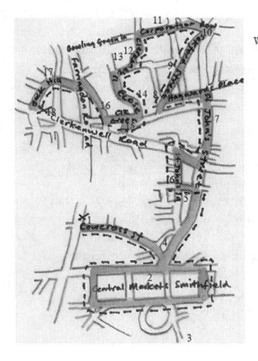

WALK 8

CLERKENWELL

"Money and friends are certainly the best of references"
(Our Mutual Friend—1864)

Although CD never actually lived in Clerkenwell he was very familiar and interested in the Borough of Islington having spent a great deal of time visiting it's densely populated areas whilst recording the people and environs. CD recorded many of his early references to Clerkenwell in his 'Sketches by Boz' (1836) and in later years when he documented journal articles together with numerous letters.

So many of CD's novels include characters which he encountered or recorded in his memory whenever he walked the streets of London, Clerkenwell being one particular district that seemed to provide a wealth of ideas. Although our walk incorporates just a small area of this historic district I feel sure that CD would have walked the same ground and marvelled as well as shown some remorse at the locations we will shortly encounter.

Historic records of Clerkenwell date back to the early 12th century when a monastic settlement evolved to the north of the district, providing a hospital run by nuns (St Mary) and a priory run by monks (St John of Jerusalem). The sisters of the convent drew water from one of the many wells in this district, which was used by City clerks and students who performed periodical religious plays. The monastic Order of the Knights Hospitallers of St John of Jerusalem based their English headquarters at the Priory and for several hundred years their traditions were upheld, certainly into the early 16th century, before Henry VIII decided to sever his ties with the Catholic religion.

Clerkenwell became a fashionable area in the 17th century and many notable people lived here during this period, however within a short period of time the district started to degenerate and become an area of social poverty laced with the upturn of the Industrial Age. Between the mid-19th century and World War I, Clerkenwell featured in many aspects of London's social history, firstly it became the centre of Radicalism, and secondly a place of penal servitude, what followed was post war decline before finally resurrecting itself in the late 20th century and becoming a desirable area once more to live and work in.

As more recent history of Clerkenwell centres around the huge number of immigrants which settled here I have decided to end this walk at Back Hill ("The Hill") simply because it was possibly the most recognised assembly point for Italians who arrived in London in the 19th century due largely to St Peters Church, and therefore had the largest concentration of immigrants within a 2 sq mile area. This select community was known as 'Little Italy', which formed a very interesting episode in Clerkenwell's social history.

Our walk begins at Farringdon Underground Station, which has recently been remodelled and provides us with the perfect introduction to this area, as it did for one of CD's characters Pip (Great Expectations), when he first arrived in London. I have decided that today is an 'indulgence' day as I shall be very busy and so I shall start by enjoying my Caffe Nero visit at their Patenoster Square coffee house which is nearby in Turnmill Street, here I enjoy an Americano and a bacon and tomato breakfast muffin.

Our walk commences after exiting Farringdon Underground Station in Cowcross Street (this street was laid down in the 13th century) and walking east along this narrow but extremely busy thoroughfare in the direction of St. John Street. Cowcross Street as its name would suggest was once a very busy route used by drovers when bringing their livestock to market, there was also a separate cow market here alongside Smithfield. Various inns once lined both Cowcross and Turnmill streets and the Castle Tavern still remains today. The former tavern was granted a pawnbrokers licence by none other than George IV in recognition of a loan made to the King to settle gambling debts incurred while he was enjoying a cock-fighting match at nearby Hockley-in-the Hole!

At the junction of St John Street and Charterhouse Street we have a good view of Smithfield Market. To the left along Charterhouse Street stands Charterhouse Square, which was once the site of a former Carthusian Monastery founded in 1371. This monastery was close to a plague pit, said to have been the largest mass grave in London during the Black Death of 1348. The Carthusian monastery was dissolved in 1537 and transformed into a mansion house in 1545. In 1614 a hospital (almshouse) and a school were built here which later moved to Godalming in Surrey. The school was taken over by Merchant Taylor who occupied it until 1933. Today the University of London is situated in the Square, as are the accommodation buildings for St. Bart's and the London School of Dentistry. Close by is Florin Court, a residential building on the east side of the Square, built in 1936 in Art Deco fashion, and featured in the fictional Hercule Poirot series.

In the middle ages this area known now as Smithfield was called Smoothfield and lay just outside the London Wall. The fields and water supply lent itself to becoming a livestock market for almost 1000 years and many of the old street names have disappeared, one however remains which is Cowcross Street.

Standing now opposite the entrance to Smithfield Market we are looking at the site of one of the oldest markets in the world, which was recognised as being the largest meat market in England. Today the former medieval market site is now dominated by a Grade II listed and covered market, designed by Victorian Horace Jones and a far cry from the once abominable conditions that livestock were subjected too. Records show that in the 19th century as many as 222,000 cattle and 1,500,000 sheep were sold here in one year, these animals driven through narrow streets and finally impounded in wooden stocks that were erected in a total area of just 5 acres.

CD felt strongly about the poor conditions that animals were subjected to here and criticised Smithfield as being 'A Monument of French Folly' in Great Expectations, when he mentioned Pip entering London for the first time. His words as Pip encountered and experienced this once filthy market were 'all asmear with filth and fat and blood and foam'. In 1843 public outcry from CD, bankers, aldermen, and local residents became so great because of the health problems and cruelty to the livestock, that Parliament eventually

closed down the fields and conveniently moved the problem elsewhere a new but smaller market simply emerged further in north Islington! In the following years the new covered market we see today was designed and built by Sir Horace Jones who also built Leadenhall and Billingsgate markets.

Royalty as well as the general public used this once large open space for an assortment of public gatherings. Jousting tournaments were a favourite spectacle, and for many centuries it was the main site for public executions, William Wallace being one who succumbed to capital punishment here in 1305. Watt Tyler was stabbed here by the Lord Mayor and taken to St. Bart's Hospital but was later removed and finally murdered in the street, which in effect ended the Peasants Revolt in 1381. Later in the Tudor period both Henry VIII and his daughter Mary I had literally hundreds of religious dissenters (both Catholic and Protestant) executed here. Executions continued until the end of the 18th century when Tyburn (located at Marble Arch) became London's public execution spot.

Every year since 1133 'Bartholomew's Fair' was celebrated here, which often continued for 3 weeks at a time, and extended to the top of St. John Street and across to the Old Baily. The fair eventually ceased as an event in 1855 by public demand, in order to control what had become an unruly event. Smithfield amazingly escaped the Great Fire of London, and history reminds us that shortly after this tragedy pilgrims from this location left London and settled in the USA and founded Smithfield Rhode Island.

A more recent interesting event took place here in Smithfield during World War II when a large underground cold store was used for secret 'experiments' in these very buildings, the cold storage unit was utilised for a top-secret experiment to produce a revolutionary product called Pykrete. Pykrete was a mixture of ice and wood pulp alleged to be tougher than steel! It was originally hoped that this new product could be used to manufacture static floating aircraft carriers in the Atlantic, which would allow cargo planes to refuel. This was one of the best-kept secrets of the war, and to achieve this secrecy a protective screen of animal carcases were hung as a barrier to hide the cold store from the testing and development area.

At the far side of Smithfield Market sits St Bartholomew's Hospital, which is the oldest hospital in London, and not far from

this building stands the church of St Bartholomew-the-Great, which is London's oldest church.

It is now time to leave Smithfield and head north up St. John Street and in doing so we pass a building on our left which was once owned by Farmiloes & Sons who were part of London's Industrial Revolution, as their factory was responsible for producing glass and lead. Farmiloes building was one of many that were constructed to withstand the immense weight of goods made and stored there. These large buildings were a product of the redevelopment that took place here once the meat market had moved.

Walking a few yards further along St John Street the road widens considerably and provides room for a central reservation, which accommodates motorcycles today. In 1611 on this spot stood Hick's Hall, which was the first purpose built session house for JP's in Clerkenwell. Hick's Hall held many notable crime sessions here, probably the most famous being the Grand Jury, which was convened to host the men who signed the death warrant for Charles I, both CD and Samuel Pepys mention Hicks Hall in their various journals. Continuing along this street we come across a small courtyard named Smokehouse Yard, which although quite inconspicuous has an interesting history. Around the late 19th century many buildings in this area were used for curing meat from the nearby market. In Smokehouse Yard one can still view a well-preserved building from CD's era that can clearly be seen when entering the yard. The building has a balcony with grills above it and portholes (ventilation shafts), and above these clearly visible on the roof are original chimney ventilation chambers, black from the industry that once surrounded this particular yard.

In more recent times, one may recognise the buildings on both sides of this part of St John Street, as those that were used in the film 'Lock Stock and 2 Smoking Barrels' featuring Vinnie Jones.

Moving away from Smokehouse Yard, and continuing along St John Street we now cross the road, walk another hundred yards and arrive at Passing Alley (previously known as Pissing Alley), which is a narrow passageway or byway. Turn left into the alley and walk to its mid-point where you can clearly see two original boundary markers issued by the Parish Clerk of 1890 they are fixed high upon the facing walls. The markers were very significant in defining who was entitled

to the services of the two adjoining parishes, services that included street cleaning (to assist with the appalling hygiene conditions) in addition to support for the poor. The original name of Pissing Alley was given for obvious reasons and I suspect not a very pleasant shortcut to use in the past!

Having walked down Passing Alley exit and turn right, then walk a short distance until you reach St John's Gate. This impressive structure straddles the road and was rebuilt in the late 19th century as a monument to the order of the Knights of St John Jerusalem (military monks) and now home to the HQ of St John's Ambulance. The original group of buildings cared for pilgrims who had travelled to the Holy Lands and covered almost the entire area we have walked so far in this chapter.

For several hundred years the Knight Hospitalers flourished in Clerkenwell, their noble order came to the front in the 11th century once they built a refuge hospital for the sick and needy in Jerusalem. The hospital that stood on this site was initially funded by Lord Jordan Briset and was built close to a former Nunnery and stood north of Clerkenwell Close. In the first crusade when the Christians took the Holy City they filled the hospital with wounded Crusaders, and those who survived dressed themselves in a livery of black robes with a white cross (a design which is still used today by St John's Ambulance). What followed was a military order of some note, and who later fought many battles against non-Christians in defence of their religious beliefs. In 1187 when Saladin retook Jerusalem it was said that he had been impressed by these honourable campaigners and allowed 10 black robed knights to remain and tend the sick and wounded. Once again in 1237 the Knights of the Order went forth into battle in the Holy Land and returned in 1247 with treasures, and it is believed a drop of Christ's blood that was previously entombed by the Patriarch of Jerusalem.

Around 1278 the Knights adopted a red cassock with a white cross, which they retained for some time, and for almost two centuries crusaders battled against the Turks at various times until some stability came about in the reign of Henry VIII.

However, during the period of Henry VIII's reign the Clerkenwell Knights were suppressed because they upheld the ideas of the 'Bishop of Rome', and were seen as a threat simply because they could

themselves muster a small army. Once the English Reformation was in full swing a large majority of Knights were forced to retire 'speedily' to the island of Malta, sadly of those who remained in England, two were considered traitors by Henry and beheaded, and a third was hung drawn and quartered. Queen Mary temporarily restored the Order but when the Protestant queen Elizabeth I came to the throne she once again drove the knights back to their refuge in Malta.

In 1612 James I eventually gave the priory to Lord Aubigny, which later came into the hands of William Cecil. During the reign of Charles II the church within the Priory grounds served as a private chapel, and was eventually extended in 1721. The present church (located across Clerkenwell Road) was restored in 1845 and the crypt below is now opened at specific times to the general public. Today this splendid church, much of which is original now houses many artefacts both inherited and acquired by the Order, visitors can enjoy the garden at the rear, which has been recreated to match the original design. I should mention the superb museum which is also open to the public, and provides a documented history of this historic Order, a real gem and well worth visiting.

On leaving St John's Gate we make our way back along Clerkenwell Road and turn left into St John's Street once again, and continue walking north. In CD's day this entire area accommodated a large number of breweries and gin factories (my research identified at least eleven such 'houses' dating from the mid-18th century), each one supplying the needs of the entire district. I also discovered there were a large number of illicit stills operating that produced and sold gin during the infamous 'gin epidemic'. Gordon's had a gin factory at 260 Goswell Road (this runs parallel east with St John Street), which traded from about 1786 and Booths gin factory was situated in Turnmill Street (which runs parallel west of St John Street). This inordinate number of distilleries and breweries was necessary simply to supply the 5204 taverns in London alone!

Whilst walking along St John Street, to the left can be seen St John's Church at the rear of a small garden, and adjoining this is a large building made up of apartments known as Mallory Buildings, these were erected in the early 1900's. This particular building was created for the needy of this parish and was one of the first examples

of a pioneering scheme to introduce Council Housing in London. Finsbury Council continued to develop housing groups and started the theme, which was adopted by other London authorities after World War II. Before reaching Haywards Place on our left, look across the road and you will see what looks like two very old large wooden gates that remain open, these were once part of the former Cannon Brewery (its name still resplendent above the building facade). This brewery being just one of many that surrounded this former industrial area, and although Cannon Brewery has long since closed, this gated entrance clearly retains the ruts in the granite sets where the high volume of brewery wagons once passed. Take a look along the alleyway which leads to an office doorway beautifully decorated with barley and malt carvings; this site is now home to modern architectural practices and apartments.

Back on St John Street cross the road and walk a few yards, where we find ourselves at Haywards Place, a wonderful memorial to early 19th century architecture. The houses along this timeless street date back to 1834 and were originally built to accommodate workers from Nicholson's Gin Factory, which stood opposite these tenanted buildings. Records tell us that this row of terraced houses, each with 4 rooms, had on average 10 people living in each house with little or no sanitation when first built. There were however slightly larger premises in the surrounding area that contained more rooms, an indication of the varying mixture of social levels and standards, the larger houses being occupied by skilled workers and clerks. Not far from this street once stood the 'Red Bull Tudor Playhouse' which was frequented by Charles II and Samuel Pepys who stated in his diary that he was very impressed by the actors and surrounding pleasure facilities! This building sadly burnt down in the Great Fire (1666).

At the mid-point of Haywards Place we come across the former Clerkenwell Medical Missionary before turning right into Sekforde Street. This interesting building was constructed in the early 19th century, its prime aim focused on the poor and needy people in this district. This building was always full according to records, as the poor working environment and overcrowded housing in this district, led to very high mortality rates especially amongst children. Communicable diseases such as influenza, cholera, measles, consumption and whooping cough were especially active in the

poorer overcrowded areas where sanitation and hygiene were at its worse, and the CMM did its best to help the situation. Just a short distance to our left in Sekforde Street stands the former home of John Groom (1845-1919) a philanthropist. Groom founded workshops for disabled 'girls', which was quite remarkable in this period as women and girls were wrongfully considered to be more expendable.

CD would certainly have known, if not visited Clerkenwell Medical Missionary on his travels as he used this street for both business purposes as well as for pleasure. When walking along Sekforde Street he would have noticed and been aware of the number of 'coal hole covers' in the pavement enabling the fossil fuel to be delivered, each one serving its respective house, and interestingly these covers were also part of the Industrial mayhem of this area as the foundries that produced them were located close by. Further down Sekforde Street on the left stands the Finsbury Bank for Savings, which was built in the early part of the 19th century and provided financial services for the middle and wealthy classes of this vibrant district. Externally, the architectural features were very avant-garde for its day, the lotus leaf stuccowork becoming very popular when this building was first designed as the craze for Egyptian archaeology was already underway. CD was a customer of this bank and regularly walked from his home in Doughty Street (about ¾ mile away) to conduct his business, as did many local traders especially those who handled large sums of cash.

Walk to the end of Sekforde St and rejoin St John Street, take time to pause a moment and capture yet another iconic building of Clerkenwell's more recent history, namely the Ingersoll Factory, easily recognised by the classic mosaic lettering high above the parapet walls. Now apartments the Ingersoll building is no longer trading here, however this edifice of period architecture has retained its classic appearance but sadly goes unnoticed due to its busy location.

Another building of important industrial interest sits across from the Ingersoll building just above what is now the 'Peasants Pub' (thought to have been named after the Peasants Revolt of 1381). This building was once the headquarters of 'Dr Scholls' before the company moved to Kansas USA and with these companies once trading here, it is easy to see that industry was alive in this area in

the 19ᵗʰ century and understand why it became an attractive place for skilled immigrants

Standing at the junction of St John Street and Skinner Street looking north, notice the rise in ground level as the road snakes its way towards ancient Islington, the reason being that the geological structure of this terrain and the surrounding area sits on large deposits of Thames gravel, below which is London clay. Between the clay and the gravel are many springs still evident today, and it was these water wells that gave their name to places such as Saddlers Wells and Clerkenwell. St John Street itself was once a country lane, which meandered from one side of the current road to the other, linking the village of Islington to the City of London. Architectural evidence shows that there were settlements here during the Roman occupation as this area was an important commercial link to the Thames. At this middle passage of St John Street to the right can be seen the large clock tower that sits above the red brick building which is now part of City University.

Our walk now takes us left into Corporation Row, which in turn leads to Bowling Green Lane, originally called 'Feather Bed Lane'. At the end of this Lane there once stood a whipping post for petty offenders, and the former Feather Bed Lane derived its name from the large mountain of cinder and rubbish which was deposited here for 'recycling'. It was used by vagrants and the like because it was always a warm area to occupy as a place of rest!

The immediate area where we stand was at various times through history used for recreational and punishment purposes. In the late 17ᵗʰ century bowling greens were laid down around this very spot, as there were in many other fashionable areas of London, this sport becoming very popular at this period. In fact licences were issued for 31 bowling greens, 14 tennis courts and 40 gambling houses in this borough alone, which is an indication of the society living here during that period. There were two bowling greens to the north eastern edge of the Lane, one laid in turf the other in gravel, both were covered which enabled players to compete all the year round. An expanded version of bowls called 'Pall Mall' was played here, which was said to be a favourite pastime of Charles II (as well as his other favourite, women)!

Fig 25 St James's Church

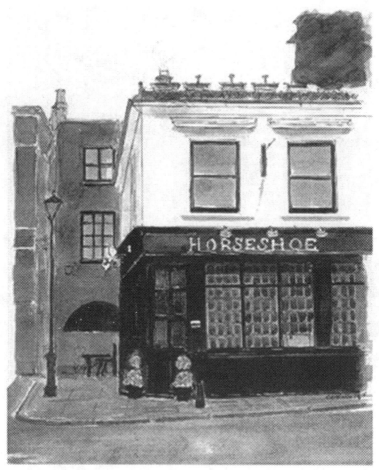

Fig 26 Horseshoe Public House

Fig 27 Clerkenwell Green

On a more sombre note, Corporation Row and Bowling Green Lane were also sites for several prisons which served as both detention centres and holding buildings for the City of London Assize Courts. Bridewell Prison was in use here from 1615-1794 and was considered the City's most influential 'house of correction'. Next door to Bridewell stood the New Prison (1617-1877), which was used to house criminals before being sent to the magistrates court. Clerkenwell Prison evolved from these two former prisons, which in time were partly demolished, then redesigned and rebuilt and later known as the 'House of Detention'.

On the 13th December 1867 the House of Detention (which was then on the site of the Hugh Middleton School) was a target of a gunpowder explosion instigated by the Fenian Society in an attempt to free an arms dealer called Richard Burke. The blast killed many bystanders in Corporation Row including 15 adults and two children (forty others were injured or maimed); those responsible were caught and later executed. One of the perpetrators of this heinous crime was a Mr Michael Barrett who it is claimed, was the last person to be publicly executed outside Newgate Prison (then situated next door to the Old Bailey). What valuable research data and inspiration these buildings must have been to CD in his quest to produce his amazing novels.

One of the many eerie stories associated with the House of Detention is centred on a series of tunnels that once interlinked various buildings within Clerkenwell Close. In these corridors (which up to recently were opened to the public as a museum) it is said that visitors allegedly witnessed shadowy figures moving quite fast ahead of them. There were also scores of sightings of an old lady apparently searching for someone, and the sound of a screaming child thought to be a little girl apparently lost in the maze of tunnels! Sadly this museum is now closed but I understand has been used since on several occasions for filming purposes.

In 1890 the House of Detention was demolished (Pentonville Prison accommodated most of the inmates) following which a school was built on the site and was named after Sir Hugh Middleton (1560-1631). Middleton was a wealthy Welsh goldsmith, banker and engineer who came to London in the late 16th century to seek his fortune, and soon became jeweller to James I. His best remembered

project was to construct the 'New River', which brought clean water from the River Lea in Hertfordshire into London, and amazingly although today subterranean, the New River still supplies Londoners with water. Hugh Middleton School had some notable pupils during its existence one famous Italian name being Geraldo, who was a popular musician in London before and after World War II.

At the crossroads of Bowling Green Lane and Corporation Row stands Clerkenwell Close, which abounds with legend and tradition mainly linked to the buildings that lined its street. The Nunnery/Monastery of St Mary which I previously mentioned once stood on the site of the Horseshoe Public House and former St James-House of Correction. This reclusive enclave required that the novices who entered would bring with them considerable gifts of property, which represented their dowry for their marriage to Christ, the proceeds of which would later be requisitioned. This substantial facility for its period consisted of the Nuns Hall, cemetery, kitchens, cloisters and Chapter House. There were many nuns and chaplains residing here, together with a small army of servants who looked after the group of buildings housed on the estate. Eventually the nunnery was dissolved during the Dissolution of the Monasteries (1536-40), and Henry VIII simply handed the entire estate to the 3rd Duke of Norfolk. Throughout the Tudor period Clerkenwell Close was considered to be quite an affluent area and several of Henry VIII's and Elizabeth I's ministers lived here as the wells and springs were considered to be healthy to use, long before the waters became polluted. The mansions that were built here gave this area the reputation for being of 'very high status', which continued until the late 1600's.

Today the northern part of Clerkenwell Close takes you through a mixture of old and new buildings, on the right what is today a very modern refurbished design centre for the arts was once a depository for furniture and a stationary depot for the local council (the Victorians engraved signs over two doorways). In the 19th century this small thoroughfare became more of an industrial area when various business's such as clock making, light engineering and printing developed, which in turn attracted numerous enterprises throughout the Industrial Age, and of course skilled immigrants.

At this point in Clerkenwell Close we reach the Horseshoe Public House that was built in 1794 in an age when gin and beer were the

fashionable pastimes of the middle and lower classes. Much of the external façade of the Horseshoe remains the same as it was over 200 years ago, the interior however has been altered slightly over the years mainly due to wear and tear, but nevertheless retains a Victorian flavour. Thankfully this gem of a pub escaped the terror of the Blitz, which was all around the area and the bombing raids had destroyed many other buildings close by.

As a writer I am allowed one indulgence throughout this book and it is the Horseshoe Pub. The reason being that my grandfather, Anthony Costella, was tenant landlord of this pub from 1909-1921 and although I only have historic records from the Post Office files and some family stories from the past, this wonderful building will remain forever in my heart. Both of my fathers' parents were immigrants who travelled from Italy around the late 1800's to escape the turmoil of Italian politics and finally settled in Clerkenwell. My grandfather is said to have walked most of the journey to England from Bardi and when he eventually arrived worked as a knife grinder in the early days. He also worked selling ice cream then progressed to being a waiter in the West End before eventually getting the tenancy for the Horseshoe (unlikely that he owned the pub). It was here that my grandparents had two of their children, first my dad in 1913, followed by his sister Enis in 1919, his other sister Hilda was born probably in Rosoman Street in1925. In view of the extended period that my grandparents kept the pub I can only assume that they made a reasonable living here, this was certainly a catchment area for 'pub locals' judging from the surrounding buildings and community, which at that period were said to be lower working class.

One source of custom must have come from the occupants of Peabody Buildings, which sits opposite the pub. George Peabody, a wealthy American entrepreneur, founded a trust, which provided £500,000 to house the City's poor. What followed was a large building scheme throughout London that provided accommodation for thousands of poor and needy families, and most of these buildings, which were wonderfully constructed, remain as a memorial to this great man. Ironically, as a young boy Peabody enlisted to join the volunteer militia who fought against the British Fleet as they advanced towards Washington in 1812, long before he himself migrated to England. Then at a much later period of his life he was

awarded the 'Freedom of the City of London' for services rendered, by the London Guild, which Queen Victoria herself endorsed. This modest honour was given because any other form of royal investiture was then thought to be inappropriate as George was an American Victoriana at its best!

Leaving the Horseshoe Pub after sampling its good fare (certainly worth a visit today) we continue walking until we reach St James Church, which sits at the southern entrance to Clerkenwell Close. This church site has a long history going back to the early 12th century and it was the same Norman baron who built the Nunnery dedicated to St Mary that founded the original church, giving it the same name; this later became the home of the Lord of Clerkenwell. The Nunnery grounds covered several acres stretching from Northampton Road to Clerkenwell Green and remained intact until the dissolution of the church by Henry VIII. The church was then renamed St James, by which time the local parish had adopted the church through various trustees who control it today. The building we see today was built in 1792, the original one being demolished due to its poor state of repair.

An article written in 1897 stated that St James was the burial ground of many Irish immigrants and was excessively overcrowded. It went on to say that the mortality rate amongst local children had been very high due to the filth and wretchedness of the major part of the inhabitants. (One of many references to the 'slum' area that had developed over the previous century). One original feature of the church, which isn't obvious today, is the Victorian 'modesty board' placed strategically around the base of the stairs, left of the entrance. Internally the church has reinstated many of the original memorials, one being to Captain Henry Penton (MP and developer, whose name is associated with both Pentonville Road and Prison). Samuel Pepys wrote of the church many times in his diary, especially with reference to 'gadding abroad to look after beauties'. There are also many memorials to the martyrs of the Reformation that were burnt alive at Smithfield, their names being displayed on a more recent plaque identifying all 66 people who died for their faith in the 'fires of Smithfield' from 1400-1558.

Walking through the church grounds we come to a 'bricked off' doorway, and to the right of the stairs stands a weathered

tombstone of Ellen Steinberg and her four children who once lived in Southampton Street. The tombstone sadly relates to the father of this family who stabbed his wife and children to death before turning the knife on himself, in September 1834. The father, Johann Steinberg, a German immigrant, was given a paupers grave in nearby Ray Street where a stake was put through his heart! The original burial grounds are now used as a peaceful garden where locals as well as visitors can sit away from the noise and clamour of the nearby City limits.

Leaving the church grounds and back on Clerkenwell Close we now head towards Clerkenwell Green through the narrow road and pavement entrance by St James Church, which was originally said to have been even narrower with its path squeezed between a butchers shop and a tavern.

Having now walked the few yards to Clerkenwell Green one can be excused for thinking that as this was once the centre of the old village, are we in the right place, the answer is "yes" as this green hasn't been grassed for over 300 years! CD used the 'Green' as the home for Fagan and the Artful Dodger in Oliver Twist and actually walked past this area regularly and would be familiar with some of the buildings that remain today. The most prominent building in Clerkenwell Green today is the former 'Sessions House' (1782), which is now a Masonic Hall; this building was erected to replace 'Hick's Hall' (Magistrates Court) in St John's Street, which I mentioned earlier. In the 18th century there were once lofty trees lining the grassed area of the Green, providing a centrepiece for the many mansions occupied by the noble and rich, it is hard to imagine that vista today. Many noted people have lived here over the centuries, including former Lord Mayor's; however probably the two most interesting inhabitants who resided here were Isaac Walton and Jack Adams.

Isaac Walton was best known for being the author of 'The Complete Angler' (1653), arguably the most referred to book other than the James I Bible. The Complete Angler was read by Kings, Statesmen, and every other manner of person in the civilised world, and even today it is used as a reference guide for many purposes. Jack Adams (1682) however, was a completely different character to Walton, said to be a simpleton even though his title was 'astronomer and fortune teller '. Many stories have been told about his cheating

ways in obtaining money from the rich and the gullible, it is said that he would give you a healthier fortune for five guineas than one for 5 shillings! An old pillory once stood at the western face of the Green, where Jack Adams and many men, women and children were punished for all manners of crime, some even killed. People sentenced to the 'pillory' were made to stand up and were more exposed to the public than those in the 'stocks' who were sat down, the general public being made aware of their crimes were left to administer punishment accordingly!

Clerkenwell Green has a long tradition of Radicalism and the Labour Movement. In 1381 Watt Tyler leader of the Peasant's Revolt camped with his followers here at this very spot before confronting Richard II at Smithfield, and was eventually cut down and killed by the then Lord Mayor. Both Radicalism and Marxist movements have used this area to stage marches that continue to this day, at No.37a stands the Karl Marx Library in honour of his memory. Karl Marx (1818-1863) was a German philosopher, economist, historian and revolutionary socialist who once said of CD that he 'had issued to the world more political and social truths than have been uttered by all the professional politicians, publicists and moralists put together'. Quite an accolade for one who was considered to be a capitalist! Vladimir Lenin (1870-1924) Russian revolutionary politician and political theorist also visited Clerkenwell many times and published several of his works at a printing house, which overlooked Clerkenwell Green. On a coffee theme I should mention Lunt's Coffee House which was located here and had the reputation for being an establishment which served as a meeting place for many radical society events around CD's period. One should also remember the references made by Samuel Pepys who often visited Clerkenwell Green to look at the 'local beauties'.

Leaving Clerkenwell Green on the final part of the walk we head towards Farringdon Lane and stop at Nos 14-16 to gaze through the street window where we can clearly see the remains of the original 'Clerks Well'. The well was once said to provide 'sweet, wholesome, and clear water' and throughout the centuries has attracted great numbers of people from the City. City dwellers were once fond of 'walking out for fresh air in the evenings', simply because the air was then foul from the waste matter and filthy conditions within its walls,

and fresh un-contaminated water was almost non-existent. Good wells were considered to be big business as they were the prime source of potable water and created vast fortunes for the entrepreneurs, who saw them as money-spinners in the mineral health market.

Ralph Agas (1562) was probably the first person to feature Clerkenwell in pictorial form as a district, highlighting its famous wells and their source of water that emanated from Hampstead, Highgate and North London. This created enormous business interest and other similar wells became well known such as White Conduit on the northern part of Penton Street, which went through Charterhouse to the Priory of St John. Situated close by was Sadler's Wells which was discovered by Richard Sadler and used as commercial mineral wells and he also developed pleasure gardens around the theatre itself. Another was Islington Spa (or New Tunbridge Wells), which continued to provide water until 1946, London Spa was also a precious mineral well which when dried up had its name transferred to a pub close by. Bagnigge Wells was on land formerly owned by the Nunnery of St Mary and Coldbath Spring wells were situated in Coldbath Square and built over in the 1970's. Most of these wells were associated with the Fleet River that was once known as the River of Wells.

Clerks Well got its name from the many religious plays performed by the Parish clerks on this spot around 1174. Biblical plays were performed there by the Clerk's of London and one reason for this was because it was outside the City limits which became a fashionable place for recreation. The plays performed here were quite novel as the performers would move from one stage to another known as platforms each of varying heights. It is said that Richard II attended these plays as did many other noted gentry and the players received payment by way of a gift. The original Clerks Well was also associated with its purity of water and therefore closely guarded and locked up at night according to medieval history, and due to its notoriety was clearly mapped on reference documents throughout the 14th-18th centuries.

The well was rediscovered whist excavating 14-16 Farringdon Lane in 1924, following which a lease was secured on the chamber by Finsbury Council and has been continually renewed to this day. When discovered the well was hidden under a wood and stone

floor, beneath the floor was brick and stone rubble which itself was approximately four yards below the street level, when discovered the well was half full of water. Documentation would suggest that by 1857 the well had become polluted and was closed and covered with building debris. Looking at the well from the street, the chamber can be seen quite clearly. On the east wall an iron pump and plaque (1800) are visible with a lead pipe displayed that once connected the well to the pump, this well was probably sunk in the late 17th century. Also visible internally is the exposed brickwork and rag-stone blocks which are in fact part of the facing that was once the medieval wall of the Nunnery of St Mary. On the north elevation of the chamber the brickwork is slightly later and several recesses can be seen which once held a windlass support above the well.

Continuing along Farringdon Lane we reach Ray Street Bridge which crosses Farringdon Road, and we have now entered a former area known as 'Hockley in the Hole', which for many years was an attraction for bear baiting activities which drew many spectators, mainly the rich, from all corners of London. This particular area lies directly to the south of what was once the popular Fleet Market (1736). We are about to cross the very busy Farringdon Road, but before doing so, it is worth mentioning that to the left beyond the traffic lights sits what is now known as the Zeppelin Building, the original structure was totally destroyed in a Zeppelin raid in 1915, as were several other buildings in this location.

The Ray Street locality has a long history of Gin Distilleries, Breweries, and other formidable properties both fictional and factual. Lenin's home stood close by, as was Fagan's Lair immortalised so well by CD. This particular spot was used by many early settlers who developed a thriving commune here for several reasons, one being its proximity to the River Fleet that flowed into the Thames, also the large number of wells which provided drinking water, and not surprisingly the arable land for food produce.

Once across the road continue down Ray Lane until you reach the Coach & Horses Public House, there you will notice that opposite the pub, at the intersection of Back Hill and Warner Street are a set of drains in the middle of the road, if you listen carefully (without getting run over) you may hear the flow of the Fleet River, London's largest subterranean river that starts at Hampstead Heath

and flows into the River Thames. The Fleet was a major river, which once flowed the entire length of Farringdon Road and in places is 40ft deep, water taken from it was once offered as a health remedy due to the sequence of wells along its path. Following the Great Fire of London in 1666 both Christopher Wren (1632-1723) and Robert Hooke (1635-1703) proposed to widen the Fleet but this idea was rejected and another scheme was adopted which entailed building 'The New Canal' an idea favoured by coal magnates from the North. In the mid-19th century when Farringdon Road was widened it was decided to make the Fleet River subterranean and link its flow into a series of tunnels, which remain today. The current path of the Fleet River discharges close to Blackfriars Bridge where a set of ladders identifies the exact location at low tide.

In the 16th century, on the site where the Coach & Horses Public House now stands, there once stood an arena for violent sports. The programme of sporting activities included bear and bull baiting, dog fighting and swordsmen prize-fights, all of which were previously held close to the site of the original Globe Theatre in Southwark. Deemed to be too 'brutal and lower class' for residents in Southwark at the time, these sports were transferred to Clerkenwell for the entertainment of the newly developed and lower class society of Islington, and the profiteers of these blood sports were said to be mainly Smithfield butchers who were also known for breeding vicious fighting dogs.

Our tour ends when we reach the top of Back Hill where it joins the Clerkenwell Road, but before leaving our trail I should mention St Peters Church which is located by turning left and walking a few yards down the road. Having written about this wonderful church extensively in my previous book 'From Battersea to the Tower' I would recommend that you visit this historic Catholic Church and enjoy its beauty and history.

Our walk is now complete but I still have an appointment at St Paul's Cathedral in the afternoon, so I will probably visit Caffe Nero in Newgate Street, which is just a short walk from where we are now.

WALK 9 - CAMDEN TOWN

1. Mornington Crescent
2. Former Carreras Cigarette Factory
3. Oakley Square
4. Richard Cobden Memorial
5. Camden Coffee Shop
6. The Jewish Museum
7. 70 Gloucester Terrace
8. Pirate Castle
9. Regent's Canal
10. Camden Lock
11. Camden Market
12. Former 'Mother Red Cap Inn'
13. 16 Bayham Street
14. St Martin's Almshouse
15. St Martin's Gardens
16. Greek Orthodox Church All Saints
17. 112 College Place
18. Royal Vetinary College of London
19. Goldington Crescent Gardens
20. St Pancras Hospital (Former Workhouse)
21. St Pancras Gardens
22. Old St Pancras Church

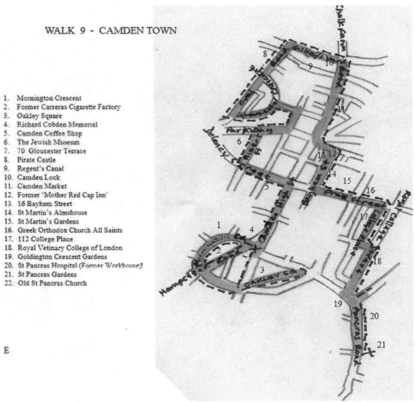

WALK 9

CAMDEN TOWN

"Most men unconsciously judge the world from
themselves, and it will be very generally found that those
who sneer habitually at human nature, and affect to despise
it, are among its worst and least pleasant samples."
(Nicholas Nickleby—1838-39)

Although CD only lived in Camden Town for a very short period of
his life, the memory and latter account of his stay there was not a
happy one. His time spent there was as a young boy who had arrived from
Kent with his family to a district of London that was expanding rapidly.
CD was soon to discover that the idyllic life he had experienced up till
now was to change radically in a neighbourhood that was fragmented
and as he recalled 'difficult to find new friends'. The terraced house that
Dickens parents first rented on their arrival from Rochester was tiny, yet it
had to accommodate both CD's parents and all their children.

However, in later years it became evident that Camden actually
stimulated CD's imagination to such an extent that many of his
early essays in Boz have Camden settings, and several of his famous
characters such as Mr Pickwick, Bob Cratchett and Mrs Gamp, to
name but a few, came from the local people of this district. It was
probably this reason more than any other that prompted me to
explore and eventually decide on a route to walk here, as initially I
found it extremely difficult to find a number of buildings and places
of interest associated with CD, how wrong I was.

Today Camden Town occupies the southern portion of what
was once known as the manor Cantlowes or Kentish Town. The

estate came into the hands of Charles Pratt (later created Earl Camden in 1786) through marriage to Elizabeth, daughter of Nicholas Jeffery's. Camden Town quickly developed with the commencement of building works on the north side of what is today Crowndale Road, Gloucester Place was the original name first given to this area. Buildings quickly developed on all boundaries, in Britton's Map of 1834 the layout when compared with slightly earlier maps shows clearly how rapidly the area had developed. Camden Chapel had been built in 1824 (now All Saints Church), Camden Road was also laid out at this period and the district had become well known largely due to the development of the Grand Union Canal and the improved railway services. Interestingly enough I was still able to reconcile many of the streets in my 1863 map with those of today, but amazed at the growth of this area from what was once vast open fields to the heavily populated community we now have.

Camden Town has developed into a vibrant district today and is famous for its markets as well as the stylish period buildings visible throughout this area. A host of cuisine delights are found almost everywhere in the central area of the town, which provide specialities from around the world, many venues offering live music to enjoy while you eat. One could even claim that Camden is the Bohemian capital of London, as its live music is legendary. Even today after launching many big names into the entertainment world over the years, visitors still fill the jazz, blues and raz-ma-taz performances found in several venues in this close knit society. As this area is rich in retail outlets and markets it attracts huge numbers of visitors each year, although it has a plentiful number of wonderful eating establishments, unlike other districts I have walked in the past it has slightly less historical evidence to discover. Having said that, Camden is not without its mysterious and sometimes macabre history, and like Whitechapel, it had in the past experienced a major criminal event known as the Camden Town Murder (1907). This particular incident was centred around a young prostitute named Emily Dimmock who was brutally disposed of by a manic attacker in a similar fashion to Jack the Ripper (more of which is featured in the Whitechapel walk). Several suspects were named and linked with this crime at the time, one of which was said to be Walter Sickert, the artist, who in later

years was thought by some to have been the Ripper himself, even though the Whitechapel murders had been committed some 19 years earlier! Sickert lived at one time in No.6 Mornington Crescent where we will visit next.

Our walk today begins at Mornington Crescent Underground Station which is another example of the creative architecture of Leslie Green whom I have mentioned in previous chapters. His entrance façade of ox-blood glazed tiles and interior finishes of classic tiling are undoubtedly of historic significance and aesthetically so pleasing. The station was built in 1907 as part of the original Charing Cross/Euston & Hampstead Railway, which following its opening remained virtually unused for many years, open only on weekdays. Long before the station was conceived a small part of the area on which it was constructed acted as the staging platform for a Gibbet used for public executions, and on occasions criminals were displayed in a suspended cage for public exhibition. In 1922 the station was closed for essential lift maintenance, the lifts were 85 years old, it subsequently remained closed for most of the 1990's as several major structural defects were discovered. During this period there were rumours that the station would close permanently, however a major media campaign was launched by the BBC to stop the closure, as Mornington Crescent had become an iconic feature in the Radio 4 panel game 'I'm Sorry I Haven't a Clue'.

From the tube station I cross the busy intersection which links three main arteries of traffic flow and walk south making my way down Mornington Crescent, a delightful street with terraced houses that has retained its Georgian elegance. The houses themselves were built using yellow stock bricks, with a channelled cream stucco finish on the ground floor, and I suspect that there were more trees lining the crescent originally, together with an area of garden at the front, there is still an air of propriety to enjoy. At the far end of the crescent, to the right, stands the former house of Walter Sickert and at the midpoint of the crescent stands an enormous obelisk structure (at the rear of the Carreras Building) which deserves some mention. This structure formed part of the Arcadia Works (Carreras Building) and is in fact an enormous chimney which was built as part of the Egyptian design for the building that was inspired by the Temple of Bubastis in the Nile Delta, more of this later.

Mornington Crescent was first built in 1820 and named after the Earl of Mornington, the brother of the Duke of Wellington. The crescent itself is designed in three parts and was originally laid out around a large communal garden which once faced open green fields, something that CD would have been familiar with. Following the advent of the railways in this district during the early Victorian period the demographic vista was sadly altered as were the majority of houses which were then occupied by multiple tenants of various classes and occupations. I think that Mornington Crescent still remains an architectural delight and has retained its original splendour, even though change has re-orientated its intrinsic properties. The communal gardens may have gone, however, the building which now stands on that ground is one of iconic status in its own right, I refer to the former Carreras Cigarette Factory which was later renamed Greater London House.

Crossing the busy Hampstead Road and now heading towards Oakley Square with Harrington Gardens to the left, one simply cannot miss noticing the wonderful building which was once the Carreras Cigarette Factory that spans the length of the final part of Hampstead Road. This building was constructed between 1926 and 1928 and its striking Art Deco appearance was modelled on the 20th century Egyptian Revival style. As I have already mentioned the building was erected on the former site of the communal gardens, that once fronted Mornington Crescent, and the architects responsible for this edifice were M.E Collins (1861-1944) and his brother O.H Collins (1864-1932) together with a Mr A.G. Porri. Unfortunately there was very little information at hand about these talented architects but their building remains for everyone to enjoy.

When viewing this building from Hampstead Road it is easy to see just why architects and the general public alike marvelled over the Egyptian theme which was so popular at that period. Today the building has undergone some major change especially in the early 1960's when it was converted into offices, however the wonderful external detail remains and is unmistakeably in the Egyptian style. When first built the Carreras Building formed part of the Carreras Tobacco Company, which was flourishing at that period as demand for their fashionable cigarettes was probably at its peak, albeit that the original Turkish tobacco was becoming less popular.

In the 1920's architecture was embracing the discovery of Tutankhamun's tomb, Egyptian styled buildings and artefacts were being created worldwide and this theme was becoming associated with luxury and wealth, in fact Egyptian motifs were being adopted almost everywhere. When the building was first opened a lavish ceremony took place outside the main entrance with mountains of sand brought in to depict the deserts of Egypt. Actors were employed to recreate and perform exotic scenes which included a chariot race in Hampstead Road!

At the entrance to the building were two bronze statues depicting the Egyptian God Bastel, and this image was later adopted as a branding media for the fashionable Craven "A" cigarette, which I remember vividly on display placards everywhere during the 1950's and 1960's. The external appearance of the Carreras Building today is almost as striking as it was when first built, the walls are faced in white cement coloured sand, it has a colonnade of 12 large papyriform columns painted in bright vivid colours, and added fragments of Venetian glass to enhance the overall effect, simply stunning. This is one of my all-time favourite buildings in London and well worth the trip on its own merit.

Having now reached Eversholt Street we cross over this busy junction and immediately ahead are the very pleasant gardens adjoining Oakley Square. Oakley Square has some fine examples of Georgian housing each with their own attractive balconies overlooking Oakley Gardens. This small but attractive area was named after Oakley House, once owned by the Duke of Bedford. It was first laid out around 1845 and only the northern elevation of terraced houses remain today. This area was originally designed for use by the Duke, his heirs and those living in the square itself, which at that period was said to be set in far more elaborate surroundings compared with today. Looking at maps of this period I see many changes have taken place since CD lived here, even the 1863 map stills shows the original church of St Matthew which has long gone, however the Old Vicarage (1861) remains (now a private home), as does the Lodge, a 19th century stuccoed building displaying the Bedford coat of arms on a circular plaque fixed on a facing wall.

The gardens are quite an unusual shape but never the less very attractive, with lots of trees, benches, snaking paths, rose beds

and laurel bushes all encompassed by robust railings which were so fashionable at that period. Judging by the amount of people using this garden, either simply sitting, reading, or eating their lunch, this is a popular escape for the office workers and residents who are local to this area.

Moving on now I continue my walk by leaving the gardens and travelling north along Eversholt Street towards Camden High Street where I pass many Georgian styled buildings with shops and eating houses on the street level, and I eventually pass Crowndale Library which I have previously used to research the history of Camden. At this point I arrive back to where we started on the east side of Mornington Crescent Underground Station, which is sited on the very busy junction of Camden High Street. In the central area of this junction stands the memorial to Richard Cobden (1804-1865) who in 1848 lived in Westbourne Terrace, Paddington, but was considered important enough to erect a remarkably well made statue in his honour.

Cobden was a manufacturer, a Radical and Liberal Statesman who played a major part in the formation of the Anti-Corn Law League which was started in 1836 to abolish the Corn Laws and create a free trade economy. He was a much travelled man who met many of the leading statesmen of his time, largely as a Radical supporting the principles of free trade, peace and disarmament. His campaigning exploits had cost him his business, as well as his health throughout his years of travelling the world in an attempt to promote a style of industry that he considered would benefit everyone. Although sometimes ridiculed by the Government and his constituents when attempting to bring about nationalisation and a co-operative industry, he was eventually praised by his country and other leading nations. A number of memorials were later dedicated to him, the statue in Camden is just one of those which was funded by public subscription as well as one noted admirer, no less than Napoleon III.

Having passed the Cobden Memorial I now walk along the east side of Camden High Street and pass the former Camden Palace Theatre, today known as KOKO. The Palace Theatre first opened in 1900 and could seat an audience of almost 2500 people, which made it one of the largest theatres in London outside of the West End. The building was designed by the Australian architect W.G.R Sprague

(1863-1933) who was an acclaimed designer of similar buildings during his career. Although none of Sprague's music halls survive today, many of his theatres remain, such as those in London namely the Aldwych, Wyndham's, St. Martin's and the Ambassadors to name but a few.

When first opened the Palace Theatre was largely used for operatic performances and then variety theatre, when in 1928 it was taken over by the Gaumont British Cinema Company. After World War II it was used for the BBC Radio Theatre, staging shows which included The Goon Show and Monty Python's Flying Circus. In 1982 it was renamed the Camden Palace and was the venue for Madonna's first UK performance. By 2004 this once vibrant theatre had become completely run down, and was sold again and completely restored for live concerts, club nights, television productions and many other commercial and corporate events. Since this transformation many famous top performers have used this venue such as Sir Elton John, Madonna, Coldplay, Amy Whitehouse and Lady Gaga to name but a few, thereby completely revitalising this venue for many years to come.

Having now crossed over Camden High Street I continue walking past the busy looking shops which line this street and I must confess that when looking above the shop fronts it is plainly obvious that many of the buildings are in need of some immediate attention as most look very tired and require a great deal of maintenance work. Unlike most people I tend to always look upward when viewing buildings and the like, and I am always amazed rather than surprised, just how dilapidated many period designed high street properties have become. Today is slightly more enlightening as I have noticed that whilst the high facades need attention, a few side streets that run off of the high street have facing walls with tastefully commissioned graffiti on display. In fact as I pass one street an artist is working from scaffolding and has almost completed an amazing portrait in a vast array of colours that is simply quite stunning. In doing so the owner of this building has turned what was originally a dark and dirty brick surface into a vibrant form of art which I question anyone to dislike. When commissioned and completed by accredited artists, graffiti work can be beautiful as is the case here, 'what was once gloom has become light'.

As I reach Delancey Street, I turn left and walk the short distance to the first set of traffic lights, in doing so I am amazed at the number of eating places which nestle between the post war and modern buildings, but the real treat comes when I sense the wonderful aroma of freshly ground coffee that is permeating from a tiny shop frontage that is the Camden Coffee Shop. Words simply can't express my delight in savouring the aromas along this passage, a rare and wonderful reminder of my early years when I lived in Sutton and walked occasionally past a similar shop at the top of the high street on the way to the cinema. Camden Coffee Shop adds such a unique and bohemian flavour to this area, its shelves are packed with coffee bean bags full of wonderful beans waiting to be ground down for people to enjoy. Today there are several people standing in this small shop therefore I cannot investigate further, but I certainly will return and purchase some fresh ground coffee at a later date.

Having dragged myself away from the front of the Camden Coffee Shop I now cross over the road to the next section of Delancey Street and continue walking until I reach Albert Street on my right, where I will be walking along next. Albert Street is a well-appointed and attractive street which is tree lined and enjoys a wide road, a substantial parking area and pavement. Many of the carefully maintained Georgian style properties have attractive and practical balconies, some houses have exterior foliage others have retained the stucco appearance, most of which appear to be single occupancy, all of which are very desirable. At the far end of this street is situated the Jewish Museum, which is an interesting venue to visit along this part of our walk.

Although the exterior appearance of the Jewish Museum would indicate that it is quite a modern and recent introduction, one would be wrong, as this museum is actually 80 years old, having said that it has only been situated in Camden since 1994. Prior to moving to Albert Street it was previously situated in Bloomsbury. Having not visited the museum at the time of writing I rely on my research, which informs me that its prime aim is to retain the history of Jewish people across London and reflect on the atrocities of the Holocaust during the Nazi regime. Today the building in Albert Street has been extensively remodelled and extended and was re-opened to the general public in 2010. The wonderful architectural façade of the

museum hides a plethora of interesting British history and houses treasured artefacts, libraries, and photographic archives that I am sure is well worth a visit. There is also said to be an extensive collection of prints and drawings of the social history of Jewish people and their way of life of which some are depicted by noted artists and caricaturists.

At the end of Albert Street we pass yet more eating houses that are all busy, which is a good sign and eventually reach Parkway which after a short walk will take us to Arlington Road. Parkway is jam packed with interesting restaurants and bistros and I suspect very popular in the evenings and at weekends. Having said that it is really busy today on a Thursday afternoon, the energy coming from this area is vibrant and judging by the number of customers eating alfresco, the cuisine looks very appetising.

After walking the short distance along Arlington Road turn left into Inverness Street and continue walking towards Gloucester Crescent, glance back and in doing so you will notice the open market with its many busy stalls in the centre of the road, and yet more eating houses which line this thoroughfare. Looking ahead we see that Inverness Street is a mixture of modern and old buildings, many post war, and to the left stands Cavendish Independent Prepatory School which was founded in 1875 by a Catholic Order. This prestigious school accepts young girls of all faiths and beliefs and I guess has plenty of pupils from the surrounding area.

At the end of Inverness Street we arrive at the central part of Gloucester Crescent, and in line with our CD theme, turn left and walk along this half of the crescent before reaching a significant house which features prominently in CD's life. Before we reach No.70 Gloucester Crescent I should comment on the crescent itself which to my mind certainly falls into the category of 'exceptional des-res', no overstatement for these extremely attractive and well maintained properties. Both sides of the crescent are lined with Georgian houses of differing shapes, sizes and levels, the levels are aided by the fact that the crescent has a steady incline on both sides from the centre point where we started. First appearances would suggest that the traditional front gardens of Dickens period have been retained, the pavement has well established trees, with some new additions, and I suspect without the modern vehicles which line the road it has not changed much in

150 years. Having said that, my 1863 map shows a number of roads went by other names in this vicinity and there appear to be fewer houses built on the northern part of Gloucester Crescent

As we make our way to the top of Gloucester Crescent which leads to Oval Road, on the right we arrive at No.70, the former house of Catherine Dickens which she moved into following her separation with CD in 1858. Sadly CD's marriage to Catherine was over when she moved into this house with her young son Charles Jnr, the breakdown of their relationship had been coming for some time. CD was later to have said that Catherine was a bad housekeeper and caused him financial worries, and even blamed Catherine for the birth of their 10 children, which I find incredible. Even stranger was the fact that Catherine's sister Georgina stayed with CD to tend the remaining Dickens' children. Ironically, CD never at any time admitted to his affair with Ellen Ternan, which came to a head once Catherine accidently received a bracelet that was originally purchased for Miss Ternan. After the separation Catherine and CD didn't correspond with each other very much, and Catherine lived the remainder of her life at Gloucester Crescent until her death in 1879.

In many ways No.70 Gloucester Crescent has an air of sadness as one views it from the street, although extremely well maintained from an exterior perspective, knowing the circumstances of this property in CD's life one can only hope that other owners have experienced happier times whilst living here.

After a few yards we reach Oval Road and turn right and walk the length of this pleasant road enjoying the architecture on both sides. To our right stands a very desirable row of Georgian styled terraced houses in Regents Park Terrace (which run parallel with Oval Road). This road like many in this area has some very attractive properties to view along our walk, best described as a mixture of old and new buildings, houses on the opposite side of the road are an assortment of large detached, and decorative style properties, which oddly enough have small back gardens that overlook the railway. One particular property which I really like is a very fashionable Art Deco styled house which embraces the early period of the 20th century.

Having now reached the far end of Oval Road it becomes clear when I pass a small castellated building across the road that we are now standing above the Regents Canal and facing Gilbeys Yard. The

view below is very inviting as I watch pedestrians and water craft alike making their way along this historic and attractive canal, but realise that I need to press on and perhaps take a canal walk another day. In 1863 I would have seen a large storage depot to my left and a flour mill to my right before crossing the canal, today my attention is directed to the castellated building which is of course the Pirate Castle, a superb water based activities adventure centre that caters for people of all ages. Although the main focus is centred on water based activities and associated training courses, Pirate Castle also provides workshops in theatre, computer classes, canal-boat hire, children's activities, singing, dancing, Yoga and Taekwondo classes. The Pirate Castle was originally created in 1966 by Lord St. David's, it is said that a group of young boys asked him if they could row his boat which was moored close by, he agreed and those boys returned again with others thereby fashioning the foundation stone for the Pirate Castle which the community now enjoy today.

Perhaps a brief description of the Regent Canal Way may whet a few appetites for future walks, which I can assure you are well worth the effort, just remember to bring some insect repellent in the summer months. The canal begins at the intersection with the Grand Junction Canal (known as Little Venice) situated near Paddington Basin and continues through Camden Town. From here it flows behind St. Pancras & Kings Cross railway stations continuing eastwards beyond the Islington Tunnel where it meets the Hertford Union Canal by Victoria Park. Finally it turns south into Limehouse and eventually into the River Thames. Historically the development of the canal really kicked off in 1812 when an Act was passed to link the Grand Union Canal to Limehouse, George IV gave his name to this project and his friend John Nash became one of the project directors. Between 1812 and 1820 the Regent Canal opened in two phases after a hazardous period of setbacks which included the embezzlement of funds, and a host of innovative ideas to spend even more money such as the formation of a massive lock in Hampstead Road! During the construction of the canal, water supplies fell short and the River Brent was dammed to provide a water reservoir for the canals needs.

The prime use for the canal was to assist trade using the large fleet of cargo barges to distribute the seaborne cargo that was unloaded at

Regent Canal Dock. From archive pictures of the day it would appear that there were scores of large warehouses and factories lining the canal each having their own specific purpose and of course providing work for the local community. By the 1840's the railway was taking trade away from the river and at one time a scheme was proposed to remove the water from the canal, lay railway lines and replace the route with railways. The intensity of the Industrial Revolution at this period was moving so fast that innovative ideas and invention were cancelling one another out at a rapid pace, thereby wasting huge amounts of money in the process to achieve progress. With the advent of the railways and motor transport, trade diminished greatly on the canal throughout the intervening years, then fortuitously in the 1920's a merger was agreed by the canal owners to form the Grand Union Canal Company. By the early 1940's traffic had increased considerably as the canals were helping the burden put on the railways during World War II. In the late 1940's the waterways were nationalised but sadly by the 1960's trade had almost ceased. Today the canal is purely for pleasure and leisure pursuits with some relaxing boat trips available which travel between Little Venice to Camden Lock.

At Gilbeys Yard I am confronted with the car park of a very popular supermarket and can see a sign some distance to my right on a small structure which houses a staircase, that informs me to take this route to gain access to Camden Lock Market. I make my way down the staircase and arrive directly into the crowded market and immediately gaze at the many stalls enclosed in this very popular site.

Camden Lock Market was in CD's day a timber yard which unloaded timber from large barges to smaller narrow boats who in turn took their cargo on the inland canals. By 1971 this means of transportation had long ceased and Camden Lock was reopened as an arts and craft market. At first the traders of this market worked from the old wooden sheds and yards which after a very short space of time turned into an industrious and trend setting industry. The artists trading here rented space where they could sell their goods, at the same time allowing the public to visit their workshops, which I suspect attracted huge crowds. By the 1980's the market scene had spread down as far as Camden Tube Station making property in the immediate area very sought after. In 1991 the Market Hall, a glass

roofed arcade was opened and got great press reviews and in the years that followed both the East Yard and West Yard followed suite.

The entire area surrounding Camden Lock Market is today alive with atmosphere especially in the evenings which attract many visitors for the active 'night life' as well as the shopping. Other markets equally enjoyable to visit include Stubbs Market, said to be the centre of the alternative fashion scene, and the recently improved Camden Lock Village together with Inverness Street Market which we glimpsed at earlier. Both these markets have a long history and were well used long before Camden was discovered by tourists.

It's time now to drag myself away from the market place and start the return leg of the walk by walking south down Chalk Farm Road towards Camden Town Underground. Although Chalk Farm doesn't feature in this walk it is never the less worth mentioning that just a short distance away from this road many notorious duelling activities used to take place in the late 18th and 19th century, I assume this is because of its close proximity to central London and the fact that there were acres of open field land. We know that during CD's lifetime this area had transformed from a quite and peaceful suburb into a busy London district, as so many writers of their day have provided descriptive accounts of their findings. CD refers to the seclusion of wonderful tea gardens scattered around Chalk Farm, comparing them with those near his Swiss residence in Lausanne. One particular article in Hone's 'Year Book' mentions the change of landscape during this period stating that 'the Hampstead Road and the once beautiful fields leading to and surrounding Chalk Farm had not escaped the profanation of the builders craft'.

Having finally reached Camden Town Underground Station by weaving my may through the crowds of visitors on both sides of this busy road, I come to what is locally known as Britannia Junction, I then cross this busy section and head towards Greenland Road at the same time noticing the World's End pub on the right. This pub has a really good selection of real ales and is noted for its quality of beer, well worth a visit, equally important is the history of this site which goes back several hundred years, in fact the first reference to an inn being here was in 1690. By the mid-18th century the drinking house was known as the Mother Red Cap Coaching Inn which stood here with its neighbour The Southampton (now known as Edwards).

The Mother Red Cap was considered a target and halfway house for highway men in the late 1600's. Sadly when Camden Road was laid down it crossed the grounds of the Mother Red Cap Inn which had to be reconstructed, the present building (Worlds End) dates from 1875. The name Mother Red Cap (real name Jinney Bingham) derived from a tale of an old lady who lived near the inn in the 17th century who was said to have practised witchcraft, the red cap being associated with witches and therefore this folklore tale. Jinney was the daughter of a brick maker, she became a mother at 16 and was said to have had several lovers, some of whom had died at her hand! Her parents were tried and hung as witches and following this trauma Jinney lived as a fortune-teller and healer in the former house left to her by her father. It is said that she travelled only at night and was protected by her black cat!

Our next destination is Bayham Street this lies just off Greenland Road and is well recorded as being the first house that CD lived in when he arrived here from Kent with his family in 1822. No.16 Bayham Street in 1822 was a fairly new built house on land backing onto meadows that was previously owned by the former Mother Red Cap Inn. The house itself was terraced and had four bedrooms, an attic, basement, and living room with a scullery at the rear, into this went CD's parents, six children, a lodger and a housemaid. During his relatively short stay here CD later recorded that it was one of the poorest districts in the suburbs of London. He said that there were no boys to befriend or play with as it was in a very remote locality, almost isolated from the town, however he did say that he enjoyed walking into town with his parents and remembered visiting his uncle Thomas Barrow when he lived nearby. Although the area was thought to be poor, he said that it was quite respectable and had newly paved roads, he also said that it was a 'damp and mean neighbourhood', a statement that I don't quite understand. I think it is fair to say that Bayham Street didn't hold fond memories for CD but he delighted in listening to the bands that played in the gardens of Mother Red Cap, he was however full of woe when he realised what he had left behind by moving from Chatham. It was here in Bayham Street that CD's two year old sister Harriet sadly died of smallpox and I am absolutely amazed how the remainder of the household escaped this horrible disease knowing the constraints of their living accommodation.

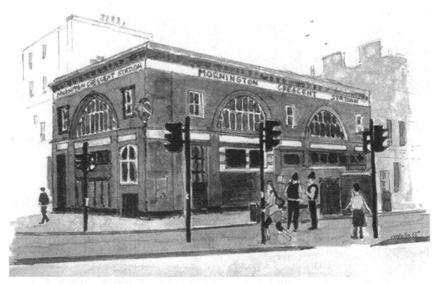

Fig 28 Mornington Crescent Underground Station

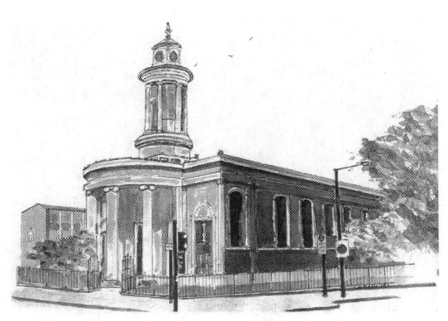

Fig 29 Greek Orthodox Cathedral Church of All Saints

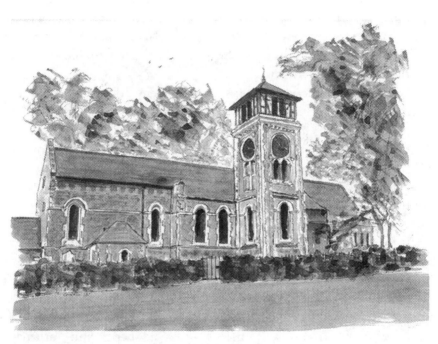

Fig 30 Old St Pancras Church

The original house that CD moved into in Bayham Street was sadly demolished in 1910, and all that remains of the site is a small plaque fixed to the wall of a more recently built property which today faces No.140. However there are other reminders to take into account that contribute to the historical value of our walk. Two interesting snippets of information come from CD's close friend John Forster who wrote in later years that the original Bayham Street house was a 'small mean tenement house, with a wretched garden', he also recorded that CD later mentioned that his next door neighbour was a washerwoman! Forster also remembered CD reminiscing about the fact that as a young boy he used to walk down Bayham Street and could actually see the dome of St Paul's Cathedral in the distance, certainly not possible today.

Whilst we walk down this street today there is one very interesting and well preserved building that CD would have walked past often, which he commented on and which was called St. Martin's Alms-houses on our left. This small group of terraced houses is partially hidden behind a high row of privet hedges and sits well back from the street, but one can still see quite clearly that they are numbered 1-9. These Grade II listed properties built between 1817 and 1818 were constructed by the Parish of St. Martins-in the-Fields. They form a row of two-story buildings with a pedimented centre piece, having granite columns and foliated capitals to the centre of the building. The alms-houses were constructed to house up to 70 poor widows or spinsters from the Parish of St. Martins-in-the-Fields, and were erected on the west side of the former burial grounds which faced Bayham Street. No.5 once housed a chapel and infirmary and additional rooms were added after 1879. A resident nurse and superintendent were on call to tend the occupants as the Alms-houses were by tradition charitable shelters for the elderly and poor to live in without payment of rent, and originate from the 10th century. They were, and still are to a certain extent, maintained by both charities and trustees usually from European Christian institutions using donated funds.

In later years William Penn (1644-1718) English real estate entrepreneur, Quaker and philosopher, introduced this charitable service to the Commonwealth of Pennsylvania. Because many of the medieval alms-houses were established simply with the aim of

aiding the souls of their respective benefactors, they were regarded as charities and therefore usually incorporated a chapel. Due to this concept many were dissolved during the Reformation, however today the religious link to alms-houses doesn't always apply. The present day voluntary sector still provide housing accommodation for the poor and needy, but they exist in their own merit largely remaining as independent schemes.

Having passed the alms-houses we continue to the traffic lights in Bayham Street, then turn left into Pratt Street (named after Earl Camden), walk a few yards and turn left into St. Martins Gardens. These gardens have a long history dating back to the early 13th century when the land was used as the site for a church, in 1801 the site was also linked to open farmland having two main fields called Upper Meadow and Upper Brook Meadow. The following year an Act of Parliament was granted to turn the four acres of land into a burial ground called Camden Town Cemetery. In 1805 the cemetery was first opened and in 1817 permission was granted to give up part of the land to build the alms-houses previously passed. By 1854 the second Act of Parliament was passed to grant development leases on certain unused parts of the burial ground and created quite a stir, by 1884 the cemetery was no longer in use and the grounds were laid out as gardens which we can enjoy today. These beautifully maintained and well laid out gardens are open to the public and consist of a manageable and well-rounded mix of established trees, grass areas, wild flower borders, and has a wonderful children's playing area which appears to be well used. I can see why it does attract many visitors as there is a comfortable air of serenity the moment you enter the garden, my only criticism is a personal one and is purely aimed at the distribution of some of the former headstones. To many the random placement of these memorials might be considered attractive, I beg to differ, but I think we would all agree that the gardens are well worth a visit. Many noted people were buried in this former cemetery none more so than Sir Richard Birnie (1760-1832) Court Magistrate who throughout his life retained the favour of George IV, some would say to gain legal advantage. Birnie was said to have taken the initiative to 'read the Riot Act' in 1822, at the funeral of Queen Caroline wife of George IV, as a large crowd had gathered in remembrance to her. Queen

Caroline separated from George IV in 1814 and left England under a cloud of rumour and unfaithfulness, which half of the relationship was responsible is for the reader to decide! In 1820 Charlotte returned to Britain to assert her position as Queen, she was a popular figure, unlike George and a reformist who opposed the King, which gave her quite a large following that was seen as being 'unhealthy'. One should remember that the Riot Act stipulated that no more than 12 people should congregate at any one time when certain events were either staged, or in this case by way of mourning, the penalty could have resulted in death!

Credit in more recent years must go to the Friends of St. Martins Gardens who have worked hard to service and maintain this area which I consider to be one of my favourite gardens in London, especially the shrub beds and wild flower borders.

It is now time to exit St. Martins Gardens by way of Camden Street (children's playground entrance), then cross over this busy road where we find ourselves facing the Greek Orthodox Church of All Saints. Externally this graceful church exterior simply dominates this location as it is not only large but it also sends out a powerful statement that this is an important place of worship. Originally this church was built for the Church of England, but in 1948 it became Greek Orthodox serving the local Greek community. The church was originally built between 1822 and 1824 and was then known by its parishioners as St. Stephen's although formerly called Camden Chapel, it wasn't until 1920 that the name All Saints was dedicated.

Designed by architects William and Henry Inwood who also blueprinted St Pancras New Church, it received some critical remarks when first built, as one noted person remarked that its tower and steeple were undersized in proportion to the main structure, I actually think the architects got it right. The external fabric is of yellow stock brickwork with Portland stone facing to both the east and west elevation, it is primarily rectangular in design having a semi-circular portico at the west end. The tower above the portico has some graceful columns said to be an imitation of the Choragic Monument of Lysicrates in Athens.

Internally the design layout consists of galleries on three sides supported by superbly decorated Ionic columns, in fact the entire church has a fresh and welcoming appearance largely due to the

sensitive renovation in 2009 which was funded by donations from the Greek Orthodox Community. There is a beautifully carved Iconic screen which separates the apse from the main body of the church that was carved by a talented artist named Chrysanthos K. Taliadorou in 1974, who resided in Nicosia. He is also responsible for the creation of the Holy Table and Ciborium (canopy supported on 4 pillars). Now a Grade I listed building the church has three wonderful 18th century stained glass circular panels which can be seen in the windows of the apse.

Originally this former Church of England house of worship received its parish status in 1852 when at that period it had a very large congregation, sadly by the late 1940's the congregation had decreased substantially thereby threatening its very existence. Fortuitously the largely Greek Cypriot community of this area regenerated this wonderful church, and today worshipers come from many other districts of London and in 1991 the Greek Orthodox Church of All Saints was elevated to the status of a cathedral.

After leaving this church we return to Pratt Street and walk east a few yards passing a mixture of old and new buildings until we reach College Place which is our next location. The short period that CD spent here at 112 College Place (then called Little College Street) has I assume altered little from what we see today. The robust terraced buildings we see have been well preserved although the majority have been sub-divided into apartments, never the less I would like to imagine it to be much the same as CD remembered it without the tarmacadam road and its modern vehicles parked in the street. Several trees line the pavements and No.112 has a freshly painted black front door which is totally in keeping with the period of design. CD stayed here with a Mrs Roylance, whom he disliked, when his family were guests at the Marshalsea (with the exception of his elder sister Fanny who boarded at her music academy). Mrs Royance was said to have taken in children at this address, and was said to have treated them abysmally. Whilst living under Mrs Royance's strict regime CD missed his family and felt distanced from the Marshalsea, which is why both he and Fanny walked there every Sunday to stay with their parents. It wasn't long before CD was moved off to a happier lodging house in Lant Street, which we visited in an earlier walk.

College Place runs parallel with Royal College Street where in 1825 a surgeon was called to treat a bullet wound to a 'gentleman' in a pub named the Camden Arms. Apparently a certain Lieutenant Colonel David Fawcett had been wounded in a duel close by. The following morning he had died of his wounds after surgeons had attended to him throughout the night, this incident was the talking point of the day as the soldier who had been killed in the duel was the brother-in-law of his opponent a certain Lieutenant Alexander Munro. Yet another duelling event which seems to have plagued this district.

At the end of College Place we turn left and walk to Royal College Street where we turn right before arriving at the Royal Veterinary College of London. Walking down this road I observe what is currently a complicated parking pattern, with vehicles doubled parked leaving a very narrow passage in the centre for through traffic . . . interesting! What is more interesting is the stylish period red brick buildings to my left which make up the Veterinary College of London. The original college was founded in 1791 via a group led by the grandson of William Penn, which was the forerunner to the veterinary profession in the UK. The Earl of Camden at that period was developing parts of his vast estate in north London, and some fields where we now stand were sold for building land in order to build the first college. At that time the site chosen was surrounded by rural countryside even though Camden Town was becoming a popular development area.

By 1792 the four founding students began their studies here in a small building and in 1793 a horse was admitted for treatment. At that period the students tended horses and livestock only but later additional breeds of animals were accepted and indeed arrived. Eventually the new college building was completed in the neoclassical style having a separate paddock across from Royal College Street, and the first qualified veterinary surgeon to leave the college was John Shipp who worked with the British Army. By the 19th century King George IV awarded the hospital royal patronage (1884) and by 1875 the college was granted a Royal Charter as a veterinary college. In 1879 The Cheap Practice Clinic was established for poorer people who could not afford to pay external surgeons fees for treatment to their animals. By 1927 the original buildings had become obsolete

and declared to be dangerous structures, therefore a fund raising scheme was devised to rebuild the entire college and by 1933 work was completed and the Beaumont Animals Hospital was opened. The name Beaumont deriving from the wealthy daughter of Mr J Beaumont, namely Sarah Martin Grove-Grady, who contributed a vast sum of money for this project. Five years later George VI opened further buildings and by 1949 the Royal Veterinary College (RVC) had become a school of the University of London. Today the RVC is one of the world's leading specialist veterinary institutions and is ranked extremely highly in the study of Epidemiology, Pathology, Clinical Science and Endemic & Exotic Diseases. Both the small and large animal hospitals treat over 20,000 patients each year.

At the end of Royal College Street we find ourselves facing Goldington Crescent Gardens which provides a very pleasant intersection for the busy roads which meet at this junction. The small comfortable gardens in front of the crescent provide a pleasant area to sit away from the hustle and bustle of city life and have plenty of benched seating to sit and enjoy some quite unusual creative artwork on display. One nice feature is the original 19th century cattle trough and drinking fountain found outside the gardens at the north end, these once common features in CD's day are not everywhere to be seen today as they were then but do compliment the overall perspective of this area.

The Grade II listed houses which we can now see were built on land owned by the Duke of Bedford and a certain Mr A Wilkinson, who between them originally owned all of the properties. I really like these 12 original buildings which are constructed of yellow stock bricks with rusticated stucco ground floors. Each rounded arched doorway is so attractive especially with the first floor cast iron balconies.

Looking at my 1863 map I feel quite sure that CD was well aware of the former St Pancras Workhouse which was in use for many years and was located adjacent to the gardens where St Pancras Hospital now stands. In its day the workhouse was considered to be one of the largest in London and before closing had between 1500-1900 inmates. The original workhouse was formed around 1777 and only supported 120 inmates, but by 1788 a new building had been erected which was isolated by a high wall surrounding

the buildings. These buildings were said to be a mixture of small houses but according to my 1863 map it clearly shows a large central building with other smaller units within the grounds. The male and female inmates of the workhouse were separated into different wings, and in true Victorian style there were wards segregating those they termed as Lunatics & Idiots. There was even provision made for a stone breaking yard, which was located fairly near the bake house and laundry. The laundry incidentally was said to have incorporated new machinery which could launder 8,000 articles of washing every week, even the cooking was said to be done on an industrial scale. By 1856 conditions were reported to be very bad within the workhouse and an investigation was carried out, its findings revealed that it was grossly overcrowded, some patients even sleeping on the infirmary floor. There was hardly any fresh air in circulation which resulted in both patients and staff continually suffering from a form of sickness, some Typhus cases were also confirmed. On the findings of this report it was proposed to build a new purpose built and much larger workhouse but this idea was shelved and the existing buildings continued to be used at the same time falling into disrepair. In 1890-96 a number of new buildings were eventually erected, parts of which were damaged in World War II, these were demolished at the same time as the main 1809 building.

In later years the workhouse became an Infirmary and eventually developed into the St Pancras Hospital that we know today, which is now controlled by the Primary Care Trust and specialises in geriatric & psychiatric medicine.

From Goldington Crescent I can clearly see my final destination for this walk which will include two commemorative and historic places in this district, one being St Pancras Gardens the other Old St Pancras Church. Having crossed St Pancras Road I enter the gardens through a wonderfully restored set of metal gates, parts of which are gilded, the entrance has a nice arch and the initials SP are clear to be seen. The gardens replaced the original churchyard of St Pancras Old Church, which incorporated the burial grounds of St Giles-in-the-Fields (Covent Garden) and was first opened as a garden in 1877. This garden has what is described as a number of little avenues to walk around and a well presented notice board provides us with a great deal of information about this site. Sitting at a higher level

several yards directly ahead of me is the impressive memorial to CD's former friend Angela Burdett-Coutts, almost a miniature replica of the Albert Memorial with an elaborate sun dial towering above, with raised mosaic plinths on all sides and small shrubbery planted on three levels, this is a nice touch. Standing guard either side of the memorial sit two statues, a lion to left and a dog to the right, all of which are contained within low iron railings.

Several other noted people were actually buried here, Johann Bach (1735-1782) composer, youngest son of Johann Sebastien and William Franklin (1730-1814) soldier, illegitimate son of Benjamin Franklin, who are just two of many. Sir John Sloane designed a tomb for his wife and himself here, and this mausoleum is said to have given Sir Giles Gilbert Scott the idea for his design of the former red telephone boxes.

At the eastern end of the garden stands a small church, which I am sure most Londoners have little or no knowledge of whatsoever, yet is arguably an icon of Christian worship in England. I refer to St Pancras Old Church which is believed to be the oldest site for Christian worship in England, and whose name is associated with a Roman martyr from 289AD who was beheaded at the age of 14 for his Christian beliefs. History suggests that the first church given the name St Pancras was here in 314 AD, other evidence would indicate that remains of the same church feature in the Doomsday Book. After the population of the Parish of St Pancras deserted this area in the 14th century the church fell into disrepair and services were only held here on one Sunday of each month.

By 1822 St Pancras Parish Church had been built, however, the derelict remains of the original Old Church were sensitively restored, the entire external carcass being reworked with a new tower being built. In 1888 and again in 1925 further restoration took place which included the plaster ceiling and removal of the side galleries. The church was heavily damaged in World War II and again repaired, following which it was awarded a Grade II listing in 1954. Although having been subjected to the wounds of age and conflict I still marvel each time I enter this small oasis of history and gaze at the internal condition which clearly shows several stages of its former construction. Having visited many wonderful churches throughout my travels and marvelled at the construction, wealth and splendour

of the majority of them, I have to confess that St Pancras Old Church sits amongst my favourites, not for the reasons I have just mentioned but simply for its resilience in surviving and the humble way it projects itself.

On that note our walk is complete and I shall simply sit and enjoy the church for a little while longer before heading home to compile my notes. When I arrive at Victoria Station I realise that I had not stopped in Camden for my coffee treat at Caffe Nero so I decided to visit their coffee shop at Wilcox Place (a short walk away) where I can sit outside alfresco and enjoy an iced mocha frappe latte and a panini the perfect way to finish a most enjoyable walk.

WALK TEN - WHITECHAPEL & SPITALFIELDS

N
W E
S

1. Trinity Square
2. Savage Gardens
3. Pepys Street
4. St. Olave's Church
5. French Ordinary Court
6. Paleys Upon Pilers
7. Aldgate Pump
8. St. Katherine Cree

9. Bevis Marks
10. St. Botolph's Church
11. London Metropolitan University
12. Whitechapel Gallery
13. Toynbee Hall
14. Petticote Lane
15. Old Spitalfields Market
16. Christ Church Spitalfields
17. The Great Mosque
18. Whitechapel Bell Foundry
19. East London Mosque
20. Former Site of Whitechapel Workhouse
21. Royal London Hospital

WALK 10

WHITECHAPEL & SPITALFIELDS

> "Take nothing on its looks; take everything on evidence.
> There's no better rule."
> (Great Expectations—1860)

This coming walk will enlighten the reader of the early history of Whitechapel and Spitalfields and certainly identify a cacophony of social deprivation, poverty and crime recorded in events that occurred from the 18th century to the 21st century. Sadly both of these interesting East London districts have taken longer to rejuvenate their once rich commercial and environmental status when compared to other former boroughs of similar historic significance. CD visited these areas often and recorded his views and feelings, always sympathetic to the plight of the underprivileged inhabitants he witnessed first-hand. Poverty was everywhere in these districts during his lifetime and there was an abundance of crime which made his travels considerably onerous on occasions.

Whitechapel itself is an East London district within today's Tower Hamlets, located approximately half a mile east of St. Paul's, which continues through to the east side of the Royal London Hospital. Its northern and southern boundaries extend from Fashion Street in the north to The Highways in the south. The earliest known church or 'chapel of ease' was St. Mary's (1329) and by 1338 it had become a parish church, it was renamed St. Mary's Matfellows, Whitechapel, and was accessed from a street that led from Aldgate to the church.

Records suggest that Charles I's executioner, a man named Brandon, was buried here and was paid the enormous sum in those days of £30 to perform this task. The street itself was rendered impassable in the late 16th century due to its poor state of repair and in 1572 Parliament approved that the surface should be paved. This road as far as I can interpret was part of the Old Roman Road, which ran from the City to Colchester and follows the same path as today's Whitechapel Road.

From the 1500's tanners, butchers, brewers, fishmongers, dairies, slaughterhouses and metalwork's applied their less fashionable trades here, each one creating monumental environmental problems due to the nature of their work. By the end of the 17th century Whitechapel was said to be a relatively prosperous, and arguably a highly fashionable district. This growth in trade attracted many destitute people into the area creating some infamous 'rookeries' that immediately downgraded an agreeable society. By the 1840's overcrowding and poverty became rife and streets such as Dorset Street acquired the reputation of being the 'worst in London'. A large proportion of the population of Whitechapel in the late 1880's were Russian, Polish and German Jews who cohabited together with the many Irish immigrants forced like them to find work of any kind. Whitechapel remained poor throughout the first half of the 20th century and is still recovering; today the Bangladeshi population make up 52% of the ward.

I hope to paint a more genteel and respectful picture of Whitechapel during the course of this walk, more so than many articles published in the past by former noted writers and biographers. I sensed that whenever I read descriptive articles about Whitechapel, especially those between 1850 and 1920, social credibility rather than circumstances were used.

Spitalfields like Whitechapel is also a district still chasing its former glory and geographically covers an area encompassing Commercial Street, Old Spitalfields Market, Brick Lane Markets, Cheshire Street and Petticoat Lane Market. The name Spitalfields is thought to have derived from land belonging to St. Mary Spitalfield, a priory hospital built in 1197. Originally Spitalfields consisted of many acres of fields and nurseries until the late 17th century when streets were laid down for the Irish and Huguenot immigrants who

fled here. The Huguenot master weavers developed many areas here by building bespoke homes in the then newly formed Spital Square, whilst the poorer weavers remained in shabby rented accommodation.

Irish weavers arrived in the 1730's creating various problems within the industrious silk industry that culminated in the Spitalfields Riots of 1769, the riots were principally caused by the concerns that producers had regarding imported printed calico from France. By the Victorian era the silk industry had entered into decline and the surrounding districts degenerated into slum areas.

In the years that followed the decline in the silk industry, the purpose built large windowed and tastefully appointed Huguenot homes were then purchased and used by the Jewish immigrants. They fully utilised the original shop fronts and living accommodation above, at the same time creating a new form of textile industry. Even with this regeneration of industry by the end of the 19th century Spitalfields sadly had become one of the worst 'rookery' areas for crime in London. Spitalfields continued to have a large Jewish presence until the late 20th century, being replaced by an influx of Bangladeshi immigrants who likewise continued in maintaining a surprisingly busy textile industry to this day.

The actual walk today will encompass many interesting locations and buildings which span several era's of these districts, CD would still be familiar with many sights we pass including a few in Aldgate, and whilst walking these streets I cannot overlook a sequence of events in Whitechapels historic past, I refer of course to the horrific Whitechapel Murders that the public probably associate with more than any other period of its former history.

This walk starts at Trinity Square Gardens which is a stones throw from Tower Hill Underground Station, and provides a very pleasant greenery area which will not be replicated on our journey, unlike previous walks today is mainly tarmac and paving. The gardens are surrounded by buildings of all ages and sizes, each having their own historic tale to tell as one would expect and there is very little in the way of peace and tranquillity here due to the high volume of City traffic. Where we are standing was once the site of the Tower Hill scaffold where many public executions took place (over 125 recorded), these continued until 1747. It is hard to believe that this barbaric public spectacle was once condoned by all classes and

even more difficult to accept that Sir Thomas Moore (1535), Anne Boleyn (1536) and Thomas Cromwell (1540) were just a few of those executed on this spot.

There is a wonderful war memorial on the south side of the garden, which commemorates those brave Merchant Navy sailors who died in both World Wars, the memorial to those who died in World War I is attributed to Sir Edwin Lutyens, and the World War II edifice to Sir Edward Maufe.

As we leave Trinity Gardens and head towards Savage Gardens, Trinity House is to our right, it is apparent that we are now entering the City district, as we are overshadowed by the imposing buildings that tower above us. Savage Gardens was named after an English peer, Sir Thomas Savage (1586-1635) who was closely associated with Charles I. His estates were taken away from him during the Civil War but were later restored; this was little consolation as tenants refused to pay his rent demands. Further problems arose following Savage's death and his estates were again taken away from his wife, who then left England for France in 1643, I cannot establish whether her family followed her there, she had eleven sons and eight daughters still living at that time!

Halfway along Savage Gardens we turn into Pepys Street whose name needs no explanation, this street is not shown on the 1863 map as the land immediately to our left then housed the East and West India Dock Company (warehouses) where Trinity House now stands. Pepys Street links Seething Lane to Coopers Row and was named after the great diarist as his home was once in Seething Lane during the time of the Great Fire of London. Although I have written much about Pepys in the past I simply cannot overlook the significance of this immediate location, as it was here that he wrote his great diaries. The Navy Office whom he worked for owned his house and he often attended services at the nearby St. Olave's Church, which we shall visit shortly. He lived in this particular house for 12 years and according to his diaries enjoyed every day of his stay here, and although owned by the Navy he spent a great deal of money effecting improvements to the property. His next-door neighbour incidentally was Sir William Penn, father of William Penn who discovered Pennsylvania. The adjoining gardens to Seething Lane sit on the original site of Pepys house and the former Naval Offices, it

was here that he reputedly buried his expensive wine and Parmesan cheese to protect them should the Great Fire reach his property. Pepys was instrumental in saving both his house and the offices by having nearby houses demolished thereby effecting a firebreak, the house did however succumb to fire when it was destroyed in 1673.

Seething Lane derives its name from a medieval word meaning 'full of chaff' and is associated with its near neighbour the Cornmarket. Today the small rectangular garden is currently closed due to a major redevelopment programme to the adjoining building but when open has a fine bronze bust of Pepys on display. The garden is blessed with some fine red rose beds that lay either side of the garden entrance and have a significant history themselves. In 1381 Sir Robert Knollys was given permission to build a bridge across Seething Lane for which the City charged him one red rose annually, this ceremony is commemorated every year by the Company of Watermen and Lightermen of the Thames.

At the far end of Pepys Street stands the wonderful church of St. Olave which is located in Hart Street, this 15th century church was just one of the very few medieval City churches to escape the carnage of the Great Fire (1666). The church we see today is the third building to have been erected on this site; the first is believed to have been a wooden structure, which was replaced by a stone edifice in the late 12th century. Dedicated to King Olaf II of Norway (as were four others in London) who fought with the English king Ethelred against the Danes here in 1014, it is thought that this church is actually built on the site of that battle.

Although the church suffered damage in World War II it did survive the Great Fire, records indicate that the flames of the fire came within 100 yards of the building before a change of wind directed them elsewhere. Pepys and his wife Elizabeth spoke of the church as 'being their own' and both were buried here in the nave.

This Anglican church of Gothic design is charming to say the least especially as you enter the small but delightful entrance, which I assume was an early graveyard as there are several former tombstones respectfully repositioned around the church wall. When I first saw the church I immediately thought how compact and overshadowed it looked in its 21st century surroundings and subsequent visits have confirmed that its historic significance is far more powerful than any

of its close neighbours. The stone and brick tower provide a rustic yet pleasing vista not devaluing the presence of the fantastic entrance arch in the churchyard with its iconic grinning skulls. CD referred to this as St. Ghastly Grim Gate in his work 'The Uncommercial Traveller' (1860). Sadly most of the interior is not totally original, having been restored in the 1950's albeit very sympathetically, but there are some original features which still remain such as the pulpit, said to be one of Grinling Gibbons works, and the monument of Elizabeth Pepys which is located on the east wall showing her looking towards the Naval Office Pew where her husband Samuel would have sat. Just two of the many interesting facts I discovered at St. Olave's is that there was a pantomime character actress called 'Mother Goose' interned here in 1586, and also allegedly the grave of one Mary Ramsey who it is said was responsible for bringing the Black Death to London in the 17th century! When walking London one simply cannot miss visiting this wonderful church.

Although the surrounding streets seem dark and uninteresting because they simply appear to be a collection of tall modern offices and hotels, each building does serve a useful purpose in the daily life of the City and tourism in general. Leaving St. Olave's turn left and head to Crutched Friars, named after the House of Crutched Friars (Friars of the Holy Cross), which was founded in 1298 by Ralph Hosiar and William Sabernes. Unfortunately Oliver Cromwell's emissaries decided that this brotherhood was corrupt and their church was closed down and used as a carpenter's yard and later a tennis court.

As we walk along Crutched Friars towards Fenchurch Street Station, I notice on the left French Ordinary Court, my first reaction to this street name conjured up some Gallic building erected to deal with French immigrants how wrong I was. The name actually derives from a Gallic eating establishment, which was fairly common in the 17th & 18th centuries, an 'ordinary' being a term for a fixed price meal, today's equivalent of table d'hote. This eating-house was destroyed in the Great Fire and never replaced, just the street name, today French Ordinary Court is an interesting whitewashed passageway, which runs beneath the platforms of Fenchurch Street Station.

Fenchurch Street Station was the first railway station to be constructed within the City of London; it was designed and built

in 1841 by Sir William Tite (1798-1873). Tite was an extremely talented architect who I have mentioned in earlier publications, as he became president of the Royal Institute of Architects. His prestigious works were varied; he designed wonderful buildings such as The Royal Exchange, many railway stations (including some in France), and churches such as St.Pancras. He was also director of several prestigious companies and a Governor of St. Thomas's Hospital. In 1854 Fenchurch Street Station was rebuilt to a design incorporating a grey stock brick finish and as we can see today this pleasing architectural feature has an interesting zigzag canopy roof above the entrance doorway, above which are some attractive round arched windows.

At the end of Crutched Friars there is a road junction and a nice view of the Gherkin building to the left, simply keep walking ahead down Crosswall, this area consists of more modern buildings until we arrive at American Square to our right. American Square is quite small in size and was originally built around 1760 to respect the American Colonies. Designed as part of an elaborate scheme by George Dance the Younger, at the expense of Sir Benjamin Hammet who was a partner of the City Bank of William Esdaile. Nathan Rothschild lived here at No.14 in the 19th century before his house was destroyed in the Blitz.

At the end of Crosswall we reach the Minories. This street runs north to south close to the Tower of London and its name derives from the Abbey of the Minoresses of St. Mary, which was founded in 1294, Minoress was a nun in the Order of the Franciscans. The nuns were said to have been those brought from Spain, by the wife of Edmund, the Earl of Lancaster. In 1539 the Abbey was dissolved and its land and properties taken over by the Crown, which were later used as the parish church of the Holy Trinity, and the remaining buildings utilised for an armoury and later a workhouse.

At the northern end of the Minories is Aldgate High Street, Aldgate is the most eastern gateway through the London Wall, its name given to a Ward of the City. When turning left to head towards Leadenhall Street one cannot miss a recent artistic introduction to the landscape, which is a commemorative structure built in 2012 to honour the name of Geoffrey Chaucer (1343-1400). This wooden structure named 'Paleys upon Pilers' is a very clever intricate

framework representing a timber palace, which sits on pillars in the central reservation of the road, to mark the location of the Aldgate. Its ingenious design creates an embroidery of timber, which is said to make good use of the passages of prose delivered by Chaucer, this work was commissioned by the Worshipful Company of Chartered Architects. Aldgate's original gate spanned the road to Colchester in the Roman period when the Wall was first constructed, the gateway stood at the corner of what is today Duke Place. In 1108 and later in 1215 the gateway was rebuilt but was finally removed in 1761.

The name Aldgate is thought to have derived from either 'Old Gate' or 'All Gate' meaning free to all. Geoffrey Chaucer occupied apartments above the gate from 1374 to 1386 during his time as a customs official. Chaucer is known as the father of English literature and poetry of the Middle-Ages and was the first poet to be buried in Westminster Abbey (the area now known as Poets Corner). He was also known for his achievements as a philosopher, alchemist and astronomer as well as holding a career in the civil service as a courier and diplomat. Best known today for his book The Canterbury Tales, he travelled extensively in Europe and is thought to have studied law in the Inner Temple around the 1360's, before gaining his title Comptroller of the Customs for the Port of London.

Within the Aldgate Ward the Jewish population settled from 1181 until their expulsion by Edward I in 1290, this area then became known as Old Jewry. In 1655 Cromwell suggested that a re-admission of Jews should be considered and the following year they were allowed to practice openly once again, acquiring a home in Creechurch Lane, which later became a synagogue. In later years they founded London's now oldest synagogue at Bevis Marks in 1698.

On the junction with Leadenhall Street and Fenchurch Street stands the site of the old Aldgate Pump, and from 1700 has been used as a positional point to measure distances to other UK counties. The pump we see today replaces the original one which was removed in 1876 and has been slightly redesigned as a drinking fountain, and stands just a few yards west of the site of the original pump. Today the ward of Aldgate is dominated mainly by major insurance companies, brokers and underwriters, each residing in the new wave of modern buildings that dominate the skyline.

Still walking west we cross the busy Aldgate Road and turn right into Leadenhall Street where in the distance we can clearly see the new Richard Rodgers creation nicknamed 'The Cheese Grater', which is still under construction. This imposing building gets its nickname from its wedge shaped appearance and is due for completion in 2014. Standing 222m high the building features a tapered glass façade with steel bracings on one side, the steel megaframe designed by Arup is unlike any other previously designed, others being of concrete. Whilst on the subject of exciting new buildings in London I should also mention a second dynamic construction in progress at 20 Fenchurch Street, which has been nicknamed 'The Walkie Talkie' building and is also due to be completed by 2014, when finished will be 160m high. This edifice designed by Rafael Vinoly appears to burst upward and outwards and will have a large viewing deck and sky garden, which they say will be open to the public. My heart is in historic London but I still get real enjoyment in seeing the creation of a new skyline, and the manner in which the City's Building Control parameters are sympathetically used to allow these historical buildings of the future to blend with the old. How I would love to see CD's reaction when being confronted with the modern and interesting skyline of London today. Central London and in particular the City in CD's time was a tight knitted maize of narrow streets, dark alleys and dingy buildings, we are at a particular point that according to the 1863 map was an area of churches, warehouses, schools and railways. What office accommodation there was consisted of cramped small rooms badly lit, together with the added problem of a black covering of smoke and fog. Whilst researching, I seem to remember reading somewhere that a large number of buildings in CD's period had fixed angle poised mirrors outside their windows simply to catch a glimmer of daylight which would reflect inside. How design has changed in a century and a half, our modern buildings have a great deal to be appreciated.

Having walked a few yards along Leadenhall Street it is time to turn right into Creechurch Lane but before doing so we must enjoy the Jacobean church of St. Katherine Cree, which is a very old and venerable building and one certainly CD would have been familiar with. This church served an early parish which existed here as long ago as 1108, ministered by Augustine Holy Trinity Priory and founded by Queen Maud wife of Henry I (1068-1135). The

present church stands on what was the priory's churchyard and after experiencing a few ecclesiastical problems formed a separate church called St. Katherine Cree. The present church dates from 1631 and escaped the Great Fire then thankfully only suffered minor damage in the Blitz. Today it serves as one of the City Guild Churches and has a wonderful vaulted ceiling displaying the arms of the City Livery Companies. Parts of the attractive stained glass are original, especially the work resembling a catherine wheel.

Creechurch Lane as the name would suggest derives from the ancient church located in this area. Until 1894 the lane only extended north as far as Heneage Street, but then it was extended into St. James Place, the former name King Street that is shown on the 1863 map then disappeared. After walking the length of Creechurch Street we arrive at Bevis Marks where we turn right, this street has a long history and has been given several different names in the past. Originally called Bewesmarkes (1407) then Berys Marke (1450) then Beresmackes (1513) and finally Bevis Marks since 1720. Why so many changes I have never discovered but according to John Stow (1525-1605) an English historian, the name derives from the abbots of Bury who had owned the surrounding land since 1020, then lost it with the Dissolution of the Monasteries in 1534. The land and title then went to Sir Thomas Heneage (1532-1595) whose name was given to the adjoining street.

CD mentions Bevis Marks often in his novel The Old Curiosity Shop (1841), where he portrayed Samson Brass as a solicitor who had an office here. One really amazing building in this street, which has stood the test of time, is the Bevis Marks Synagogue that was built at the beginning of the 18th century. This historical orthodox synagogue was built primarily for the vast number of Spanish and Portuguese Jews who settled in London. By 1747 it was eventually purchased by Benjamin Mendes da Costa (1803-1868), English merchant and philanthropist, who subsequently handed the deeds over in order to secure the future of the synagogue. Internally the synagogue has many interesting features such as the ornate brass candelabra and the Renaissance styled ark, similar to church reredos (altarpieces) of that period.

Bevis Marks links up with Dukes Place before we return to Aldgate High Street. The majority of land now known as Dukes Place was once occupied by the Priory of the Holy Trinity, Christ

Church, until Henry VIII took the land and gave it to Sir Thomas Audley (1488-1544) a barrister and former Chancellor of England. Audley succeeded Sir Thomas Moore and featured quite prominently in Tudor history as being a supporter of Henry's divorce to Catherine of Aragon, supporter of his marriage to Anne Boleyn and eventually her execution. He also sanctioned Henry's dissolution of marriage to Anne of Cleeves and finally condemned Thomas Cromwell for his incompetence. The connection with Audley continues as his son-in-law Thomas Howard, the Duke of Norfolk, later inherited the land for which the street is named, but he sadly was beheaded for his 'intrigues' with Mary Queen of Scots.

After many local disputes the residents of this area sought and gained permission from James I to build a church on this ground and when completed in 1622 named the church in his honour. During the following two hundred years St James Church remained open, surviving the Great Fire, but by the early part of the 19th century it fell into disrepair and was eventually demolished. The former site of the church is now the location for the Sir John Cass School; John Cass (1661-1718) being a merchant, politician and philanthropist is certainly worth a mention, for his charitable works alone. Born in the City of London, but moved to Hackney in 1665 to avoid the Plague, Cass became a Tory MP in 1710 and was later elected sheriff for his Ward in 1711, prior to being knighted in 1713. He founded a mixed school for children in what is now the churchyard of St. Botolph's without Aldgate, which remained open and continued to provide teaching opportunities for children for a full twenty years after his death. After many years of haggling in order to proportion Cass's wealth (he left an incomplete will) his trustees eventually petitioned Parliament and the Court of Chancery to establish a foundation in his name in 1748. Through this foundation a School was funded as well as a Technical Institute (1899) which is now located in Jewry Street. By 1950 the Institute became recognised as a College and after several mergers over a period of fifty years became the London Metropolitan University in 2002.

Having now reached the end of Dukes Place we are facing St Boltolph without Aldgate church, which sits strategically on the busy one-way system that connects a number of arterial roads. In order to visit the church, which sits in the centre of the traffic system we have

to cross the road at the pedestrian crossing and make our way to the front of the church. Historically the first record of St Boltolph church appears in 1115, however it is thought to predate 1066. The name St Boltolph comes from an English Abbot who died in 680 and is mentioned in the Anglo-Saxon Chronicle. He is the patron saint of travellers and there were four churches named after him, each built at the gates of the city and were extensively used by folk who travelled into and away from London.

By the 16th century the church was rebuilt, and again in 1744 to a design by George Dance the Elder, it is built of brick with stone quoins and window casings and is a fine example of period architecture with an interesting square tower and obelisk spire. Internally the church has suffered much damage and has been sympathetically restored by architect John Bentley (1839-1902), designer of Westminster Cathedral, he restored the church and created a wonderful carved ceiling with added decorative plasterwork, in addition to creating a chancel with side screens. He also replaced large boxed pews with seating we can enjoy today. Amazingly, although St Boltolphs roof was damaged by bombing during the Blitz the valiant Rector was said to have slept in the Crypt and following the bombing raids went onto the roof and extinguished incendiary bombs! Much like the heroic wardens of St Paul's Cathedral. In 1965 a fire caused considerable damage and architect Rodney Thatchell was called upon to restore the church once again and did succeed in improving the interior and creating the Baptistry as well as opening up the space under the tower.

One very special feature in this church is the organ, recently restored to its 1744 specification and is claimed to be the oldest church organ in the UK. Built by Renatus Harris, long before the church was completed, but later donated to its present owners by Thomas Whiting. Victorians gave this wonderful church a very unsavoury title as prostitutes were said to parade themselves around the pavement surrounding the church and because it was situated close to Mitre Square, one of the locations of the five Whitechapel murders attributed to Jack the Ripper.

Today this pleasing church welcomes people of all faiths but remains Church of England and a member of the Anglican Communion.

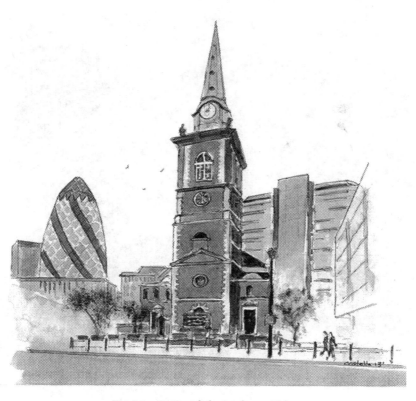

Fig 31 St Botolphs without Aldgate

Fig 32 Paleys Upon Pilers

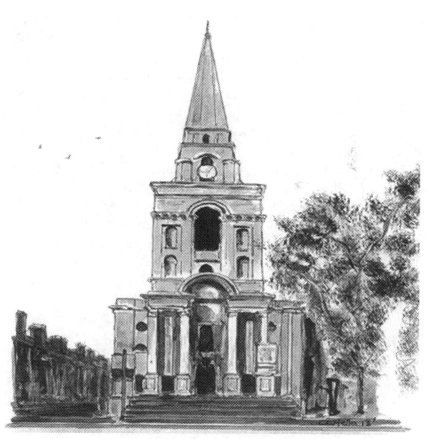

Fig 33 Christ Church, Spitalfields

Re-crossing the busy road that encircles St Boltolph's church, I now head east along the extremely busy Whitechapel High Street and eventually find myself in Whitechapel Road.

Whitechapel High Street was once the old Roman road which led to Colchester and much later the location for many coaching inns for travellers both into and out of London, much the same as Borough High Street. In 1708 the Whitechapel Haymarket was given its charter and traded in this very spot before eventually closing in 1929. Today much of the north side of this road consists of 19th and 20th century buildings, whereas the south side has been almost completely redeveloped and judging by the development in progress will inevitably extend the City boundaries from Aldgate. The high street today is said to be one of the most multicultural areas in London. Before moving on I have to mention one small but very well-known trading stall which until this summer of 2013 is located to the left as we walk at the beginning of Whitechapel High Street, I refer to Tubby Isaacs Jellied Eel Stall which has traded in this district since 1919. I don't remember his stall being in this location when I first savoured jellied eels, in the 1960's he was trading in Petticoat Lane Market and I shall always remember how good they were when I made the occasional visit to this busy London venue. I mention Tubby Isaacs today simply because I recently read an article which said that due to a downturn in business he will no longer be trading in Whitechapel and I can only salute this enterprising business which has won the hearts of most East Londoners for almost a century.

Whitechapel Road has many interesting buildings none more so than the Whitechapel Bell Foundry which we will discover later in the walk. There were few factories in this area in the 1850's the main body of work however was directed to the nearby shipping docks and the housing situation was controlled by landlords rather than the local council therefore standards were primeval. Residents were living on a day to day basis which controlled living standards that were well below the 'poor' national standard, in fact poverty had reigned in this area since the days of Samuel Pepys! Taking all these facts into consideration Whitechapel Road was not best favoured by its location, however it is as important today as it has been for many hundreds of years, in retaining both the social and trading history of the Whitechapel district and its neighbouring areas.

Having reached an area of Whitechapel which features in the more macabre history of this district, it is probably the right time to briefly identify the heinous crimes, which occurred here. I do this, not to revel in the theatrical but to paint a clearer picture of the conditions that led to these crimes in the more deprived areas of the Victorian age. Much has been written about Jack the Ripper and the spate of vicious murders that took place in Whitechapel and surrounding areas between 1888 and 1891. Although this walk is not based on this episode of carnage, several of those murders did occur in close proximity. The circumstances allied to the women who were victims of these crimes are a reminder of the social depravity that not only affected them but thousands of others who lived here. Of the eleven murders that occurred only five have been attributed to the Ripper and it is these five, which present themselves on or close to our walk today.

On the 31st August 1888 in Durward Street (close to what is now Whitechapel Underground) Mary Nicolls was murdered, it is said that she was a heavy drinking prostitute, aged 43, who was separated from her husband and had five children. Her body was discovered at 04.00am with her throat cut and abdomen slashed.

On the 8th September 1888 in Hanbury Street (close to Fornier Street where we will shortly arrive) Annie Chapman, aged 47, was brutally murdered and her body found at 06.00am. She was also a mother, heavy drinker and a prostitute whose throat was cut and intestines; uterus, vagina and bladder were strangely removed.

On the 30th September 1888 at 01.00am Elizabeth Stride, aged 40, also a prostitute and alcoholic was murdered in what is now Henriques Street (formerly Berner Street), situated opposite London Metropolitan University (just off of Commercial Street). Her throat was cut.

That same day at 01.45am in Mitre Square (close to St Botolph Church) the mutilated body of Catherine Eddowes, a prostitute aged 46 and an alcoholic, was discovered. Her throat was cut and mysteriously her intestines, kidney and uterus had been removed. This murder was one which the press labelled Anti-Semitic as a chalk message on a nearby wall was deemed suspicious.

On the 9th November 1888 the mutilated body of Mary Kelly, aged 25, was discovered at Millas Court (close to Dorset Street,

opposite Christ Church) where we will shortly pass. She was found indoors and the extent of her injuries were horrendous, her body being mutilated beyond recognition and most body parts removed.

Sadly this grim reminder of Whitechapel's past is often remembered rather than the pageantry and groundbreaking history that once existed here. Never-the-less it is a stark reminder of just how desperate these women must have been to even consider their profession, poverty was obviously uppermost in their thoughts, living standards were the worst in London, they lived in overcrowded accommodation with their children, all this amidst crime which was on an uncontrollable scale. CD is said to have visited the East End (albeit a few years before the murders) to 'experience the danger and excitement', and recorded the malnutrition and disease that was everywhere, he also records opium dens and gin houses, all of which contributed to those dark events in Whitechapel that time will not forget.

We have now reached Commercial Street where we will shortly be walking, but before doing so I should mention the Whitechapel Gallery, which was founded in 1901 as a publicly funded gallery for temporary exhibitions in London. When first opened it exhibited works by the Pre-Raphaelites, Constable and Rubens, following which it has premiered world famous artists such as Pablo Picasso, Jackson Pollock, Mark Rothko, Frida Kahlo and Lucien Freud, a remarkable list of some of the worlds leading artists. I marvel when I think that Picasso's iconic 'Guernica' was on display here in 1938 as a protest to the Spanish Civil War. Today Whitechapel Gallery attracts many contemporary artists and provides superb retrospective exhibitions, and at the same time one can enjoy the number of wonderful galleries, collections, displays and educational resources as well as the rather nice dining room and bookshop. The building itself was designed by Charles Harrison Townsend (1851-1928) an English architect who also designed Horniman Museum and the Bishopsgate Institute, each having a distinctive Art Nouveau and Arts & Crafts style. The gallery has been extensively refurbished during the past twenty years and now incorporates the former adjoining Passmore Edwards Library.

Turning into Commercial Street I instantly register that this area remains 'work in progress'; I can immediately see two working

tower cranes and tower blocks ahead of me, this entire area seemingly accustomed to its present state of degeneration. Historically this street was laid down to provide a thoroughfare which would accommodate the industrial and commercial activities of the City, activities which were deemed to be noisy, environmentally unacceptable and less burdensome for transportation and travellers. Sir James Pennethorne (1801-1871) architect and planner, laid the road in 1843 as part of a slum clearance scheme and to connect Whitechapel with Spitalfields Market. In doing so 250 properties were demolished and several roads disappeared which later allowed the introduction of the Eastern Counties Railway. In 1864 the first of the Peabody Buildings opened in Commercial Street and contained 57 dwellings. The Peabody Donation Fund, as it was then called, was created in 1862 by George Peabody whom we mentioned earlier, a caring person who tackled poverty in his adopted London.

Up until the late 20th century Commercial Street mainly consisted of Spitalfields wholesale fruit and vegetable market (closed in 1991) and outlets for the textile industry. Today this extremely energetic, if somewhat outdated street has been subjected to the process of 'gentrification', a word used to describe the shift in poor urban areas when residential processes and urban planning affect the composition of a neighbourhood. This results in the poorer business's not making the increased commercial rents and industrial buildings are converted for more affluent residents and retail outlets.

It was here in this street that CD on one of his 'night walks' came upon a 'depot' and eating establishment, which served cheap food for the poor and needy. Whilst there he ate a meal where he described and commented on the quality of food provided, he said that it was not only remarkably cheap but was the equal, if not better, than some noted establishments he normally frequented!

As we progress along Commercial Street we pass Toynbee Hall (1884) on our right, which CD would have approved of had he been alive to witness the approach taken by those who established this noble society. Founded in 1884 by Samuel Burnett (1844-1913) Anglican clergyman and social reformer, and Henrietta Burnett (1851-1936) his wife, who was also a social reformer and author who had worked with Octavia Hill. The hall was named after their friend and social reformer Arnold Toynbee (1852-1883) British economic

historian, who encouraged trade unions and co-operatives. This Gothic styled building, designed by Elijah Hoole became a centre for social reform in the hope that it would bridge the gap between people of all walks of society and financial status, thereby reducing poverty and bringing together the classes. As this group developed it became known as the University Settlement, this reformist social movement initially established many settlement homes in poor urban areas. In more recent times the American Settlement Movement, which followed the work of Toynbee Hall, is said to have developed even more and now provides a more comprehensive service, due mainly to a larger working capital.

I mentioned Petticoat Lane earlier, which is in fact on the other side of Commercial Street in Wentworth Road. Arguably one of the oldest surviving markets in Britain, this fashion and clothing market as known throughout the world and its amazing history is a social calendar of Whitechapel. Open six days a week this market attracts thousands weekly and is a listed tourist attraction. Its name derived from the sale of petticoats but is cheekily referred to as 'the lane that would steal your petticoat at one end of the market and sell it back to you at the other'. In the Tudor period the surrounding area and in particular Hog's Lane (now Middlesex Street) was a rural scene where bakers and butchers were allowed to keep pigs outside of the City walls, in addition to it being a prime droving trail for livestock on their journey from the east to Smithfield. As early as 1608 the immediate district became a place where second hand clothes and other used items were exchanged and it was at this period that the name Petticoat Lane evolved. At the time of the Plague (1665) the rich who had settled here fled, and later in the century a large influx of Huguenots arrived, the master weavers settling in Spitalfields. By then the clothing industry was established as were the dyeing works, records inform me that for a long period of time many pieces of dyed cloth were pegged out in most of the surrounding fields.

In the middle of the 18th century Petticoat Lane became a centre for manufacturing clothes and patrons were mainly from the well-to-do classes. The name Petticoat lane was changed in 1830 to Middlesex Street, and it is well documented that the local authorities made vain attempts to disperse the market by creating events that would disrupt trading, such as police cars and fire engines being

driven through the centre of the market with bells ringing aloud. The authorities legally had a case as the market was then unregulated and illegal, but by 1936 an Act of Parliament issued a set of rights for the traders and fortunately the market remained.

Religious beliefs and places of worship are foundation stones in London's history; this area is no exception as it has seen much change through the ages. The original Huguenots moved on, the Jewish then populated the area and gradually moved away, making way for the current Asian settlers, all however having a common industry, textiles and clothing. It is pleasing to think that whatever society trades here, Petticoat Lane has and will always be known for the traders 'patter' and crowd pulling exhibitions that are used to embellish their selling skills.

Back to Commercial Street and having walked a few yards further on we arrive at the next building of historical interest, which is Christ Church, Spitalfields. This church features very highly on my London Walks not only for its distinctive design but also for the remarkable way it survived the threat of being totally demolished. The church was designed by Nicholas Hawksmoor (1661-1736), an English architect famed for his input into many notable works which include Chelsea Hospital, St Paul's Cathedral, Hampton Court Palace, Greenwich Hospital, St Georges Bloomsbury, All Souls College, Oxford, the list is endless. Christ Church was one of a group of churches named 'Commissioners Churches' that were established by an Act of Parliament in 1711. In commissioning these churches land was sought, and a total of 12 (originally 50 were considered) ecclesiastical buildings created to accommodate London's new settlements, Hawksmoor being responsible for 6 of them.

The parish of Spitalfields then had a huge Huguenot population who at first only used this church for baptism's, marriages and burials, but later decided to use it for prayer. Architecturally the church has many fine attributes, a magnificent Tuscan porch with columns, a Gothic styled steeple, and Venetian windows to the east elevation all of which confirms Hawksmoor's admiration of Palladian architecture. I refer to the creative genius of Andrea Palladio (1508-1580), an Italian architect who was arguably one of the most influential people in the annuals of architecture, and someone who I have admired and mentioned in previous articles and books. Internally the church has

a remarkable early 18th century organ, said to be one of the most significant instruments of European importance that has survived in this country. In saying that, it still awaits full restoration even though it has most of its original components, but, as I discovered, before the full restoration can take place donations are desperately needed for the Richard Bridge Organ Appeal.

Unbelievably, in 1960 this remarkable church was virtually derelict, the roof was considered to be unsafe for purpose, but thankfully a committee was formed to save the building from demolition. Funds were raised for a new roof that was built in a short space of time; the major restoration work however was completed in stages throughout the 1980's and 1990's and completed in 2004. Christ Church can boast a superbly decorated ceiling, with aisles having elliptical barrel-vaults, and interestingly enough the Crypt was excavated then reinstated by a team of archaeologists. The later part of the internal work ensured that the fabric of the church is now in its pre-1850 condition, a remarkable feat that was made possible by the efforts of the Friends of Christ Church who have raised millions of pounds to ensure that Spitalfields and Whitechapel can enjoy this magnificent landmark of history.

Looking across Commercial Street from Christ Church (Church of Spitalfields) stands the historic Old Spitalfields Market. My research informs me that a market has traded on this site since 1638 when Charles I licensed the sale of flesh, fowl and roots in an area known as Spitalfields, following which Charles II re-issued a licence in 1682 to ensure there was adequate food on sale for an ever increasing London population. Market buildings were built on this rectangular site and later rebuilt in the latter part of the 19th century by the City of London Corporation, which was used as a wholesale market. The buildings we see today were designed by George Sherrin for Robert Horner, the owner of the fruit and vegetable market, between 1885 and 1893. These buildings have been tastefully restored in the 21st century and have become one of London's top markets, selling fashionable clothing, food and other general market products. The original wholesale fruit and vegetable market has now moved to the New Spitalfields Market in 1991, which is situated in Leyton.

Having reached the most northern point of Commercial Street for this walk, it is time to head down Fournier Street but before doing

so we pass Fashion Street which features on the 1863 map. Fashion Street runs parallel with Fournier Street and is a derivation from the historic 17th century name of Fossan Street, named after brothers, Thomas and Lewis, who owned the estate. By the late Victorian period Fashion Street had become a slum area and remained that way until 1905 when the road underwent a major development scheme. Buildings, shops and a factory were erected, one such building resembling a Moorish-style red brick structure in the form of a retail arcade with horseshoe arches (which closed down 4 years later). Today this interesting street retains many of those older buildings, including the arcade at the north end, however, many buildings have been redeveloped and are now apartments, offices and art galleries and of course the home to several contemporary textile houses.

Just past Fashion Street we arrive at Fournier Street, which like many others in this immediate area have undergone some change in the past 150 years. Fournier Street however is arguably one of the most attractive roads in this district as it provides us with a very interesting and delightful picture of the past. Originally named Church Street when CD walked this district, Fournier Street was primarily developed for the large community of French Huguenots who brought silk weaving skills to London from several French cities.

Huguenots were members of the Protestant Reform Church of France who were inspired by the writings of John Calvin in the 1530's. Calvin (1509-1564) was a French theologian during the Protestant Reformation who published several controversial works, laying the seed for the branch of theology that bears his name, Calvinisism. It is thought that the nickname Huguenot is associated to the Swiss politician Besancon Hugues, who although originally Catholic later followed the Protestant cause. The French Huguenots struggled with Papacy and criticised the doctrine and worship within the Catholic Church, in particular the sacramental rituals. The French King, Francis I (1515-1547) allowed the French Parliament to eradicate these reformers and by 1562 had a following of two million people in the south and central areas of France.

By 1559 France had a new king and civil wars were breaking out throughout the country, one particular bloody event was the St Bartholomew's Day Massacre (1572) when Catholics killed thousands of Huguenots throughout France. During the long years of civil wars

and unrest many Huguenots were persecuted and killed and in 1685 Louis XIV declared in his Edict of Fontainebleau that Protestantism was illegal. It is estimated that almost one million fled to Protestant countries around the world, with over 50,000 coming to England alone.

When CD visited Spitalfields the weaving industry was in decline, he was interested in seeing first hand what he described as 'the ramshackle wooden constructions upon tops of homes used for breeding pigeons', formerly weaver's workshops. With his close companion William Wills (1810-1880), sub-editor of Household Words, CD entered Spitalfields and immediately noticed the weavers who were unemployed. He said that they sat brooding on doorsteps as he observed the poor dwellings and filthy streets whilst they both travelled to what is today Spital Square, which lies at the rear of Spitalfield Market. From the Square they entered a gateway and weaved through narrow streets before meeting a Mr Broadelle (their guide) who escorted them to a silk warehouse, which he managed. Mr Broadelle informed CD that there were once between 14-17 thousand homes in this district, weaving silk, stating that only 10 remain, all located within this most densely populated district of London, where an estimated 85,000 human beings were huddled.

CD mentions the strange homes within this maze of streets and says 'it is as if the Huguenots had brought their streets along with them from France, and dropped them down here.' He also mentioned the strange shops, which seem to be open for no earthly reason, having nothing to sell! Food produce he said was unattractively jumbled together in one baker's dirty window and the butcher's meat of liver, lights, sheep-heads, freckled sausages, and strong black puddings although unattractive by display would be readily acceptable to the mouths of Spitalfields.

The pair were also taken to a Ragged School, which comprised of a room on the upper floor of one of these strange buildings. When CD and company finally arrived at a weaver's warehouse and climbed the narrow winding staircase they entered into a room that had 4 looms, one idle, three at work. One weaver he spoke to 'through the deafening noise' stated that he worked 16hrs a day to earn 8 shillings (40p), but only when work was available. The room was said to be unwholesome, close and dirty, in one corner was a bedstead, on one

wall was a fireplace, and there was a table, 2 chairs, a kettle, tub of water and little crockery. The children were squeezed into whatever space was available between the looms, and this particular weaver had six living children!

CD's article in Household Words concerning the weavers of Spitalfields was meant to bring to the readers the harsh reality of their work and social conditions, he cleverly described each account of the different components of the silk industry, and in comparing his findings the reader was asked to draw their own conclusions about the contrasting distribution of profits between weaver and the retail traders/owners. Unbelievably it was recorded that one silk weaving warehouse alone 'turned over an average of £100,000 of good and lawful money of Great Britain' in its heyday! A clear reality check if ever there was one.

Many of the original Huguenots that settled in Spitalfields had come from a wealthy background and their homes in Fournier Street were considered grand, whereas others owned by the silk artisans were less imposing. Each house on view whilst walking down this street is architecturally appealing, their original wooden panelling and elaborate joinery remains in many of these properties today. No.14 for example is a former mansion house built around 1726 and leased to silk weavers who were classified as being 'by appointment', the reason being that Queen Victoria's Coronation gown was woven here. No.23 is an example of the classic single fronted three storey brick built early Georgian town house, which has retained its original mansard garret (curved French style roof), weather boarded front, cellar basement and wide windows which allowed the weavers to display their goods.

Once the silk weaving industry fell into decline, Fournier Street and the adjoining Brick Lane became the heart of the Jewish East End, and the Methodist Church (formerly a Protestant Huguenot Church) was converted into a synagogue, which would in later years convert again into a great mosque when the Bengali community arrived. At the far end of Fournier Street where it joins Brick Lane, stands the remarkably old and well-preserved building now known as the Great Mosque, first built in 1743 as a Protestant Chapel by the French Huguenot community, and used by them for over 60 years. In 1809 it was converted into a Wesleyan Chapel for a short period

of 10 years, its aim in promoting Christianity within the Jewish community. In 1819 the building was then adopted by the Methodist Order which continued to function until the late 19th century.

The church then changed denomination once again and became known as the Spitalfields Great Synagogue as the area became home to the Jewish refugees from Russia and Central Europe. When the Jewish community decreased considerably in numbers following the move of many immigrants to North London, the synagogue eventually closed. During the 1970's the Bangladeshi community mainly populated this area, they required a place of worship so they purchased the building and completely remodelled it internally, finally opening it as the Great Mosque in 1976. From the exterior elevation one can clearly see the remarkable façade, which apart from the variety of former denominations it has accommodated, remains virtually unchanged from its original design. One really nice feature is the 1743 sundial that sits high on the apex of the façade.

Leaving Fournier Street we now turn right into Brick Lane and notice instantly the change around us as this popular East End street is today the heart of the city's Bangladeshi-Sylheti community and is known to locals as Banglatown. The street was originally called Whitechapel Lane before being given its current name by the brick and tile manufacturers of the 15th century who used the local brick-earth deposits to produce their wares. Brewers arrived at Brick Lane in the 17th century as there were deep wells in this location, which supplied plenty of water, and the first recorded brewer was Joseph Truman, but it was Joseph's son Benjamin (1699-1780) who created the Truman Empire. When Benjamin inherited his father's brewery he expanded and grew faster than his competitors, mainly due to production and demand of their 'porter', a heavily hopped beer produced from dark brown malts. After taking over their main competitor in 1873, Truman's Brewery claimed to be the largest brewery in the world, made possible by its expansion, productivity and pub estate portfolio.

In the 17th century Brick Lane Market was opened allowing fruit and vegetable traders to sell their produce outside of the City limits. When the Huguenot immigrants arrived in the area buildings grew in number, which expanded the district around Brick Lane, the master weavers were based at Spitalfields. The street soon became a

centre for weaving and tailoring and formed the foundations for the forthcoming clothing industry. The Sunday Market dates from the 18th century when Parliament allowed the Jewish immigrants to trade on the Sabbath.

At the northern end of Brick Lane the market deals in bric-a-brac as well as fruit and vegetables, and heading south at the junction with Hanbury Street are two indoor markets named Upmarket and Backmarket. In 2010 the Brick Lane Farmers Market opened and trades in nearby Bacon Street, which is situated in the northern extremes of the lane. Today eating out is a delight in this street as there is an abundance of curry houses, mostly serving traditional Bangladeshi food, well worth sampling as I have in the past, but be for-warned, as some eating-houses do not sell alcoholic drinks.

Having walked to the southern end of Brick Lane we reach Whitechapel Road once again and turn left into this active pedestrian passage and busy traffic concourse. Walking further east along this road we pass the Whitechapel Bell Foundry on our right, which has a very interesting history. Given the title of Britain's oldest manufacturing company, Whitechapel Bell Foundry (1570) has been in continuous business for almost 450 years!

The site on which the foundry stands was formerly an inn known as the Artichoke and in 1670 the already established bell foundry moved here from smaller premises, which were situated on the northern side of Whitechapel Road. A number of extremely important historical bells have been produced by this company including those for Westminster Abbey, the Liberty Bell (Pennsylvania) and Big Ben, to name but a few. The Liberty Bell was cast in 1752 and is an impressive 12ft in circumference, sent to Independence Hall it was thought to have been rung on the 8th July 1776 after American Independence was secured. Unfortunately when the bell was first rang after arriving in the USA it cracked and was recast by a local foundry.

The Whitechapel Bell Foundry overhauled Westminster Abbey's bells in 1971. There are 10 bells for ringing in the Abbey, in addition to this there are 2 service bells, cast by Robert Mot in 1585 and 1598 respectively, a Santus Bell cast in 1738 by Richard Phelps & Thomas Lester, and 2 unused bells one which was cast in 1742 by Thomas

Lester. All these men were founders of distinction who once worked in the Whitechapel Bell Foundry.

Big Ben was the largest bell ever cast by Whitechapel Bell Foundry and as one would expect has a great provenance. Prior to the Elizabeth Tower (which houses Big Ben) being completed the construction of its clock was commissioned to Astronomer Royal, George Airy, who specified that the first stroke of the hour bell should register the time, correct to within one second per day, which was thought to be unachievable by most clockmakers. Airy remained adamant that this specification should not be changed and along came Edmund Denison who was a barrister and self-accredited expert on clocks, who thought the task possible. Denison, who was thought to be an arrogant and zealous person, eventually designed the clock and then worked on the bell specification. His specification for the bell design was awarded to a foundry located in the north of England who completed the task in August 1856, following which it was transported to London but unfortunately cracked whilst undergoing tests in the Palace Yard.

Denison then turned to Whitechapel Bell Foundry whose master bell founder, and owner George Mears cast a second bell which was eventually transported to the new tower and fixed into position by May 1859. Sadly by September the bell had cracked again and Denison was adamant that it was due to poor casting. George Mears then went public and stated that the hammer designed by Denison was twice the maximum weight for the bell, thereby causing the damage, and a lengthy lawsuit ensued. Unfortunately, there were two unsavoury legal disputes held in court, between the designer and maker of the bell, but in the end the verdict went in favour of Whitechapel Bell Foundry. Happily Mears effected a repair to the bell and it has worked to this day and although still cracked it gives a distinctive but less than perfect tone.

This impressive foundry, which sits proudly in Whitechapel Road, has no doubt many interesting tales of the past to tell and I would thoroughly recommend a visit to gain a fuller understanding of its amazing history. I should point out that the visiting times can be restrictive and need to be booked well in advance. Moving on from this foundry we continue walking until we reach a more recent but still very important building associated with Whitechapel, I refer to

the East London Mosque. This impressive mosque is hard to miss as it sits majestically in Whitechapel Road amid the continual hustle and bustle of people and vehicles, and is said to be one of the largest in the UK, as it can accommodate up to 5,000 worshippers.

The mosque was built on a former World War II bomb site, and designed by the architectural practice of John Gill Associates, it has a distinctive red brick exterior in a fine patterned design which compliments its surroundings. The roof is capped with a wonderful golden dome and alongside stands a minaret, which rises to 22m. Internally there are two large halls, a gallery, classrooms, offices and a retail unit. Historically the mosque has a very interesting chronological past, which dates back to the beginning of the 20th century. Between 1910 and 1939 various rooms were hired for Friday prayers when in 1940 three houses were purchased in Commercial Road to be used as a permanent mosque site. In 1975 the local authorities bought these properties and provided temporary buildings in Whitechapel Road, it was at this stage that the local community began fund raising to build a purpose built mosque to fulfil the needs of an ever increasing Bangladeshi population. With funds aided by a donation from the King of Saudi Arabia, foundations were laid in 1982 for the new mosque. The adjoining building known as Phase 1 was constructed in 2004 and designed by Studio Klaschka Architecture & Design Group, called the London Muslim Centre, it has two multipurpose halls, a seminar suite, nursery, classrooms, fitness centre, Islamic library, radio station, retail units and offices. Whenever I pass the East London Mosque I am always impressed by the architectural way this building has been designed as it is not simply pleasing to the eye but blends into the landscape very well and is obviously the centrepiece of this multicultural society that has transformed the surrounding district.

As we enter the final stage of this particular walk I should mention the fact that like most districts of London in CD's era there were inevitably workhouses in Whitechapel. In 1856 CD, on one of his many walks was horrified to see people shut out of workhouses simply because there was no place inside for them. Many workhouses were built in this district from the early 18th century, namely those in Ayliffe Street (1794, near Goodman's Fields), Bell Lane 1728, Whitechapel High Street 1830, and Charles Lane 1830. A former

workhouse, which once stood close to our walk and built in 1842, was originally situated in New Charles Street (between Selby Street and Lomas Street today, and by walking along Whitechapel Road then turning left into Vallence Road you will arrive at the site of a former workhouse.

The workhouse called Whitechapel & Spitalfields Union Workhouse consisted of a long block shaped building which ran in parallel with New Charles Street (Vallence Road) and had a separate "A" wing layout to the rear. By 1859 a major building scheme was carried out by Thomas Barry, architect, which created a much larger group of buildings incorporating various wards, and a larger kitchen. A few years later another building project was underway which brought all previous buildings today to form an "H" layout that provided additional rooms, wards and laundries. As was the case in most workhouses, male and female occupants were accommodated at opposite ends of the building. Obviously the need for sheltered accommodation was escalating judging by the speed and rate of development of workhouses, and I wonder just how the selection criteria for both inmates and staff were decided.

Much has been documented regarding the way workhouses were managed, and although they did provide food and shelter for the destitute, they still made heavy demands on inmates who worked long hours often on either heavy or laborious tasks, who were in the main treated poorly. In 1867 a new workhouse was erected at South Grove after which New Charles Street took the role of a Union Infirmary, and in 1888 received one of the Rippers unfortunate victims, Mary Nicholls. When Mary's body was placed in the mortuary, visiting family and others dealing with the sinister murder, complained vehemently about conditions and the following year a new mortuary was built. The Union Infirmary was taken over by the LCC (London County Council) in 1930 but was eventually demolished in the 1960's.

Our final part of the walk takes us further along Whitechapel Road and to a building on the south side, which plays such an important and vital role in the community; I refer to the Royal London Hospital. Historical records of this prestigious hospital go back to 1740 when it was called The London Infirmary and built to tend to the sick and poor among 'the merchant seamen

and manufacturing classes', a statement that refers to most of the community at that time. In 1742, through the vision and hard work of many professional men, business associates and philanthropists, work on a new hospital commenced and by 1757 patients were admitted in what was then said to be an unfinished building. By the early 19th century the population of East London had grown considerably and the health of inhabitants in the district became a national issue when there was a succession of cholera outbreaks between 1830 and 1866.

The recruitment of nurses during this period was difficult and Elizabeth Fry (1780-1845) Prison and social reformer, Quaker and philanthropist, formed the Nursing Sisters Movement under the control of Matron Jane Nelson. Florence Nightingale (1820-1911) was one of the original hospital trainee's (later to move to St Thomas's) who inspired a nation through her Crimean work and later teaching activities. One of Florence's trainees, Annie Swift, came to the London Hospital as an Assistant Matron, and by 1873 had formed and started her own School of Nursing.

In common with most other hospitals, surgery was developing at a fast pace by the 19th century and the first operation by doctors using an anaesthetic in the London Hospital took place here in 1847, and by 1870 surgeons had finally realised the importance of hygiene and the use of antiseptics such as carbolic acid! In 1866 Thomas Barnado (1845-1905) was a medical student here, and in later years set up his first Barnado's Home near to where we are today, in Stepney Causeway. By 1876 30,000 patients were being treated annually at the London Hospital with an average of 650 in care, one patient being Joseph Merrick (the Elephant Man) who was admitted and remained here until his death in 1890 aged just 28. In 1903 Edward VII & Queen Alexandra opened the New London Hospital Department, and by 1914 the hospital received the first wounded soldiers from the Western Front.

During World War II the hospital played a major role in dealing with casualties from both North & East London wards, at the same time suffering heavy damage throughout the Blitz. In the 1990's the hospital gained its Royal title while celebrating its 250th anniversary, and shortly after in 1994 merged with St. Bartholomew's and the London Chest Hospital, two years later Queen Elizabeth Hospital for

Children joined this illustrious group. In 2012 the first phase of the new state-of-the-art Royal London Hospital opened and became part of the Bart's Health NHS Trust. Interestingly enough, two bells hang in the Hospital Entrance, which were cast by the Whitechapel Bell Foundry, one called the 'Operation Bell' (1791) the other simply the '1757 Bell', both of which were used to summon hospital attendants to hold surgical patients still whist being treated!

Today this Trust is the largest in the UK serving a community of over one million in East London and beyond; it is Europe's largest academic health scheme partnership. The Trust's values, objectives and vision are second to none in clinical quality and patient safety and well being.

Although our walk stops at this point CD walked beyond this district into Limehouse and Stepney and in doing so found more material to store in his memory for later novels, today I shall simply make my way back to Leadenhall Street to visit Caffe Nero and as it is warm and sunny I have decided to have a Classic Frappe Latte, a perfect match for the Tostati I shall also order.

This wonderful feast will be in some-way a celebration for completing this book, but like those which I have written earlier will only prompt me to start another. There is however a glimmer of sadness whenever a book is completed but I am enlightened by the fact that I shall return to these walks often and share with others the delight I gained from walking the streets of London with my imaginary companion Charles Dickens.

EPILOGUE

In exploring CD's London I was able to visit the majority of homes, institutions and social establishments that arguably have played a major role in his life. Every effort was made to capture the essence of his relationship with the capital in the Victorian era and in doing so I know that I have gained a limited perception and imagination of what life was like in an age of momentous change. What did become apparent to me was the cruelness, naivety and ignorance of so many people in all walks of life to the issues of society, health, hygiene, politics and welfare, which in a developing nation appeared stifled and misguided.

Of the many locations that I visited I did identify my personal favourites which I am sure CD would have also done, but I never lost interest when walking in less attractive districts, quite the opposite, as they provided me with the complete picture.

My personal perception of CD has changed considerably whilst writing this book as I feel I now have a better understanding of the man himself rather than just the brilliant novelist he was. Whilst his literary acclaim was never in question, I do now have questions to ask about his motives and reasons for certain incidents in his life, which I am not really sure can be overlooked or forgotten simply because he lived in a Victorian society that was thwart with innuendo, snobbery and imperialism. Having only a limited knowledge of CD himself, mainly through the words of talented biographers, who each seem to share their understanding of the great man in a similar vein, I think that recorded events alone are enough to base an opinion on CD's character.

Whilst I salute the efforts CD made to improve the lives of the less fortunate it was his methods that I sometimes questioned. One

problem I had was gaining an understanding of the true essence of the Victorian period in London, which proved difficult indeed whilst the various districts themselves didn't seem to hide any secrets, perhaps their geographical location was reason enough. I must confess that I did find it difficult to totally envisage and appreciate the smells, noises and general conditions CD would have experienced, even though these have been graphically shown and explained in many films and literature.

My imagination took over on all of the walks and I visualised this character Charles Dickens having been transported through time in a similar fashion to the 'Time Traveller' in H.G.Wells gripping novel, The Time Machine. CD in effect walked with me and I did my best to link his time period with today, not as difficult as it might seem as I generally take a digital recorder when planning my walks to record detail, on this occasion I had a walking companion by my side. On occasions I got some strange looks, but that is what I do and it has served me well in the past! In doing so my imagination would sometimes question the change that has occurred, quite 'spooky' one might say seeing that I never experienced first-hand what each location was in real time, even stranger is the fact that I generally question photographic evidence which can sometimes be purely subjective.

Having spent endless hours researching data to complete this book, both by paper and electronic means, I hope that the information I absorbed and published is a true representation of the facts and that the detail is correct. Knowing CD slightly better now, I certainly would not wish to undermine his contribution to the literary world.

How I would love to visit London when CD lived there, only then would I fully understand that period in its entirety. Would CD have been equally as impressive with his age as I am with mine? Would he have wished to live in the 21st century? Would he have devoted the same amount of time to noble causes in the present age? What would he consider appropriate material for 21st century novels? My list goes on and on and perhaps an author one day will attempt to answer these and many more questions.

Finally I should mention other addresses which are associated with CD and London, all of which I feel sure would have a story to

tell and have been stored away in the brilliant mind of Charles John Huffam Dickens.

92 North Road (1832)
21 George Street (Adelphi)
Cecil Street
30 Upper Norton Street
Old Wylde's Farm (1837)
3 Hanover Square (1860-1861)
6 Southwark Place (1866)
Linden Grove (1868-1870)

"Facts alone are wanted in life plant nothing else, and root out everything else."

(Hard Times—1854)

Index